PALGRAVE STUDIES IN THEATRE AND PERFORMANCE HISTORY is a series devoted to the best of theatre/performance scholarship currently available, accessible, and free of jargon. It strives to include a wide range of topics, from the more traditional to those performance forms that in recent years have helped broaden the understanding of what theatre as a category might include (from variety forms as diverse as the circus and burlesque to street buskers, stage magic, and musical theatre, among many others). Although historical, critical, or analytical studies are of special interest, more theoretical projects, if not the dominant thrust of a study, but utilized as important underpinning or as a historiographical or analytical method of exploration, are also of interest. Textual studies of drama or other types of less traditional performance texts are also germane to the series if placed in their cultural, historical, social, or political and economic context. There is no geographical focus for this series and works of excellence of a diverse and international nature, including comparative studies, are sought.

The editor of the series is Don B. Wilmeth (EMERITUS, Brown University), PhD, University of Illinois, who brings to the series over a dozen years as editor of a book series on American theatre and drama, in addition to his own extensive experience as an editor of books and journals. He is the author of several award-winning books and has received numerous career achievement awards, including one for sustained excellence in editing from the Association for Theatre in Higher Education.

Also in the series:

*Undressed for Success* by Brenda Foley
*Theatre, Performance, and the Historical Avant-Garde* by Günter Berghaus
*Theatre, Politics, and Markets in Fin-de-Siècle Paris* by Sally Charnow
*Ghosts of Theatre and Cinema in the Brain* by Mark Pizzato
*Moscow Theatres for Young People: A Cultural History of Ideological Coercion and Artistic Innovation, 1917–2000* by Manon van de Water
*Absence and Memory in Colonial American Theatre* by Odai Johnson
*Vaudeville Wars: How the Keith-Albee and Orpheum Circuits Controlled the Big-Time and Its Performers* by Arthur Frank Wertheim
*Performance and Femininity in Eighteenth-Century German Women's Writing* by Wendy Arons
*Operatic China: Staging Chinese Identity across the Pacific* by Daphne P. Lei
*Transatlantic Stage Stars in Vaudeville and Variety: Celebrity Turns* by Leigh Woods
*Interrogating America Through Theatre and Performance* edited by William W. Demastes and Iris Smith Fischer
*Plays in American Periodicals, 1890–1918* by Susan Harris Smith
*Representation and Identity from Versailles to the Present: The Performing Subject* by Alan Sikes
*Directors and the New Musical Drama: British and American Musical Theatre in the 1980s and 90s* by Miranda Lundskaer-Nielsen
*Beyond the Golden Door: Jewish-American Drama and Jewish-American Experience* by Julius Novick
*American Puppet Modernism: Essays on the Material World in Performance* by John Bell

*On the Uses of the Fantastic in Modern Theatre: Cocteau, Oedipus, and the Monster* by Irene Eynat-Confino

*Staging Stigma: A Critical Examination of the American Freak Show* by Michael M. Chemers, foreword by Jim Ferris

*Performing Magic on the Western Stage: From the Eighteenth Century to the Present* edited by Francesca Coppa, Larry Hass, and James Peck, foreword by Eugene Burger

*Memory in Play: From Aeschylus to Sam Shepard* by Attilio Favorini

*Danjūrō's Girls: Women on the Kabuki Stage* by Loren Edelson

*Mendel's Theatre: Heredity, Eugenics, and Early Twentieth-Century American Drama* by Tamsen Wolff

*Theatre and Religion on Krishna's Stage: Performing in Vrindavan* by David V. Mason

*Rogue Performances: Staging the Underclasses in Early American Theatre Culture* by Peter P. Reed

*Broadway and Corporate Capitalism: The Rise of the Professional-Managerial Class, 1900–1920* by Michael Schwartz

*Lady Macbeth in America: From the Stage to the White House* by Gay Smith

*Performing Bodies in Pain: Medieval and Post-Modern Martyrs, Mystics, and Artists* by Marla Carlson

*Early-Twentieth-Century Frontier Dramas on Broadway: Situating the Western Experience in Performing Arts* by Richard Wattenberg

*Staging the People: Community and Identity in the Federal Theatre Project* by Elizabeth A. Osborne

*Russian Culture and Theatrical Performance in America, 1891–1933* by Valleri J. Hohman

*Baggy Pants Comedy: Burlesque and the Oral Tradition* by Andrew Davis

*Transposing Broadway: Jews, Assimilation, and the American Musical* by Stuart J. Hecht

*The Drama of Marriage: Gay Playwrights/Straight Unions from Oscar Wilde to the Present* by John M. Clum

*Mei Lanfang and the Twentieth-Century International Stage: Chinese Theatre Placed and Displaced* by Min Tian

*Hijikata Tatsumi and Butoh: Dancing in a Pool of Gray Grits* by Bruce Baird

*Staging Holocaust Resistance* by Gene A. Plunka

*Acts of Manhood: The Performance of Masculinity on the American Stage, 1828–1865* by Karl M. Kippola

*Loss and Cultural Remains in Performance: The Ghosts of the Franklin Expedition* by Heather Davis-Fisch

Uncle Tom's Cabin *on the American Stage and Screen* by John W. Frick

*Theatre, Youth, and Culture: A Critical and Historical Exploration* by Manon van de Water

*Stage Designers in Early Twentieth-Century America: Artists, Activists, Cultural Critics* by Christin Essin

*Audrey Wood and the Playwrights* by Milly S. Barranger

*Performing Hybridity in Colonial-Modern China* by Siyuan Liu

*A Sustainable Theatre: Jasper Deeter at Hedgerow* by Barry B. Witham

*The Group Theatre: Passion, Politics, and Performance in the Depression Era*
by Helen Chinoy and edited by Don B. Wilmeth and Milly S. Barranger

*Cultivating National Identity through Performance: American Pleasure Gardens and Entertainment* by Naomi J. Stubbs

*Entertaining Children: The Participation of Youth in the Entertainment Industry* edited by Gillian Arrighi and Victor Emeljanow

*America's First Regional Theatre: The Cleveland Play House and Its Search for a Home* by Jeffrey Ullom

*Class Divisions on the Broadway Stage: The Staging and Taming of the I.W.W.* by Michael Schwartz

*The New Humor in the Progressive Era: Americanization and the Vaudeville Comedian* by Rick DesRochers

*American Playwriting and the Anti-Political Prejudice: Twentieth- and Twenty-First-Century Perspectives* by Nelson Pressley

*Staging the Slums, Slumming the Stage: Class, Poverty, Ethnicity, and Sexuality in American Theatre, 1890–1916* by J. Chris Westgate

*The Theatre of the Occult Revival: Alternative Spiritual Performance from 1875 to the Present* by Edmund B. Lingan

*Performance Reconstruction and Spanish Golden Age Drama: Reviving and Revising the Comedia* by Laura L. Vidler

*W. C. Fields from Burlesque and Vaudeville to Broadway: Becoming a Comedian* by Arthur Frank Wertheim

# W. C. Fields from Burlesque and Vaudeville to Broadway

## Becoming a Comedian

*Arthur Frank Wertheim*

palgrave
macmillan

W. C. FIELDS FROM BURLESQUE AND VAUDEVILLE TO BROADWAY
Copyright © Arthur Frank Wertheim, 2014.

All rights reserved.
First published in 2014 by
PALGRAVE MACMILLAN®
in the United States—a division of St. Martin's Press LLC,
175 Fifth Avenue, New York, NY 10010.

Where this book is distributed in the UK, Europe and the rest of the world,
this is by Palgrave Macmillan, a division of Macmillan Publishers Limited,
registered in England, company number 785998, of Houndmills,
Basingstoke, Hampshire RG21 6XS.

Palgrave Macmillan is the global academic imprint of the above companies
and has companies and representatives throughout the world.

Palgrave® and Macmillan® are registered trademarks in the United States,
the United Kingdom, Europe and other countries.

ISBN: 978–1–137–30066–9

Library of Congress Cataloging-in-Publication Data

Wertheim, Arthur Frank, 1935–
    W. C. Fields from burlesque and vaudeville to Broadway / Arthur
Frank Wertheim.
        pages cm.—(Palgrave studies in theatre and performance history)
    Includes bibliographical references and index.
    ISBN 978–1–137–30066–9 (alk. paper)
    1. Fields, W. C. (William Claude), 1880–1946. 2. Comedians—United
States—Biography. 3. Entertainers—United States—Biography.
4. Burlesque (Theater)—United States—Biography. 5. Vaudeville—
United States—Biography. 6. Theater—New York (State)—New York—
Biography. I. Title.

PN2287.F45W48 2015
791.4302′8092—dc23                                              2014026632
[B]

A catalogue record of the book is available from the British Library.

Design by Newgen Knowledge Works (P) Ltd., Chennai, India.

First edition: December 2014

10 9 8 7 6 5 4 3 2 1

*For my grandson*

*Samuel*

*May you grow up to find*
*"peace in oneself, peace in the world"—*
*Thich Nhat Hanh*

*And*

*For Scarlet*

*"My little [companion] dog; a heart beat at my feet"—*
*Edith Wharton*

# Contents ⌘

*List of Illustrations*                                                    xi

*Acknowledgments*                                                          xiii

*Symbols and Abbreviations*                                                xix

*Prologue*                                                                 xxiii

Introduction                                                              1

### Part I    The Fledgling Years

1.  Meet the Dukenfields                                                   9

2.  Life with Father                                                       27

### Part II    The Training Ground

3.  The Tramp Juggler                                                      43

4.  Initiation Rites                                                       57

5.  The Sly Conjurer                                                       71

6.  The Big Time                                                           85

### Part III    "All the World's a Stage"

7.  "A Master Pantomimist"                                                 97

8.  "My Art Never Satisfies Me"                                            113

9.  To the Antipodes                                                       125

10.  The Trouper on the Flying Trapeze                                     139

11.  The Ham Tree                                                          149

**Part IV   "What Therefore God Hath Joined Together, Let Not Man Put Asunder"**

12. The Breakup                                     157

13. The Affair                                      169

**Part V   The Labyrinth to the *Ziegfeld Follies***

14. The Road to the Palace                          181

15. The Second Home                                 197

16. "They Had Me Sweating Blood"                    213

17. Backstabbed                                     219

*Epilogue: The Defining Moment*                     227

*Notes*                                             231

*Index*                                             251

# Illustrations ❧

P.1   As Professor Eustace P. McGargle, head of a ragtime
      traveling circus, Fields operates the old army or shell
      game in *Sally of the Sawdust* (1925)                          xxiv
1.1   The Darby Furniture Exchange (1922). Formerly the
      Arlington House, Darby, PA. W. C. Fields's birthplace            11
1.2   View of Industrial Sheffield, 1854, the year John
      Duckenfield (Fields's grandfather) left the city                12
1.3   Kate Felton Dukenfield, Fields's mother                         16
2.1   Market Street at Delaware riverfront, ca. 1894                  31
2.2   James Lydon Dukenfield wearing his Civil War uniform
      and medals. Note his war wounds, the missing fingers on
      his left hand                                                    32
4.1   Fortescue's Pavilion, Atlantic City, NJ, where Fields
      performed and faked being drowned during August
      1898 for "Ten Dollars and Cakes" weekly                         60
5.1   W. C. Fields as a minstrel performer with Murphy and
      Gibson's American Minstrels in Atlantic City, July 1899         75
5.2   Fields blaming Hattie for a missed trick. *Irwin's
      Burlesquers*, 1899–1900                                         78
5.3   Poster advertising Fields in the *Irwin's Burlesquers*,
      1899–1900                                                       82
8.1   Performers from the Great Orpheum show, who traveled
      together as a group, 1901–02                                   114
8.2   Fields performing his signature stick and hat trick           119
9.1   W. C. Fields in Sydney, Australia. ca. July–September 1903     130
10.1  Fields showing his father the sights of Paris,
      November 1904                                                  143
12.1  Portrait of Maud Emily Fendick, ca. 1897–1904                 158
12.2  Happier times with Claude Jr.                                  162

14.1   A typical newspaper illustration by Fields depicting fellow
       performers on the playbill at the Detroit Temple Theater        191
15.1   Fields performing his cigar-box trick at the London
       Coliseum, October 1908                                          204
17.1   As Gabby Gilfoil, Fields performs his cigar-box stunt in
       the lost silent picture *Two Flaming Youths* (1927)             224

# Acknowledgments ❧

F irst and foremost, I owe a debt of gratitude to the grandchildren of W. C. Fields: Dr. Harriet A. Fields; Ronald J. Fields; William C. Fields, III; and Allen Fields. All graciously granted me full support and cooperation to write about their grandfather. They consented to interviews, which yielded significant information and insights. During a visit to the Library of Congress to research Fields's copyrighted stage sketches, I learned that Harriet Fields lived in Washington, DC. Over lunch we had an informative conversation about her grandfather during which she encouraged my project and offered to assist me. From that time to the present, her help has proved to be invaluable. Her family's goal is to ensure that current generations and generations to come know the joy of their grandfather's art through humor, and most importantly, to make his work accessible to the world community.

Toward that end, the family has given the Margaret Herrick Library at the Academy of Motion Picture Arts and Sciences Fields's papers, memorabilia, and artifacts—a voluminous treasure trove that covers the humorist's entire life and career from beginning to end. Since Fields appeared in nearly every form of popular entertainment during the first half of the twentieth century—from burlesque to the talkies—the papers provide a wealth of information for researchers in the performing arts. Its vast scope (correspondence, writings, illustrations, scripts, movie production files, stage files, radio files, subject files, scrapbooks, contracts, financial papers, estate and probate research files, among others) makes it possibly the nation's richest collection of a performing artist.

Many thanks are extended to Linda Harris Mehr, the director of the Margaret Herrick Library and to the diligent archivists in the library's Department of Special Collections for their aid in helping me research the Fields Papers: Barbara Hall, Research Archivist, and Howard Prouty, Acquisitions Archivist. Faye Thompson, Photograph Department Coordinator, helped me select the many photographs in the Fields collection and order digital copies. The staff behind the desk was extremely

efficient in paging the material, making items available every day, and photocopying what I needed. Together they made my innumerable visits to the library a very pleasant experience. The Fields family chose a superb archive for a researcher place to work and a wonderful home for their grandfather's valuable collection.

I might still be wading through the Fields Papers if it were not for my research assistant, Dr. Emily Carmen. I can not thank her enough for her diligent work. She shared in the research at the library, typed documents unavailable for photocopying, and did numerous transcriptions. A superb film scholar, Emily's knowledge of cinema history aided me in understanding Fields's movie career.

Individuals at other libraries and archives also deserve my gratitude for their help. Utmost is the help of Dr. Barbara Bair, Historian, Manuscript Division at the Library of Congress. She helped guide me through the collections that deal with W. C. Fields, especially the large number of copyrighted stage sketches he deposited at the library. Barbara introduced me to Literary Manuscript Historian Alice Birney, the American literature and culture specialist, in the Manuscript Division. Her knowledge of Fields's manuscript material in the library proved extremely helpful. Besides the stage skits, I found a rare manuscript of *The Ham Tree*, a play in which Fields performed and other valuable documents. Through Barbara I also met Alan Gevinson, Special Assistant to the Packard Campus Chief, Motion Pictures and Recorded Sound Division, who shared his knowledge of vaudeville and Fields's career. The staff of the Motion Pictures Division helped me view *So's Your Old Man* (1926), a silent feature starring Fields, only available at the library. Bruce Kirby, Manuscript Reference Librarian, Manuscript Division, answered many questions regarding pertinent holdings.

I am extremely appreciative to individuals in Darby, Pennsylvania, who helped me find information about Fields's birthplace. My gratitude begins with the staff of the Darby Public Library, considered to be the nation's oldest public library (1773). The librarians, particularly Betty Schnell, provided me with information about Fields's birthplace. Besides the town librarians, John Haigis conveyed a wealth of knowledge about the Arlington House, Darby history, and photographs. Howard Tyson also sent me helpful information about the Arlington House, his website series on "The Legend of Whitey," and his chapter on Fields in *Penn's Luminous City*.

My thanks are also extended to the staff of numerous other libraries who were very helpful: Ned Comstock, Cinematic Art Library, University

of Southern California, who helped guide me through their various collections and oversaw the photocopying of important material; Geraldine Duclow, archivist, Free Library of Philadelphia; staff, Harvard Theatre Collection; Margaret Stevens-Garmon, Theatre Collections Archivist, Museum of the City of New York; Rick Watson, Research Associate, Performing Arts Collection, Harry Ransom Research Center, University of Texas, Austin; Nick Munatian, James McIntyre and Thomas Heath Archive, Charles Deering McCormick Library, Special Collections, Northwestern University; staff, Charles Dillingham Papers, Manuscripts and Archive Division, New York Public Library; staff, Billy Rose Theatre Collection, New York Public Library for the Performing Arts; and Lauren Buisson, Head of Operations, who provided access to the Emmet Lavery Papers housed in the Arts Library, Young Research Library, UCLA. Without access to the voluminous book collection at UCLA's Charles Young Library, I might never have been able to attain all the known and obscure secondary sources needed for understanding Fields's life and career.

I would like to mention special individuals who contributed to the research. Ron Hutchinson of The Vitaphone Project gave me a film of the 1928 *Earl Carroll Vanities* starring Fields. Thanks also to Brad Smith, who sent me a home movie taken by his father (George K. Mann of Barto & Mann; performers in the 1928 *Vanities*) showing Fields outside his home in Long Island when he starred in the *Vanities*. Denise Sanborn Schoo provided crucial knowledge regarding her great aunt Maud Emily Fenwick and her family, including a rare photograph of Maud. My thanks also to Nils Hanson, author of an excellent book on Lillian Lorraine, who made available information about the *Ziegfeld Follies,* photographs from the show, and newspaper accounts about Bessie Poole.

I would be remiss if I failed to mention the authors of several books on Fields. Their findings and writings were extremely helpful to me as guideposts to the Fields story. Extremely useful are the two books by his grandson, Ronald J. Fields, *W. C. Fields by Himself* (1973) and *W. C. Fields: A Life on Film* (1984). The former is an excellent groundbreaking book comprising considerable letters and documents about his grandfather. His other book on his grandfather's films contains a gold mine of information about Fields's movie career. I very much appreciate his kindness in granting me permission to quote from the two books.

Other books were valuable to my research. Wes D. Gehring's *W. C. Fields A Bio-Bibliography* (1984) and *Groucho and W. C. Fields: Huckster Comedians* (1994) contain gems of information and insights about the

comedian's life and comedy. Gehring deserves special credit for first writing about Fields's valuable stage scripts in the Library of Congress. The scripts proved crucial to understanding the evolution of Fields's comedy and the importance of his stage work to his film career. David T. Rock's *W. C. Fields—An Annotated Guide* (1993) is also valuable for its lists of chronology, bibliography, filmography, cartoons, recordings, and miscellaneous subjects. Two other books, *W. C. Fields: A Biography* (2003) by James Curtis and *Man on the Flying Trapeze: The Life and Times of W. C. Fields* (1997) by Simon Louvish, provide a wealth of new information about their subject. They are important for disproving many legends about Fields. Both books were helpful to my study, especially for cutting through the fog of fabrications and double checking facts.

The preparation and production of this book included several individuals, whom I especially wish to thank. First, I very much appreciate the strong support of Don B. Wilmeth, editor, Palgrave Studies in Theatre and Performance History, who granted me the opportunity again to contribute to his outstanding series. Named Asa Messer Emeritus Professor of Theatre and English, Brown University, Don has contributed more than sixty works in theater and performance history, including recently coediting *The Group Theatre* (2013). He was honored with the 2012 Theatre History Preservation Award from the Theatre Museum for his remarkable achievements. I wish very much to thank him for recognizing the important need for a study about W. C. Fields.

Crucial to the book's publication are the diligent editors at Palgrave Macmillan in charge of Studies in Theatre and Performance History. Robyn Curtis, editor, has been wonderful to work with, extremely helpful in answering my queries, and finding solutions to the many problems I encountered. Erica Buchman, assistant editor, answered my queries quickly and helped me complete the numerous required documents necessary for the book's publication. I wish to extend my thanks to both for their conscientious assistance.

In May 2009, I attended Professor Deborah Martinson's seminar on biography at the Norman Mailer Center in Provincetown, Massachusett. In this regard, I would like thank Lawrence Schiller, the Center's president and co-founder, and the Center's staff for granting me an award to attend the seminar. Deborah Martinson is the author of the well-received *Lillian Hellman: A Life with Foxes and Scoundrels* (2005). Her knowledge about the art of biography was extremely helpful in shaping this book. In addition, she provided significant support for my proposal

to Palgrave about undertaking this study of Fields. My acknowledge-
ments unfortunately must end on a sad note. Deborah recently died
from cancer before she could finish another biography. Her sudden pass-
ing is a great loss to the community of biographers, to her colleagues,
and to her students at Occidental College. Deborah's inspiration will be
deeply missed.

# Symbols and Abbreviations ❧

## FREQUENTLY CITED NAMES AND SOURCES

WCF        William Claude Fields

WCFBH    *W. C. Fields By Himself: His Intended Autobiography,*
commentary by Ronald J. Fields (Englewood Cliffs, NJ:
Prentice-Hall, 1973).

WCFP      W. C. Fields Papers, Academy of Motion Picture Arts
and Sciences, Margaret Herrick Library, Department of
Special Collections, Beverly Hills, CA.

## MANUSCRIPT COLLECTIONS AND ARCHIVE SYMBOLS

AEFTAM    Actors' Equity Files, Tamiment Library, Robert F.
Wagner Labor Archives, New York University, New York,
NY.

AMPAS    Academy of Motion Picture Arts and Sciences, Margaret
Herrick Library, Department of Special Collections,
Beverly Hills, CA.

CBD       Charles Bancroft Dillingham Papers, New York Public
Library, Manuscripts and Archives Division, New York,
NY.

CFOHCU    Center for Oral History, Butler Library, Columbia
University, New York, NY.

ELP       Emmett Lavery Papers, Arts Library Special Collections,
Young Research Library, University of California at Los
Angeles, CA.

HTC       Harvard Theatre Collection, Houghton Library, Harvard
University, Cambridge, MA.

KAC       Keith-Albee Collection, University Libraries, Special
Collections, University of Iowa, Iowa City, IA.

| | |
|---|---|
| MMIOHP | Museum of the Moving Image Oral History Program, Astoria, Queens, New York, NY. |
| MOMAFST | Museum of Modern Art, Film Study Center, New York, NY. |
| MPD-LOC | Motion Picture Division, Library of Congress, Washington, DC. |
| MRR-LOC | Main Reading Room, Library of Congress, Washington, DC. |
| MSD-LOC | Manuscript Division, Library of Congress, Washington, DC. |
| NYPAL | New York Public Library for the Performing Arts, Billy Rose Theatre Collection & Robinson-Locke Collection, Lincoln Center, New York, NY. |
| PFL | Philadelphia Free Library, Philadelphia, PA. |
| PHS | Philadelphia Historical Society, Philadelphia, PA. |
| THTS-SCNU | *The Ham Tree* Script, McIntyre and Heath Archive, Special Collections, Charles Deering McCormick Library, Northwestern University, Evanston, IL. |

## BOOKS

| | |
|---|---|
| VW | Arthur Frank Wertheim, *Vaudeville Wars: How the Keith-Albee and Orpheum Circuits Controlled the Big-time and Its Performers* (New York: Palgrave Macmillan, 2006). |
| WCFALOF | Ronald J. Fields, *W. C. Fields: A Life on Film* (New York: St. Martin's Press, 1984). |

## NEWSPAPERS AND MAGAZINES

| | |
|---|---|
| BG | *Boston Globe* |
| CEP | *Chicago Evening Post* |
| CT | *Chicago Tribune* |
| HR | *Hollywood Reporter* |
| LADT | *Los Angeles Daily Times* |
| LAEE | *Los Angeles Evening Express* |
| LAHE | *Los Angeles Herald Examiner* |
| LAT | *Los Angeles Times* |

| | |
|---|---|
| LST | *London Sunday Times* |
| NYC | *New York Clipper* |
| NYDM | *New York Dramatic Mirror* |
| NYEJ | *New York Evening Journal* |
| NYEP | *New York Evening Post* |
| NYEW | *New York Evening World* |
| NYG | *New York Graphic* |
| NYH | *New York Herald* |
| NYHT | *New York Herald Tribune* |
| NYMT | *New York Morning Telegraph* |
| NYN | *New York News* |
| NYP | *New York Post* |
| NYST | *New York Sunday Telegraph* |
| NYT | *New York Times* |
| NYTEL | *New York Telegram* |
| NYW | *New York World* |
| NYWT | *New York World Telegram* |
| PPB | *Paramount Press Book* |
| PI | *Philadelphia Inquirer* |
| PSB | *Philadelphia Sunday Bulletin* |
| PSBM | *Philadelphia Sunday Bulletin Magazine* |
| SEP | *Saturday Evening Post* |
| SFC | *San Francisco Chronicle* |
| SFDM | *San Francisco Dramatic Mirror* |

# Prologue ∽

"It's the old army game," shouted the Professor. "One will get you two, two will get you four, four will get you eight. Find the little pea. It's the old army game. A boy can play as well as a man." A lean Irishman with curly thinning hair, the Professor was giving his spiel to lure customers to play the shell game at the Trenton Inter-State Fair in New Jersey. Known in small-time show-biz circles as William (Bill) T. Dailey, he performed on stage as a boisterous singer and eccentric dancer. A petty conjurer, Dailey "was considered an expert shell manipulator."[1] Standing by his side was his assistant, a young thin teenager with fair skin named Whitey Dukenfield. He was called "Whitey" by his friends because of his bright flock of light blond hair perched atop a handsome boyish face with striking blue eyes.

On a chilly day in October at a train stop outside Philadelphia, the Professor and Whitey sneaked on board a baggage car where the tender that carried fuel and water was located. On a bridge over the Delaware River a train worker scooped a large amount of water from the river into the tender's trough causing the tank to overflow onto the two stowaways. Soaked by "an unexpected cold shower," Whitey and the Professor arrived at the fair shivering in damp clothes.[2]

The Professor expected to make some easy money at the Trenton Fair. Since 1888 the fair had become a popular event advertised as "unapproachable in excellence of exhibits and magnitude of attendance."[3] The grounds contained exhibition buildings that displayed regional agricultural products, livestock, culinary arts, and handicrafts as well as a grandstand with a half mile track where horse races were held. Among the events during its first year had been a shooting match featuring Annie Oakley and Miles Johnson from Pawnee Bill's Wild West Show. On the day the Professor and Whitey sneaked into the grounds, the grandstand featured a race between a horse and a two-man bicycle team.

From his luggage the Professor unpacked three walnut shells and a tiny ball made of rolled dough called the "little pea" and placed the items on

several boxes that served as a table. As soon as a crowd of people surrounded him, the Professor started the shell game, a centuries-old rigged gambling scheme. During the Civil War, soldiers played it to relieve boredom during bivouac and called their pastime "the old army game." Whitey's father had told him "that immediately following the Civil War the circus grifters and con men working the shell game all used the expression 'It's the old army game; a boy can play as well as a man.' The idea was to inspire confidence in the sucker. I never really got the low-down from Pa whether he went against the game or was a worker, but he was well up on it."[4]

As the shill or shillaber for the Professor, Whitey's role was to make the first bet and to win by correctly guessing which shell the pea was under. His aim was to entice a customer called the mark, or victim, to play the game. "If the 'sucker' didn't come quickly enough...the shillabers would heed the signal and proceed to buy." Placing a dollar on the table, Whitey pointed to the correct shell and doubled his money. "This interested the

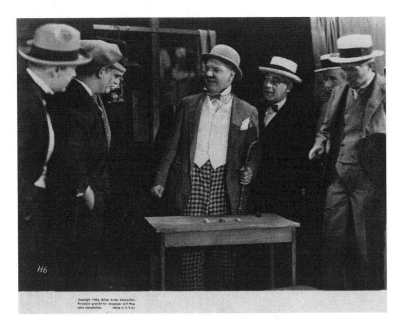

**Figure P.1**    As Professor Eustace P. McGargle, head of a ragtime traveling circus, Fields operates the old army or shell game in *Sally of the Sawdust* (1925). Courtesy W. C. Fields Productions, Inc., www.wcfields.com

customers," he recalled. "The ball was rolling." Thinking it was easy, a spectator played the game but never won due to the Professor's speedy sleight of hand. He could easily take a pea and put it under a shell unnoticed by the mark or make it disappear through a secret compartment. The ruse continued until a policeman spotted the illegal gambling, arrested the Professor, and with a swift, hard kick booted Whitey on his buttocks. "[I] headed for the brambles still dark and damp from $H_2O$," he recalled. "I made Philadelphia late that night." Whitey had learned that day that scams were easy money and "never to give a sucker an even break."[5]

Whitey later became a world renowned comedian using his stage name—W. C. Fields. The experience at Trenton was instrumental in forming Fields's comic personae as a scam artist and hustler. In the play *Poppy* (1923–24) and its film versions, *Sally of the Sawdust* (1925) and *Poppy* (1936), Fields plays Professor Eustice P. McGargle, a circus juggler and charlatan who makes money playing the shell game. "I never dreamed then that someday I'd have a chance to use all the stuff I unconsciously absorbed from these guys," Fields said. "But when I started to rehearse the part all sorts of things came back to me, things that I didn't even know I remembered. So if Prof. McGargle seems like a real person that is the reason why."[6]

Movies, he once declared, had become "too nice, too refined...I want to restore the old hokum—the old army game."[7] Fields used his comedy to become an irreverent iconoclast who lampooned and debunked society's sacred cows.

Behind his comedic mask lay a deeply troubled individual plagued by emotional anguish, which originated in his childhood and persisted throughout his life. Fields's comedy largely sprung from this pain and became a way to ease his distress. When his agony later became increasingly unbearable, he smothered his hurt with alcohol. The unparalleled saga of W. C. Fields rising from a tramp juggler in vaudeville to a celebrity on stage and screen does not end with his death. Whitey Dukenfield grew up to become a legendary American comedian, who left a legacy of laughter for generations to come.

# Introduction ✌

M y life with W. C. Fields started on a spring day in May 2007. An article in *The Los Angeles Times* announced that the Academy of Motion Pictures Arts and Sciences was staging an exhibition on its fourth floor gallery titled: "The Amazing Peregrinations and Pettifoggery of One William Claude Dukenfield, late of Philadelphia, Pa., familiarly known to Crowned Heads and Hoi Polloi alike as W. C. Fields."

Entering the door to the show, I was bowled over by the sight. The walls were covered with colorful posters; original playbills; handwritten and typed personal letters; contracts; cartoons; photographs; stage scripts; movie scenarios; souvenirs from his performances abroad; and much more material. At one end of the room gales of laughter stemmed from visitors watching his films. The show embodied a treasure trove of memorabilia recently donated by the Fields family so that the public might encounter the astonishing career of an eminent comedian, who brought so much hilarity to people around the world.

As if he was a skeleton in a closet, the Fields Papers were once padlocked in the basement of his widow's home. Fields's five grandchildren were not even allowed to see what was hidden behind the bolted door. They believed that the "Bogeyman" lived in the basement. After Fields's widow died, the contents were placed in storage. The curse of silence about the comedian was finally broken by his grandson, Ronald J. Fields, who gained access and released his findings in his groundbreaking book *W. C. Fields By Himself* (1973). His complete papers still remained unavailable for researchers until the family gifted them to the Academy.

After the show, I was granted permission to research the material with the goal of possibly writing a book. After perusing the multi-page inventory and the material for a few months, I became convinced that the more than seventy boxes in the Fields Papers were possibly the most voluminous and valuable collection of a performer's career in the nation. The material begins with his date book listing his first stage appearances in 1898 and

ends with papers about his lengthy confrontational probate trial lasting until the mid-1950s.

The Fields Papers are a gold mine. A journey through Fields's professional career from 1898 to 1946 is an incredible ride that yields significant information about his appearances in practically every performance art during the first half of the twentieth century: club shows; burlesque; medicine, museum, and minstrel shows; US vaudeville; British music halls; leading European variety theaters; and three Broadway revues. The list never seems to end: performances in seven annual *Ziegfeld Follies* productions; a star in the long-running Broadway show *Poppy*; twelve silent movies; thirty-two sound shorts and features; guest spots on radio comedy programs; and a recording artist six months before his death.

As I worked my way through the research, a number of revelations stood out. Fields's long stage career from 1898 to 1930 had a major influence on his comedy. While on the stage he created comic characters such as the sly charlatan and aggravated husband, two impersonations which reappear in his films. He repeats his first vaudeville act juggling balls and manipulating cigar boxes for the screen. His stage sketches as a pool hustler and frustrated golfer are recycled in his films, *Pool Sharks* (1915) and *The Golf Specialist* (1930). Three of his four shorts for Mack Sennett stem from his stage sketches. Fields's classic "Back Porch" scene from the 1925 *Ziegfeld Follies* is repeated in the silent picture *It's the Old Army Game* (1926) and the sound film *It's a Gift* (1934). Three of his last movies can even be traced back to his theatrical career. His tendency to repeatedly reuse his stage scenes in his films might have wrecked his career. But Fields possessed an amazing talent to make his sketches appear pristine and side-splitting on the screen.

Compared to his career in films, books and articles about Fields devote less space to his experience before the footlights. The public mostly think of Fields as a screen comedian rather than an itinerant trouper—and with good reason. Many films have survived, are screened at festivals and on television, and are available on DVD. To understand his work in the theater, one needs to study scripts of his stage performances, fortunately available in the Fields Papers and the Library of Congress, trace their conception, read reviews, and dig further to find additional material.

A pressing need exists to examine in depth the significance of Fields's stage career and how it shaped his artistry. Fields undoubtedly added new dimensions to his comedy after he went to Hollywood permanently in 1930 to make films. But he took with him not only his stage scenarios but the techniques he had learned in the theater. *W. C. Fields from Burlesque*

*and Vaudeville to Broadway: Becoming a Comedian* is the first of two books that aim to fill this large gap in our knowledge of a legendary comedian.

The Fields Papers unearthed another finding—Fields first became a comedian not on the screen but on the stage. The transition from tramp juggler to a comic juggler occurred very early in his stage career. While a performer in *Fred Irwin's Burlesquers* in 1899 he makes a monumental decision—he will use juggling as a means to furnish comedy in his act. This conversion partly occurred because he wanted to make his act stand out among other jugglers. A second more compelling reason is that comedy came naturally to him. It was in his DNA.

Since Fields's juggling act was mostly silent, he turned to pantomime to amuse his audience. He never trained as a pantomimic artist; it happened instinctively. Fields intentionally misses a trick, grimaces, feigns embarrassment, and then completes the stunt, which provokes theatergoers to laugh heartily. Building on his talent, he shows various emotions by using different body movements, diverse facial expressions and gestures, and unique mimicry. As a universal language, pantomime became especially useful while he entertained in a foreign country. Soon Fields is advertised as a silent humorist, an eccentric comedy juggler, and a *komischer jongleur* in Germany.

Compared to Chaplin, film aficionados rarely think of Fields as a pantomime comedian. This area of his comedic talent has been sorely neglected in books and journals. Fields hones his flair for pantomime on the Broadway stage and uses this skill in his silent motion pictures, which require feelings to be expressed by an actor's movements. Although his inimitable voice usurps the screen in his Talkies, Fields still uses pantomime to demonstrate his emotions. His most noticeable nonverbal action on the stage and screen is his famous Fieldsian flinch—the way he winces when assaulted by a threatening object or human being. *W. C. Fields from Burlesque and Vaudeville to Broadway: Becoming a Comedian* breaks new ground by showing how his humor initially evolved on the stage in the form of pantomime.

Fields's massive correspondence sheds light on considerable new information about his private life—another major subject in the book. The letters help to unravel many legends about him. To know the real Fields presents an awesome challenge to discover the truth behind the many fabrications, beginning with the comedian's own exaggerated tales about his life. Adding to the conundrum are the numerous trumped-up stories written by studio publicists and fan magazine hacks anxious to create an exciting rags-to-riches tale about a runaway poverty-stricken lad who climbed

to fame. Thanks to the Fields Papers the book is able to answer numerous questions about Fields's life. They range from the commonplace (what was Fields's birth name?) to the intriguing (who was the woman who broke up Fields's marriage by living with him?).

His letters reveal that his comic persona and private life are strongly intertwined. The correspondence provides insights into his tragic relationships with his wife and son; affairs with other women; clashes with his father; battles with censors; confrontations with stage producers and film moguls. They expose his complex and contradictory dual personality—prejudice vs. tolerance; stingy vs. generosity; spitefulness vs. kindheartedness, and many more paradoxical antitheses. Because Fields's wife refused to divorce him the correspondence between the two ranges from the practical (constant complaints that the money he sends her is too little) to the vitriolic (wild accusations about each other). His wife controls their son and feeds him unflattering stories about his father. Fields and his son consequently remain estranged for years.

The letters unearth a life full of despair. In his mind his tyrannical father becomes a demon who haunts him all his life. He is caught in a never-ending repetitive cycle with women. Fields's occasional lengthy affairs disintegrate, leaving him lonely until he finds another companion, who eventually departs. He pays the price for treading on a continual precarious path as an entertainer. His roller coaster show biz career alternates from the depths of unemployment with its depression to the pinnacle of fame. Adoration from his fans filled a void in his life. Needing recognition, Bill was persistently afflicted by a relentless insecurity about his reception by the public. The Fields Papers reveal that alcoholism ran in both the paternal and maternal sides of his family. Besides inheriting the DNA marker, he turned to heavy drinking partly as a means to drown his demons in a sea of liquor. His imbibing began when he was on the Broadway stage in the 1915 *Ziegfeld Follies*. With its bars, restaurant, and nightclubs, the Broadway scene was conducive to the practice. Fields never broke the habit, increased his consumption to such a degree that it became part of his on-screen personality. By then he was on the road to self-destruction.

Fields felt that emotional pain was a springboard for his comedy. His excruciating relationships impacted his persona on stage and screen; propelled him to impersonate the beleaguered husband tormented by a despotic wife and sassy son. Fields's role as a confidence man, pool hustler, and card shark stems from the crookedness he experienced as a showman and from his fellow beings. Fields's personal life and public

persona coalesced to create a famous stinging American iconoclast, who through satire and parody lashed out at sacrosanct institutions and society's fraudulence.

*W. C. Fields from Burlesque and Vaudeville to Broadway: Becoming a Comedian* (and its sequel subtitled *Becoming a Cultural Icon*) chronicle the saga of a virtuoso humorist, often called a comic genius, legendary iconoclast, and "Great Man." The two books tell a story about a legendary comedian who brought so much hilarity to millions while enduring so much anguish. Fields's comedy and drinking were a means to keep his demons at bay. The two remedies—liquor and comedy—generated different endings to the same life. If alcoholism precipitated Fields's death, his comedy gave the world the gift of laughter for generations to come.

# Part I  The Fledgling Years

# 1. Meet the Dukenfields ᡈ

On a mild winter day on January 29, 1880, a baby was born a month earlier than expected to Kate Dukenfield. The birth occurred at the Arlington House in the borough of Darby. Located on the northeast corner of Main and Mill Streets in the town's center, the Arlington House was an unpretentious inn, where Kate and her husband, Jim, worked. A hearty British immigrant nearly forty years of age, Jim tended bar for the inn's guests, numerous horse traders, local dock laborers, and mill workers who drank well into the night. When Kate suddenly experienced labor pains she was rushed to a room where she gave birth. According to family legend, Kitty, an African American soothsayer and hotel employee, placed a golden spoon in the boy's mouth. She predicted that the newly arrived infant was "going to get someplace." Kitty was prophetic. Later known as W. C. Fields, the baby grew to become, "the foremost American comedian," Harold Lloyd stated.[1]

Located about five miles southwest of Philadelphia, Darby was settled in 1662 by eight Quaker families, who were encouraged by William Penn to form a community nestled in a bucolic area between two waterways, Darby and Cobbs Creeks. The town, named after the English city of Derby, is the birthplace of John Bartram (1699–1777), America's first botanist, who created the country's first botanical garden on his homestead, which today is a 45-acre national historic landmark. The town claims to have the nation's oldest public library (1743), which still serves patrons today.

When Fields was born, Darby had grown into a bustling mill town and freight transportation center with 1,776 inhabitants, but during the day, thousands of workers crowded the town's center. Darby Creek served as a navigable passageway on which barges brought supplies for the borough's many factories, mills, farms, and stores. Sawmills, tanning mills, and textile mills provided commodities for its settlers and for shipment to other communities. The mills' chimneys combined with the smokestacks from other industries emitted a perennial gray haze over the town and a smelly odor, which varied according to which way the wind blew.

The exact location of Fields's birth remains a subject of considerable controversy. Known as the Gateway to the South for many travelers on their way to Philadelphia and other destinations, Darby once included thirty-nine hotels, taverns, and boardinghouses. The hotels catered to travelers; the boardinghouses lodged numerous mill laborers; and the noisy taverns hosted hardened drinkers noted for their late-night carousing. The Buttonwood, the town's most famous historic hotel, has often been mentioned as a candidate for Fields's entry into the world. But the hotel underwent construction in 1879 and, unlike the Arlington House, was an upscale lodging unlikely to hire the Dukenfields. (George Washington is rumored to have slept here and given a white horse.) Other inns such as the Blue Bell do not match the birthplace's description.

An early history of Delaware County described the Arlington House's origin and its brief period to serve liquor. "In 1880 the stone house which had formerly stood near the old Steel mill, and was moved bodily several hundred feet to the main street, was licensed as the Arlington House, but after a brief period the court refused to continue the privilege there."[2] The Arlington stood adjacent to the three-story Griswold textile mill with its large brick smokestack hovering over the town. Harold S. Finigan, longtime Darby resident and store owner, recalled that his grandfather owned the Arlington House and hired Jim Dukenfield as the manager. The Arlington was known as a noisy establishment noted for its nightly revelry at the bar where Fields's father busily poured shots of whisky and sometimes sang for the guests. After a short time, the Arlington House closed as an inn and tavern. Its failure to obtain a renewed liquor license might have caused its closing, leaving Jim unemployed, a circumstance he regularly experienced.

Finigan's grandfather decided to convert the inn into a furniture store. A photograph taken in 1922 of the Darby Furniture Exchange matches a description of the three-story Arlington House with its stone facade and rectangular belvedere on the roof, which served as a fire lookout and offered a birds-eye view of the town.

The paternal side of Fields's ancestry hailed from England, a heritage that played a significant role in his career. John Duckenfield, Fields's grandfather born in 1810, traced his lineage to the aristocracy. (The family's surname has several variations in spelling.) John's grandfather was Lord Dukinfield of Cheshire, a wealthy aristocratic landowner in northwest England. John's father was George Dukinfield, the lord's third son, who failed to inherit the lord's estate due to the laws of primogeniture that passed wealth to the firstborn son. When close friends of Whitey

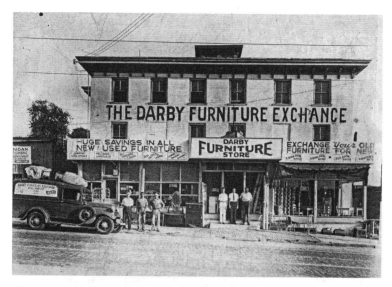

**Figure 1.1**   The Darby Furniture Exchange (1922). Formerly the Arlington House, Darby, PA. W. C. Fields's birthplace. Author's collection. Courtesy, Haigis/Barnes collection.

(Fields's boyhood nickname) learned about his ancestry, they sometimes jokingly called him Lord Fields. The town of Dukinfield is now in Greater Manchester.

John Duckenfield, Fields's grandfather was born in Sheffield, Yorkshire, a city famous for its silver plate and a thriving center for the production of steel and other products during the Industrial Revolution. The only physical characteristic known about John was that he had a large protruding nose like Fields. An artisan, John earned his living as a skilled master combmaker in Sheffield where he and his brother George operated a small cottage industry with four employees on Rockingham Street. Here they produced beautiful handmade haircombs made from cow horns. The combs were fashionable adornments for women who used them to shape long braided hair into attractive buns during the Victorian age. Their factory also made eyeglass frames, buttons, and pocketknives from animal horns. Button making in Sheffield was a trade that dated back to the late seventeenth century.

John, his Irish Catholic wife, Ann Lyden, and their ten children lived in a small rented cottage on Backfields Street, near their workplace and the city's center. As the street's name suggests, their cottage stood "back

to back" against another residence—one facing the street, the other a
court or yard. These typical working-class accommodations consisted of
a ground-floor room used as a kitchen, with an oven and broiler next to
the fireplace, and as a dining and living room. According to custom, John
and Ann slept with their small children in a single room, while the older
children lived in the attic.

Considering the number of children, their cottage must have been
extremely crowded. Among the siblings was Fields's father, James or Jim,
who was born in 1841. Ann and the older children helped out by stain-
ing and polishing the combs. Rumors abounded that Ann's Catholicism
caused considerable friction within the Duckenfield extended Protestant
family.

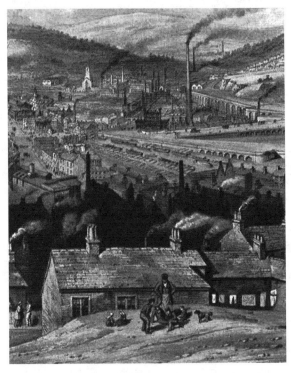

**Figure 1.2**   View of Industrial Sheffield, 1854, the year John Duckenfield
(Fields's grandfather) left the city. William Ibbis, English school (nineteenth cen-
tury/Sheffield Galleries and Museum Trust, UK/photo © Museums Sheffield.
Courtesy the Bridgeman Art Library).

The black smoke emitted from industrial chimneys made Sheffield among the most polluted cities in England. Angus Reach, a reporter for the *Morning Chronicle* charged with investigating working conditions in 1849, found numerous people living in crowded filthy conditions and afflicted with lung diseases due to the massive amounts of dirt in the air. Life expectancy for the steel grinders, who spent long hours stooped over their work, averaged 18.15 years, while the gentry and upper classes, who resided on estates outside the city, lived nearly forty-six years. As late as 1937, the author George Orwell found Sheffield to be the dirtiest and ugliest city in Europe with a stench smelling of sulfur and its river Don polluted and yellow-colored.

The Industrial Revolution impacted artisans such as John Duckenfield. When synthetic haircombs composed of celluloid began to be mass produced in large factories in the mid-nineteenth century, mechanization forced master craftsmen like John out of work. With a large family to feed and seeking a new opportunity, he immigrated to the United States in 1854. Since Ann was pregnant, John decided to travel alone and to send for his family later. He embarked on a ship that was capsized off the coast of Glen Cove, Long Island, but managed to survive the accident and travel to Philadelphia.

John might have selected Philadelphia as a destination for several reasons. It had a reputation as a city for craftsmen called Philadelphia Mechanics. Among them were many British or German immigrants who were skilled artisans. Quite likely the Duckenfields also had relatives in the city. Once he arrived he continued in the combmaking business using horns obtained from surrounding farmland where cattle were plentiful. On November 13, 1854, John filed a declaration of intent to become a citizen.

Contrary to other accounts, Jim did not accompany his father to the United States. With two-year-old Godfrey in her arms, Ann and her six children, including Jim, left Liverpool on the *S. S. Kangaroo* in the freezing winter and arrived safely in Philadelphia on January 2, 1857. The trip must have been an ordeal for forty-one-year-old Ann, despite evidently being a very strong woman with considerable stamina. The family initially lived in the Kensington area in northeastern Philadelphia, known as Little England, where many immigrants from Great Britain worked as weavers in the textile industry. John and his brother worked as combmakers while his industrious wife sold stockings and trimmings from their lodgings on Norris Street. According to the 1860 census, there were thirteen Duckenfields in the household.

Fields's father, age twenty, labored as a peddler and his two brothers as a weaver and bricklayer, unskilled workers subject to unemployment in a fluctuating economy. Even with three older sons and Ann as breadwinners, the family had difficulty making ends meet. In the year Fields was born, Philadelphia's "working-class families suffered a more than $100 short-fall in income over expenses," wrote labor historian Walter Licht. "Their incomes were needed for family survival, especially when layoffs were a persuasive reality. Philadelphia in fact had the largest percentage of fami-lies with more than one breadwinner of all industrial cities."[3]

Industrialization in Philadelphia eventually put many artisans like John out of work. Constant employment was a rarity among craftsmen like John and even rarer for unskilled workers. As a combmaker, John worked in a specialized market whose handicraft goods were replaced by mechanized facilities, which made cheaper, standardized synthetic products. "Even in normal times, irregular commerce led to frequent job furloughs. Underemployment and unemployment were also key, if less glorious, features of the Philadelphia industrial system."[4] Adding to his economic problems was the panic of 1857, which caused business collapses and unemployment. By 1859 John faced a choice between continuing his craft with little profit or finding a job in a factory. Having always worked in a small family-operated business, John was far too independent to become an industrial worker. To have crossed the Atlantic to escape the competitiveness of industrialization in Sheffield only to experience similar circumstances in Philadelphia must have had a profound impact on John's disposition.

Once he lost his business, squabbles increased between John and Ann over his inability to support his family. Described by an acquaintance as "a man of intemperate habits" who "earns a very scanty livelihood," John began to drink heavily. His inebriation, employment difficulties, and impetuous habits caused his relationship with his wife to deteriorate. Seeking a new start in life, he left Philadelphia and headed west, leaving his family practi-cally destitute. Ann applied for a Civil War Mother's Army Pension based on the death of her son, George, killed in action at Gettysburg. In her 1863 claim, marked by an "X" since she could not write, Ann declared that her husband "abandoned her without just cause four years ago, and has done nothing toward her support." (Perhaps he left later since the 1860 census reported that John was living at home and working as a combmaker.) She was unaware of his whereabouts or if he was still alive. Ann was awarded a pension of eight dollars per month, and to make additional money, she operated a tavern on Norris Street.[5]

John settled in San Francisco where he opened a notions business that sold woolen goods and other items. Apparently he did not lose contact completely with his family, and some relatives sent him material to sell at his store. According to family lore, he might have speculated in real estate in Berkeley or Oakland. But if he did, he must have lost money, because his circumstances never changed. The 1880 census reported that John, age seventy, lived alone in a rooming house on Montgomery Street and worked as a merchant/peddler. In 1888, Fields's grandfather died in San Francisco at age seventy-eight, probably with little or no knowledge about his eight-year-old grandson. My grandfather "left for California," Fields recalled in a letter to a relative. "My father was always very vague on the doings of his father and his family in general." Fields shared some of his grandfather's personality and behavior, chiefly his addiction to liquor, his wanderlust spirit, impulsiveness, and failings in family relationships.[6]

As the fourth of ten children, Fields's father received little nurturing from his mother, who was always busy working. With limited schooling, he never learned to read and write, and without a professional skill, he had trouble seeking employment. Known as an undependable employee, he was sometimes fired and subsequently went from job to job. When the Civil War erupted, he enlisted as a private in the Union army on August 10, 1861, joining company M of Pennsylvania's 72nd Regiment, an elite group of firemen, who wore colorful Zouave uniforms with Chasseur pants and jackets. Jim's enlistment record describes him as a person with blue eyes, light hair and complexion, and five foot five in height. He fought during the Seven Days Battles, a campaign against Confederate forces protecting Richmond. While on picket duty near Fair Oaks, Virginia, on June 27, 1862, two fingers and the top of another on his left hand were shot off. Fields mentioned sarcastically that a vengeful soldier had placed fish hooks in his dad's pocket "in order to trap the fellow that was rolling his poke for a dollar or two every night."[7] Three weeks later his wound led to a medical discharge and fifteen dollars a month disability pension. Jim remained proud of his service in the Union army and once posed for a photograph wearing his uniform decorated with medals (see figure 2.2, p. 32).

Jim married twenty-four-year-old Kate Spangler Felton at the Memorial Methodist Church on May 18, 1879, eight months and eleven days before Fields was born. Fifteen years younger than her husband, Kate appears in a photograph as a strong matronly woman with a round stone-like face, slanting eyes, and thin sealed lips.

Her English ancestors had been living in northern Philadelphia for over a century, working as farmers in the Bristol area, which includes the town

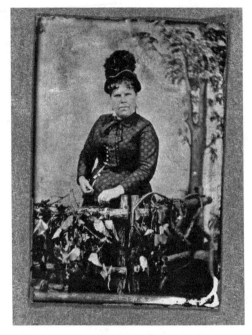

**Figure 1.3**   Kate Felton Dukenfield, Fields's mother. Courtesy, W. C. Fields Productions, Inc. www.wcfields.com.

of Feltonville (named after the Felton family), known in the nineteenth century for its farms on rolling hills and stately homes.

In his 1933 short film, *The Barber Shop,* Fields remembered his mother's roots. The film opens showing a banner:

<div style="text-align:center">

YOU ARE NOW

ENTERING

FELTON CITY

WELCOME

population          elevation

873        2 FT. **Below Sea Level**

</div>

Two workers who are holding up the sign hear men conversing. "Pretty good town you got here." "Yes we have," replies the other, "We have a public library and the largest insane asylum in the state."[8]

With their earlier Philadelphia roots, civil service appointments, and education, the Felton family had a higher status than the Dukenfields. Kate regularly reminded her husband that she was descended from the Feltons. Kate's brothers held jobs with the city government; William Claude Felton, an ex-butcher and produce dealer, became chief of the Bureau of Street Cleaning.

The matriarch of the Felton family was Kate's mother Annie, a strong-willed, well-mannered woman who disliked the disreputable habits of her daughter's husband. She wanted her grandson Claude, as the family called Fields, to attend school and grow up to be a proper gentleman with a respectable job. Annie had a favorite saying about longevity: May you "live to eat the chickens that pick the daisies off your grave."[9] If Annie Felton was upright, her husband, Thomas, a butcher and city lamplighter, was the opposite. A drunkard, Thomas was often too intoxicated to light the arc lamps in his neighborhood. His drinking eventually undermined his health, and he died of cirrhosis of the liver at age fifty-five. Thus both the maternal and paternal sides of Fields's family, starting with his grandfathers, had chronic drinking problems.

At the time Fields was born, his parents were renting a modest two-story brick row house in southwest Philadelphia at 6320 Woodward Avenue, accessible by horsecar that went directly to Darby's Main Street. The working-class area where they lived was populated with carpenters, shoemakers, blacksmiths, and other tradesmen. The house included a backyard and a front porch that was protected by an overhanging roof that kept the snow off in winter. Due to the city's spacious layout and grid system, inspired by William Penn's ideal of a "country side within the city," Philadelphia consisted of long stretches of neighborhoods with one- or two-family row houses surrounded by farmland. Philadelphia was known as a City of Homes where residents strongly identified with their locale. The area where the Dukenfields lived resembled a village with open spaces. Fields recalled that his "first memory is that my father took me out of bed and stood me by the window so that I might see a heavy rain, thunder and lightning storm. There was a great field across the way where hundreds of horses were put out to pasture. The storm caused the horses to stampede and there were several men in the field trying to quiet the equines."[10]

During Fields's youth the city underwent an industrial boom epitomized by large factories that produced products ranging from locomotives to elevators. With its bustling port and the expansion of the Pennsylvania Railroad, Philadelphia became a thriving commercial, financial, and transportation center. A labyrinth of manufacturing plants, foundries, and railroads exuded smoke, steam, and grit. Industrialization fueled a population

increase from 847,170 inhabitants in 1880, the year Fields was born, to nearly 1.3 million in 1900, making it the third largest city in the United States. Due to its horizontal gridiron plan, Philadelphia lacked the densely packed sordid tenements of other highly populated cities such as New York and Chicago. The downtown area, however, included segregated slums in the back alleys and courts where poor African Americans resided in wooden shacks and faced hostile discrimination.

Famous authors commented that the city's horizontal layout with its repetitious row houses made Philadelphia appear dreary and monotonous. Arriving in 1842, Charles Dickens found the city a gloomy place, "rather dull and out of spirits. It is a handsome city, but distractingly regular. After walking about it for an hour or two, I felt that I would have given the world for a crooked street... Treating of its general characteristics, I should be disposed to say that it is more provincial than Boston or New York." In 1905, Henry James called the City of Brotherly Love a place of "bourgeois blankness." Compared to other American cities, Philadelphia resembled a cluster of dull villages "that didn't *bristle*."[11]

The "bourgeois" reputation of Philadelphia lasted for years. Fields later became well known for lampooning the city's provincialism: "If a woman dropped her glove on a street, she might be hauled before a judge for strip teasing" and "anyone found smiling after the curfew rang was liable to be arrested." Or take the famous statement that Cuthbert J. Twillie (Fields) makes as he is about to be hanged in *My Little Chickadee* (1940). When asked what his last wish is, he says: "I'd like to see Paris before I die. Philadelphia will do!"[12]

Nearly four months after Fields's birth an 1880 census taker visited his parents' home. He listed three inhabitants: J. L. Dukenfield, age forty (hotel keeper); Katie S., age twenty-five (keeping house); and Claude W., four months old, born in January. Was Fields's real name Claude William Dukenfield or did the census taker made a mistake? His birth certificate has unfortunately never been found. Some accounts state that his first name was William and that he was probably named after William Claude Felton, Sr., his mother's brother. A strong case nonetheless can be made that his first name was legally Claude. Most annual Philadelphia city directories between 1902 and 1913 list him as Claude W., actor. The 1900 and 1910 federal census record his first name as Claude, including a school certificate awarded in 1889. Fields's parents, wife, and other family members regularly called him Claude. His father once told him that he was named after Claude Duval, the famous seventeenth-century French highwayman who robbed stagecoaches outside London and was popularized in cheap

dime novels at the time Fields was born. Fields disliked Claude intensely because he felt the name was old-fashioned and sounded effeminate. If you ever called him Claude, "he'd expectorate in your face," said his youngest brother Leroy.[13]

Because he believed Claude Dukenfield sounded stodgy as a stage name, he reversed his initials in 1898 to W. C. and shortened his last name by dropping the first two syllables and adding an "s" at the end. On May 13, 1908, he changed his name legally to W. C. Fields.[14] Using the initials W. C. over the years perpetuated the belief that his first name was William.

The date of his birth has likewise stirred considerable debate. Some authors believed that he was born on April 9, 1879, a date Fields put on his 1900 marriage certificate in San Francisco, because under California law he needed to be over twenty-one. Other dates were erroneously reported by magazine and publicity writers. As mentioned above, he was actually born on January 29, 1880, a date listed on numerous official records, including his passport applications. This was the day Fields always celebrated as his birthday.

After Kate gave birth to her first child, she no longer worked at the inn and devoted herself to raising five children. In addition to Fields, she reared two other sons—Walter (1882) and Leroy (1895)—and two daughters—Elsie May (1888) and Adele (1890), better known as Dell. (Kate also gave birth to a stillborn baby, an event so heartbreaking that the family never mentioned the tragedy.) Leroy, who was never close to his famous sibling and disliked being called W. C. Fields's brother, felt that their mother was "an old-fashioned homebody. She would put on a wrapper and leave that on for a couple of days and never go out of the house." Fields recalled that sometimes she would lie in bed "besotted with gin." At noon she put on an apron, poured water on her face, and sat down on the front porch. As a neighbor passed by, she pretended to wipe perspiration from her forehead with the tip of her apron. "Been working all morning over a hot stove," she said.[15]

As she sat on the porch, Kate made wry quips about the neighbors who passed by. "Good day to ye, Mrs. Muldoon." Once out of sight, she murmurs, "Terrible gossip, Mrs. Muldoon." Another neighbor soon appears. "Oh, how are you today, Mrs. Frankel?" Seconds later she whispers, "Nasty old bitch, Mrs. Frankel." Mrs. Barton is the next neighbor to pass Kate. "Why you're just too sweet in that tailored suit. You must a been to Paris." As soon as Mrs. Barton is out of earshot, Kate remarks, "She's been looting a farm somewhere. There's not a clothes-line in town that she could steal rags like that." "Our mother was a real comedian," said Dell, Fields's sister.[16]

Kate's sly sense of humor influenced her son. He found his mother's remarks hysterical and used her asides and murmurs in his routines. In *The Barber Shop* (1933), Cornelius O'Hare (Fields) sits on a chair in front of his barber shop sharpening his razor blade on a block while watching his neighbors pass. A man with two cows in tow asks: "What do you know?" "Not a thing, not a thing," replies O'Hare. As soon as he leaves O'Hare mutters, "that lunk tells his wife everything he knows." Mrs. Scroggins appears, who tells O'Hare that her husband, the mayor, is sick.

> *O'Hare*:   Ah! It's unfortunate. I'm sorry to hear that.
> *Wife*:      I am worried about him.
> *O'Hare*:   I am too. (wife walks away)
> *O'Hare*:   He was out on one of his benders last night again. (aside)
> Boy, how he can drink that raw alcohol and live, I don't know. Fine mayor he is.[17]

Kate once watched her son's comedy routines at the *Ziegfeld Follies*. Afterwards she complimented him on remembering the times he overheard her on the porch.

Fields had several unique styles of comic repartee. In one method he utters a line or two, pauses until he senses it is the right time, and then delivers the clincher. Take for example his love scene with Peggy Joyce in the film *International House* (1933). Turning to her, he brags about his prowess in bed: "I shall dally in the valley." After a pause, he launches the pungent laugh-getter—"and believe me, I can dally in the valley."[18] The first line plus the pause leaves the audience wondering what comes next. Due to his long training on the stage, Fields developed an incredible sense of timing. He was not a traditional one-liner comic who rapidly rattled off one gag after another. Field instead was a master of timing, who waited until he knew he had the audience in his hand. Then he unloads his sure-fire zinger, which propels the spectators into fits of laughter.

Fields's humor is often rooted in his own experiences. When he performed in Philadelphia, he stayed at his parents' house. In order to let him sleep late, Kate would try to quiet the neighbors and visitors usually without success. Dell recalled that her brother told her that "he could never sleep in the morning because mother was downstairs at the front door, telling everyone from the milkman to the mailman that 'he's home now, he's asleep downstairs.'"[19] In "The Sleeping Porch," a hilarious stage sketch in *The Comic Supplement* (1925), Pa (Fields) tries in vain to nap on the back porch but is continually awakened by delivery people and other intruders.

The porch skit is repeated with variations in his films *It's the Old Army Game* (1926) and *It's a Gift* (1934).

Compared to her tyrannical husband, Kate could be kindhearted. Dell recalled that when Fields left home for his first vaudeville tour their mother made him sandwiches and a thermos full of coffee. After accompanying her son to the trolley, she cried on her way home. Kate possessed a tenderness that caused Fields to have the words "A Sweet Old Soul" engraved on her tombstone. By contrast she was not the nurturing type and found it difficult to show affection. Fields's younger brother, Leroy, once said that he could never remember a time during his childhood when his mother kissed him.

Kate tried to keep peace in the house by attempting to curb her husband's temperamental outbursts. She often interceded when the arguments between Jim and young Fields became too intense. To distract Jim, she would ask her husband to go outside and predict the weather. "No one can tell about rain and snow the way you can, Pa. Now come here to the door and look yonder at the sky the way you always do, and tell me if I can hang out the wash tomorrow. Come on. Pa, you're better than the weather man in the newspapers."[20] Jim would lick a finger and point to the sky to see if it was going to rain.

Given their different personalities, Kate and her husband often clashed. Jim's coarse habits, especially his habitual drinking and cigar smoking, regularly embarrassed his wife. She mocked his English Midlands accent and constantly reminded him that she was a proud Felton, a Philadelphia native, and not a Dukenfield. She constantly complained that Jim did not earn enough money to support his family and frequently nagged him to find a job.

Besides lacking the temperament to keep a steady job, Jim and his family faced hard times due to a five-year long depression caused by the Panic of 1893. When European countries withdrew their security investments from the US Treasury, the action caused massive business failures, a stock market crash, deflation, and widespread unemployment. More than 2.5 million people were seeking work during the harsh winter of 1893–94. The economic slump precipitated mass protests and labor strikes. At downtown Philadelphia streets homeless children could be seen begging or peddling cheap goods. The Panic of 1893, wrote a historian, "sent shock waves through Philadelphia's economy and contributed to profound transformations in the lives of many Philadelphians."[21]

These problems exacerbated Jim's attempt to find work and triggered discord within the Dukenfield household. Loathing authority of any kind,

Jim disliked working under the thumb of employers, who found him unreliable. His drinking problem added to his reputation as an untrustworthy worker. Around 1883 he returned to bartending at a saloon. Four years later, he was apparently fired for stealing money from the till. Fields joked that he "lost his job on account of not knowing which drawer or pocket to put the nickels, dimes, and quarters in."[22] But Jim could have lost his job because the saloon failed to renew its liquor license due to a law that increased the fee to five hundred dollars.

Jim loved horses. He was reputed to own a thoroughbred and entered it several times in a local horse-drawn sled race, which he never won. He was employed as a driver of a two-horse street car, a popular form of transportation due to Philadelphia's spacious layout. Fields joked that "he frisked an inebriated passenger for a diamond ring" and "didn't split the cash with the conductor who turned him in."[23] More than likely he was laid off due to the introduction of electric trolleys in December 1892.

Jim became a huckster hawking fresh fruits and vegetables from a wagon pulled by his horse "White Swan." As a peddler he felt independent and free from the jurisdiction of a supervisor. His income, however, varied because he depended on loyal customers to buy his provisions. "Father was a produce merchant," Fields said. "One week he'd make big money and the next he wouldn't make any money. It all evened up to mighty little." Any savings were spent on drinking and his enjoyment of horses. He bought a thoroughbred and entered sleigh races. "Father had to have his horses, too, no matter how little money there was."[24]

Fields inherited many personality traits and physical characteristics from his father. Both had blue eyes, light complexion, blond hair, and a larger than average nose, the latter a distinctive feature handed down from the paternal side of the family. The two shared a talent for entertaining. As an innkeeper, Jim sang sentimental ballads and danced for the enjoyment of customers. Like his father, Fields was fervently independent and disdained authority. Depending on how he felt, Jim's mood varied daily from bad-tempered to good-natured. Fields likewise possessed a mercurial personality—he could be benign one moment and heartless the next. Jim's sons found him cold and overly strict. Leroy called their father a "foreigner." "He never seemed to take much interest." Jim was unforgiving when he lost his temper. My father "was likely to become superheated under provocation," Fields said.[25]

To get attention, Fields enjoyed taunting his father, which only aggravated their relationship. "As a child I was a brat," admitted Fields. "A man once said to my father in our parlor: 'I've never met such a repulsive child

as your son.'" Dell recalled that Fields and his brother Walter "used to needle him mercilessly to get his goat, but it was all for fun." Fields mocked his father's singing of sentimental ballads and mimicked his strong British accent. He made fun of Jim's old horse, White Swan, as the animal slowly pulled the produce wagon up the streets. His father had little tolerance for his son's brashness. He regularly scolded Fields for his pranks by strongly smacking him.[26]

Fields grew up during the late Victorian age when children were expected to obey their parents, never talk back, and behave properly. According to Dell, her brothers and sister "respected and loved our parents."[27] But Fields never had a "loving" relationship with his father. Being ten years younger than Fields, Dell was only a child when most of the turmoil between her father and older brother occurred. By the time she was ten, Fields had already left home to go on the stage.

Fields's family regularly lacked money to pay their rent and frequently were forced to find another home. "He [Jim] moved my family quite often during my childhood. The expenses of living always embarrassed him, and he put himself to an endless amount of trouble rather than discuss them with creditors." During Fields's youth they resided in five rented houses primarily in working-class districts in northern Philadelphia known as Rising Sun and Franklinville.[28]

Fields was well liked by the neighborhood boys who called him "Whitey" because of his light blond hair. "[Whitey] was a great fellow," said George Young, a childhood friend. John Bowyers, another boyhood pal, wrote Whitey a fan letter reminding him that he grew up with him in Franklinville. Fields fondly replied: "I remember you and your brother very well and have many fond memories of Franklinville, where I ran around in the dust and dirt in my bare feet."[29]

Living in so many houses in his youth had its consequences. Like his family, Fields constantly moved from one leased residence to another during his career. He felt restless and rootless most of his life. "I do not think I could settle down anywhere now," he once told an interviewer. "I have caught the wander-lust so badly that I must always be on the move." As an itinerant entertainer, he enjoyed meeting different people and exchanging ideas. "I think if I had to go straight home and stay there every night it would soon weary me. It is meeting people after work is over, and having a little chat that I enjoy, and you can do that when you travel and move about from place to place."[30]

Fields's parents had a difficult time getting him to attend school. "I was always a lazy boy," he admitted to an interviewer. "I hated to get up and

go to school. I loved to stay in bed."[31] Wearing secondhand clothes, Fields attended the neighborhood Oakdale elementary school starting in 1885. A rambunctious child, Whitey was more interested in performing pranks than learning. Whether true or not, Fields said that he picked the pockets of his schoolmates' jackets. When he jammed the door tracks between rooms with various objects, his teacher banished him to the student cloak-room. Realizing that the punishment was not working, she sent him to the school principal, who slapped his hands with a ruler. He continued acting as the class clown known for his shenanigans in school and playing outside with his friends.

In the autumn of 1889, he began fourth grade at the Cambria School near his family's house at 2803 Germantown Avenue. For a short time, he was a conscientious student and won a certificate naming him one of the week's best pupils for his punctual attendance, good behavior, and excellent lesson recitals. Most accounts suggest that he never got beyond the fourth grade, but Fields could have had slightly more education. In 1913, the *Philadelphia Oakdale Weekly*, a neighborhood newspaper, pub-lished a "picture of Cambria school pupils taken over 20 years ago which shows among others a very insignificant lad who is none other than Claude Dukenfield, or as he is known on two continents as W. C. Fields."[32] If the photograph was shot between 1890 and 1893, he might have attended the fifth or sixth grades.

Bored of schooling, Whitey remained an indifferent student, who later stated that he learned more through life experiences than the classroom. Fields lampooned his educational experience in the sketch, "My School Days Are Over," a slightly risqué skit he performed in the 1928 *Earl Carrol Vanities*. In a school room are three pupils, including Fields, and a strict female teacher with a "ruler in hand." Dressed in shorts with a large black string tie attached to his shirt, Fields resembles Lord Fauntleroy. Two of the pupils are suspended for laughing at the teacher when she drops the ruler and bends over to pick it up with her back to the pupils. "Well, what are you laughing at?" she inquires. "I saw your stocking garter," replies one pupil, and the other, "I saw your bare leg." Left alone with the teacher, Fields fiddles with a pea shooter and puts his hand over his mouth to pre-vent laughing. "Well, what is the matter with you?" she yells. Sensing the punishment to come, he runs out of the classroom announcing "my school days are over."[33]

Jim could no longer tolerate his son's rebellious behavior in school and at home. "If you won't go to school you must go to work," insisted his father.[34] During Fields's youth it was very common for the oldest children

of working-class families to leave school and find a job in order to improve household income. By 1900, 40 percent of Philadelphia's fourteen year olds were working. Child labor remained a widespread practice in the industrial age. Although Pennsylvania was one of the few states that limited a child's workday to ten hours, no minimum age law existed in the 1890s. Children's wages were legally the property of their parents. An enormous number of children joined the working force in Philadelphia, and immigrant youngsters were exploited by employers as cheap labor. They worked long hours toiling in factories, as newsboys, peddlers, bootblacks, and in numerous other low-paying capacities. On downtown Philadelphia streets homeless children could be seen peddling cheap goods or begging.

Fields resented that he needed to work because his father, an unskilled worker subject to market forces, "forgot to get one for himself." Rising at dawn was a bitter experience. "My father would always wake me, as he often said that he did not want a child of his to be late to work." During the winter the house was freezing cold, and when it snowed the horse-led street cars were not operating. "The snow was so deep I would have to arise half past three or four o'clock in the morning and wade thru a blizzard hip deep." "It was my bad luck to be the oldest child in the family," Fields remembered. "We were all very poor, but I was poor first."[35]

# 2. Life with Father ∾

L ike his experience at the Trenton fair, the jobs Fields held as a boy influenced his vision of a world where lying and cheating were prevalent and suckers could easily be duped. These eye-opening experiences furnished Fields with material he later used to ignite gales of laughter. Possibly as early as age nine, he assisted at a neighborhood cigar shop where he learned that it was permissible to hoodwink customers. The owner "only carried one brand of cigar," Fields remembered. "It sold for three cents. If a customer asked for a ten cent cigar, he was handed one which sold for three cents." My boss often said, "the customer is always right, so never allow him to be disappointed."[1] Whitey manned the cigar counter alone often until midnight. One night he was so sleepy, he carelessly pushed over a kerosene lamp, burned his arm, and scattered cigars all over the floor. The owner discovered that Fields had placed the fallen cigars in the wrong boxes, and for his negligence, he was fired.

Like his father, Whitey was a born huckster. While hawking newspapers on street corners on a commission basis, Fields discovered that he could sell more papers if he hyped the news found on the back pages. "Bronislaw Gimp acquires license for two-year-old sheep dog!" he bellowed. "Details on page 26!" After a customer bought a paper he quickly changed the headline. "Five Men Swindled! Five Men Swindled!" he yelled to a passerby, who purchased a copy. Next he hollered "Six Men Swindled! Six Men Swindled!"[2] If a buyer complained he could not find the swindler story, Whitey told him a printing error was responsible. Duping the public came easy to the youngster. As a newsboy he was already practicing the chicanery like the small-time con man in his films.

Fields also assisted a driver delivering blocks of ice hauled by a horse-drawn wagon. Before refrigeration ice was critical to keep food from spoiling, especially in the hot summer. Because the ice was delivered early in the morning, Whitey woke up at 3 a.m. to begin his rounds with the driver, Andy Donaldson. For a percentage of the proceeds, he rented the wagon from the prominent Knickerbocker Ice Company, known for its bright

multicolored wagons resembling circus carts and gypsy vans. "We take great pains in painting and lettering it to attract attention on the street," the firm advertised.[3]

Earning four dollars a week, Whitey carried the twenty-five and fifty-pound blocks with large tongs from the wagon to houses on busy Germantown Avenue and neighborhood streets in the Tioga district. Children enjoyed pursuing the wagon as it moved slowly along its route. Fields boasted about his ability to help the driver, who dawdled at his work. "On hot days he would deliver the ice in buckets. I taught him how to handle the ice with a flourish, and juggle it on his shoulder. Being on the route a long time, he knew quite a few women in the different kitchens, so while he tarried, I juggled the ice picks."[4] After finishing their deliveries, by midday, the pair headed for a saloon where Donaldson bought him a bottle of ginger ale, which he drank while eating edibles from the free lunch counter.

According to one story, Whitey lost his job when the driver was fired for cheating the company of its percentage of the profits. He never forgot his experience on the ice wagon. Whitey was given an iceman union card, which he kept as a memento. In the 1925 *Ziegfeld Follies*, the ice delivery man appears as an intruder who disturbs his sleep in the "Back Porch" sketch (recycled in the films *It's the Old Army Game* and *It's a Gift*).

Whitey saved money from his salary with the intention of buying his mother a copper-bottom clothes boiler for Christmas. He hid his savings in a brown crock in the coal bin at his house. According to Fields, his father pilfered the money. He never forgave his Dad for stealing his savings and the incident increased his animosity toward his father.

Around 1893, Fields was employed as a cash boy at Strawbridge and Clothier's five-story department store, located at Eighth and Market Streets. Opening in 1862, the store was among the city's most prominent emporiums named after its two Quaker founders, Justus Strawbridge and Isaac Clothier. According to family lore, Fields obtained the job when he went to the store on a windy day only to find a long line of applicants. He picked up the help wanted sign that had been knocked over by the wind and promptly took it to the employment office. Impressed by his resourcefulness, the management employed him as a cash boy carrying money in a change box between departments. Out of his two dollars a week salary, he paid sixty cents each week to ride a horse-led streetcar to work.

Working at the emporium was Fields's first exposure to wealthy Philadelphians, who bought expensive goods such as the latest high-end women's fashions, including silk evening wear, velvet dresses, and satin

taffetas. Dressed in hand-me-down clothes, Fields must have noticed that his parents belonged to a much lower class. Philadelphia was polarized by social hierarchies that segregated the wealthy from the working class and split the city into diverse neighborhoods. Families descended from the city's founders and successful early settlers formed a snobbish patrician class. They were the Philadelphia blue bloods who lived in Georgian town houses bordering Rittenhouse Square and in other handsome residences south of Market and west of Fifteenth Street.

Beginning in the mid-1870s, the well-heeled began moving to elegant estates located in au courant suburbs, such as Chestnut Hill and towns like Bryn Mawr bordering Pennsylvania Railroad's Main Line. The upper classes joined restrictive social and sport clubs, prestigious fraternal and secret societies, and sent their children to elite private schools. Economic development fueled another large wealthy class: the nouveaux riche plutocrats who made fortunes in banking, manufacturing, mining, and the railroad industry. Executives of the Pennsylvania Railroad, for example, lived in suburbs on the Main Line, including the railway's vice-president A. J. Cassatt (brother of Mary Cassatt, the notable artist) as well as wealthy financiers such as Anthony J. Drexel. The city's northern sections, where the Dukenfields lived, were viewed by rich Philadelphians as the other side of the tracks. In Philadelphia a large gulf separated the Dukenfields from the city's rich.

Growing up at the lower end of Philadelphia's class structure had a lasting impact on Fields's work. He later mocked the snobbery of the upper class in films such as *So's Your Old Man* (1926) in which he plays Samuel Brisbee, an unsophisticated ne'er-do-well inventor and henpecked husband from the town of Waukeagus, New Jersey. His daughter, Alice, wants to marry the son of a wealthy family headed by Mrs. A. Brandewyne Murchison, known as "the bellow cow of Waukeagus' social herd." Mrs. Murchison opposes the marriage until Brisbee's wife tells her that she is a relative of "Martha Washington Warren—you know, the Warrens of Virginia." Brisbee spoils the affair when he shows Murchison his family's scrapbook with photographs of criminal and scandalous relatives, including his cousin Sadie, "the best dancer in burlesque until she lost her voice." All ends well when Sam sells his rights to his shatterproof windshield for a million dollars to an automobile company and his new wealth convinces the Murchisons to accept the marriage. "I'm the happiest girl in the world," his daughter says. "So's your old man," says Brisbee. Despite his financial success, he refuses to join the nouveau riche crowd and keeps his values. The same scenario is played out in the sound remake, *You're Telling Me* (1934).[5]

At Strawbridge and Clothier's, some cash boys eventually became store executives, but Whitey was too unruly to even become a white-collar worker. He found that stealing the cash he carried from one department to another was too tempting. "This was really too much to bear, and I did everything possible to get myself discharged." Fields liked to tell a far-fetched tale about how he purposely tried to get fired by falling through the store's skylight three times, but the management thought the incidents were accidental. On the fourth try, he landed on the general manager, and when Fields refused to apologize, he was finally fired. More likely his job was eliminated when the store installed pneumatic tubes in late 1893 to transport money from the sale counters to the second-floor gallery. Fields later joked that if he had stayed at the store he would have needed to work 377 years without a vacation to equal his weekly pay in show business.[6]

Years passed before Philadelphia recognized Fields's employment at Strawbridge and Clothier. The long-term snub inferred that the citizens wanted to forget their hometown comedian, who lampooned their city. In 1997, Philadelphia finally honored him by erecting a navy-and-gold marker atop an eight-foot pole outside the building with the following inscription: "W. C. Fields (1880–1946): American comedian raised in Philadelphia, noted for his irreverent wit. Starting out as a vaudeville juggler, he won enduring fame on screen and radio. He was in over forty motion pictures, 1915–44. As a lad, he worked for a time at Strawbridge's here."[7] If alive, Fields would have stared at the sign in bewilderment and then cracked a joke about all the hoopla.

Whitey also found a job as a scullery boy in the galley of a Chestnut Street oyster house. Here he performed menial chores including washing the dishes and carrying cans full of foul-smelling shells to the garbage. The oyster bays, as Philadelphians called their restaurants, were extremely popular. The oyster industry, which dated back to the colonial era, produced one to two million bushels annually during the 1890s. The city was famous for its Delaware Bay oysters, a delicacy relished due to its delicious taste. Fields intensely watched skilled chefs shuck the oysters with specialized knives that scraped the meat from the shell while carefully preserving the liquid. Favorite dishes for the customers also included fried oysters and oyster croquette. Although Fields enjoyed the bustling atmosphere, the work entailed long hours with little pay, and he soon tired of the job.

During the early 1890s, Fields helped his father sell fruits and vegetables from his horse-drawn wagon. Rising before dawn, the two traveled several miles to the large Delaware River street market where they

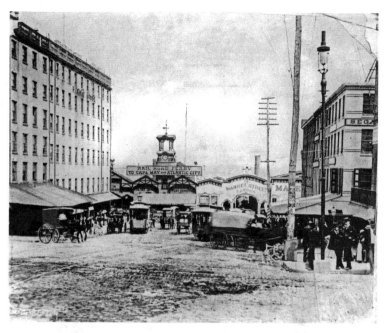

**Figure 2.1** Market Street at Delaware riverfront, ca. 1894. A location where Jim Dukenfield and his son obtained groceries to sell. At street's end is the railroad ferry to Cape May and Atlantic City, which Fields took to perform at the beach resort (albumen print). American photographer (nineteenth century), Free Library of Philadelphia/ Bridgeman Art Library.

obtained fresh local produce, especially seasonal vegetables and fruits, at wholesale prices.

They attained provisions shipped by rail or boat including delicious summer peaches and watermelons from nearby states and in the fall apples from western New York and Michigan. Fields and his father worked until dusk selling their fare in the neighborhoods of northern Philadelphia. To feed his horse, his father told him to walk behind passing hay wagons. "You must not steal any hay," he cautioned. "But, of course, if you can just grab a handful now and then for the horse, it will be all right."[8] Whitey learned from his father that petty theft was permissible under the right circumstances.

To gain the attention of customers, Jim promoted his daily supply of edibles in an earsplitting voice: "Watermelons! Red Ripe Tomatoes! Sweet

Sugar Corn!" Fields joined in by pitching other produce in a singsong tone: "Getcher roo-tah-bay-gaahs" and "caa-laa-baa-shes."[9] His easily provoked father scolded his son when customers discovered that these items were not on the wagon. Once the buyers were out of sight, Jim smacked his son on the ear with the back of his fist, his favorite remedy for Whitey's impertinence. His son cringed in response. Jim's whacks happened so frequently that Fields never forgot his father's punishment.

Jim's blows and Whitey's reaction bring up a significant question. Is there a possible connection between Whitey's wince and the way Fields often flinched on the stage and screen when threatened by a foe and assaulted by an object? As a vaudeville juggler, he recoils when he fears a ball or cigar box might hit him or cringes when Baby Leroy sticks Fields's watch in molasses and tweaks his nose in *The Old Fashioned Way*. The correlation suggests that his father might have had a very significant influence

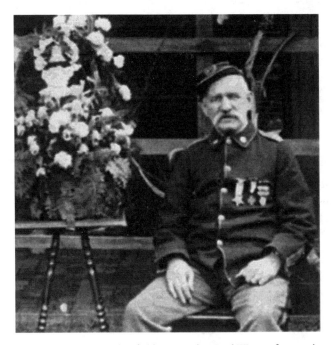

**Figure 2.2**   James Lydon Dukenfield wearing his Civil War uniform and medals. Note his war wounds, the missing fingers on his left hand. Courtesy W. C. Fields Productions, Inc., www.wcfields.com.

on his son's persona as the frustrated Everyman besieged by every imagin-
able menacing entity and ominous being.

His father had no tolerance for his son's misbehavior and mischievous
pranks. The more Jim punished him, the more Whitey defied his father.
A troublemaker at home, he was always showing off. As the oldest of four
siblings, he had an unrequited need to get attention from his busy, indif-
ferent parents. Fields grew up at the end of the Victorian age when strict
parenting still dominated child rearing. Jim possessed a quick temper, but
his harsh treatment of his firstborn belonged to the culture of the time.

The discord between father and son exploded one day around 1892–93
due to an incident that ignited his father's rage. Over the years Fields told
different versions of the event. In one of his few autobiographical accounts,
he wrote: "I was digging up the yard, preparatory to planting some grass
seed. Papa strolled up the yard, stepped on a shovel which I had care-
lessly left there and patted me on the spine with it whilst I was leaning
over. When I regained my breath, I conked the old patriarch on the nog-
gin with a peach basket." According to Fields's sister, Dell, the part about
Fields smashing his father over the head was apocryphal. The handle of
the shovel could have hit his father's shin, which was already badly scraped
from stepping into a buggy. Fields possibly laughed at the mishap caus-
ing his father to become furious and smack his son with the shovel (other
accounts relate that the gardening tool was a rake). My father had a "pretty
hot temper," Fields recalled in an interview, and "was likely to become
superheated under provocation...Being a bit of chip off the old block, I
retaliated in language vigorous but not well chosen. This naturally added
fuel to the flames. Father's anger became a conflagration."[10]

From that point on the story gets so apocryphal and hyperbolic that
it becomes impossible to separate truth from fiction. The tale grew more
inflated when Fields arrived in Hollywood. Studio publicity and movie
magazine writers anxious to create sensational copy dreamt up more fabri-
cation. Although it is an impossible task to penetrate the fluff and discover
the truth, the tale of Whitey as a runaway Huckleberry Finn is worth
relating.

Fields said that he fled his house as fast as he could. "My father, unfor-
tunately, lost his poise and angrily pursued me. Finding that he could not
catch me, he shouted through the balmy air that I was never to return." "I
was frightened to return home and slept in various places too numerous
to mention," Fields wrote. He first lived in a dug-out called the "bunk"
in a nearby vacant lot that he had learned about from neighborhood
youngsters. They built the hideaway by digging a large hole in the ground,

placing boards on the dirt floor, and covering it with wooden slats. The tiny space was cold and damp at night, leaked when it rained, and was so small that Fields could not fully stretch out. In the morning he awoke wet, caked with mud, and stiff. To get warm, "I used to sit for hours with my back against a board fence," he recalled.[11]

Unable to withstand the dampness any longer, Whitey moved to the Orlando (or Orland) Social Club, a retreat for Whitey's neighborhood pals. Although there is an Orland Street in Philadelphia, the best guess for the club's name is Orlando, who is a major character in Shakespeare's *As You Like It*. To escape his tyrannical brother Oliver and the ruling Duke Frederick, Orlando flees to the pastoral Forest of Arlen where he finds his true love Rosalind. To evade the oppressive atmosphere at their homes, Whitey and his friends find sanctuary and camaraderie at the club. Named possibly after the play's hero, the Orlando is their Forest of Arlen.

The clubhouse was situated in rooms on the second floor above a wheelwright's shop near Germantown Avenue and Somerset Street. The building stood at Marsh's Court, an area dominated by an arch surrounded by shady trees. Clubs were then a rage in Philadelphia ranging from the most exclusive rowing, cricket, and lawn tennis clubs to organizations such as German singing societies. Filled with fun-loving youngsters, the Orlando boys parodied these organizations. The members liked Whitey due to his daring pranks and elected him an honorary member without dues. Tommy Hunt, the club's president, appointed him the official janitor. In the winter, Whitey pilfered buckets of coal from the wheelwright shop.

Furnished with discarded chairs and stools, the club became Whitey's home for a time—a place he called his "town residence." How long he lived at his "residence" remains a matter of conjecture. Fields claimed that he resided here about three years but a better timeframe is measured in months. "I slept in the back room on an improvised bed made by removing one of the doors and using several bags of hay to pinch hit for a box-spring mattress," he recalled in a letter to Hunt years later. During the winter, snow would drift in under the entrance and onto the rug Fields used for his bed covering. "Many's the night I would wake up covered with snow," he wrote to Jack Norworth, a longtime Philadelphia pal, who became a well-known vaudevillian and songwriter.[12]

Fields never forgot the experience. In his film *A Fatal Glass of Beer* (1933), based on his stage sketch, "Stolen Bonds," Fields plays Snavely, a northern territory trapper. Each time he opens the door of his rustic cabin, snow hits him in his face. "It ain't a fit night out for man or beast," he exclaims—an expression that became a famous Fieldsian adage. He later

told people how much he enjoyed a good bed and clean sheets due to sleeping on a makeshift mattress during the cold winter. "When I get into bed and stretch out—god damn, that's a sensation!"[13]

Food was never a problem since most members lived at home. The "boys brought me food from their own tables," Whitey recalled. "They may have swiped some of it; but I know their mothers provided a great deal, for at Thanksgiving a benevolent lady sent me a whole turkey." The boys told their parents he was a homeless orphan. "Otherwise my parents would have been told of my whereabouts."[14] Whitey also pilfered food from stores including bakery goods, especially his favorite lemon meringue pies, and milk bottles sitting on neighborhood porches.

Fields later wrote about the experience in a story entitled "The Most Delectable Food I Ever Tasted." He and his friend Charles Probischer stood on the trolley track in front of a bakery shop in order to make the motorman blast his horn loud enough to drown out the "faint tinkle of the bell on the bakery shop."[15] Fields entered the shop unnoticed, filched a lemon meringue pie, and hid it under his coat. The baker once spotted him and grabbed him by the throat, causing the pie to drop to the floor.

Having failed to retrieve a pie, they played a similar trick at a nearby Chinese laundry. Fields and Norworth participated in the escapade. "Bill thought up a way for us to steal money from the Chinaman's till without getting caught," Norworth recalled. "He'd have one of the boys throw his hat onto the car tracks and dash after it. The trolley man would clang his bell like mad. The clanging would cover up the sound of the Chinaman's bell, so Bill or I could get in without being heard."[16] With the money, the boys bought two twenty-cent meringue pies from the bakery.

Whitey discovered free lunches at local saloons where he told the waiters that his father would be coming soon to order a drink. "You might as well bring two plates of soup now," he said. He also got cheese, crackers, and cold cuts from the free lunch counter and bought a soft drink for a nickel. He was kicked out a number of times. "You might get away with the saloon lunch and you might not," Whitey recalled.[17]

When he was certain that his father was not home, he would sneak back to see his mother, who often made him lunch and gave him a little money. Fields's brother, Walter, said that "he would come up to the house when father wasn't around." Once Whitey unexpectedly encountered Jim at home, quickly grabbed his packed lunch, and ran out the door. Kate was not happy that her husband did not permit their son to return home. "She gave me the sad news that my father was firm in not allowing me to share in the family troubles again. I told my mother that we Dukenfields

had always been proud people, that if a man would not allow me to stay at his house—then I did not want to stay there. Blood will tell...and no Dukenfield ever subjected himself to the will of another."[18] Whitey's pungent remark suggests that he is already starting to develop a streak of bulldog tenacity, which would later drive his film directors into fits of exasperation.

For a time he lived with Kate's mother, Annie Felton. She felt that Jim was partly responsible for his son's bad habits. She opposed the street-life her grandson lived and youngsters pilfering food. Annie tried to get Whitey under her wing. She had encouraged him to apply for the job at Strawbridge and Clothier's store. Whitey often visited Uncle William Felton, his mother's brother, and developed a warm, supportive relationship with Grant, Annie's youngest son. Fields also claimed that he found shelter in cellars located in friends' houses, slept on a pool table in a billiard hall, and in the backroom of a saloon.

As he grew older, Fields stayed in touch with some of his Orlando friends, who had given him much needed companionship during a trying time. Fields looked back at his time as a youngster on the loose with considerable nostalgia. "Your letter recalled many fond memories of the old days when you and I used to sleep in wagons and privies," he wrote to his Philadelphia pal Harry Antrim in 1943.[19]

He corresponded most often with Thomas Hunt. In a 1938, Fields reminisced about what he called "the old days at the Orland[o] Social Club over Mr. Wright's wheelwright shop...Those were the happy days. Of all my friends...you are the most vivid in my memory." Enclosing twenty-five dollars to aid him during the Great Depression, Fields signed the letter warmly, "your old tramp friend, Whitey." Fields had no qualms about exposing his true feelings to Hunt. When Hunt wrote him that he felt lonely, Fields wrote back: "I realize it is tough to be alone. I have been alone and unattached so many times that I believe I understand your position thoroughly."[20]

Fields was reluctant to reveal any sentiment to most people that might undermine his reputation as a robust, cynical figure in his films. Only a few close friends knew what resided beneath his protective veneer. In private Fields could become very emotive, show deep-rooted feelings, and, in depressing situations, cry. "Sentiment," he said. "I hate it!" Except for a few instances, pathos is mostly lacking in his movies. Fields does show compassion, especially in the play and film *Poppy*, when McGargle sadly bids adieu to his adopted daughter. "Let me give you one word of fatherly advice...Never give a sucker an even break."[21] There are a few tender

moments in other films such as *The Old Fashioned Way* when the Great McGonigle says goodbye to his daughter Betty at the end. Playing to the emotions of his audience was not Fields's forte.

At the club, Fields felt free from his family, an experience that nourished his independence. "I felt bad at first on account of the old man hitting me and me hitting him, but before long I was in high spirits." The rebellion against his father fueled his lifelong distaste for any type of authority that curtailed individual freedom—from censors and movie moguls to the laws of the federal government. He called his time away from home "a glorious adventure and every boy in the neighborhood would have been glad to change places with me... I was a regular king among them because I was my own boss and could sleep away from home—which is what an adventurous boy longs to do."[22]

His "adventure" was inflated into a hyperbolic boyhood legend of a poor, homeless, and hungry urchin. Articles were published that he ran away as early as age nine and never returned home. But the incident with his father occurred when Fields was twelve or in his early teens. After interviewing Fields during his 1904 music hall tour in England, the reporter spun a fictitious tale that he rode freight trains out West where he was robbed by Indians and bandits. Fields, he noted, "is a good revolver shot and a capital horseman; his favorite hobby is to mount his fiery mustang, Fluke, and ride hot-hoof over the trackless prairie into the sunset." That same year he told another reporter about a "midnight ride" out West when his wagon got stuck in a ditch. Fields was chosen to get help, mounted a horse, and promptly fell asleep until dawn when he heard his fellow travelers laughing. "The horse was fastened to a stake and had been going around all night." Another farfetched story about Whitey at age eleven dramatized an adventurous carefree lad riding freight trains as a hobo as far as Omaha. He teamed up with a piano player and performed their act at men's clubs for pocket change.[23]

Fields likewise spun wild tales about his desperate hunger. "I slept in parks and was always hungry," he told an interviewer. "When I could stand it no longer I'd swipe fruit or vegetables from the street stands... Never had a chance at sweets or rich foods. I was fifteen when I had my first real meal; steak and fried potatoes."[24] He boasted about the occasions he escaped the police for stealing and other times when he was caught and jailed.

In Hollywood, Fields fed studio publicists and movie fan magazine writers more hogwash about his nomadic youth. The number of his years as a runaway increased exponentially. "[I] never went back [home] till I was earnin' good money," he told Ida Zeitlin, who wrote articles about Fields

for *Screenland*. Teet Carle, Paramount's publicist, recalled "beating the drums" for Fields and his movies. On his first day on the job, Carle's supervisor told him that the studio needed a longer, more intriguing biography about Fields. On the set of *Two Flaming Youths* (1927), Carle sat down with Fields for several hours. He told Carle about how he "had become a juvenile hobo" who slept in sheds, coal bins, and cellars. In numerous press releases Carle reiterated the legend about Fields's "hand-to-mouth scrounging to stay alive as a boy." Carle later admitted that the legendary stories about Fields were concocted by publicists. The runaway street urchin story made good copy. "You could write anything you wanted," and "he never complained about publicity."[25]

Stories of entertainers who rose from humble beginnings to become celebrities were relished by adoring fans because they illustrated the dream of rags-to-riches. Some were true. Charlie Chaplin, the son of a chronic alcoholic father and mentally ill mother afflicted with a syphilitic brain infection, experienced a childhood of extreme poverty in the slums of London. Chaplin's parents, down-and-out music-hall performers, were forced to send their son to a workhouse at age seven and then to a school for orphans and destitute children. The entertainers, George Burns and Eddie Cantor, were poor children who were raised in New York's Lower East Side, a Jewish ghetto. Both children worked at menial jobs before show business offered them an opportunity to make a decent living.

Fields's boyhood was never as destitute as Chaplin's youth. Although Whitey's low-income working class family faced hard times during the 1890s depression, they were never poverty stricken. Publicists and reporters therefore needed to transform Fields's early life into an American success story by making up an impoverished boyhood. "Fields' life history is one of those incredible rags-to-riches stories that show business sometimes turns up," wrote the drama critic John Chapman. Jim Tully, a prolific hard-boiled novelist who experienced a vagabond boyhood, interviewed Fields for several magazines in which he contributed to the mythmaking. Rising from poverty, Fields had become "one of the world's greatest comedians" through hard work and perseverance.[26]

A long account of Fields's career was penned by Alva Johnston, who published a three-part profile for *The New Yorker* in February 1935. A former Pulitzer-prize reporter, Johnston "set the pace, clarified the idea, and produced the pieces" for the profiles in *The New Yorker*, wrote the humorist E. B. White. The comedian called Johnston's pieces "the best and the most authentic" story of his life. Fields lived "on a poverty-stricken street," and "for four years Fields was a big-city version of Huck Finn," wrote Johnston.

After bashing his father's head with a heavy lug box in revenge for being hit by his Dad with a shovel, he "ran out of the house and never returned." Between ages eleven and fifteen, "he never slept in a bed and often was sick, cold, and hungry." He engaged in numerous fist fights with local boys and was beaten up by a sailor, which left Fields "discolored and lumpy." According to Johnston, Fields's vagabond years verged on the heroic. "As long as he slept in doorways, in lavatories, in holes in the ground covered with oilcloth, under stairways, and in box cars, he had a renown which could be stolen from him by no boy who slept on a mattress."[27]

Tom Geraghty, an ex-newspaper reporter who befriended Fields and wrote screenplays for him, recognized that Johnston's profile was mostly bunk. "You don't frighten me with that Big Bad Wolf Autobiography...," he wrote to Fields. "You wuzzn't so tough...Why man, you're gentle as a lamb." Geraghty, however, recognized its public relations value: "Good stuff, though...will create no end of comment...and box office returns...it's a composite, like Lincoln and the log cabin...Chaplin and his poor house days...[and] Jack Dempsey riding the rods in his hobo days."[28]

Robert Lewis Taylor's 1949 biography of Fields repeated much of the same hokum. "There can be no doubt, in view of the evidence at hand, that Fields may now be regarded as Philadelphia's most distinguished vagrant since Benjamin Franklin," he wrote.[29] As Fields's first biographer, Taylor perpetuated the legend of a runaway urchin, which lasted for decades.

Fields joined in the mythmaking because he enjoyed spinning yarns and later became a recognized raconteur. The comedian felt there was little distinction between truth and fiction. "We must have always exaggeration, I always maintain either in fiction or on the stage if we are to enjoy it. It is the fact of the types being overdrawn which makes their funny side appeal to our sense of humor...What's the good of telling a story if you don't embroider it a bit, and so win a laugh?"[30]

From his jobs such as selling cigars and hawking newspapers, Fields had learned as a boy that lying was permissible. He therefore had no qualms about weaving a trumped-up story and conning the public with fabrications that camouflaged the truth of his life. Fields's cunning behavior resembles the con men he impersonates on the screen, the lying charlatans, pompous windbags, and humbugs who hawk fake medicine. His puffed-up life story was a clever sales job pitched to a gullible public.

He undoubtedly did run away from home, lived with the Orlando boys, and participated in their adventures. But he had safe havens in his relatives' abodes. The entire episode is better measured in multi-months than

multi-years. Rather than a tale of a homeless vagabond, his experience with the Orlando boys was more like adolescent fun with daring pranks shared with neighborhood kids.

Within the tall-tale ballyhoo, there stands a major story that rings true—his estranged relationship with his father. The turmoil generated by Jim became indelibly etched in Fields's mind. He never forgot his fights with his tyrannical father, how he kicked him out of his home, pestered him to get a job, pilfered his savings, and failed to provide any nurturing. In a rare moment, he admitted: "My boyhood recollections are not too pleasant, so maybe it's best to skip them."[31] His clashes with his dictatorial father left a permanent wound that never healed and morphed into a demon that tormented him all his life.

# Part II  The Training Ground ❧

# 3.  The Tramp Juggler ❧

From the top balcony of Philadelphia's People's Theatre, thirteen-year-old Whitey Dukenfield intently watched the popular extravaganza, *Eight Bells*, starring the Byrne Brothers. The show dazzled the audience with its acrobatic stunts, knockabout comedy, pantomime, and breathtaking stunts, including the explosion of a horse carriage. The spectacle caused the reviewer for the *Philadelphia Inquirer* to laud the performance: "The comedy, harmony and pantomimic and spectacular effects seemed to catch the fancy of the house, and the applause was frequent and loud."[1]

Integrated into act three was a brief divertissement in which a servant, performed by Matthew Byrne, enters a room in a French mansion and juggles a hat, cane, cigar, and other objects.[2] Whitey sat spellbound as he watched the juggler deftly toss and spin his props into the air. Whitey Dukenfield's long and tortuous road to fame in show business begins at this pivotal point.

Fields was inspired to become a juggler by seeing the four Byrne brothers (James, Matthew, Andrew, and John) in *Eight Bells*. The brothers were incredible acrobats, gymnasts, and pantomime artists. "The smartest brother was a juggler," Fields recalled, and he often singled out Matthew as the performer who inspired him.[3]

Fields had other opportunities to see jugglers perform in Philadelphia. At age fourteen he went to the circus and "and saw one of the clowns tossing four balls in the air at the same time. That fired my youthful ambition." In an early scrapbook, Fields saved a program from a show presented by a specialty company at a Philadelphia music hall on March 21, 1890. One of the artists listed is the Arabian juggler Nevarro. Fields saw other jugglers entertain in Philadelphia by buying a cheap gallery seat with his small savings or by sneaking into the theater. "I haunted vaudeville houses whenever there was a juggler on the bill and studied his feats, determined to outdo them." He felt confident: "This is the job for me. I felt sure I was as good as any of the jugglers I saw around Philadelphia."[4]

Fields especially marveled at Paul Cinquevalli, a sensational Polish showman known as the king of jugglers for his spectacular feats. Although Cinquevalli appeared more frequently in Europe, Fields might have seen him during his US tour in 1894 or 1896 when he performed at major vaudeville houses on the East Coast. A former trapeze acrobat, he turned to juggling after he suffered serious injuries when he fell seventy feet onto a guy wire. A handsome man with a pointed wax mustache and slick curly hair, Cinquevalli was especially admired by ladies in the audience. He dressed in a skintight one-piece garment with long sleeves, similar to the costume Jules Léotard wore as a trapeze artist in the 1860s. The leotard gave Cinquevalli the freedom of movement and displayed his strong physique developed by lifting heavy weights. He also wore a brocaded vest adorned with sparkling jewels, short ornamented trunks, and shoes similar to ballet slippers.

Known for his amazing feats of strength, Cinquevalli balanced a wooden tub weighing forty-four pounds on a pole, tossed the tub in the air, and then let it fall onto a spiked helmet that sat on his head. The audience gasped when a forty-eight-pound cannonball fell from seven feet above him and hit his spine. Another breathtaking feat was juggling three balls while simultaneously lifting an assistant seated at a desk.

For his famous act, "The Human Billiard Table," he wore a green felt tunic with six pockets. Spectators sat mesmerized as he flipped billiard balls from one pocket to another with sharp jerks. Watching Cinquevalli's amazing feats of technical skill and dexterity, Fields must have felt intimidated that he could never match his act or his strength. But the strongman/juggler undoubtedly inspired Fields, who did a variation of his billiard ball act. Using a cue he shot pool balls that ricocheted from the back cushion into his coat pockets.

If it were not for Philadelphia's rich tradition of theater culture and its multitude of performance venues, Fields might never have become a performer. The City of Brotherly Love was associated with a number of famous actors: Edwin Forrest, lionized as the nation's most talented legitimate stage actor in the mid-nineteenth century; the captivating Charlotte Cushman, noted for her powerful performance as Lady Macbeth; and the renowned actor Joseph Jefferson. Louisa Lane Drew managed the popular Arch Theatre that offered legitimate dramas and comedies for three decades (1861–92). Her daughter Georgiana, a well-known stage performer, married fellow actor Maurice Barrymore. Their three children (Ethel, Lionel, and John) became famous stars.

The number of theaters in Philadelphia multiplied as its population escalated to nearly 1.3 million in 1900, making it the nation's third largest

city. Besides the legitimate theaters, there were popular showplaces for melodrama, variety, operetta, dime museums, and minstrel shows. Fields could have seen a variety show downtown at Gilmore's Grand Auditorium (1893), Hashim's Grand Opera House (1888), and the Trocadero Theatre (1870), where Fields later appeared in 1899. The center of Philadelphia's theater life was on North Eighth Street between Race and Vine Streets, an area that boasted more than twenty-one theaters by the late nineteenth century. Among them was B. F. Keith's Bijou, which opened on November 4, 1889. Called "The Drawing Room Theater of Philadelphia," the vaudeville venue offered "High Class, Refined Entertainment."[5]

"I had no idea of going into the show business when I started...I did it just for fun," Fields recalled. A career as a performer offered him definite advantages. "I guess it was hatred of getting up in the morning that made me a juggler. I just lay there and thought and thought of a trade that would let me sleep in bed till the day got warmed." Working early in the morning as an ice-delivery assistant and as a cash boy at a department store had given him a distaste for the regular workday. "The idea of getting up at 6 a.m. and being full of pep sent chills down my spine and made me lie in bed longer." "I was the laziest boy in Philadelphia," he confessed. "It was a heroic task for mother to drag me out of bed in time for school." Except for afternoon matinees, the theater was chiefly a "nocturnal profession." After an evening performance, he could stay up until the wee hours and "sleep steadily onward." Who knows: "I might have grown up to be a night watchman, or a porch climber, but I was deeply impressed by the tricks of a vaudeville juggler."[6]

Stories differ about how Fields began juggling. More than likely he first experimented by practicing with any fruit he could find. One day while reclining under a sickle tree, he found some pears and began throwing them into the air. "I started juggling with three pears, and then I took on a fourth," he told a reporter. He set up what he called a "self-training school" under an old apple tree in a neighbor's yard where "the ground was strewn with fallen apples and I found them excellent substitutes for rubber balls." Much to his father's annoyance, Fields grabbed some fruits and vegetables from his father's grocery wagon. "By the time I could keep two oranges going I'd ruin 40 dollars worth of fruit," he joked. Soon he "went to work tossing balls and things. The first time I tried to juggle three balls, I could do it. I never remember anybody teaching me—it just came natural, and I puzzled things out for myself."[7]

Although "born with a fatal facility for juggling things," Fields soon realized that to master the art, he needed to persistently practice. It did not

matter, he said, "if I felt ill or tired or discouraged or plain lazy." Cinquevalli had advised novices that sometimes tricks can take "years of application and assiduous perseverance before it is perfect and even then it does not permit of a holiday. Ball juggling is the foundation of all; therefore practice diligently, and see that you keep yourself always fit and in good form, otherwise your show will be uncertain and unsuccessful." "Practice! Practice! Practice! PRACTICE!" Cinquevalli urged.[8]

At times Fields had to push himself. "The hardest thing for a juggler to do is to practice, for he must do his routine five or six hours a day. It is only by such painful effort that juggling is made to look easy." He believed in the age-old adage "practice makes perfect." "Any man can be a champion in anything... if he only takes the time and trouble to concentrate on it and practice for hours at a stretch as if it were a penance." Even as a successful juggler Fields needed to practice. "If I miss practicing one day, I know it. If I miss two, the critics know it. If I miss three, the audiences know it." Fields believed that his jitters before a performance had one advantage. "It is the nervous man, who makes the most successful juggler, the man who wants to be doing something with his hands all the time. Otherwise he would not have the patience to practice sufficiently."[9]

Juggling is an art that depends on being able to master a number of skills, among them timing, speed, balance, and surprise. The performer needs to manipulate diverse props, to suddenly change trajectory while keeping one's balance, and using one's eyes correctly. "Balancing can only be acquired by finding the true center of gravity, and learning to keep it. In doing any act of this type, the eye must always watch the extreme top of whatever you are performing with, otherwise you will be unable to retain the balance," wrote Cinquevalli. Because it fosters timing and gesture, juggling provided great training for a budding comedian such as Fields. The art requires being able to make quick mental and physical decisions, especially when accidentally missing a trick. A juggler could mask the mistake by a one-liner—"If I did it the first time, you wouldn't think it was a good trick."[10]

Fields's neighborhood pals and fellow members at the Orlando boys club encouraged him to practice his juggling. He called his friend Thomas Hunt his first press agent. Fields never forgot the support he received from Hunt. In 1944, he sent a letter to him and signed it "Your Old Friend Claude Duckenfield Whitey the Stage Actor." Other buddies shared Fields's ambition to go on the stage. "I was one of W. C. Fields' boyhood friends," wrote Charles Van Tagen. "Like a lot of youngsters, we played

theater and all had a certain leaning towards the stage, the writer eventually playing theater in stock for two or three seasons."[11]

At the Orlando boys club, Fields assembled an array of props for practice. He found discarded objects in trash cans such as empty cigar boxes. A friend who was employed in a stove foundry gave him three steel balls and another furnished his father's old high hat. The club members helped him string a cable from the chimney of the nearby wheelwright shop to a tree so that he could practice high-wire walking. In a 1941 letter to Jimmie Lane, a club member he fondly called "Jinksie Pie," Fields wrote that he still kept these objects at his house. "All the props on the table and underneath the table were assembled, garnered, or what have you, during my stay at the Orlando Club."[12]

He practiced with H. M. Lorette, a teenage neighbor who also desired to be a juggler. Lorette remembered Fields as a scrawny kid—"a nondescript character." "We both had good routines with tennis balls and high hats." Lorette, who later became vaudeville's "Original Dancing Juggler," attempted to teach Fields tap dancing but found that his "sense of rhythm was very inadequate." "We had lots of ideas of our own, too." Lorette tried to get Fields to juggle heavy Indian clubs, but he was not interested. "A single juggler can't get any comedy out of clubs," Fields insisted. The statement suggests that Fields was already interested in injecting humor into his act. "I finally got him into doing a comedy break fairly well," Lorette recalled. "We both profited from our association."[13]

"[Juggling] was hard work at first, dreadfully hard," Whitey remembered. In a public park he pilfered loose tennis balls coming from the lawn tennis courts, which lacked fencing. "I was never caught," he proudly admitted. "I started in with two balls juggling in the first place and after I got so that I could do all the tricks that I had seen others do. With two balls I would add another and still another." He discovered that three balls was easier than two. "Evens are the hardest." he said. "It's all rhythm and spacing or perhaps you'd call it timing. It isn't how you throw the balls, but at what moment, and how high... You just don't hang on to what you catch. You just sort of brace it, and start it up again. You keep the rhythm and timing in your hands... You do your designs, and get your speed, with uneven number of balls... But you do your faking with the evens."[14]

Fields later described how the three-ball "cascade" was done: "Start with two balls in your right hand and one in your left. Toss Ball No. 1 upward from the right hand, giving it a slight inward motion. As it begins to descend, toss Ball No. 2 from your left hand into the air. Now, as ball No. 1 is reaching your left hand, toss Ball No. 3, from your right hand,

into the air." By making the thrown ball go underneath the incoming ball a "cascade" is created. Any number of odd balls can be used but they must be thrown higher in order to accomplish the cycle.[15]

Another odd ball trick called the "shower" was more difficult. The juggler holds the balls in a similar manner as the "cascade," Fields wrote.

> "The left hand is held a little higher than the right. First you toss up Ball No. 1 from the right hand [and] throw it a little higher than the rest...As soon as the first ball gets into the air, Ball No. 2 goes up after it. This leaves the right hand empty. Now, quickly, toss Ball No. 3, from your left hand, into the empty right hand, not in the arc-like path followed by the other balls but straight down...You've got to keep them moving fast now. As you're catching Ball No. 1 in the left hand, you're throwing Ball No. 3 into the air from your right hand. You continue this with all the balls from now on—the right hand up through the air and down into the left hand—from left hand straight across to the right." As a result a circular pattern is formed that resembles a "shower."[16]

After about two years of practice, he felt confident enough to go on stage and sought opportunities to display his skills. One way to break into show business was to perform at the many neighborhood fraternal lodges, union halls, church socials, and clubhouses. These local organizations raised money by staging programs of variety entertainment featuring amateur talent. Grateful for the opportunity, budding entertainers often performed free and food was their only compensation. "They would fill me up with sarsaparilla and sandwiches and I thought no one was as lucky as I."[17]

Around 1897, he performed with Harry Antrim, a boyhood pal, in a duo act. "A sandwich and a soft drink was our reward," he wrote to Antrim years later. "You would whistle and play the clappers, as they say in Philadelphia, I would juggle and try to sing and then we'd do our double. Those were the happy days but I don't think I could stand them again." Another early experience "was in a comedy duo" that did parodies of songs and other routines."[18]

His first single act was on a variety program at the Natatorium Hall on a cold Thursday evening, January 13, 1898. Located at Broad Street and Columbia Avenue, the building was one of several natatoriums in the city that included indoor swimming pools, fitness activities, and clubhouses. The nearly eighteen-year-old youngster was billed as a comic juggler—evidence that he was already thinking of an act that blended comedy with juggling. Worried that his father might discover his appearance, he was listed as Wm. C. Felton (his mother's maiden name) rather

than Dukenfield. He came on stage as the seventh performer in a twelve-act variety show that interspersed comedy and musical numbers. His act was going smoothly until an out-of-tune piano started to accompany him and he began to miss his tricks. He could have given up his ambition but instead persistently practiced every day. About two months later on Friday evening, March 11, he appeared at Peabody Hall in a grand concert and hop sponsored by the Lady Meade Lodge.

Although audiences liked his routine, Fields felt he did not wow the crowd and believed his act lacked novelty. He discovered that standing on stage in his regular clothes did not make him stand out. He needed to portray a character—one that was popular with theatergoers as well as complemented his personality and experience. He decided to dress as a tramp, a rebellious character and outcast who defied society. Fields believed he had been a homeless drifter after running away from his father. "I've been a tramp," he said. He claimed that he once stood on a ladder at the end of a freight car for several hours as the train traveled for miles. "A jump on a moving train needs skill and nerve. You make a little board, lodge it between the cars, and travel comfortably."[19]

As discussed in the previous chapter, Fields's so-called tramp experience was overblown, an example of his lifelong tendency for hyperbole and pressure to weave tall tales for show business publicity and to create a comic persona for the stage and screen. But during his short vagabond boyhood, he did encounter enough vagrants to empathize with their wanderlust life. During the severe depression of the 1890s, he saw many desperate homeless beggars in the skid row area in the eastern portion of Philadelphia near the river and warehouses. Unemployed tramps dressed in rags were roaming the city streets searching in vain for jobs. Hungry vagrants looked for food in garbage cans; hobos hopped freight trains from town to town; and to keep warm during the frigid winter the homeless sought shelter anywhere they could. Tramps were judged critically by the public as dangerous outcasts, drunkards, and lazy idlers who undermined the values of family and home. During the hard times unemployment and homelessness was so widespread that a growing sympathy developed for their plight. As a free spirit Fields identified with the hobo's rejection of society's mores. During his career he empathized with the underdog both on- and off-screen. Take, for example, *It's a Gift*, released in 1934 at the height of the Great Depression, in which Harold Bissonette (Fields) and his family join the car caravan of evicted farmers heading to California. They stay overnight at a migrant camp where Bissonette joins the wayfarers in a sing-along around the campfire.

He also decided to dress as a tramp for a practical reason. He spurned the costly chic costumes of popular "gentlemen jugglers" who dressed in tuxedoes and performed in fashionable settings. "I settled on a tramp make-up, because I was short of the money to buy any other. I just had to go on in any clothes I could scrape together so the tramp stunt came easier." He created a basic outfit by wearing a battered top hat found in a dump, paying a dime for an oversized coat, and blackening his chin. "The tramp character was about the best thing I could have hit upon. Somehow tramps are always credited with a sense of humor, and their scarecrow appearance seems to emphasize the impression. They have also a certain philosophy, according to the comic papers, which gives a quaint aspect to their outlook on life."[20]

The tramp as a stage character became a craze in popular theater entertainment during the 1890s and early 1900s. At least one hundred performers were dressed as tramps in vaudeville, burlesque, musical comedy, melodrama, and other forms of amusement. Some were jugglers; others were comedians, monologists, mimics, and minstrels. Among them was Lew Bloom, who claimed that he performed the first tramp in 1885. Wearing just a plain tattered coat and little makeup, Bloom's act in variety was marked with considerable patter and pathos that accented the difficulty of tramp life. Charles R. Sweet played a tramp burglar who walked on stage carrying a lantern looking for property to steal during the night. Paul Barnes, dressed in rags and a torn derby, told funny stories about the city where he was performing.

The most popular figure was Nat Wills, known as "The Happy Tramp." His attire and makeup verged on the grotesque. He wore patches over his ragged coat and a tiny tattered hat over his messy hair that flew out from the sides. Layers of black greasepaint thickened his mustache and chin. By blackening his front teeth, he created a gaping hole that resulted in a toothless smile. On stage he did topical monologues, farfetched stories that ridiculed the conventions of domesticity and wealthy ruthless industrialists who underpaid their workers. "I think the men who run our big railroads are only a little different from cannibals," he alleged. "You see, cannibals, cut men up to eat and the owners of railroads cut men down so they can't eat." He lauded the independence of the homeless and the value of life on the road. "Some of the most charming gentlemen it has been my good fortune to meet were tramps; men who had no visible means of support, no homes, no families, no friends, no professions, and no place in the social scheme." Fields later appeared with Wills on several vaudeville programs.[21]

Well before Charlie Chaplin immortalized the character, the tramp appeared in Sunday newspaper comic strips and turn-of-the-century short silent screen comedies. Several tramp films were made in 1901 including *The Tramps' Dream*, *The Tramp's Miraculous Escape*, and the *Tramp's Strategy That Failed*. Three popular comic strips featuring tramps were "Happy Hooligan," "Weary Willy," and "Burglar Bill." Happy Hooligan was a popular figure, an unlucky Irish vagrant with a tin-can hat, who continually encountered trouble with the law. He was the lead character in the films, *Happy Hooligan* (1900) and *Happy Hooligan April-Fooled* (1901). Hooligan and the other comic-strip tramps were portrayed sympathetically, romanticized as outcasts who rebelled against the conformities of society.

The most significant influence on Fields's act was the tramp juggler James Edward Harrigan, a popular big-time vaudevillian. Early in his career he was scheduled to appear at a camp show but was so broke he hocked his stage outfit. To appear as a tramp, Harrigan quickly borrowed odd garments from the other entertainers, mussed his smooth hair into a tangle, and created a half-inch beard by applying a handful of burnt paper to his face. He was such a hit that his manager threatened to shoot him if he "ever got his dress suit back from the pawn shop. So I remained a tramp behind the footlights ever after."[22]

Harrigan appeared annually on the big-time Keith Circuit during the mid-1890s with engagements in major cities on the East Coast, including several appearances in Philadelphia. Fields could have seen him perform during the last week of September 1895 at Keith's Bijou. To accent his appearance as a down-and-out tramp, Harrigan arrived on stage wearing a shabby coat and baggy pants, facial makeup that included fuzzy dark whiskers, heavily black-painted eyebrows, piles of paste on his nose, and scruffy unkempt hair. Billed as "The Eccentric Comedian and Juggler," he dazzled audiences with his juggling of cigar boxes, balls, bottles, pieces of paper, and a top hat. He interlaced his tricks with amusing patter, including jokes to cover his misses and sardonic comments about his unfortunate life as a tramp. A reviewer reported that Harrigan's feats at the Bijou "created roars of laughter."[23]

In his 1897 copyrighted script, "The Tramp Juggler," Harrigan revealed the essence of his routine. To draw the audience's sympathy, he told the spectators that he had just been fired by his manager and needed money. "I will pass my hat and I might chase up a few pennies" by doing "business tricks," he commented. To gain their attention, he lit a match on his

whiskers. He tossed a hat in the air, caught it on his head, threw it up again, and then balanced the hat's rim on a stick. "Don't you think it is a shame to take money for doing this," he declared. He next performed a trick with a bottle and a box with a lid done by throwing the "bottle in and out of the box, making the lid open and shut, as the bottle passes in and out." Then he balanced a long strip of paper on his nose, flipped it into the air, and caught it on his chest. Using a plug hat that had a disguised hole on the top and a flap on the side, he threw a ball in the air that went through the hole and out through the flap. "You have all heard of people talking through their hat, but you have never seen anyone that could juggle through his hat," he quipped. "Oh! Pretty fair," he exclaimed. Then he juggled three cigar boxes as he kept time with the orchestra music. "What is the use of working when you can do this for a living," he told the audience. He described his finale: "Putting lamps on top of a pyramid of cigar boxes on table, pushing pyramid over until it is about to fall, then catch on stick, balance all of them, then let the whole thing drop, and catch lamp on a stick." As he exited the stage, he said, "Well, so long fellows."[24]

In order to avoid being accused as a copycat, Fields never directly mentioned Harrigan as an influence. He once admitted that after he saw a juggler, he "immediately became obsessed with the idea I would emulate him." Another time he hinted that "there was tramp juggler showing in America then. I'd reckon I'd be a tramp juggler." His friend H. M. Lorette remembered that both he and Fields imitated Harrigan's juggling tricks. "We were both able to do about all that Harrigan did with cigar boxes," Lorette wrote.[25]

Filching routines was a common practice in vaudeville since troupers could not prevent the practice. Fields not only copied Harrigan's tramp appearance but performed many of his juggling tricks with cigar boxes, including striking a match on his whiskers. Inspired by Harrigan's act, Fields practiced regularly with cigar boxes during his training. Later, he pilfered his billing as "The Eccentric Juggler."

O. K. Sato (Frederick L. Steinbrucker), another popular tramp juggler who Fields met on the vaudeville trail, was well aware of Harrigan's influence. "You had so many looks at [Harrigan] before they ever let you onto a stage," Sato wrote to Fields. "You had a shiny example to copy from."[26] Harrigan knew that Fields was stealing his act. Sato jokingly reminded him about the time Harrigan was waiting in front of Miner's Bowery Theatre in order to "aim a few pouts in Your direction. And did You put only a pair of scissors and a hammer on Your clothes as a little precaution should He happen to catch a glance of You, or did You as rumor has it have

a whole hardware shop concealed on Your clothes?" Fields and Harrigan feuded until the latter retired from the stage. As the years passed, Harrigan forgave Fields and invited him for dinner in 1912 at his home in Buffalo. Not until 1943 did Fields confess to his business representative Bill Grady that he had stolen his tricks.

On Friday evening, April 29, 1898, Fields made his inaugural appearance as a tramp juggler at the third grand concert of the Manhattan Athletic Club. The event occurred at Batley Hall, a basement beer saloon owned by Thomas Batley, a real estate builder who had offices next door. The hall was located at 2746 Germantown Avenue, next door to a Quaker meeting house. Since Fields lived nearby, he was already a familiar face at the beer hall where he entertained customers as a member of Bill Amey's troupe, a group of neighborhood friends who staged shows. Patrons called Fields "Whitey the Play Actor."

Before appearing at the club, he wanted to change his stage name. Using Felton again, his mother's maiden name, was problematic. He felt that his tramp attire might offend the Feltons, especially his pious grandmother Annie. He believed Dukenfield was too long for show business, difficult to pronounce, and lacked cache. He also hesitated using Dukenfield since his father strongly opposed his goal of becoming a juggler. He consequently decided to use the last syllables of his last name and added an "s" at the end. On the playbill, he was listed in the number three spot as "Tramp Juggler—H. Fields."[27]

A few weeks later he appeared on a variety bill of musical numbers and comedy acts presented at the hall of the Brotherhood of the Union, a labor organization and patriotic fraternity. The long program featured primarily dance numbers, piano and violin solos, and comedy bits. Listed in the third position on the playbill was the tramp juggler—Mr. W. C. Fields. This was the first time he used initials with his last name. He did not want to use "C. W. Fields," since, as mentioned earlier, he despised the name Claude. Not until May 13, 1908, was his name legally changed to William C. Fields. To his regret, "Fields" as a stage name turned out to be common in show business. Some performers using the name were the comic Lew Fields of Weber and Fields; Gracie Fields, a British music-hall songstress; Benny Fields, singer and partner of Blossom Seeley; and "Happy" Fanny Fields, an English character singer.

Fields next performed at a Methodist church hall with a partner named Troubles, known as a troublemaker for his crooked pranks. When the minister informed Fields that he could not juggle his cigar boxes because smoking was a sinful habit, he replied: "If you'll pardon us a moment, your

worship, my associate and I will withdraw and confer."[28] After talking with Troubles, he convinced the minister that the boxes never contained tobacco and were strictly for juggling. At the show's end, the pair discovered that the treasurer had suddenly disappeared with their payment. In retribution, Fields and Troubles stole a batch of umbrellas, pawned them the next morning, and with the proceeds bought a steak dinner.

The club appearances gained him experience but to advance his career Fields needed to obtain professional bookings. His friend William T. Dailey, a song and eccentric dance performer, knew the intricacies of show business and could help him get engagements. A lean Irishman with curly thinning hair in his late twenties, Dailey was called the "Professor" because he taught youngsters like Fields card tricks and gambling games that duped the naïve. Fields called Dailey "my first manager."[29]

To get his young protégé noticed, Dailey discussed staging a benefit on his behalf at Batley Hall under the pretense that he was near death at a local hospital and urgently needed money to pay his bill. He suggested hiring an orchestra for dance music, making cards advertising the show, and selling tickets for fifteen cents. "You engineered the whole thing," Fields later wrote to Dailey. A number of budding entertainers among Fields's friends volunteered to perform at the event, held on Monday evening, June 13, 1898. The evening was advertised as "'Select' Vaudeville Entertainment Tendered to William C. Fields (Tramp Juggler)."[30] Fields claimed that he hid during the show, and when no one was looking, he filched the box office receipts.

Grandma Annie, the matriarch of his mother's family, was suspicious about his friendship with Dailey, who had an unsavory reputation due to his gambling schemes. On one occasion the Professor and Whitey were taken to a local police station on the grounds that they were burglars. Annie, who wanted her grandson to become a respectable citizen, believed that Dailey was a corrupting influence and wanted him arrested. By now she had learned about her grandson's juggling appearances. She lived near the Orlando Club and once saw him practicing his high-wire walking, stormed into the premises, and confiscated some of his equipment. After he became successful, Fields often wondered what his grandmother would now think of "his foolish juggling notion." "I suppose the home folk thought I would do better in a foundry or some place like that."[31]

His father also opposed Fields's "juggling mania." "My people did not like it very much, and had tried to discourage me in every way in their power. They used to hide the things I practiced with, and interrupt me." His brother Walter recalled that Fields "didn't get along with father so

good, because father wanted him to work and he would not do it; he wanted to be an actor." Fields quarreled with Jim who felt that his son was wasting his time practicing. "[Fields] was constantly reminded that a big strong boy like me ought to go to work." "This juggling business is no good to me," his father told him. "There's a lot of money in it," Fields replied. "He was a determined man and I was a fractious kid...so we quarreled."[32]

Although his mother was more supportive, Fields's family shared a typical nineteenth-century attitude toward actors who were viewed as disreputable, drunkards, and immoral. "They disapproved very much of the idea of it as a profession and were rather ashamed of me," Fields said.[33] But it was too late to stop their son who had been bitten by the show-business bug. The eighteen-year-old youngster had discovered a calling that excited him. Fields knew it was a risk opting for a precarious career in show business. As he prepared for his next engagement, he suddenly grew insecure, an agonizing nemesis that surfaced constantly during his career. Beset by a period of self-doubt, he felt as if he was leaping off a mountain peak into an uncertain future.

# 4. Initiation Rites ❧

Fields's insecurity ceased when his mentor, Bill Dailey, came to the rescue. Dailey contacted Tony Baker who managed the Casino Pavilion's open-air theater at Plymouth Park, one of Philadelphia's newest and most popular getaways. He convinced Baker to book Fields for a one-week engagement starting August 1.

Bordering Norristown in the bucolic Schuylkill Valley, the park was situated about eighteen miles northwest of the city. Opening in 1895, the area was developed mainly to attract customers to ride an extension of the trolley line beyond the city limits. In the summer, hordes of people left the hot city for a Sunday picnic under a shady tree on its lovely grassy grounds. The pastoral park featured a lake for boating, a carrousel, and a restaurant with band music.

Fields's appearance was significant because he was now on a program with variety professionals rather than amateur singers and musicians. Billed as "The Wonderful Tramp Juggler, in Original, Intricate and Difficult Feats," he arrived on stage as the third act. "I was nervous," he told a friend. "I wasn't sure Norristown was ready for me."[1] During his eight-minute performance, dressed in sparse tramp attire, he juggled rubber balls and other props. His reception was adequate but not remarkable.

In vaudeville lingo, Fields's performance was classified as a "dumb" or silent act, the #1 playbill spot usually reserved for performers such as acrobats, jugglers, and bicyclists, etc. They were placed there because seated spectators would not be bothered by the audience still arriving. Among its disadvantages was that reviewers tended to ignore the first act, especially if they were late to the show.

Why was he billed as a "dumb" act? As a novice he had too much stage fright to speak. In a 1901 interview Fields said he stuttered: "You may notice that I stutter badly when I talk, and I therefore concluded that I would go through my act without saying a word."[2] According to recent research, stuttering is a complex communication disorder due to a number of factors including child development and family dynamics. If the latter

played a role, his stuttering could have developed due to Fields's overbearing, strict Victorian father who believed that children should remain silent in front of adults. Moreover, he punished his oldest son whenever he verbally taunted his parents.

The interview is possibly the only instance that he admitted stuttering. Family and friends never spoke about it. If he did stutter, it was short lived, because a few months later, he was taking speaking parts in a burlesque show and before long he would add comic asides to his act. Thus his stuttering, if true, might have been caused by his initial stage fright. His reluctance to fully talk onstage had one major advantage. Instead of a steady stream of patter, he relied on pantomime gestures to amuse the spectators. Fields consequently developed as an extraordinary pantomime and used this talent to provoke laughter from audiences on the stage and screen.

Baker offered him five dollars a week to give matinee and evening performances. "I guess I can get along on that," Fields replied. But "a dollar and a half comes out of that as my commission," Baker told a shocked Fields.[3] Knowing that the engagement was an opportunity, he had no other recourse but to accept the manager's outlandish 30 percent commission, which was much higher than the usual 10 percent. The experience was an initiation into the shady practices of deceitful show biz managers who swindled performers. His mistrust of fraudulent Broadway impresarios and Hollywood studio czars would grow over time. The encounters gave him firsthand material for his razor-sharp portrayals of scheming showmen.

The star at the Casino Pavilion was the ethnic comedian "Sliding" Billy Watson, who received his nickname by skidding halfway across the stage as his curtain raiser—a surefire laugh getter. Fields had befriended Watson, who had his next engagement at Fortescue's Pavilion in Atlantic City, New Jersey. He asked Watson to recommend him to the management. Fields soon received a telegram informing him that he was hired at ten dollars a week with "cakes." "We had the privilege of ordering what we wanted to eat several times a day," he recalled. "So that was a little better." To reach Atlantic City, Fields wanted to hop a freight car, but he had to ride coach due to his large trunk containing his juggling outfit and props. "It broke my heart to pay a dollar for a train ride and sit in a stuffy coach," he recalled.[4]

When Fields arrived in 1898, Atlantic City was booming as a favorite summer retreat for people from Philadelphia. The resort was formally opened on June 16, 1880, when a new boardwalk was built, and by 1883, nearly one hundred types of stores lined the walkway. Hordes of tourists

seeking sun, surf, and entertainment took a short ferry ride across the Delaware River to Camden where they boarded a train and after a ride of about two and a half hours arrived in Atlantic City. Here tourists found luxury and modest hotels, wooden boardinghouses, and an expansive sandy beach. Men dressed in white slacks and bowler hats, and the ladies in stylish ankle-length silk dresses strolled leisurely along the boardwalk or were transported in unique rolling chairs. Lining the boardwalk was an array of attractions: shooting galleries, merry-go-rounds, restaurants, bazaars, and a potpourri of entertainments ranging from vaudeville and burlesque to minstrel shows.

Visitors were lured to the two-story 624-foot long Applegate Pier, which advertised a ballroom, concerts, and a vaudeville theater. The H. J. Heinz Company's Iron Pier was highlighted by a huge white building topped by a large eye-catching "57" sign that advertised its number of food products. Even more impressive was the Steel Pier, which over the years had five theaters, including a 3,500 seat music hall, an opera house, and a ballroom, as well as hundreds of exhibits on display—"all for one admission price." Perched above the structure was a huge marquee with brightly illuminated bulbs that spelled out, "The Showplace of the Nation—A Vacation in Itself."[5]

Before his debut, Fields met his friend H. M. Lorette, who was doing a two-week engagement at the pavilion. While sitting on the porch of the Biscayne Hotel, the two talked "things over." Lorette found Fields "a little nervous, which wasn't characteristic for him because he had plenty of guts." Lorette was correct in his assessment. Fields's fear of missing juggling tricks was then veiled under a mask of bravado. "Juggling is difficult and the first five, six or seven years, you don't know your tricks well enough to do them with your eyes shut," Fields admitted. "What would worry me, therefore, especially on an opening night, was failure...Occasionally in those days I'd miss a trick and so I began to worry: supposing I go out tonight and do twenty tricks of juggling and miss most of them. Suppose I miss every trick. It was just torture. I prayed for the day I could get over this misery, the dread of missing—those fear complexes. Out on that stage I was frightened to death—desperate."[6]

Opening in 1878, Fortescue's Pavilion was an older establishment, a combination beer garden and variety showplace in a long two-story building fronting the beach where Arkansas Avenue intersected the boardwalk. Despite the sea breezes, the open-air pavilion reeked with a pungent odor of cigar smoke and beer. The entertainment was free provided patrons bought at least a five-cent glass of beer. The entrepreneurial owner, Jane

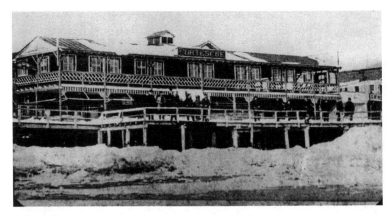

**Figure 4.1** Fortescue's Pavilion, Atlantic City, NJ, where Fields performed and faked being drowned during August 1898 for "Ten dollars and Cakes" weekly. Courtesy W. C. Fields Productions, Inc. www.wcfields.com.

Fortescue, stressed the wholesomeness of her acts. The Zartinis, a German family act, were described in 1897 as "chaste, artistic, beautiful, and worth seeing."[7]

Whitey was listed as "W. C. Fields—Tramp Juggler," number seven on a nine-act playbill. Lorette saw Fields perform on his first day. "He wanted me to start applause for certain moves and give him my opinion on the whole arrangement. He did fairly well and I left."[8] Fields performed his tramp juggling act up to twenty times a day for two weeks.

When he joined the cast, Fields had no idea he would be a "drowner," a sleazy scheme to lure customers into the pavilion. "When we thought we were not getting our full complement of patrons, I was sent out to drown," he recalled. Fields dived into the water, swam some distance out, cried help, disappeared under the water, and then surfaced spitting out a mouthful of water. Imposters hired by Fortescue's would holler that someone was drowning and then swim out to save him while the commotion caused crowds to gather along the shore. "I was rescued and dragged back into the pavilion. The crowd would usually follow." He was laid on a table but as soon as the band began playing the customers forgot about the drowning. "The show would go, and the waiters would get busy taking orders." After the first act began Fields quietly snuck off and waited for his turn. Much like the old army game at the Trenton Fair, Fields felt that the drowning stunt was "a great racket" that showed him how the gullible can easily be

duped by a con scheme. The customers at Fortescue's, he thought, were suckers who did not deserve an even break. "And we got plenty of fun out of it."[9]

Hoodwinking the public made a lasting impression on Fields. In the film *You Can't Cheat an Honest Man* (1939), Fields plays Larson E. Whipsnade, a snake-oil salesman who operates a debt-ridden wagon circus. Outside the tent he ballyhoos the show by having his performers exhibit their routines. Enticed by his sales pitch, the spectators buy tickets. Whipsnade warns them to "count your change before leaving the box-office—no mistakes rectified after one leaves the window."[10] Instead of receiving the correct change, he gives them a wad of worthless paper money. Feeling they have cheated Whipsnade, the customers leave without looking at their bills.

"Atlantic City was really the beginning of my theatrical career," recalled Fields. His appearance fortuitously led to his first appearance in a burlesque show. He told two different stories about how he joined *The Monte Carlo Girls*. "The manager of the burlesque show next door saw me at Fortescue's and engaged me for $17 a week." Another time he stated that William Bryant, a vaudevillian on the Plymouth Park Pavilion's playbill, "commended me to the manager."[11]

Joining a burlesque show was "another step upward," wrote Fields. The show gave him his first opportunity to be in a touring troupe that promised many weeks of continuous work on the road. Because he could experiment with various juggling tricks and play other parts, burlesque turned out to be a valuable training ground for Fields. Burlesque had helped develop numerous up-and-coming comedians and singers such as Bert Lahr, Joe Weber and Lew Fields, Al Jolson, Fannie Brice, Ed Wynn, and Eddie Cantor. "Burlesque is good training for a man in the early stages of a theatrical career," Fields later said. After a year, a performer "ought to know if he is cut out for this business."[12]

Burlesque derived from meshing several theatrical forms, among them the buffoonery of comic opera; travesties on dramatic and literary classics; the structure of the minstrel show; the risqué dancing and blue comedy found in concert saloons and honky-tonks; and the accenting of the female figure in leg shows. As a result burlesque became an extremely popular stage entertainment after the Civil War.

The pioneer showman Michael Bennett Leavitt, considered the "father" of American burlesque, managed the country's first popular burlesque show in 1869, Mme. Rentz's Female Minstrels (renamed the Rentz-Santley troupe after its star Mabel Santley). The show wowed an all-male audience each time Santley daringly bared her stockings and ankles while dancing

the cancan. A pathfinder in the creation of theater circuits, Leavitt used the new transcontinental railroads during the 1870s to develop a nation-wide road tour for his numerous burlesque companies.

During the 1870s, a potpourri of similar shows appeared with a standard format partly modeled on the three-part minstrel show: an opening such as a humorous and lively song and dance number accenting the charms of the chorus girls and the risqué humor of male jokesters, followed by an olio that featured diverse entertainers performing their specialties. The last act was the afterpiece, often a travesty lampooning society's hypocrisies, poli-tics, and many other subjects. A lewd burlesque simultaneously emerged that accented bawdy songs, salacious jokes, cootch dancers, and chorus girls in different degrees of undress. Besides highlighting the female figure, burlesque's low-admission cost especially appealed to working-class males, but it also attracted wealthier men seeking a night on the town. As Sime Silverman, the founding editor of *Variety* wrote: "Were there no women in burlesque, how many men would attend? The answer is the basic principle of the burlesque."[13]

*The Monte Carlo Girls* was a production that mixed respectable acts with racy production numbers featuring titillating songs and dances with stunning chorus girls in short skirts baring their legs. Variety performers such as Fields were viewed by burlesque producers as wholesome fillers between the chorus numbers. The male spectators sat impatiently waiting for the "girls" to reappear, which made the challenge more difficult for clean acts such as juggling to wow the audience.

Compared to Leavitt's first-class extravaganzas and other top-notch burlesque shows, *The Monte Carlo Girls* was a second-rate production. It was operated by James C. Fulton, an acrobat and comedian turned bur-lesque producer. A fancy dresser known as the Beau Brummell of the bur-lesque managers, Fulton was reputed to change his clothes three times a day and never wear a suit more than a month old.[14] Small in stature with diminutive hands and feet, he wore size five gloves and size three shoes. He compensated for his physical appearance with a Napoleonic complex accented by a domineering, ruthless personality.

During the summer of 1898 Fulton compiled an itinerary by negotiat-ing with each theater individually—a method known as "wildcatting." He aimed to create a schedule with stops as close to one another as pos-sible in order to save railroad costs. "Wildcatting" was a risky business for performers. Second-class shows were run on a shoestring. Since they never received contracts, the troupers could be easily fired. If the show was not receiving enough box office receipts, salaries were often not paid.

The actors could be suddenly stranded in a distant place without funds to return home.

*The Monte Carlo Girls*, however, was not a low-class "turkey" show because of its professional musical numbers and talented performers. Fulton hired Theodore A. Metz, composer of "There'll Be a Hot Time in the Old Town Tonight," to write bouncy music. He also engaged the blackface sketch comedian William T. Bryan, who with his partner, Ida Burrows, performed a skit called "The Saving Woman." Fulton appeared in an act with his brother William entitled "A Hot Chase." The show's main star was Fulton's wife, the singer Eva Swinburne.

Among the chorus girls was Harriet "Hattie" Veronica Hughes, a thin, stunning woman with radiant pale skin and flowing curly black hair. She had seen Fulton's advertisement in the *New York Clipper* on September 3, 1898, for chorines, which drew 232 aspiring applicants. Her looks won her the job—her first professional appearance on the stage. She was paid fifteen dollars a week and was listed in the playbill as Flossie Hughes. In addition to dancing and singing in chorus numbers, Hattie performed the role of Miss Holdout in the "Ki-Ki" afterpiece.

Show business ran in Hattie's family. Her mother, Elizabeth "Lizzie" Hughes, was a singer with a wonderful voice, who once performed with Lillian Russell in the opera *Pepita*. But her career conflicted with her busy responsibilities as a housewife in New York City, where she raised three girls and two boys. She consequently never became a leading performer in her own right. Hattie's father, John Hughes, an Irish immigrant, worked as a porter in a grocery store and later as a coffee merchant.

Hattie had a strict middle-class Irish Catholic rearing due to her mother's devoutness. She went to parochial schools and regularly attended St. Michael's neighborhood church. As a young girl, Hattie was given song and dance lessons by her mother. A talented singer, she entertained at church socials and at school functions. But she lacked the passion to become a professional performer. Instead, she attended Normal College (now Hunter College) hoping to become a teacher. When her father, the family's main breadwinner, unexpectedly died of a heart attack, she needed to quickly find a job and joined *The Monte Carlo Girls*.

Fields first encountered Hattie at a party before the show went on tour. She told a different story later to cover up her embarrassment about appearing as a chorus girl in burlesque. Hattie stated that she met Fields at a reception given by a girls' school, an event that Fields had no reason to attend. To conceal her show biz past, she later crossed out her name in the programs she kept.

Hattie found Fields shy, awkward, and uncomfortable while talking to her. His lack of experience with reputable women such as Hattie caused him to appear ill at ease. He was then a scrawny eighteen-year-old youngster, five feet, eight inches tall, and weighed one hundred and thirty pounds. But his charming baby face, blue sparkling eyes, and eye-catching white blond hair attracted her. "[He] looked like a young boy," recalled Hattie, who was nearly two years older than Fields. "He was young and green and so was I." Fields was immediately drawn to Hattie's pretty face, sparkling eyes, slim figure, and charm. "Your skin is still so beautiful," he once told her.[15] Fields dated Hattie several times in New York during the summer of 1898. They took walks, strolls in Central Park, and went to the theater. Hattie invited him to her mother's home knowing that Lizzie would like Fields since both shared a passion for show business. Unless he had an earlier teenage infatuation, Hattie was his first love.

Fields knew the so-called notch joints located in a downtown Philadelphia alley where prostitutes offered cheap sex. An investigator discovered three hundred houses of prostitution in eastern Philadelphia's tenderloin district and in the southern area of the city. Given the number of vice districts, the Orlando boys more than likely participated in the rite of sexual initiation.

Fields could not keep his eyes off Hattie when *The Monte Carlo Girls* opened in Troy, New York, on September 19. The performers called Fields "Bill" and recognized Hattie as "Bill's girl." "Bill" was the moniker most entertainers used during Fields's show biz career. Except for close family, no one dared call him Claude, not only because Fields disliked his birth first name but by now his initials "W. C." were embedded like cement in show biz publicity.

During the long tedious tour with its continual train rides to the next town and dingy hotel rooms, it was quite natural for itinerant performers to feel lonely and in need of companionship. Fields recalled that before the show went on the road Fulton gave a speech that prohibited men and women from sharing a room, known in show biz circles as "sketching" or doubling up. The performers ignored his objection. "The show wouldn't be running two weeks before girls and boys would be paired off according to their liking; though sometimes ill-sorted—a stage hand with a prima donna and the veteran comic with the youngest chorus girl," Fields recollected. "If this happened the manager might slice their salary in half with the excuse that "two can live as cheap as one."[16]

The show's itinerary during its first three months consisted mostly of one- to three-night stands primarily in mid-size towns in New England

and the Mid-Atlantic states although it also played in large East Coast cities. The one-night appearances were especially grueling. It meant packing up after the evening performance, catching a midnight train, and arriving in the next town in time to unpack and perform. The troupe slept in run-down boarding houses run by families who mostly served mediocre meals. Finding clean clothes to wear was a problem. The advance agent would collect the performers' laundry once a week and have it ready at another stop many days later. The exhausted troupe appreciated several week-long engagements. After three successful days in Altoona, Pennsylvania, the show was so popular it was held over for the entire week.

*The Monte Carlo Girls* opened with an operatic burletta, a scene on the picnic grounds at Camp Wikcoff, which featured flirtatious chorus girls dressed as military maids cavorting with handsome men in naval cadet uniforms. In one act, variety performers personified various states of the country. James Fulton, for instance, played "Mississippi, hot as they make them" and his brother William "Alabama, never in the shade." Members of the cast sang patriotic songs such as "Brass Buttons" and "Army and Navy, or Can You Beat Them?" The military themes reflected the winning of the 1898 Spanish-American War and the goal to annex the Philippines.

Most newspaper reviewers gave the show good notices, but a few panned the production for its offensiveness. A reviewer called *The Monte Carlo Girls* a "burlesque extravaganza" that attracted "patrons of the masculine gender" with its "female contingent being large and prepossessing." The critic who saw the show in Manchester, New Hampshire, wrote a scathing review that criticized "two of the most suggestive songs ever heard here in public." The dialogue between a female team "excels in vulgarity the previous worst thing of the sort Manchester has heard in many years." The *Johnstown Pennsylvania Democrat* called the show "very sensational and vulgar."[17]

Fields arrived on stage in the number two spot billed as "William C. Fields, As a Tramp Juggler. We think you will like him." At other times he was advertised as "The Hobo—First Time in America." Fields received mostly rave reviews for his facile juggling of balls, hats, cigars, and other objects. The *Pittsburg Leader's* critic wrote that "William C. Fields, as the tramp juggler, made the hit of the evening," and in Portland, Maine, the *Daily Press* reported that "William Fields gave the best exhibition of tramp juggling ever seen on Portland boards."[18]

The audience never noticed that Fields was "sick with nervousness every night." "I knew my show was rotten, and I reckoned I'd be surely found out sooner or later. When it didn't happen to-night, I thought it

would be to-morrow night. When it didn't happen in this town I figured it would sure happen in the next." He masked his jitters by appearing non-chalant. Lacking self-confidence, he worried that his act might flop. What he feared was ending up as another forgotten juggler "laid on the shelf." To avoid the fate of oblivion, he needed to "use his mind and not just my hands." Otherwise, "people would be saying, Bill Fields? Oh, yes! He used to be a juggler, didn't he?"[19]

Besides juggling, Fields was given acting roles plus the job of moving scenery and passing out playbills. To get rid of a batch of programs, he once scattered them on a pond where people were skating, which caused them to fall. The angry skaters ran after him all the way to his hotel where he hid. He was added to the opening act called "The Folks," playing Si Flappam, a regular play actor. He appeared as Dr. Newpenny in the afterpiece, a burlesque on "Mlle. Fifi," a provocative antiwar short story by Guy De Maupassant about German officers who vilify French prostitutes in their occupied chateau during the 1870 Franco-Prussian War. His stuttering must have subsided since Fields was probably given lines to speak.

Fields possessed the will power to endure the endless grind of perform-ing each night in a different town. "That eighteen months I spent with the company were the most miserable of my life," he later said. "I would never have gone through with it if I had known what it was going to be like." Despite the rigors, he gained invaluable experience. "I juggled, played a dozen bits, and got a chance to develop a line of humor."[20]

His time with *The Monte Carlo Girls* turned out to be another encoun-ter with the shady practices of show business. Fields soon learned that Fulton was a notorious sly con man. After a few weeks on the road, he began to realize that his job was insecure when Fulton suddenly stopped giving him his salary of twenty-five dollars a week. Fulton depended on getting wealthy suckers, called "angels," to invest in his show by using his attractive chorus girls as bait. According to Fields, the practice often back-fired when the potential investors "got stuck on his wife" instead of one of the twenty other girls in the show.[21] When Fulton discovered that his wife was the object of an investor's desires, he had a temper tantrum.

Fields and the other performers were faced with a precarious situa-tion. When Fulton was broke some cast members just left. "Sometimes the whole company would disband and reorganize and on we would go," Fields recalled. "It was not unusual to have a reorganization every three weeks."[22]

Their circumstances grew desperate when the performers heard rumors that Fulton and his wife were about to skip town and go to New York. "We

used to stand watch in the hotel all night long in front of the manager's door to find out if he was going to duck," Fields remembered. One night it was Fields's "turn to stand guard. Being a kid, I was so sleepy that I thought if I could get one hour's sleep I wouldn't care if the whole world came to an end. For hours I sat in the dark narrow corridor of the old hotel staring at the manager's door under the faint little gas jet, and trying to keep awake."[23] To prevent falling asleep, he practiced juggling.

During the month of December the show appeared in Ohio. In Ravenna on December 10, the troupe performed a one-night stand at Reed's Opera House. An advertisement for the *Monte Carlo Girls* publicized twenty-five artists in the group headed by Miss Eva Swinburne, the "Queen of Burlesque Stars." They next travelled to Kent for appearances at the Opera House on December 16 and 17. The local paper called the show "an aggregation of ordinary merit" with only nine people "playing to small audiences." On December 23, the *Kent Courier* printed a story on its front page headlined, "**BUSTED. Monte Carlo Girls Theatrical Co. Ends Its Career.**" The paper felt the troupe "failed to dwell in harmony. A female trapeze performer sued the management and the case was heard before Justice Genet. She got $2 and the cost amounted to $7." The last sentence announced the show's epitaph: "After Saturday night's performance the company went to pieces. One went to Cleveland and the others left for the east in the hope of reaching New York."[24]

On a freezing cold night in Kent, Ohio, Fulton and his wife absconded with the funds and left town, leaving the thespians stranded. Lacking money, Fields could not pay his hotel bill. He recalled that the manager routed the entire troupe out of bed at 3 a.m. with the words "be gone." Fields recounted that the snow was one foot deep outside his boarding-house perched on a steep hill, and that he put his trunk containing his props on a sled and ran downhill next to it. When the sled started to bruise his feet he ran faster hoping to reach the train station on time. "I think I hold the record of being the only man ever chased out of Kent by his own trunk," he joked. Another story still circulating in Kent is that Fields stayed at the Central Hotel and left two trunks in lieu of paying his hotel bill.[25]

His hasty departure is captured in *The Old Fashioned Way* (1934), a feature film ghostwritten by Fields under the nom de plume Charles Bogle. Fields plays The Great McGonigle, the roguish leader of wandering entertainers, who, like the Monte Carlo troupe, fears being abandoned and losing his salary. Pursued by the sheriff for his unpaid debts, McGonigle resembles Fulton and his deceitful ways. Similar to Fulton's attempt to get

wealthy benefactors interested in his chorus girls, McGonigle courts the wealthy widow, Cleopatra Pepperday, to invest in his show by promising her a role. To avoid paying his boardinghouse bill, McGonigle attempts to skip town. While sliding his trunk down the stairway, he is spotted by his landlady. McGonigle lies that the trunk belongs to a trouper who is going to stay with him. She refuses to have any more performers in her boarding-house and orders him to take the trunk outside, which allows McGonigle to escape without paying his bill. Fields must have recalled his experience in Kent, Ohio, when he wrote the scenario.

Tales about how Fields paid his fare to New York are as numerous as the tales about his trunk. After reaching the train station, Fields discovered that he only had eight dollars to pay the eighteen-dollar fare to New York. He asked the station agent to help him. According to one story, the agent received permission from the train company to give Fields a ticket for eight dollars. Another tale suggests the agent George Hinds loaned him money because he had seen his performance at the local opera house. "I'm goin' to give you a chance to do some juggling...I got a feelin' you're honest," he told Fields, who boarded the train six days before Christmas. He would never forget the agent's help. He later invited him to attend a show when he was in Akron, Ohio, where he repaid him the money. "His pride in my suc-cess could have been no greater had I been his son," said Fields. "Different members of the troupe entertained him and made him feel glad that he had once been kind to a member of their fraternity."[26]

Fields's travails as a neophyte entertainer were far from over. He arrived in New York with the temperature hovering below freezing, with no warm clothes, and an epidemic of grippe infecting the populace. He walked the streets looking for work while shivering in a thin blue serge suit and car-rying a raincoat an actor had loaned him. He haunted Union Square with its legitimate and vaudeville theaters, including Tony Pastor's famous vari-ety venue. At the square's southeastern corner, called the Slave Market, unemployed actors congregated during the summer hoping to meet agents and producers. But being winter jobs for a novice juggler were scarce and he landed only a few one-night stands at clubs and smokers. He felt lost amidst the crowded streets in the bustling city now populated by three million inhabitants. One day a storm covered New York in a blanket of snow. "It was a blessing to me," said Fields, who earned thirty cents an hour shoveling snow off the sidewalks.[27]

He continued to see Hattie who had likewise fled Kent and returned to her family in New York. Fields introduced her to his family in Philadelphia. They liked Hattie, especially Elsie May, Fields's sister. Their courtship,

however, had reached a roadblock. The time had arrived to either pro-
pose marriage, as Hattie wanted, or end the relationship. He thought of
marriage, but being unemployed and unable to support her, he decided to
wait.

In a letter to a cast member, Fields later recalled his time with the bur-
lesque show. "Do you recall the Monte Carlo Girls disintegrating in Kent,
Ohio, Jim Fulton, and Eva Swinburne running out on the show, salaries
unpaid, no money for hotel bills or eats not to mention railroad fares? But
we all got back to New York somehow. Those were the happy days—I
hope they never come again." He signed the letter "W. C. Fields Comic
Juggler."[28]

"Whenever I see a gas jet I think of those nights spent in cold halls
seated against the manager's door," he told a writer with a movie magazine.
His experience at Kent was another encounter with the disreputable prac-
tices found in entertainment. "Although I have been in this business for
forty some odd years, I've never felt it was a stable business," he admitted.
"My first time of being stranded was Xmas...in Kent, Ohio. It didn't seem
then as though I was ever going to get back in the theatrical business."[29]

Within a year he had experienced the initiation rites of a neophyte
trouper. The manager in Norristown had overcharged his commission; in
Atlantic City he was told to hoodwink the public by faking being drowned
in the ocean; and a mendacious manager had abandoned him on the road.
As he walked the streets in New York, he felt terribly distressed about his
future.

# 5. The Sly Conjurer ❧

Hungry, broke, and determined to find work, W. C. Fields stopped at various dime museums that hired entertainers for their variety shows. During the last half of the nineteenth century, museums attracted millions of patrons daily in cities across the country, especially the working class because of its inexpensive admission. Besides displaying curios, stuffed animals, waxworks, menageries, and dioramas (illuminated panoramas), they had raised wooden platforms or regular theaters where variety entertainment was presented continually from late morning through the evening. Several proprietors were former circus sideshows owners who advertised sword swallowers, magicians, human oddities, mechanical wonders, and many fake illusions. Museums became a training ground for budding entertainers and a launching pad for managers. Benjamin Franklin Keith, for example, started with a tiny museum in Boston and eventually headed the largest vaudeville theater circuit in the East.

Fields obtained an engagement during the last week of December at a museum in the Bowery area located in downtown New York. Before the Civil War the locale had been the home of the finest legitimate theaters in New York, but it was now a neighborhood where cheap entertainment drew newly arrived immigrants who had settled in the area. The Bowery museums advertised their attractions by hanging large banners and colorful canvas paintings on the outside. Barkers on the street lured pedestrians to buy tickets by pitching the entertainment—a sales gimmick called a ballyhoo that was also common in medicine shows and circus sideshows. Sometimes the museum owner hired a shill to buy the first ticket hoping the crowd would follow. An attraction, usually a unique human curiosity, stood on a platform outside the museum as the barker did his spiel. Fields mentioned that he once worked in a circus, but since no evidence exists, he probably was referring to his museum experience.

After performing his juggling act for one week, he again walked the streets until he found work at George H. Huber's famous museum at 106–108 East Fourteenth Street in the Union Square area. Huber's Palace

Museum was a huge five-story L-shaped structure consisting of three build-
ings that had eight rooms full of glass-encased curios. Human curiosities
and animal oddities were featured, ranging from Jo-Jo, the dog-faced boy,
to the largest hog in the world. When Fields performed at Huber's, he
recalled that the star attraction was a headless woman resting in a coffin.
A considerable number of museum attractions were nothing but hoaxes
aimed to titillate and deceive the spectators.

Huber's theater advertised wholesome family entertainment with con-
tinuous stage performances from 1 p.m. to 10 p.m. The showman's slogan
was "a dollar show for ten cents." Fields appeared in sometimes twenty
shows a day for a few dollars per week. "It seemed as if I did my act every
five minutes all through the day and half the night." Looking back, Fields
felt there was an advantage performing to different audiences. "The aver-
age beginner spends years in getting as much experience."[1]

Fields was exposed once again to the hype, scams, and bogus found in
cheap entertainment. With its fake attractions, shills, and ballyhoo, many
museums were operated by defrauders who would stop at nothing to cheat
their customers. After purchasing a ticket to a dime museum, customers
learned that they had to pay more money to see not only some of the main
attractions but also extra exhibits—a ruse known as a blow-off. Behind
the doors were quack doctors who sold fake remedies and inner sanctums
where patrons paid to see female nudes only to view mannequins. The
printed biographies of the human oddities touted to the public were noth-
ing more than hyperbolic tales.

The atmosphere made a lasting impression on Fields. His encounters
with hoaxes in museums coupled with fake "drownings" in Atlantic City
and a crooked operator in burlesque provided the foundations for his role
as a roughish confidence man in his films. In *Two Flaming Youths* (1927),
Gabby Gilfoil (Fields) owns a bankrupt traveling sideshow. Standing on a
platform bedecked with banners, Gilfoil gives the barker's spiel to lure cus-
tomers to buy tickets to see his attractions: the universe's strongest human,
a giant nearly nine feet tall, a midget measuring *four feet*, and the human
pin cushion. To get out of debt, Gilfoil organizes a shell game to cheat a
wealthy person out of his money. During his early show biz experiences,
Fields discovered that society was replete with con artists, swindlers, and
charlatans who easily victimized the gullible. These encounters would
nourish his comedy and enable Fields to depict the frauds that occurred
regularly in American life.

With its low pay and exhausting turns, Fields soon realized that enter-
taining in dime museums was a dead end. He was so desperate that he

joined the cast of a new edition of the *Monte Carlo Girls*, despite his realization that he might find himself again unpaid and abandoned on the road. By January 1899, Fulton had found another "angel" to back his show and the *Monte Carlo Girls* with practically a new cast was hastily assembled.

Fulton arranged the show to open at the famous Bowery Theatre (1878) owned by Henry Miner, who was the proprietor of numerous other venues in New York and a former congressman. The serving of alcoholic beverages from the saloon annexed to the building created an atmosphere that resembled an old-time concert saloon. The auditorium reeked of beer served from the theater's saloon and there was so much smoke in the air the performers could barely see the audience. "Boys went around hawking popcorn, peanuts, cigars, chewing gum, and the latest song hits," the dancer Fred Stone recalled.[2] The gallery became a popular hangout for neighborhood youngsters, known as the gallery gods, who made so much noise that Miner had to hire a policeman to keep order. During an amateur night in 1903, Miner's son Tom yanked an atrocious singer from the stage by slipping a cane with a crook handle around his neck. Every time a mediocre act appeared, the gallery gods yelled "get the hook" and the phrase became a favorite way to jeer an entertainer.

Fields's juggling act received a good reception at the Bowery Theatre. The *New York Dramatic Mirror* reported that "William C. Fields proved a fairly pleasing juggler." Afterwards the troupe toured cities in upstate New York and New England performing mostly one-night, three-night, and occasional weekly stands. In an appearance at Boston's Palace Theatre, the reviewer called Fields's act "wonderful." "William Fields gave the best exhibition of tramp juggling ever seen on Portland boards," wrote the critic for the city's *Daily Press*. Even his role in the afterpiece was praised. W. C. Fields "proved himself quite a comedian as the doctor in the afterpiece," reported the critic in Lowell, Massachusetts.[3]

Fields returned to Philadelphia in May where he performed before a hometown audience at the Trocadero Theatre. The *Philadelphia Record* gave Fields a rousing review, calling him "one of the best jugglers in America." Members of Fields's family possibly attended the show. Bill Dailey wrote Fields years later that he got his uncle Bill Felton to attend the "Troc" in order to prove to his family that he was now a professional entertainer.[4]

The inevitable recurred when the *Monte Carlo Girls* fell into deep financial trouble. Fulton abandoned the troupe at the end of February, leaving the company under the management of two performers. The company's solvency did not improve and other managers assumed control. In a last ditch effort, the troupe decided to forgo their salary for a

share of the profits. Fields began to record the earnings of each theater in his date book. The troupers, apparently, never got their share. In late May, the company issued an attachment against Fulton for back pay. Fulton agreed to pay their salaries for their "Troc" appearance and not a cent more. The company was scheduled to perform next at Washington's Lyceum Theatre but the troupe failed to appear. Owed considerable salary, the performers had suddenly walked out, closing the show. Fields questioned why he had trusted Fulton a second time. He felt like a gullible sucker—a chump. The episode increased his suspicion of managers.

Left without a job, Fields had to quickly find work—not an easy task since theaters without air conditioning closed to avoid the summer heat. Fortunately, he obtained an engagement with the *New York Vaudeville Stars*, which was scheduled to play the summer park circuit. A reporter, who reviewed the show at the Lakeview Theatre in Lowell, Massachusetts, wrote that Fields was "unusually witty" and "can extract more amusement and entertainment" than other jugglers. When the troupe moved on to Lancaster, Massachusetts, another critic lauded his use of humor. "He interspersed some original juggling tricks with some rapid fire comedy that is a welcome relief from the usual run."[5]

Fields was now viewing his juggling act not as an end in itself but as a means toward comedy primarily through amusing asides and pantomimic gestures. "I didn't just stand up and toss balls, knives, plates, and clubs," he said. "I invented a little act, which would seem like episodes out of real life and I used my juggling to furnish the comedy element." At the Park Theatre in Manchester, New Hampshire, the reviewer found his act "original to the core, his manner and business laughable to the limit, his asides most enjoyable and his juggling excellent. Fields is a show all in himself." Looking back, he called his act "a rough affair." "My comedy business was all dragged in as it occurred to me. I did whatever I thought would appear funny. If I remembered what had gone well at the last performance I worked it in, but generally I didn't remember."[6]

At the end of June, Fields returned to Atlantic City where he performed with John E. Murphy and Alf A. Gibson's American Minstrels on the Steel Pier. Recently built by Quakers in 1898, the pier was advertised as a luxurious resort with smoking and reading rooms, parlors, fishing decks, and as a showplace for clean family entertainment. The 1,000-foot long pier offered daredevil attractions such as a high-wire motorcycle act, breathtaking rides, world-record pole sitting, a big-band Marine Ballroom, and four theaters that attracted thousands daily during the summer.

By 1899, the minstrel show was a dying performing arts form, having reached its apex in the mid-nineteenth century with over a hundred nationwide companies in the 1860s. Due to competition from variety, melodrama, and musical comedy, minstrelsy slowly declined during the following decades so that by century's end there were only about ten full-fledged productions. As members of Philadelphia's Dumont's Minstrels, Murphy and Gibson were experienced performers who hastily arranged a summer attraction with five performers to entertain in the casino hall. Wearing burnt cork makeup, Fields and Gibson sat at the ends of a semi-circle on stage playing the part of Bruder Bones; in the center was Murphy

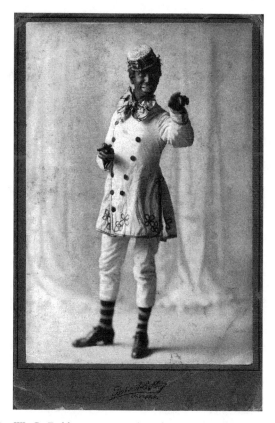

**Figure 5.1** W. C. Fields as a minstrel performer with Murphy and Gibson's American Minstrels in Atlantic City, July 1899. Courtesy W. C. Fields Productions, Inc., www.wcfields.com.

as the interlocutor or master of ceremonies, while Neil O'Brien and Ed Bogart performed Bruder Tambo. Advertised as "America's Greatest Comic Juggler," Fields performed his juggling routine during the second or olio part and possibly acted in the comic afterpiece skit.[7] If the entertainment followed the traditional minstrel show formula, Fields also played the traditional rhythmic clacker bones, cracked rapid-fire jokes in a repartee with the interlocutor, and participated in the circular walk-around, a hand-clapping strutting song and dance by the entire company.

Given that it was the height of the Jim Crow era with its discrimination, segregation laws, disenfranchisement, and lynching, Fields probably had no hesitation joining a show that had offensive racist connotations and perpetuated stereotypes. Three years before Fields's appearance, the Supreme Court had legalized segregation in *Plessy v. Ferguson*. Born in the late nineteenth century and raised in a white working-class family, Fields inherited the usual biases toward African Americans and was susceptible to making occasional racist remarks. (As discussed later, he defended blacks at other times.) He had grown up in white working-class neighborhoods where bigotry toward blacks thrived. Philadelphia had three race riots in 1834, 1842, and 1849, primarily instigated by newly arrived Irish immigrants who were competing with blacks for unskilled jobs. W. E. B. Du Bois's groundbreaking social study *The Philadelphia Negro*, which was published the same year that Fields appeared in the minstrel show, poignantly describes how African Americans lived in the city's segregated Seventh Ward, a densely populated downtown area where poverty, crime, unemployment, and slum-like conditions prevailed. Du Bois found that race prejudice ran deep among the white citizenry and intense discrimination prevented blacks from obtaining jobs, education, and improving their standard of life.

The minstrel show, with its blackface makeup, was not Fields's forte. Compared to successful blackface entertainers such as Eddie Cantor and Al Jolson, demonstrative minstrel singing and clowning had little in common with the type of subtle comedy he was developing. Given his need for employment, Fields grabbed at any offer that came his way. He stayed with the show for four weeks while looking for an opportunity for the 1899–1900 season.

A lucky break occurred in August when he found a job with *Fred Irwin's Burlesquers*. Compared to Fulton, Irwin was a well-known and respected manager. Fields called Irwin the "Ziegfeld of burlesque and an honorable man. Ran a show legitimately; was on the up and up. Old Circus man; and circus people were always honest and real people in those days." Irwin and

his two brothers, George and Jacob, were gifted acrobats and gymnasts on the flying trapeze and horizontal bars. They had performed in numerous traveling circuses before managing their own companies, including the successful *Irwin Brothers' Circus* (1891–95). A zealous showman, Irwin next organized a number of burlesque productions, and in 1905, he helped create the Columbia Circuit or Eastern Wheel in order to streamline scheduling in the burlesque field. The members, who favored cleaner shows, would meet annually to route their troupes around a geographical circle with each company starting in a different city to avoid competition. Looking back on his roller-coaster career, Irwin called himself "The Man Who Can Come Back." "I have played the circus game, switched to the variety or vaudeville end, and finally dipped into burlesque with results," he wrote. [8]

Bill Dailey, Fields's mentor, might have played a role in helping him join Irwin's show. Do you recall "the time we went down to see Fred Irwin about your first professional job?" asked Dailey in a letter. Irwin met Fields while both were performing with the *New York Vaudeville Stars*. Impressed by Fields's skillful comic juggling, Irwin signed him for his new show. Irwin offered to pay him twenty-five dollars a week. But Fields asked for ten more dollars realizing that he had to pay for his train fare, baggage expenses, and lodging. "Irwin was so amazed at my nerve, that he almost had apoplexy. All I heard from Irwin was that he could never make any money paying me such a big salary. But he finally agreed."[9]

Irwin placed him in the number one spot reserved for "dumb acts" or nontalking routines. Fields called it "Irwin's way of punishing me...half the audience would be coming and blundering past the people, who were already in their seats, so that nobody would get a good view of the stage." "Dumb acts" lacked recognition and therefore had a difficult time moving to a better position on the playbill.[10]

"A young woman dressed as a page, whose business is to hand things to the juggler and receive the applause, accompanies the act," wrote a reporter after watching Fields's act in the Irwin show. Bill had enlisted Hattie as his assistant realizing that her presence would add luster to his act. Dressed smartly in male attire—trousers, coat, bow tie, scarf, and topped with a trendy bouffant curly hairdo—she contrasted with Bill's tramp outfit. She was kept busy on stage handing Bill his numerous props—top hats, cigar boxes, rubber balls, as the orchestra kept time. She also acted as a foil for Bill's comedy. He blamed Hattie whenever he either intentionally or mistakenly missed a trick by indicating her as the cause. Pretending to be scared, she leaned in fear against the backdrop. With an exasperated look,

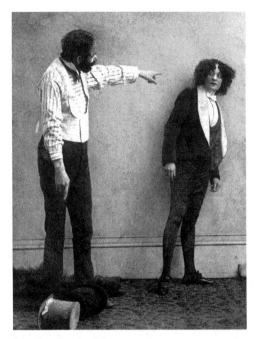

**Figure 5.2**   Fields blaming Hattie for a missed trick. *Irwin's Burlesquers*, 1899–1900. Courtesy W. C. Fields Productions, Inc., www.wcfields.com.

he ordered her off the stage by pointing to the exit— a surefire laugh-getter.

Tired of playing "second fiddle," she soon asked Bill if she could perform some easy juggling tricks but she remained his assistant. "I was just atmosphere," she recalled. "He was the one people came to see."[11]

Around the time the Irwin show opened, Bill wrote Hattie's mother asking for her permission to marry her daughter. Such a letter reflected polite Victorian etiquette, a formality still prevalent at century's turn. Although it seems strange coming from the hand of Fields, he could be very proper when it came to women. Hattie, who was more genteel due to her Catholic upbringing, might have insisted that he write her mother. Lizzie politely wrote back on August 22, 1899, giving her consent, believing that Fields "possessed of every noble quality of a man, and gentleman." She praised Hattie in her letter: "She is a noble, and superb girl well worthy to be a wife, qualified with every amiable trait of character." Knowing the travails of show business, Lizzie wished them well: "Trusting your path through

this life of struggle may be truly happy, and prosperous as husband to my dear Hattie."[12]

Smitten with her looks, Fields was unable to see that they came from two different worlds. Infatuated with Hattie, Fields failed to recognize the wide gulf that existed between them in the areas of upbringing, education, and principles. Bill came from rough Philadelphia neighborhoods and Harriet from a middle-class Catholic family. By contrast, Fields was an agnostic who felt, like José Ortega y Gasset, that "religion was the opium of the masses." Compared to Bill, Harriet was much more educated, an asset that would enhance Fields's book learning. Harriet sometimes became embarrassed by Bill's lack of education, Philly speech, and uncouth manners. Harriet's commitment to show business as a career was much less than Bill's, a difference that would eventually drive a wedge between them.

Hattie later called their time together in the *Monte Carlo Girls* "a crude courtship." She was embarrassed about living with Bill initially as an unmarried couple. When they joined the Irwin show she "tried to get several priests to marry us before the opening performance and when I did locate a Protestant minister it was too late that night to get a license and we had to open in Redbank, New Jersey. After taking a room as Mr. and Mrs. Fields in the eyes of the company, we had to keep it up just through fear—fear of losing the good show, and fear of having to go back to the horrors of the Fulton style show!"[13] About thirty-five performers entertained at the sold-out opening night at the People's Theater in Cincinnati. Irwin's shows mixed variety and minstrelsy with burlesque. They cast Baroness Waltenburg, who did an imitation of Anna Held; Bailey and Madison, Irish humorists; Louise Carver and Genie Pollard "coon" singers; Smith, Doty, and Coe, a musical trio; and the Hague Sisters. Irwin also offered risqué acts such as Mlle. Marie, the modern Venus, who did tableaux poses wearing flesh-colored see-through undergarments that titillated the male audience. The afterpiece's title, "A Hot Wave," suggests that the final act was likewise provocative.

According to the reviewers, Fields stole the show. While juggling a variety of props as the orchestra kept time, his act had become much more entertaining. On opening night a critic wrote that Fields's "low comedy" and juggling was "immense" and the olio's best act. Why was he in the opening spot asked the writer? He "is strong enough to close a bill instead of opening it."[14] The review helped Fields obtain a better spot on the playbill. The troupe moved on to the Buckingham Theatre in Louisville, Kentucky, where Fields continued to get favorable reviews. A Louisville

reporter wrote that he was not only the show's best act but also "the best juggler who ever came to this city." At the Park Theatre in Dayton, Ohio, the *Journal* critic called him the "feature of the olio" and that "his act surpassed anything in his line ever seen at this theatre." Feeling he deserved an increase in salary, he took his rave notices to Irwin who raised his salary to fifty dollars a week.[15]

Fields performed at Miner's Bowery Theatre the night the clock struck midnight ushering in the twentieth century. Its advent promised a fresh start and a bright future. On the chilly night, thousands flocked to the old Trinity Church in lower Broadway to participate in the annual ritual of hearing the church's bells strike midnight. Loud noises emitted by nearby marching bands and firecrackers drowned out the chimes. Wealthy tycoons hosted parties in their Fifth Avenue mansions while four hundred homeless people obtained a free meal and lodging at the Bowery Mission—a reminder that despite all the hoopla, a wide gulf existed between the rich and poor. As prizes for winning the 1898 Spanish-American War, the US now controlled Cuba and the Philippines, the start of its march to becoming a world power. The new era would be called America's century. The nearly twenty-year-old Fields had no idea what lay ahead—the drastic struggles and failures on his path to fame.

Treading the boards with the Irwin show required perseverance and hard work. Fields found life on the road exhausting with fourteen shows a week, including matinee and evening appearances. Years later in 1930, he wrote a piece in the *St Louis Post Dispatch* recalling his February 1900 stand at the city's Standard Theatre. Arriving in time for a Sunday matinee appearance after a Saturday evening show in Indianapolis entailed boarding an all-night train that reached St. Louis about noon. After checking in at the hotel, he went to the theater "half dopey from lack of sleep." Upon reaching his dressing room he found a stool and rested until a stagehand entered and took it away. When Fields demanded the stool back, the stagehand hit him over the head with it. "I caught up with sleep right there," he wrote. "They brought me around in time to play that afternoon but with what a headache." Fields had learned that the Standard's gallery doorkeeper was Frank James, brother of Jesse, who to his surprise was a quiet, gentle man with a drooping mustache and cold gray eyes. He called the venue with its "hard-boiled audience" a "tough spot" on the tour.[16]

But the endless grind was worth it. The Irwin show enabled Fields to broaden his repertoire and especially to work on his comedy. "I juggled, played a dozen bits, and got a chance to develop a line of humor." He was becoming more of a showman. To capture the audience's attention, he

deliberately missed tricks. "When, after a series of fumbling, I eventually did the trick, I had the audience in complete laughter." His roles in sketches allowed him to do some singing and comic patter. "I was all over the stage and never had a minute to rest in the show. When I stopped to figure how often I made appearances for that sum I threatened to quit." Not wanting to lose his star, Irwin increased his salary to seventy-five dollars, which he received until the season ended. "Now, I wasn't simply suffering from a swell head. I knew I was worth what I was asking; and if I was worth it I was entitled to get it." Irwin's show also gave him more confidence. "I was becoming more sure of myself and was never so thrilled as when waiting in the wings to go on... To keep my nerves steady and eyes alert, qualities so necessary to a juggler, I refrained from late hours and dissipation."[17]

To move up the rung of show business, he knew that he had to do some self-promotion. He bought calling cards with his name in the center, and at the bottom was printed "tramp juggler," the title of the Irwin show, and the dates "1899–1900." A poster was printed with *Irwin's Burlesquers* in large type at the top and at the bottom "Wm. C. Fields Different from the Rest" to stress his uniqueness. In the middle is a picture of Fields dressed in tramp gear, but his appearance is less garish compared to his initial outfit. His facial makeup is now a thick and scruffy black mustache and beard that makes him appear older. Perched on the top of his head is a worn stovetop hat, and in his right hand, he clutches a long stick and a cigar. A tattered overcoat was open in front and revealed an equally ragged knee-length coat with buttons over baggy pants. By his side is a table with his props: two stacks of cigar boxes, fake wooden cigar, balls, and underneath four white and black top hats.

"With three rubber balls, a few old hats and cigar boxes W. C. Fields does one of the neatest juggling arts seen here," wrote a reviewer. Although he looks poor and slightly pathetic, his garb is purposely intended to gain the audience's sympathy. "Fields believes that the 'hobo' is the most picturesque vagabond in the world," wrote a reviewer. "Fields offers an illuminating portrayal of the gestures, attitudes and expressions of the genus hobo Americanus." Annoyed by Fields's advertising, Harrigan started to bill himself as "The First Tramp Juggler."[18]

Fields described his cigar and hat trick in the first article he published entitled "New Juggling Tricks" for London's 1901 *The Magician's Handbook*. He began with a disclaimer: "In availing myself of this opportunity of blossoming forth as a writer, I hope my gentle readers (as novelist say) will not laugh as heartily at my efforts in scribbling as they do at my endeavors to amuse them while on the stage. It is a very difficult matter to

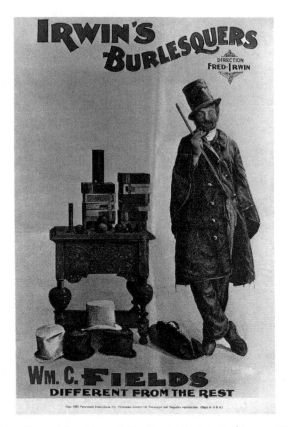

**Figure 5.3**   Poster advertising Fields in the *Irwin's Burlesquers*, 1899–1900. Courtesy W. C. Fields Productions, Inc., www.wcfields.com.

describe a feat of dexterity, but I have heroically decided to do my best, and if you do not think it 'much potatoes', as we Americans have it, you are at liberty to come and hiss me off the stage when we next meet."[19]

Fields had practiced the cigar-hat stunt for three years until he was confident that he could do it on stage. To execute the trick, he first warmed up the audience by using two tall black hats, one on his head, the other on his foot, and with a jerk exchanged the positions of the hats. Then he would put an imitation cigar on the brim of the hat. He next boosted the spectators' expectations by performing "one or two comedy actions" that suggested he was about to do a "big feat." Once the spectator's suspense peaked, he tossed "the two articles upward with one smooth swing,

causing both to perform just one revolution, which takes the hat to the head and the cigar to the mouth." By manipulating the hat and cigar in one simultaneous movement "the effect never fails to be justly appreciated by the audience," Fields wrote.

Later he added a third prop, a whisk brush which was tossed simultaneously with the hat and cigar. As the cigar landed in his mouth and the hat on his head, the brush would settle in his back pocket. Because of his nonchalance, Fields made the trick look easy, but it actually took a great deal of skill.[20]

He had experimented with cigar boxes in his Philadelphia amateur shows, and over time it became one of his most popular routines. He put five cigar boxes together by drilling holes in the ends and threading an elastic cord through the holes. The elasticity of the cord allowed him to manipulate the boxes into any shape. He would stack the boxes horizontally on a table, bring them to the front of the stage, and grip the bottom box. As he tossed them into air, the boxes would return and balance on his hand in a tall vertical column, and then by the flip of his wrist he quickly formed a horizontal column.

A reviewer watching his performance in March 1901 at London's Palace Theatre noted his masterful use of deception:

> [Fields] produces from his table a few cigar boxes, reposing one on top of the other in the orthodox manner. He makes a great show of a *coup*, something to startle you; and does, in fact, perform what you believe to be a really remarkable feat of manipulation. Anyway, you applaud vigorously, and are sorry for it afterwards. I freely admit I did not applaud and was sorry; annoyed, almost savage, I was within an ace of blushing, a thing I have not known myself to do for many years. Well, with a sudden twist of the wrist the boxes are shot into the air and come to rest end on end. Then, when the applause is at its loudest the juggler allows the boxes to fall over, but not to the ground. They are fastened together *with a string!*[21]

Because of his quick hands, it was difficult to tell if Fields was faking when he missed a trick. A prop would fall to the stage either by accident or on purpose, usually the latter. In either case, he had a dropped box gag ready in which he would kick his left leg in the air while simultaneously sharply turning the heel of his shoe on the right foot to move and connect the box to the others. The audience believed that his raised left foot had moved the box. What spectators saw was the deceptive moves of a sly conjurer. Fields called it "dodgery designed partly to astonish partly to amuse. People enjoy being spoofed." "The performer," wrote Fields, "nearly brings

the house down with appreciation for his almost miraculous dexterity, and afterwards secures a laugh so hearty as to nearly shake the foundations of the theatre when the audience sees how they have been sold."[22]

His actions during the cigar-box routine show signs of some significant roles he would later play on stage and screen. Here is the con man who tricks the audience into believing his stunt is pure art until he reveals that the boxes are manipulated by a hidden string. Fields's quick hands have conned the gullible audience. In Germany some spectators had applauded so vigorously that when they discovered the duplicity they hastily departed the theater. They were hoodwinked by a master of deception. Slowly but surely, the Fields persona known to millions is starting to take shape.

The seven months with the Irwin show turned out to be a very significant stepping stone in his career. He performed unique juggling tricks that became an integral part of his act. Most importantly, he developed his ability to integrate humor into his routine "I was singing, clowning, juggling and talking comedy, and kept it right up until now," he later recalled. The Irwin show, said Fields, was "another step upward" in his career.[23]

The show led to an even greater step forward. When the Irwin troupe played the Trocadero in Chicago in late February 1900, Fields was spotted by the impresario Martin Beck, a leading impresario of big-time vaudeville, who managed the Orpheum Circuit's Midwestern office in the Windy City. A German-speaking immigrant from Slovakia, Beck managed and acted in a traveling company before joining the Orpheum organization as a booking agent. Short and stout with a leonine appearance, he possessed one of the sharpest eyes in the business to spot potential headliners, among them Houdini. A strong authoritarian personality and persuasive showman, Beck held lofty expectations for vaudeville. Amazed by Fields's performance and hearing the earsplitting ovation from the crowd, Beck was convinced that on the stage taking encores was a rising star. What happened next turned out to be a watershed in Fields's stage career.

# 6. The Big Time ❧

Fields looked "thunderstruck" when his agent William Morris told him that Martin Beck's Orpheum Circuit wanted to offer him a contract. In 1900, the Orpheum was the most dominant big-time chain west of Chicago with five theaters stretching from Kansas City to the Pacific Coast. Its circuit assured performers multiple weeks on the road at its theaters and via an alliance with the Western Circuit of Vaudeville Theatres (WCVT), which operated venues in midwestern cities.

In hopes of obtaining a better salary and by now smart enough to negotiate, Fields pretended not to jump at any offer. "[I] had wit enough not to show it. I said I'd have to take time to consider it." He asked some members of the Irwin troupe what salary the circuit paid its performers. "The artists I approached told me it was like my hide to ask what salary they got, but when I explained that I thought I was worth about a third of their salary they told me they had been getting 250 dollars a week. They were wonderful liars. I reckoned I was 50 dollars better than they, and went back to the agent and told him that I would tour the Orpheum for 300 dollars a week. He threw several kinds of fits and finally signed me up for 125 dollars a week." News of Fields's engagement made the *New York Clipper*: "W. C. Fields leaves Fred Irwin's Burlesquers, March 12, in Buffalo, N. Y., closing his thirtieth week. He opens on [the] Orpheum circuit, March 18, in San Francisco, Cal."[1]

Fields's leap from burlesque to big-time vaudeville in a span of eighteen months without playing the small-time chains was an amazing achievement. The small time offered programs with younger performers on their way up and older entertainers on their way down, cheaper ten-cent ticket costs, and run-down theaters. The big-time, by contrast, had larger venues, higher salaries, and the most popular headliners and talented performers on its playbills. Elated by joining the Orpheum Circuit, Fields sent letters to the Orlando boys telling them about his success.

Before he left for the Orpheum tour, Fields returned home for a brief visit. He wanted to tell his family that he was gaining recognition for his

talent. His father still remained unconvinced that his son had chosen the right path. Coming from the hard-working class, Jim felt estranged from show business and held the widespread view that actors were mostly a licentious and slothful lot. Fields's sister, Adele, recalled that their mother made sandwiches for him and filled a thermos with coffee. Kate walked him to the corner where he boarded a trolley to the train station. As the trolley left, his mother burst into tears. She cried all the way back to her house—tears of joy for his success and tears of sadness from a mother who held a warm spot in her heart for her first-born son. Claude, as the family called him, likewise had tender feelings for his mother, who had often interceded when heated arguments erupted with his father. When he was better paid Claude reciprocated by helping his mother financially. "I sent my mother $10 each week, and never failed to remind her that her oldest boy was doing well."[2]

But in 1900, Fields did not have enough money to buy train tickets. Hattie needed to borrow money from her mother so that they could travel to San Francisco. During their three-day railway trip, they could not wait to get to the city to begin their big-time tour. Despite the fabricated stories that he leaped on western bound freight trains as a teenager, Fields had never been west of the Mississippi. Looking out the window, he was amazed at the vast expanse of the Great Plains, the majesty of the Rocky Mountains, and the snow-capped Sierra Nevada.

He found San Francisco a bustling, colorful city with a thriving commerce marked by its busy Pacific Rim trade. As the nation's ninth largest city, with a population of nearly 350,000, San Francisco had more than doubled in size since Fields's grandfather had lived here during the 1870s. Market Street was packed with cable cars, carriages, and pedestrians dressed in fashionable attire. One-third of its population was foreign born, chiefly Germans, Irish, and Italians. A city of striking divergences between rich and poor, its class structure ranged from wealthy merchants and white-collar workers to Irish servants and longshoreman. The city's affluent entrepreneurs lived in elegant mansions on Nob Hill, ate oysters, and drank champagne at Delmonico's and the Maison Doree, and frequented the dining room at the luxurious Palace Hotel. By contrast, squalid slums tarnished the city's working-class neighborhoods.

The city exuded a flamboyant bohemian flavor. Gelett Burgess, the city's celebrated fin de siècle bohemian writer, noted the city's multicultural mixture of Hispanic, Asian, and European cultures. He called the bayside city a place of "contrasts...where every language under the moon

is spoken, and every street climbs a half-dozen hills, changing its character at every lamppost."[3]

The diversity of San Francisco's theater life was unmatched in the West: drama, opera, minstrel and burlesque shows, melodrama, and vaudeville. Variety shows flourished in numerous venues: German beer halls, raucous concert saloons, squalid honky tonks, and stately theaters. In many music saloons, where liquor freely flowed, customers danced to the beat of ragtime tunes emanating from a pianist. Two boisterous showplaces that gained fame were the Barbary Coast's Bella Union noted for its buxom chorus girls and the Midway Plaisance where the bawdy hootchy-cootchy dance was first performed by the belly dancer Little Egypt.

The Orpheum Theatre, by contrast, offered "high-class novelties," featuring top US entertainers and acts imported from Europe and Asia. Its jovial, carefree atmosphere mirrored the city's vibrant fin-de-siècle culture. As the most renowned vaudeville theater in the West, the 3,500-seat venue attracted a diverse crowd from the upper class who sat in box seats costing fifty cents to the working class who sat on ten-cent balcony benches. Sunday nights were a special occasion when San Franciscans attended the theater attired in their latest costly fashion. Patrons frequented its popular bar and waiters served liquor during the performances. In its "dull, smoky, colorless hall," wrote Burgess, were assembled "men-about-town, gamblers, debutantes, mothers-of-families, mondaines and demi-dittos, black-legs, touts, Chinamen, Italian fisherman, bankers, princes, and tourists of all descriptions." In his novel *McTeague*, Frank Norris described the odor in the hot and smoky auditorium: "A thick blue mist hangs over the heads of the audience. The air is full of varied smells—the smell of stale cigars, of flat beer, of orange peel, of gas, of sachet powders, and of cheap perfumery."[4]

For his tour Fields experimented with a new look by changing his makeup and costume. Bill altered his stage appearance from a poverty-stricken hobo to an eccentric-looking ethnic character. At century's turn, eccentricity on stage had become a fad led by acrobatic hoofers who could leap across the stage and, like contortionists, twist into odd shapes. Fields's routine, however, was based more on his odd looks and the zany manner he juggled his props to gain laughs. To appear eccentric, he placed a tight skull cap over his head with hair pasted only on the sides, which made him appear half-bald. On the top of his head he wore a tiny hat resembling a tin can. On his face he applied grease paint to create thick black whiskers and a mustache. Around his eyes were a ring of rolled strings made to look like toothpicks (see cover photograph).

A sold-out crowd packed the theater on March 18 when Bill and Hattie made their debut. As a newcomer to the big time, his name was listed among many others acts on the playbill. The headliners were the magician Howard Thurston, famous for his card manipulations, and the actors Sydney Drew and his wife Gladys Rankin in a comedy playlet. Fields's new billing as an eccentric juggler pleased the critics. "W. C. Fields, an eccentric juggler, at once established himself as a prime favorite. His tricks are exceedingly clever and amusing, and the rubber balls were a marvel," reported the *San Francisco Dramatic Mirror*. Another reviewer singled out Hattie as a fine addition to his act: "Not a small feature of his successful reception was furnished by a beautiful young woman in skin tight silk knickerbockers, who assisted him and looked a captivating vision as she did it." The pair was such a success that they were held over for a third week.[5]

"My! How I clung to that money," Fields declared when he received his first week's salary in gold. The experience of Fulton skipping town without paying him gave him a lifelong fear of losing money. "I felt sure that there must be sharks waiting to steal it from me," Fields recalled. He later deposited money in numerous banks around the country in case he was ever again stranded in a city. One night in San Francisco a burglar hit him over the head and stole his money. To prevent another loss, he invested in a one hundred dollar gold ring. The ring "kept me awake at nights for fear it should be stolen or lost. Finally, I sewed it up in the pocket of my pajamas."[6]

"I sunk my salary in a stock of photographs." His publicity photos in newspapers and on billboards were needed to boost his reputation. The photograph on the cover derives from the Frederick Bushnell studio, then the city's most renowned photographer. Bushnell presented his patrons "in a new and attractive light...by posing, by retouching, and by using novel representational techniques.[7]

Once they arrived in San Francisco, Hattie became extremely anxious that they tie the knot. Seven months had passed since her mother had agreed to her daughter's marriage. As a devout Catholic, she became increasingly uncomfortable with living together unmarried. They applied for a marriage license in San Francisco on April 7. In order to qualify for marriage under California law, Fields needed to be twenty-one years of age, but he was only twenty. To qualify, he wrote on the form that he was born on April 9, 1879. Nearly twenty-two and wanting to appear younger, she declared that she was born a year later than her birth date. On the following day, Palm Sunday, April 8, they were married at the Methodist

Episcopal Church by its pastor, Rev. John A. B. Wilson, in front of two witnesses. They were unable to marry in a Catholic church since Fields had never converted or taken lessons in the faith. To appease Hattie, Bill had earlier attended a Catholic high mass with her in New York but felt the church rituals were all smoke and mirrors. He even made sly, irreverent comments during the sermon. Already a nonbeliever, Fields felt religion was a form of quackery, a sacred cow that he would later thrash.

At their next stop in Los Angeles, the newly married couple found the city dull compared to San Francisco. Its population had mushroomed to 50,000 in 1890 due to land promotion, railroad transportation, the discovery of oil, and the arrival of thousands of health seekers seeking a mild climate. The sudden influx of inhabitants generated a need for entertainment. The Orpheum leased the 1,500-seat Grand Opera House on Main Street in 1894 and turned it into the city's premier vaudeville theater. With ticket prices ranging from 10 cents in the gallery to 50 cents in the orchestra, the theater attracted a diverse audience, low-income workers, middle-class clerical employees, and the well-to-do. Given the city's strong evangelical religious tradition and conservative morality, its programs offered clean entertainment that appealed to families. Unlike the San Francisco Orpheum, the venue prohibited smoking and drinking inside the venue, although patrons could buy drinks at a saloon attached to the theater.

During their one-week engagement Bill and Hattie appeared every evening, including Saturday and Sunday matinees, in the attractive auditorium lit by gas lights. They performed their routine in front of a painted drop before the footlights—called an act in one. His wife handed him a series of juggling props that sat on a table: cigar boxes, matches, hats, rubber balls, and a big bat. The reviewer in the *Evening Express* called Fields's juggling "quick and clever" and pointed out that he "has the rare gift of being funny." Another critic, who noticed his elaborate facial makeup, wrote that his "pawnbroker attitudes while juggling the balls are irresistible."[8]

Fields highlighted his eccentric actions on stage through more physical comedy and pantomime. While manipulating his props he gained laughs through bizarre facial expressions and antics. He mugged, grimaced, feigned astonishment and disdain, mumbled, and cursed in cleverly timed asides. His clowning stemmed from the unconventional and unexpected handling of objects. "The principal thing is to take an audience by surprise," he once said. As Fields explains: "If they can guess what is coming they don't care for the show. I lead them to think that my trick is not coming off, and that I am about to fail, when finally I suddenly spring another trick on them which they have not been looking for...The whole secret is

to make the act funny." Vaudevillian Jim Harkins recalled another technique: "If a ball bounced close to his hand or went up in the air and back into his hand cupped backwards, the registering of surprise at the thing of finding it in his hand would send the audience into gales [of laughter]."[9]

He pretended to view his props as threatening objects that at any moment could deceive him, fall to the floor, clunk him on his head, and upset his stunt. This scheme enabled him to capture the audience's attention and empathy and made it easier to implement an element of surprise. His reaction to perilous menaces—the famous Fieldsian flinch with a pained facial expression—appears continually on the stage and screen.

On Sunday Bill and Hattie rented a horse and buggy with a fringe on top and took a trip to nearby Pasadena, then a small town, a health resort, and a retirement community. Hattie recalled "looking at all the nice homes" on its boulevards where wealthy New Englanders resided to escape the cold winter. On the forested hillsides of the Arroyo Seco were abundant eucalyptus trees and flowering plants. They could see in the distance the San Gabriel Mountains; its highest peaks still capped with snow.

Fields enjoyed looking at the verdant gardens and orange orchards. He loved nature and the outdoors. The smell of fruit trees ripening in the balmy April air might have reminded him of the time he helped his father peddle fruits and vegetables. The mesmerizing scenery suddenly transported him into musing about his future. Recalling the tortured path that had gotten him to this point in his career, he told Hattie "that he would like to get out of the business he was in and settle down there in Pasadena." Perhaps, he thought, he could manage a theater or try the grocery business. "From then on we had it in mind to settle down there," Hattie recalled.[10] She forgot that her husband was bitten with a wanderlust that prevented him from living anywhere for a long time. He had chosen show business to escape from the drudgery of the workaday world. Paradoxically, years later Fields spent considerable time in Pasadena sanitariums recovering from various severe ailments including alcoholism.

Despite some petty arguments they remained infatuated with each other. Bill called her affectionate names such as Hunky-Punky and Bricket and she called him Sod or Sodder. Bill relished the "captivation vision" she presented on stage, her sleek figure displayed "in silk tight knickerbockers," and immaculate facial features. Hattie admired Bill's muscular physique and athletic ability. He was a fast runner, skillful boxer, and excelled in other sports. Hattie felt her husband had "wonderful hands. So long, so slender, so quick, so graceful. I used to watch him by the hour when were

touring. It seems to me as if the balls went to the hands every time—not the hands to the balls." Being a juggler, he continually worried about his hands and to protect them, he wore gloves. "He couldn't take a chance with his hands," said Hattie, "they were as important to him as the hands of a pianist."[11]

Bill was very protective of his wife. If anyone made a negative remark about her, he would become angry and get into fights. Possessing a short temper like his father, he could explode at the slightest provocation. He bought a blackjack for these occasions, which he never used because Hattie eventually threw it away. He also carried a gold-headed cane for self-defense. Hattie recalled that Bill once hit Lord Byron's grandson over the head with the cane at the horse races in England because he felt he was flirting with his wife. In Berlin a man once made a comment about Hattie that he did not like. After socking him, he was jailed for the assault. "I was a Knight of the Round Table, a Sir Galahad," he stated. "I was always defending a woman's honor, it seems."[12]

After Los Angeles, they headed East and played the recently opened 2,024-seat Orpheum in Kansas City, Missouri. A reviewer lauded Fields as an eccentric juggler who received "many laughs without resorting to conversation." In May, they performed their last Orpheum engagement in Omaha where Fields made a big hit and "took one encore and two bows." A large advertisement appeared in the *New York Clipper* on May 19 that hyped his achievements on the Orpheum tour: "W. C. FIELDS, THE UNIQUE ECCENTRIC JUGGLER. W. C. FIELDS TREMENDOUS SUCCESS ON ORPHEUM CIRCUIT." Kudos from newspaper reviews were featured below the bold print.[13]

The couple next played the B. F. Keith Circuit, which had a booking arrangement with the Orpheum Circuit, which enabled performers to jump from one chain to the other. Keith's ascent from a New England farm boy to the kingpin of big-time vaudeville resembled an American success story. A born huckster with a flair for humbuggery, much like P. T. Barnum, he peddled gadgets on street corners, became a circus grafter, an assistant at a Bowery dime museum, and in 1883 opened his own dime museum in Boston. His museum offered continuous refined vaudeville all day and evening to throngs of customers anxious to see the show and his physical curiosities. Keith's museum became the springboard for creating a quadruple circuit of four first-class theaters by 1902 in major East Coast cities. A shrewd, tenacious, and strong-willed showman, Keith extended his circuit over the years until it became an empire that ruled over most big-time theaters in the East.

Keith's able right-hand man, Edward F. Albee, believed that the booking process could be made much more effective if they created an association with other theater owners. Equally contentious, shrewd, and ruthless like his boss, Albee later inherited a large part of the circuit when Keith died in 1914. In 1900, he led the formation of the Association of Vaudeville Managers (AVM) to expedite booking, regulate salaries, and reduce the need for agents. For the first time, the Keith and Orpheum circuits and other chains were linked in an agreement, which gave vaudevillians such as Fields the opportunity to move from one circuit to another as they traveled across the country. Earlier a performer had hired agents or wrote theater managers asking for an engagement by using stationery with fancy letterheads, calligraphy, and mentioning favorable reviews. Fields designed his own eye-catching stationery by drawing each letter of his name in different poses as an eccentric juggler. But the process was slow and cumbersome compared to the new booking arrangement, which guaranteed troupers thirty to fifty-two weeks on the road.

On a whirlwind tour, Bill and Hattie mostly entertained at Keith's theaters for the next six months. Their itinerary also included engagements playing summertime outdoor venues in parks and theater roof gardens. Along with executing amazing feats with his juggling props, the creation of a comic situation now became an equal part of his act. "A man who can juggle everything from a burnt match to a plug hat, and incidentally introduces original humor is a star," wrote a Detroit critic.[14]

"He is assisted by a pretty girl in boy's attire, to whom he refers as excess baggage," wrote another reporter about Hattie.[15] To make her presence more noticeable, she appeared in a new stylish outfit, a sleek black tux with skin-tight pants and a new bouffant hairdo that accented her curly black locks. From a table she handed her husband the juggling props that he used. Feeling she was an asset to his act, she asked Bill for a larger role and more recognition. To appease her, Bill consented to give her a try. In Kansas City, Missouri, they were billed as "Mr. and Mrs. W. C. Fields." The paired billing did not last long much to Hattie's chagrin. Her husband told her that she needed more practice to become a costar. But the main reason was that he did not want her to share or steal the limelight.

To keep his act continually fresh, he worked on adding new juggling tricks. A critic noted the addition of a new hat act. "He kicks a hat from his foot and catches it on his head, at the same time throwing a second hat from his head and catching it on his foot. It is an exceedingly difficult feat, and was neatly executed." The critic called Fields "a natural comedian" but

felt his occasional "grizzly bear growl" when talking marred his "excellent pantomimic comedy."[16]

In Philadelphia they appeared at Keith's new Bijou, called "The Drawing Room of Philadelphia" for its refined entertainment, which drew a heterogeneous crowd, including the city's socialites. Returning to the city of his birth was like a homecoming. Quite possibly some of the Orlando boys and Fields's relatives attended the show. Bill took the opportunity to introduce Hattie to his family. They apparently liked her immediately. Hattie found Jim "a nice, rather sporting gentleman."[17] Fields's father naively hoped that Hattie might get Bill to settle down and pursue another career.

They appeared at Keith's venerable Union Square, considered "the prettiest, coziest, daintiest vaudeville theater in New York." Since the Union Square offered continuous vaudeville from afternoon to late evening, Bill and Hattie performed three shows daily. "The juggling and fun-making of W. C. Fields was admirable," commented a reviewer. "He is as clever as he is funny, and as much of either as he is of both. He sprang surprises every minute, and each surprise caused a roar of laughter." Fields kept the audience alert by making them wonder how the trick was executed and what stunt would come next.[18]

Another high point was their appearance at John Koster and Adam Bial's famous New Music Hall. Instead of respectable vaudeville, Koster and Bial's offered risqué entertainment for its mostly male audience. The owners were beer brewers who focused on selling liquor and food to their patrons as they watched the show. With its saloon and smoke-filled atmosphere, the huge establishment resembled an old-time concert hall.

"Morris put me on before they got hungry," Fields joked about his Music Hall experience.[19] An agent on the rise, Morris possessed a keen eye for spotting new talent such as Will Rogers, Eva Tanguay, and Sophie Tucker. He had unflinching faith in Fields's gifts and helped launch his career at this time. As an independent agent, Morris later fought the Keith-Orpheum vaudeville trust and its UBO booking agency, a behemoth that almost drove him out of business. Clever and resolute, Morris survived and eventually built a powerful coast-to-coast talent agency, which still carries his name.

Bill was billed as an eccentric juggler in the seventh position amongst a long list of performers. "Wm. C. Fields, in his eccentric juggling act, won well deserved approval for his work," reported the *New York Clipper*. Another reviewer noted that Fields was making jokes during his act. "Now I'll eat fifty cents. If I like it I'll eat a dollar and a quarter." His successful reception caused his engagement to be extended two more weeks. Fields

never forgot the "exhilaration" he felt playing Koster and Bial's, calling it the greatest venue he ever performed in during his vaudeville years.[20]

The showplace was "frequented by agents in search of talent which might please European audiences," Fields remembered. "I was soon signed by a European agent for a tour of Europe at $150 per week." On September 15, the *Clipper* announced that Fields would open at Berlin's Wintergarten Theatre on January 1 for a four-week engagement. To perform at the Wintergarten, one of Europe's most prestigious variety theaters, was an incredible leap forward for a twenty-year-old trouper who had tread the boards for only two years. Fields had no hesitation about going to Europe. The engagement was a major step professionally and traveling aboard complemented his wanderlust. He summed up his passion for globe hopping in six words: "I wanted to see the world."[21]

His infectious itch to travel was offset by fears. Underneath his bravado exterior resided an insecure individual who lacked self-confidence. Uncertainties about his future became an Achilles' heel, which assailed him all his life. Even when Fields reached the pinnacle of his fame, he realized it was a dead end. The only path left was downward on "a treadmill to oblivion," as fellow juggler and comedian Fred Allen titled his book.[22] Any day now, he thought, the roof could fall on him. He was plagued by questions. What would his European audience be like? Would he have to change his act for an audience that did not understand English? How would he be greeted by German spectators known to be very critical of poor performances? As he packed for his trip abroad, his mind became jam-packed with trepidations.

# Part III "All the World's a Stage" ❧

# 7. "A Master Pantomimist" ∽

On December 12, 1900, Bill and Hattie departed on the 2,050-passenger *S. S. Deutschland*, an ocean liner that had just won the *Blue Riband*, an honor given to the fastest transatlantic vessel. Traveling at an average speed of 23.06 knots (26.4 mph), she had crossed the ocean in five days. The ship's record-breaking velocity caused Bill and Hattie to have a very uncomfortable crossing. Its high-powered twin-screw turbine engines produced such noisy vibrations in the passenger rooms that it was nicknamed the "cocktail shaker." Constant winter storms and huge waves rocked the ship in the mid-Atlantic.

Hattie discovered that she was prone to sea sickness, an experience which caused her to dread trips across the ocean. Bill, by contrast, was not bothered by the steamer rolling in the high seas. He practiced juggling when the ocean was calmer. The voyage represented the first of his numerous trips abroad. He cautioned the public not to be envious of performers who were paid to entertain in distant lands. It "seems so romantic on paper. Let them bear in mind that every journey is a hazard almost equal to a flight across the North Pole."[1]

With Hattie's help, Bill worked on his writing, typing, and spelling skills. His initial letters had numerous typos, grammar, spelling, and punctuation errors, and run-on sentences. In correspondence to relatives and friends he needed several dictionaries. "I had to get them all out again to see what I had written, and what it meant." Typing did not come easily, and he usually limited his letters to two pages. He told a fellow juggler in a letter that "dancing on the keyboard is enough misery to inflict on any one person, even he be a comedy jug[gler]." He practiced diligently to improve his grammar and spelling and carried a dictionary and an encyclopedia with him on his travels. Whenever he saw an unusual word, he wrote it on slips of paper and a notebook. His fondness for words is reflected in the unusual names he gave his characters and locales on the stage and screen. "As a boy in Philadelphia, I had neighbors named Fushwantz and Muckle. So I have used them in the movies...Posthlewhistle I got from a town in England where half the population is named Posthlewhistle."[2]

"It was from his wife that Fields acquired a lively interest in literature, from which he later improvised and burlesqued chapters, names, places, and events," said their son Claude, looking back in 1967.[3] Hattie had packed numerous books and read to her husband during the long voyage. As his wife read Mark Twain's *Huckleberry Finn,* Fields quickly identified with Huck's runaway escapades. The attempts by Aunt Sally to civilize Huck reminded Fields of his grandmother's efforts to convince him to lead a respectable life. Twain became one of Fields's favorite authors due to his exposé of greed, hypocrisy, and depictions of con men, charlatans, and riverboat gamblers—characters he later immortalized on the screen.

To her credit, Hattie initiated her husband's lifelong passion for literature, which enhanced his intellectual development and formed his irreverent *weltanschauung.* Inside the covers he discovered characters and language that greatly influenced his persona on stage and screen. Fields discovered other favorite authors by himself during his long vaudeville itineraries and ocean voyages. He voraciously consumed the novels of Charles Dickens, identifying with the author's young wayward lost souls, finding bizarre names of characters he later imitated, and the long-winded florid Victorian speech that he sometimes adopted. Whether he travelled by car, train, or steamer, he habitually packed a suitcase, which swelled over time to a trunk full of books.

With more formal education than Bill, Hattie was embarrassed by her husband's lack of schooling. His "Philly speak" or local lingo particularly grated on her nerves. There are about fifteen distinct dialect features spoken in Philadelphia. According to the linguist Dr. William Labov, "Fields is a Philadelphian in his dialect pattern…The vowel of *caught, hawk, off, lost,* etc., is an 'upper mid in gliding' vowel in Philadelphia." Caught, for instance, is pronounced caut; off →auff; and lost →laust. Although she tried to teach him proper English diction, he balked at her attempts.[4]

Once the boat docked in Hamburg, both were relieved that the voyage was over. They quickly headed for the railway station where they caught a train to Berlin. The German capital and Europe's third largest city was a vibrant Weltstadt (a world-class metropolis) and an exciting center of culture. The mile-long *Unter den Linden,* the grand boulevard, was the city's focal point that led to the Arch of Triumph at the Brandenburg gate, beyond which was the spacious Tiergarten Park. Lining the *Leipziger Strasse* and the *Freidrichstrasse* were luxury department stores and austere buildings of German banks and companies that reflected the city's booming economy.

The city's pulsating wide-open nightlife was unparalleled in Europe. Berliners never seemed to sleep. Entertainment ranged from elegant

legitimate theaters and concert halls to intimate cabarets and large variety venues seating more than one thousand patrons and featuring international stars. Kaiser Wilhelm II believed that the theater should elevate morals and reflect the soul of the German Fatherland. There were also intimate cabarets and all-male saloons with raised stages where soubrettes sang risqué songs and afterwards meandered among the table encouraging customers to order more drinks or agree to a tryst. The city's exciting atmosphere camouflaged Germany's growing military power—an ominous sign of tragic events to come.

Bill and Hattie reached the city on New Year's Eve, called Sylvester, when the entire population celebrated on the street, cafés, and theaters. In the Wintergarten the audience went wild at the stroke of midnight yelling, *"Hellige Neu Yahr,"* as they toasted the arrival of 1901. Streams of confetti, napkins, and tablecloths were tossed everywhere. The tooting of horns on the streets was deafening.

Celebrations also occurred at the famous Wintergarten, a leading variety theater in Europe. The venue originated from a gigantic hall covered with a glass dome, which featured a pleasant garden where visitors enjoyed seeing exotic plants and waterworks. Refurbishments over the years led to a lavish 3,000-seat theater that attracted famous international variety stars. The headliner when Fields appeared was the dancer, La Belle Otéro, a striking French beauty with an hourglass figure and captivating dark black eyes, a courtesan of rich and powerful men including royalty. Renowned for her daring costumes, she often appeared on stage wearing a diamond-studded bra that covered her copious breasts. According to lore, they inspired the two huge conspicuous cupolas on the roof of the landmark Carlton Hotel in Cannes, France.

At its regularly sold-out shows, patrons sat in regular seats, boxes, and change on to at tables where they could eat and drink while watching a long program featuring a dozen or more acts, which included a range of performers: jugglers, acrobats, dancers, circus acts, comedians, strongmen, magicians, and singers, among others. With prices ranging from fifty cents to five dollars, the Wintergarten attracted both the middle and upper classes. Unlike US vaudeville theaters where artists usually performed for a week, the Wintergarten offered its performers multi-week engagements. The magician Houdini found entertaining in Germany "a positive pleasure...Vaudeville performers who are clever are respected in Germany as they are in no other country in the world."[5]

Knowing that some of the best jugglers had performed here (i.e., Bellini, Kara, Paul Salerno, Paul Conchas, and Paul Cinquevalli), Fields realized

that he was facing stiff competition. Since he did not speak German or any other language, he also knew that he faced a problem performing before an international audience who would never understand his accent, asides, and muttering. Thus Fields decided to remain silent and depend exclusively on juggling while amusing the audience with pantomimic gestures. His use of pantomime started early in his stage career as a tramp juggler in burlesque. He would juggle balls with hands folded below his waist, slouched shoulders, and head bent with a forlorn expression. In that way he radiated a pathetic appearance that drew sympathy from the audience. "Pantomime is a universal language," he wrote. "A passport everywhere. I never attempt the language of any foreign country, for almost everywhere, particularly in Germany, imperfect diction offends the natives... One of the beauties of my kind of entertainment is its cosmopolitan character."[6]

Mimicry also prevented other jugglers from stealing his material. Fields was fearful, almost paranoid, about other jugglers copying his routine. The pilfering of a competitor's repertoire was common in vaudeville, especially in Germany. An actor's pantomime, however, was almost impossible to imitate. "Anyone can copy a joke and repeat it, but acting is not so easily pirated," Fields stated. Adding more pantomime to his act made it more distinctive. "Speech is silver, silence is golden," he wrote. "I resolved to cut out the talk and try if there was gold in silence."[7]

Although he never attended an acting school for pantomimes, Fields possessed an innate gift for using gestures and expressions to indicate emotions. Fields saw pantomimes perform in the Byrne brothers' show and at the circus where clowns drew laughter through their exaggerated facial expressions. Standing in the wings, he could have also watched mimes entertain on the vaudeville stage. He knew that mimicry required practice and patience. Juggling, he believed, called "for perfect synchronization between muscle and nerve." He aimed not to catch the ball completely but to slightly support it before releasing it back into the air. "Then if you add pantomimic comedy, a third element must be kept under control—Mind."[8]

Standing in front of a mirror, "I examined the natural protuberances of my face as if I were scrutinizing someone I wanted to poke fun at. Fighting down all instinctive admiration, I said 'look at his funny nose!' Then I began experimenting with it for caricature. I did the same with my eyes and cheeks." Then he concentrated on the motion of his limbs while doing a trick. He called it "the outward expression of an inward idea. It is my ambition some day to reduce this to its logical conclusion. I want to act my act so that I can play it with my back to the audience." To make his tricks

look effortless, Fields pretended to be nonchalant—almost lackadaisical—on stage. Since he was always on edge, he was actually bluffing, essentially playing a con game with the audience.[9]

A facial gesture he mastered was to cringe when he feared a prop he tossed would fall and hit him. The British author, J. B. Priestley, who called Fields "one of the truly great clowns," watched him perform at an English music hall. The young Priestley saw through his deception. "I seem to remember him balancing a number of cigar boxes and staring with horror at a peculiar box, in the middle of the pile, that wobbled strangely, as if some evil influence was at work. All his confidence, which you guessed from the first to be a desperate bluff, vanished at the sight of this one diabolical box, which began to threaten him with the nightmare of hostile and rebellious things."[10] Pantomime gave birth to the Fieldsian flinch when assaulted by inanimate objects and menacing humans, a reaction that regularly appears in his performances on stage and screen. He employs facial gestures and physical movements to mirror the helplessness and frustration people feel when confronted suddenly by a precarious situation.

A missed trick gave Fields the opportunity to gain laughs by staring defiantly at the prop, to utter barely audible growls, and make other movements to express his aggravation. W. (Bucky) Buchanan-Taylor, a good friend, who later became Fields's agent in England, recalled that "he would reprimand a particular ball which had not come to his hand accurately, whip his battered silk hat for not staying on his head when it ought, mutter weird and unintelligible expletives to his cigar when it missed his mouth."[11]

Fields had numerous other mannerisms on stage. Bill made bizarre twists and turns as he juggled props; glared at the conductor when the orchestra struck a discordant note at the wrong time. With the cigar boxes precariously perched end to end, Fields pretended to let them fall to the ground but instead they returned to a horizontal position. His manipulation drew ear-splitting applause.

Fields's debut at the Wintergarten occurred on New Year's Day; the playbill listed him in the seventh spot as a *komischer jongleur* (comedy juggler). While waiting his turn on stage, his nerves caused his stomach to ache. His first five minutes on stage were nightmarish. The glaring footlights and spotlights, much brighter than at home, blinded him. He consequently missed seven tricks. "[You're] a darned fool to come here in the first place!" Hattie whispered. Highly annoyed, he swore at her. "It was a sort of counter-irritant," he recalled. "I got my eye back and redeemed the act."[12]

To Fields's surprise, his performance resulted in "a bunch of good notices. The *Clipper's* European correspondent reported that he "made a terrific hit, and they would not let him off before he responded to several encores." Impressed with his act, the management moved him to the twelfth spot on the playbill, a better position nearer the headliner. As the reviews continued to be favorable, he felt more confident at each appearance.[13]

After the show Bill and Hattie joined the performers for a late-night supper at a beer hall. Fields sometimes drank an occasional beer, but as a juggler who depended on hand-and-eye coordination, he feared its effect on his nerves. He especially refrained from alcohol before a performance. Afterwards the couple returned to their hotel room and slept through the morning. With the winter weather cold and raw, they stayed mostly in their room during the day.

While in Berlin, Bill celebrated his twenty-first birthday on January 29. Fields recalled that a friend visited him in his hotel room and started looking behind the chairs, in the closet, and under the bed. "What's the matter?" Fields asked. "S-s-sh!" the friend said, "there's a man in this room." "The man was myself!" said Fields. "It was my twenty-first birthday, and I had just come of age." His natal day, as he called it, seemed uneventful. Given the travails he had experienced as a youngster trying to become a success on the stage, he felt much older and wiser than his age. "I had gone through more strange experiences than the average person crowds into a whole lifetime," he said.[14]

The Wintergarten management wanted to extend Fields's engagement two more weeks, but he was scheduled to open on February 18 at the Palace Theatre of Varieties in London. He agreed to entertain until it was time to cross the Channel. Fields was looking forward to the country where his father and grandfather were born. But once he arrived, his enthusiasm was dampened by the cold rain, fog, and overcast skies that continually blocked the sun. London appeared dreary and dull compared to Berlin. Beset by numerous colds and coughs since childhood, Fields was especially bothered by the dampness. He blamed his condition on sleeping outside in a dugout during cold nights as a youngster and at the Orlando clubhouse where the wind blew snow underneath the door onto his bedding,

Fields arrived at a transitional moment in English history. At the dawn of the twentieth century, Great Britain had reached the apex of its economic progress due to the Industrial Revolution. But industrialization had brought a wave of labor unrest and produced a larger gap between the rich and the poor, who lived in atrocious slums. The nation's avid

imperialism had created an empire that stretched across the globe, but a general unease that its power would eventually crumble gripped the country. Colonization precipitated anger among native inhabitants, a desire for freedom that would fuel wars for independence.

Contributing to the anxiety about the future was the mourning for the death of Queen Victoria on January 22, several weeks before Bill and Hattie arrived. After reigning for more than sixty-three years and beloved by many, the Queen's passing cast a somber tone over London, despite her wish to festoon the city with purple and white instead of black. Films of the funeral were shown as the last number on the Palace playbill the evening Fields debuted at the Palace.

The queen's death ushered in the Edwardian Era, named after her successor Edward VII (1901–10). The end of the Victorian Era and the Edwardian Era unleashed a cultural explosion in the performing arts. London's theater life pulsated with excitement. Fields was astonished by the numerous music halls and legitimate houses that made London the most vibrant theatrical city in the world. The golden age of the music hall from 1890 to 1912 was at its apex. At the start of the twentieth century, the British stage journal, *The Era*, listed approximately fifty music halls and variety theaters in London. The terms *music hall* and *variety theater* were often used interchangeably, although the venues usually differed in atmosphere. Music halls featured disparate acts called "turns" in showplaces where food and drink might be served and risqué acts appeared along with less offensive routines. Larger variety theaters presented more respectable programs geared for a genteel audience, but their bar area might be frequented by ladies of the street.

Fields's numerous visits to England corresponded with the burgeoning of the country's popular theater. During his six stays between 1901 and 1913, he entertained in both music halls and variety venues. His usual itinerary included performing in Britain and the Continent from early fall to late spring. Then he returned to the United States until autumn, which signaled his return to Europe. There were several exceptions to Fields's merry-go-round of transatlantic crossings. During the period from June 1910 to March 1912, the wandering expatriate lived abroad nearly two years performing mainly in Great Britain, which became his second home.

The English music hall, a venerable performing arts tradition, dates back several centuries. Its origins can be traced to the eighteenth-century pleasure-gardens with their saloon theaters. In the mid-nineteenth century, popular song-and-supper concert rooms presented late-night vocal and instrumental music. Three other influential nineteenth-century popular

entertainment venues were the "free and easies," informal taverns where loyal patrons sang; the catch and glee clubs; and harmonic societies, which featured plays, concerts, and dancing.

At the early music halls, performers entertained on small stages with raised platforms so that patrons could watch the show while eating and drinking at tables or on seats equipped with counters. Many halls had three-sided horseshoe balconies which offered theatergoers a bird's-eye view of the stage. Instead of a printed program, a charismatic chairman with an earsplitting voice sat at a front table where he announced the turns. The chairman also controlled the boisterous crowd with stern reprimands. These halls varied from dingy, noisy venues that attracted the working class to more luxurious halls, which drew a more upscale audience.

Although quite similar to American vaudeville, the British music hall followed its own format. Under the English system, it was not unusual for a performer to remain at a hall for weeks. In London a performer might appear at more than one theater on the same night. Fields once complained that he received only one salary for doing his turn at three theaters. Keeping his makeup and costume on, he took a taxi to each theater where his appearances were timed so that they did not overlap. Compared to US vaudeville, the music hall had more turns on its playbills and therefore longer performances.

Although salaries were lower than in the United States, the cost of living was less in England. Companies offered discount railroad and baggage tickets to their entertainers. Almost every populated city in the provinces had a music hall and many had more than one. Their proliferation led to the formation of circuits as in the United States. In the larger cities the performers usually resided in hotels, but in the smaller ones, they stayed in "Digs," comfortable boarding houses run by a landlady called "Ma" who did the cooking.

Due to the country's size, shorter railroad distances between engagements prevailed. Fields therefore much preferred touring England where he could either take a train or drive. At home, he sped from one city to another each week, which made the vaudeville tour much more grinding as Fields describes. "As soon as the show is up on Saturday evening you jump into a Pullman sleeper, go to bed, wake up on Sunday morning in a town 400 or 500 miles away, get up, go to the theatre, rehearse your music, and in the afternoon perform at a matinee."[15]

Due to its long-standing theatrical tradition, entertainers were judged more critically in England. If you were good, the audience greeted you with long outbursts of applause and curtain calls, but if you flopped the

management sent you home early. Legend has it that an American team was fired after a terrible performance on a Monday and left the following Wednesday. The most outstanding music hall artists were icons idolized by the public compared to American headliners, who could slide from fame to obscurity in a flash. The venerated stars included Dan Leno, a beloved pantomime artist and comic singer; Albert Chevalier, a cockney comic singer; Harry Lauder, a Scottish songster; Alice Lloyd, known as "The Ideal Daintee Chanteuse," and Vesta Tilley, a male impersonator. On the day of Leno's funeral in 1904, throngs of people lined the three-mile thorough-fare from his home to his burial site where thousands of others, including women and children, gathered at the cemetery gate. "The English have been loyal to their artists and to vaudeville while we haven't," wrote the *Variety* reporter and historian Joe Laurie Jr. "Over there when you become a favorite, you stay that way in their hearts, regardless of age and failing talents. In America you remained a favorite as long as you remained a hit; when you flopped you were soon forgotten by bookers and the public."[16]

The Palace of Varieties, where Fields entertained, was considered among the premier showplaces in England. A fashionable venue suitable for ladies, the Palace contrasted with the numerous male-only music halls and variety stages deemed decadent by moral crusaders. At the Empire Theatre, for example, gorgeously dressed ladies of the town attracted gentlemen by parading on the promenade that separated the bar from the orchestra. By comparison, families were encouraged to attend the Palace, and the management offered children half-price tickets to matinees. The Palace's 1,697-seat plush interior included four tiers, which reflected Britain's rigid class structure. The wealthy patronage watched the show in the most expensive orchestra stalls and private boxes, while the working class sat in cheaper gallery seats.

Class divisions remained sharply divided during the Edwardian Era. The landed gentry lived in luxurious manor houses on large estates, while downstairs lived numerous domestic servants paid low wages. "It was a leisurely time when women wore hats and did not vote, when the rich were not ashamed to live conspicuously, and the sun really never set on the British flag," wrote the author Samuel Hynes.[17] Rumblings of discontent, however, were heard among laborers demanding better pay and less hours and women organizing for equality and suffrage. After World War I ended, their disgruntlement erupted into human rights movements that changed British society forever.

At the time of Fields's debut, the Palace was managed by the legendary Charles Morton, considered the "father" of the British music hall. A pioneer showman, he first managed a tavern that staged harmonic meetings

featuring amateur vocalists. From that time forward he opened numerous halls, the 900-seat Canterbury Arms; the luxurious Oxford Music Hall; and the popular Alhambra and Tivoli Strand. Still energetic at eighty-one and a reputed martinet, Morton sat habitually at a small table on the Palace's promenade at half-past nine sipping a cup of tea or cocoa with a biscuit. Faultlessly dressed in evening clothes and his face adorned with his long grey muttonchop whiskers, he was easy to spot as he tapped his spoon in time to the orchestra's music. He worked over thirteen hours a day overseeing the Palace and took the bus home at midnight. "I am always here," Morton said, "and my staff know that I want things done, methodically, promptly, and well. They know that I go about with my eyes open."[18]

Worried about his reception before an English audience, Fields was nervous on his opening night. He knew that numerous US acts had flopped in London due to the audience not understanding American humor, characterizations, and slang. McIntyre and Heath, a famous blackface team that impersonated racial stereotypes, bombed because the audience could not understand their jargon. Zany performers in "nut acts," who broke objects, screamed, and did other bizarre antics, failed because the British were then not fond of far-out anarchistic humor. Although he was performing before an English-speaking audience, Fields still decided to rely more on pantomime than comic patter. He knew that the British enjoyed pantomime shows, especially at Christmas time, and his act might appeal to them. He found that the spectators were sometimes slow to react to his stunts. "Never test a joke on an Englishman. By the time an Englishman solves one, they're already sweeping out the theater."[19]

At an evening show in early March, he was listed as the sixth turn in a sixteen-act playbill. He was scheduled to go on stage at 8:29 p.m. for thirteen minutes. Fields consequently needed to condense his act that usually ran twenty to twenty-three minutes. As the curtain rose the audience saw Fields wearing a tattered sable coat, which he had earlier found backstage at a theater. Removing the coat, the spectators saw his costume. Although he had toned down his more grotesque makeup, Fields still resembled a tramp. A reviewer described his appearance: "Clothes—old, torn, loose, and unclean; boots—big and bulging; hat, an artistic wreck. And the face! Hirsute and blotchy, with a ludicrous expression of countenance that was most diverting."[20] Hattie was dressed in an eye-catching dark pants suit with a coat accented by long white lapels, dress shirt, and bow tie. With her neck-length black curly hair parted in the middle, she looked stunning. Hattie's smartly tailored outfit seemed purposely designed to offset her husband's shabby look.

Acting as Bill's assistant and foil, Hattie handed her husband the props piled on a small table. Here were tennis and rubber balls, top hats, a balancing stick or cane, a cigar or a wooden one, a whisk brush, and empty cigar boxes. He began juggling balls in time to the orchestra music. "He juggles everything with such unconcern, and looks such a happy lazy tramp, that we are obliged to hold our sides when he drops a ball, waits for it to rebound, and then recommences to manipulate the three just as if they are not there," wrote a reviewer.[21] The critic found his mixture of "delightful refreshing comedy" and "difficult and dexterous experiments" while juggling extraordinary. He astonished the audience by lighting a match on his whiskers as Harrigan did. Fields continued to do his stunt with two battered black and white tall hats, simultaneously flipping one to the top of his head and the other to his toe and then exchanging their position with quick jerks of his face and leg.

A reviewer was amazed at his ingenious dexterity with balls: "They fly about all over his body, resting now and again in the most inconceivable places, with a maximum of movement to a minimum of effort. He will bring them to the closest possible quarters, still revolving—the balls, not the juggler—and expand again into a long-distance aim with perfect ease and smoothness."[22]

For his British audience, he had a new trick that involved a hat, cigar, and a whisk brush. He would manipulate all three props and then finish with the hat landing on his head, the cigar in his mouth, and the brush in his specially enlarged back pocket. He continued to get laughs by blaming Hattie for a missed trick by pointing at her with an annoyed expression on his face. "Get out of my way," he admonished. "How can I do this?" Fields ordered his "charming lady assistant off the stage with such a comic absurdity that we want him to drop something else," wrote a critic. Even though Fields was faking, Hattie eventually began to feel humiliated by the scolding.[23]

While in England, Fields obtained engagements at three music halls in the provinces: the Birmingham Tivoli, the Leeds Tivoli, and the Bradford Palace. The music hall business was flourishing outside London. At the start of the twentieth century, the *Era* listed approximately 226 halls in the provinces. Due to industrialization in the large provincial cities, population was booming, which caused a degree of prosperity among the middle class. The availability of a ready-made audience offered opportunities for entrepreneurs to build opulent music halls. An entertainer usually performed two shows at night in the provinces, one at seven and the other at nine. The playbills in the provinces usually did not feature famous music-

hall stars but mostly up-and-coming talent. Fields consequently "topped the bill in the Provinces" wherever he played.[24]

Birmingham was the start of a whirlwind tour playing principal provincial music halls. Bill's initial engagement starting March 18 occurred at the industrial city's Tivoli Theatre of Varieties, operated by Thomas Barrasford, a prominent music-hall magnate who operated twenty venues. The Tivoli's handsome neo-Classical auditorium with a deep fan-shaped balcony and twelve boxes seated more than two thousand spectators. The reviewer for the *Birmingham Daily Argus* called Fields's juggling "extraordinary" and "so peculiarly funny that his exhibition fills the audience with wonder and keeps them laughing all through." Bill and Hattie next took the train to nearby Leeds to perform at another Barrasford venue. Since he operated another theater in the city, the impresario had his performers appear at both venues on the same night. After Bill and Hattie played a two-week engagement at Leeds, they next took a short ten-mile train ride to nearby Bradford. At the People's Palace Music Hall, Fields continued to delight crowds with his clever tricks. He was such a hit that he "had to retire from view after repeated calls from his delighted audiences." Fields is "a juggler of rare skill and the manner in which he manipulates rubber balls, top hats, etc., is superb and spiced with quaint pantomimic humor." Still in love despite occasional disputes, Bill and Hattie celebrated their first wedding anniversary here.[25]

After their Bradford engagement they crossed the channel again, took a long train ride to Leipzig, Germany, and arrived in time to open at the Krystall-Palast Theatre on April 15. A thriving commercial city, Leipzig was famous for its old town with its labyrinth of narrow, twisted streets and huge market square surrounded by picturesque medieval houses with high-pitched roofs. As a center of culture, Leipzig's musical heritage included Johann Sebastian Bach, who composed for many years. With its numerous legitimate theaters, opera houses, and venues for popular entertainment, Leipzig offered a thriving theater life.

Built in 1850, the Krystall-Palast was one of Germany's most famous variety theaters. Patrons watched Bill and Hattie perform while eating and drinking at tables or sitting in seats in the orchestra or along the horseshoe-shaped balcony. One afternoon Fields snapped a photograph of a smiling Hattie standing near a tree fashionably dressed in a full-length black skirt with matching coat and wearing a large plumed hat. She took several snapshots of her husband in costume on the roof garden of the Krystal-Palast. One shows him coatless while juggling three balls and inscribed "Beastly,

silly isn't it?"[26] Another depicts the soles of his worn-out shoes. In the third, he is sitting at a table wearing his stage paraphernalia: a shabby tux, white shirt with black bow tie, top hat, cane, and gloves.

From Leipzig Bill and Hattie took a train to Paris where they were scheduled to open at the famous Folies-Bergère on May 1. Mesmerized by the captivating beauty of the city, they walked everywhere. As they strolled along the Seine's riverbank, Bill and Hattie were greeted by spring-like conditions with blooming flowers and trees. Paris reverberated with a splendor and charm manifested by its grand boulevards, palatial edifices, historic monuments, verdant parks, and art galleries. The illuminated boulevards at night and many boisterous cafés reflected a city of pleasure constantly *en fête*. They arrived at the height of the Belle Époque, an era for the rich with their fortunes earned from industrialization. The entrepreneurs' wives and mistresses dressed in the latest *haute couture* finery accented by exquisite feathered hats and furs. They drank champagne in lavish Paris restaurants such as Maxim's and attended opulent theaters such as the Opéra Garnier.

In paintings, posters, architecture, furniture, and other decorative objects, freedom of expression was displayed in art noveau's sinuous lines and foliate forms. Defying conventions, artists pursued a bohemian lifestyle in the cabarets and studios in Montmartre. Here Henri de Toulouse-Lautrec, who died the year Fields arrived, had gained fame with his paintings and posters of Parisian night life and portraits of popular entertainers such as the French chansonneuse Yvette Guilbert. Paris offered a cornucopia of entertainment: opera, operettas, drama and comedy, cabarets, dancing halls, circuses, and music halls.

The Folies-Bergère was the most famous Parisian theater. Fields's engagement at the premier variety venue reflected his growing reputation. Opening on May 2, 1869, the Folies-Bergère began as a showplace for pantomime and operetta until it was remodeled three years later into a glitzy theater with stunning decor. The interior featured antique mirrors, crystal chandeliers, and the infamous *promenoir* located between the stalls and the bar. Here gorgeous demimondaines, who were required to have fortnightly renewable passes, strolled hoping to lure wealthy lovers. Its long playbills included a wide range of every imaginable variety act: acrobats, pantomimes, singers, ballets, operettas, weight lifters, animal acts, magicians, comedians, eccentric dancers, and wrestling matches, among others. During Fields's engagement, the show girls wore gorgeous Gibson Girl costumes that accented their protruding breasts, bulging hips, and shapely legs. As the twentieth century progressed, the *Folies* became known for its

opulent revues with mostly nude chorus girls wearing large headdresses and trailing sequin gowns.

Bill and Hattie were scheduled to perform for seven weeks, a lengthy engagement but not unusual since variety theaters abroad regularly offered artists multi-week contracts. Fields was overjoyed when he spotted the billboard outside the theater and saw his name highlighted in large, bold print. The billboard called him an *americain jongleur comique* and announced that he had top billing. Hattie snapped a photograph of her handsome husband standing in front of the billboard, dressed smartly in a suit, bow tie, fashionable hat, and carrying a cane. At other times during his long stay, Fields shared the spotlight with famous international performers.

During his act Fields mainly used his facial expressions and body movements to get laughs. The French raved about him due to their appreciation of pantomime; the country being the home of the great masters of mime such as Jean-Louis Barrault, Charles Dullin, and Marcel Marceau. A free spirit, Bill enjoyed the venue's carefree sensual atmosphere while Hattie, with her proper upbringing, felt uncomfortable and could not wait to leave Paris.

They finished their *Folies* engagement near the end of June and crossed the channel again in time to play a four-week engagement at the Tower Circus in Blackpool, a popular seaside resort. The Tower Circus, still in existence, is located near the beach underneath the landmark Blackpool Tower, which dominates the city's skyline. Over the years, the Tower Circus featured the most popular music-hall stars and its huge arena also presented aquatic shows.

Their four-week engagement starting July 1 was enjoyed by the audience, especially children who were entranced by Fields's magical feats of dexterity. In an interview with a Blackpool reporter, he stressed his need to practice and find new tricks in order that his act would not become stale. "I have never stopped practicing. Every now and then I strike an entirely new idea, and if it can be carried out I keep at it until I can rely upon myself—and then I practice it all over again." He talked about the essentials of juggling—"good eyesight, sound nerves, a special ability to judge distances, and unlimited patience and perseverance in practicing." When asked where he obtained his props, Fields replied that he picked "things up anywhere I may be in want of them." Noting Hattie's role, the reviewer called her "a charming young lady . . . who by causing affected irritation at the necessary moment, adds greatly to the effect of the tricks."[27]

A few days after finishing their engagement, Bill and Hattie boarded the *R. M. S. Majestic* on July 31 and headed home. "Regarding my European

tour, it has been a most successful one," he wrote to the *New York Clipper.* "Have been a tremendous success everywhere I have played and have return engagements at each place...I will return to Europe shortly after closing with the Orpheum Show."[28]

Despite having signed a commitment to return to big-time vaudeville in the United States, he had mixed feelings about leaving. He felt audiences understood and appreciated his pantomime act better than in the United States. During his seven month stay, he had gained considerable experience performing before different audiences at Europe's most prestigious theaters. His appearances at the Wintergarten, London's Palace, and the Folies-Bergère in Paris were amazing accomplishments considering he was only twenty-one and had plied the boards for three years.

While abroad pantomime comedy had become a significant element in his juggling act. "Many people have told me that my facial expression is the secret of the laughs my act secures," he once said. The body movements and physical gestures he used would stay with him the rest of his career both on the stage and screen. Without the distraction of his remarkable voice, his silent movies especially reveal his pantomime skill: his look of aggravation, his show of surprise, the way he walks, the swift movements of his hands, and an enigmatic face radiating hundreds of expressions. Leading silent comedian Harold Lloyd summed up Fields's expertise in three words. He is "a master pantomimist."[29]

# 8. "My Art Never Satisfies Me" ❧

From his seat at Keith's Union Square Theater, "Chicot" (Epes Winthrop Sargent), an influential vaudeville critic, saw Fields perform soon after he returned home. His perceptive eye observed that Fields had changed his appearance by toning down his grotesque makeup. He "was not like most of the tramp jugglers who took Harrigan for their model. His dress was neater and cleaner without being less funny." With the depression of the 1890s over, the tramp costume on stage had mostly become passé, although Chaplin revived it for the screen in 1914. Fields later felt that the "grotesque, big false noses, weird wigs, outlandish costumes and frightful make-ups" caused an act to be overdone, "insulting the intelligence of the audience."[1]

When Bill and Hattie performed in New York, they occasionally ate dinner at her mother's home. Hattie's sister, Kitty, recalled that Fields once balanced a bottle of ketchup on his head over the table. "Oh, Claude my goodness you will certainly drop that on my good china!" exclaimed Harriet's mother. "Oh, no mother just leave it to me" retorted her son-in-law. After waving "his hands up and down the table," finally he sat down with the bottle still on his head and the china in good condition," recalled Kitty.[2]

They soon began their thirty-week tour with the Orpheum Show. The production was the brainchild of Martin Beck, now the circuit's general manager in charge of bookings. An admirer of fine music, dance, and the arts, Beck wanted to bring high culture to the popular theater by presenting "elegant vaudeville," starring the most talented performers.[3] Unlike a regular itinerary where performers separated after a week-long engagement, the troupers remained together at every stop on their tour west of the Mississippi.

Beck assembled a program that highlighted as many as fifteen different specialties. The headliners were the popular blackface team of James

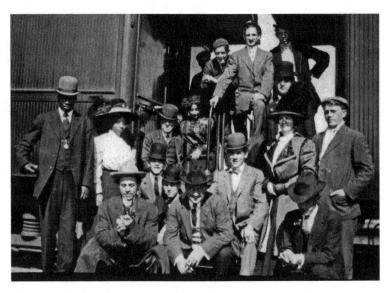

**Figure 8.1**   Performers from the Great Orpheum show, who traveled together as a group, 1901–02. Hattie and Fields are sitting on the train steps, third row, far left. Courtesy W. C. Fields Productions, Inc., www.wcfields.com.

McIntyre and Thomas Heath. They had started as a team in minstrel shows during the 1870s and became well known for numerous sketches, including "The Georgia Minstrels." Another star was Joe Welch, a popular ethnic dialect comic who did a belly-laugh monologue about Jewish life. Wearing an oversized worn black coat and pants, a derby hat that covered half of his head, and a fake beard, Welch forlornly stood on the stage with hands clasped and arms crossed, stared at the audience for thirty seconds, before uttering his opening line: "Mebbe you t'ink I am a heppy man?"[4] Then he related his financial misfortunes as a peddler, encounters with criminals, appearances in court, and problems finding food and shelter

For the Orpheum Show, Fields thinned his dark black beard and mustache, applied less paste on his face, and was dressed in evening clothes with opera hat. The change of outfit matched Beck's ambition to stage a classy show. Feeling that she was a significant part of the act, Hattie kept pestering Bill that she again deserved to be listed on the playbill. By watching her husband and practicing, she had learned some simple juggling tricks and possessed a natural gift for acting. Tired of her persistent nagging, Fields agreed. The program at the Chicago Olympic Theatre listed

them as "W. C. Fields and Wife—comedians and tramp jugglers" and the following week at the Windy City's Haymarket Theatre as the "funniest and most expert of jugglers." Critics backed Hattie's role as a significant foil for her husband. "He has a partner, a pretty woman, who hands him his material, and pretends to be frightened. When he fails a trick he growls at her and she runs out. The idea has proved so valuable that Fields misses purposely at times." The skimpy black silk tights that she wore attracted one reviewer. "His wife helps dress the stage and the black satin panties have not yet given way."[5]

But the billing "W. C. Fields and Wife" did not last long. Fields had worked hard on his juggling and, and given his insecurity and ego, did not want to share the limelight with his wife. Hattie was unhappy about returning to her role as assistant and foil, and it tended to make their relationship testy. "I was just atmosphere," she later said. "He was the one people came to see."[6]

The long Orpheum Show tour with its frequent stops during winter got on their nerves. They often quarreled over their act and domestic issues. Hattie increasingly began to see her husband's other disposition when Bill's uncontrollable anger frequently exploded. "He had a terrible temper and liked to bully people," Hattie said, and he could become malicious and belittling. Fields even admitted that he possessed a dual personality. "I'm a peppery stubborn cuss, but I'm not bad at heart." Equally strong-willed, Hattie stood her ground and the arguments grew progressively more vitriolic.[7]

Bill complained about Hattie in a letter to his Uncle Grant Felton, his mother's brother. While playing at the Orpheum Theater in Kansas City in early February, Fields received a reply. "Well, Claude, I see you are having a hell of a time with Hattie but as a Brother don't do any harm to her that will get yourself in trouble way out there but wait till you come east and then settle things right up with her because Claude if any thing happens to you out there, how would I get to your side. Now for God's sake hold your temper till you get home and don't get into trouble for my sake." He added a postscript: "Please do as I ask you. Will you Claude."[8]

During the Orpheum tour Fields was billed as an eccentric juggler. Eccentric performers were now a fad on the vaudeville trail. They ranged from zany nut acts doing madcap antics to knockabout artists, who beat up a partner and threw props around the stage. Eccentric dancers were noted for their flips, twists, and shakes or rubbery legs when they imitated drunks. Fields was called eccentric due to his bizarre physical comedy,

exaggerated facial expressions, and wacky body movements while juggling. He sometimes did acrobatics and somersaults as he did a trick. "If you act out a good trick it can't be stolen," he believed. Because his costume hardly matched the description "eccentric," he felt uncomfortable in the fancy clothes—calling the experiment a "dismal failure." He consequently went back to a grotesque appearance. "So now I daub rouge on my cheeks," he told a reporter, "put on a grotesque beard and look as senseless and ridiculous as I can." His twenty-one minutes on stage often ran overtime due to laughter, applause, and encores. The tour travelled from the Midwest to the Pacific Coast and then backtracked. Most bookings were for one week, but there were also tiring one-night stands in smaller cities. On his twenty-second birthday, he performed in Evanston, Wyoming, at a freezing cold theater. Then the troupe continued to Cheyenne, Wyoming; Lincoln, Nebraska; and Atchinson, Kansas. The exhausted company ended its tour in mid-April in Chicago.[9]

"You're always livin' in a trunk," said Fields about the grind on the vaudeville trail. "You arrive in town on a Monday... You rush over to the theatre to rehearse your music and see that your props are set." According to a standard contract, if you did not arrive on time for rehearsal you could be fired by the theater's manager. At the Monday matinee the manager judged you and sent a report to the head office. A bad review could land a trouper back to the small-time with less salary, more stops in towns, and eventual oblivion. "If things go wrong, you fuss and fume yourself into a stew," said Fields. "You do your night show prayin' it'll go better than the matinee. You know the critics are sittin' out there, ready to roast hell out of you." To save money, Fields often bought a regular seat on a train rather than pay for sleeper coach. "So you find yourself a seat and curl yourself into knots, and spend the night listenin' to fifty-seven different varieties of snores and the yowl of the baby that no train's complete without." Sometimes he thought of going "out West, get a job managin' a little theatre, draw cartoons for the papers, play around in the sunshine, live like a human being."[10]

After about ten grueling months on the road, Bill and Hattie reappeared at the Union Square. In a review of Fields's performance again, "Chicot" wrote that his act had greatly improved. "There has been a lot of work put in this season and the new work shows better and is further away from his old style. Fields has individuality and if he keeps at work on this line he would have an act that stands alone."[11] The review was an inspiring bon voyage gift printed just before they boarded a ship for their second trip to Europe.

After a pleasant voyage compared to their first crossing, they opened at the Wintergarten on August 15. Fields had more confidence compared to his first visit since he knew the audience. But to his surprise, his reception was poor on opening night. "This time I didn't get a tumble," he recalled. "My act was good or better. They just didn't like me. Maybe it was because I followed a horse act. Maybe they figured the horse could've done my tricks better."[12] After the first night at the Wintergarten, his act was generally well received.

One program listed Fields again as a *komischer jongleur* in the eleventh position in a thirteen-act playbill. He arrived on stage at 9:44 p.m. and did a 19-minute performance. He was not the star attraction since the headline act that night was Cléo de Mérode, a well-known dancer from the Parisian Opera. On another evening he followed Herr Grais's acrobatic baboons. After the baboons finished Fields came on stage completely unnerved and missed his opening tricks. It took him several minutes to get his timing back. A noisy act, he felt, made the audience unable to appreciate his subtle comedy. Given the work he did to perfect his performance, he hated "to get kicked in the pants."[13]

After their six-week engagement ended, the Fields did a whirlwind tour of Central Europe—Vienna, Dresden, and Prague—before arriving in London where they appeared at the famous Hippodrome. The theater's huge neo-classical red brick and terracotta five-story edifice, designed by the renowned architect, Frank Matcham, towered over Leicester Square. The spacious horseshoe-shaped auditorium was an engineering marvel with space designed for circus, aquatic, and variety shows and its cantilevered balconies created improved sight lines, which gave spectators in gallery seats a bird's-eye view of the stage. Fields called the Hippodrome the most "regal establishment" that he had ever performed in to date.[14]

The Hippodrome's proprietor was Sir Horace Edward Moss, an industrious impresario, who became Britain's most powerful circuit owner. After launching numerous first-class music halls in the provinces, he opened the Hippodrome, on January 15, 1900. Like the Keith and Orpheum chains, he combined his properties into the Moss' Empires syndicate, which at its height controlled thirty-three theaters in Britain. The arrangement enabled Moss to route acts for many weeks in major cities throughout the provinces. Moss saw Fields perform at the Wintergarten and was so pleased with his "droll entertainment" that he signed him for an engagement at his new theater and several other venues in the provinces.[15]

Before leaving for the United States in the summer of 1901, Fields had promised his European fans that "I will do a somewhat different act

when I return." Fields knew that to be successful he needed to create new routines. Fearing being a has-been, he was constantly driven to always improve his act. "Years go to the perfecting of an art. I am always working on mine... My art never satisfies me. I am always experimenting."[16]

He began by creating a new appearance on stage. He came on stage at the Hippodrome in a new outfit, wearing a tattered sable coat that he had found backstage in a vaudeville house, a string bow tie under a turned-up collar, white gloves on his hands, and oversized goggle-like glasses over his eyes. Besides his false black beard and mustache, he applied layers of putty on his nose and instead of a battered top hat he wore a military-sized officer's cap on his head. On his feet were long shoes with a specially designed broad toe.

The shoes were used to perform a new trick with a walking stick and a hat that he had been working on for several years. Fields described it as his most difficult trick. "The hardest trick I do is to balance a stick on my chin while I am standing on one leg. On the leg in the air is a hat. I throw this up and after it turns a double somersault, as it were, it is caught on the stick... It took me two years' hard practice to perfect that trick... I stuck to it and now I can do it practically every time."[17]

While practicing the trick, Fields worked on maintaining his equilibrium by balancing a four-foot stick on the back of his hand and moving it to his forehead, nose, and chin. "I still carry scars on my legs from my early attempts at juggling. I'd balance a stick on my toe, toss it into the air and try to catch it again on my toe. Hour after hour that dratted timber would land, end foremost, against my shin bones. I'd work until tears were streaming down my face, but I kept on practicing—and bleeding—until I perfected the trick." The most difficult maneuver was to keep his balance while kicking the hat to the stick. "You see there is a double balance to maintain. I have to balance myself on one foot with the hat on the other while balancing the cane on the chin, and when I kick the hat up I throw both balances out. Then I have to recover myself, get the two balances again."[18]

Although others did the trick, Fields felt that he was the only juggler who made the hat do a double somersault before it landed on the stick. A reviewer who saw Fields do the stunt at the Hippodrome called it "a most startling exhibition of skill. An amazing accuracy and neatness of execution are distinctive features of Mr. Fields' act, which is received with hearty applause."[19]

Described by a critic as "a radiant clothed assistant," Hattie watched her husband add a third prop to the trick, a lighted cigar. "He would balance

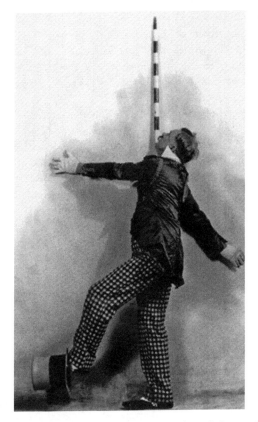

Figure 8.2   Fields performing his signature stick and hat trick. Courtesy W. C. Fields Productions, Inc., www.wcfields.com.

the cane on top of the shoe, the cane holding a hat, the rim of the hat hold- ing a lighted cigar. He kicked the cane in the air; the hat would do a per- fect somersault landing on his head, the cane would land on his forehead, and the cigar, burning side out, would land in his mouth." Sometimes it took four attempts to do the stunt, and to divert the audience's attention between misses, Fields would talk to the orchestra. The musicians kept time to his tricks by playing songs and once Fields completed a trick the drummer rang a cow bell.[20]

Fields recalled that when he first tried his cigar and hat trick, he waited for the applause but none came. "I might have been waiting yet. That

experience made me very bitter for a while. What's the use of burning out your soul for people who don't appreciate the better things in life? I could have juggled five rubber balls and got a bigger hand, but was it art?" Fields learned that many audiences only appreciate the easier "showy" stunts. They "scarcely applaud at all to a trick that has taken months and months to practice."[21]

Fields believed in putting his tricks in the proper sequence. "Every trick has to be placed, and provision has to be made for the amount of time necessary to give the impression of dawdling through the whole things. Speed is killing to comedy." He strove "to crowd into the time on stage as much as possible...In this way a lot of the most difficult feats appear as mere asides—something en passant." He reduced his stage time from thirty to twenty-two minutes and within that time he performed more than one hundred different tricks.[22]

"The chief cause of Mr. Fields' success lies in his constant effort to improve his act and originate new material," claimed a critic. "The new ideas come at almost any time" wrote Fields, "particularly when practicing in the dressing room. My use of an extension pair of nippers came from seeing them employed by the Vienna shopkeepers to lift articles from the window." It is the "little extras that count. One must be original. Many artistes may be seen nowadays doing things with rubber balls, hats, and cigars, etc. But so long as I can give the public just that little bit extra that keeps me 'different' I am satisfied. It is a big world."[23]

Since the end of 1902, Fields had been thinking of adding a new routine using a pool table. He was already a proficient pool player before he exhibited the sketch on stage. As a youngster he had worked as an assistant at a pool hall where he placed balls in a triangular rack to start the game for cunning hustlers who fleeced unsuspecting players. Philadelphia was one of the country's leading billiard capitals and the birthplace of world champion Willie Mosconi, who first learned the game at his father's pool hall. Hundreds of popular parlors in Philadelphia reeked from cigarette and cigar smoke and the pungent smell of beer and liquor. Some were small dingy joints with only one table, while others were large raucous parlors with dozens of customers.

Because they were frequented by unscrupulous hustlers who swindled naïve players, many had an unsavory reputation. To lure a newcomer to a bright green-cloth table, a skilled pool shark or hustler pretended to be a mediocre player by missing shots. Sometimes the hustler feigned being drunk by staggering around the table. Familiar with the tables at the parlor, the hustler knew both the speed of the cloth and the nap that affected

the swerve and direction of the balls. The pool shark began by betting a small amount of money against his opponent. Using a low-quality billiard cue or a disguised professional cue known as a "sneaky pete," the shark pretended to lose on purpose by playing poorly for a few games, a scheme known as sandbagging. Then he would wager a higher amount against his overconfident opponent, run the table, and pocket his earnings. The hustler's racket was another trick similar to the shell game that took advantage of suckers. Working at the pool hall further exposed the young Fields into the shady world of the scam artist—the cunning con man, a character he plays in his films.

Fascinated by the game, Fields learned to play by studying the expert finesse and shot making of the sharks. He noticed how they stared at the cue rack, carefully selected the right stick, smeared chalk on its end to increase friction between the cue stick and the ball, and sauntered around the rails until they reached the correct place to line up their shot. He observed how they cleverly placed the stick between their fingers, deftly positioned it behind the cue ball, and paused before the shot. Using a variety of spin techniques or a jump shot, a shark then banked a selected ball by caroming it into a pocket. He watched in wonder how the hustler using a "draw" or back spin made the cue ball reverse direction to the correct position in order to pocket the next object ball and eventually run the table.

The hustlers taught Fields the basic techniques of the game. "While hanging around pool halls as a kid, I noticed that every player went through the same gyrations," declared Fields. "He elaborately chalks his cue, he sights the ball, he wiggles around and sights it again, and he always preens and struts when he makes a shot. So, I enlarged upon this routine and it became one of my bright spots of pantomime, for everyone who ever played pool recognizes himself and laughs heartily."[24]

With practice he became a more proficient player and developed a lifetime passion for pool. Fields loved the look and feel of the green felt that reminded him of a large patch of grass. He always installed a table in his homes and enjoyed fleecing his friends in a friendly game. Some nights Fields dreamt he was back in his first pool hall and could hear the customers ordering him to "Rack 'em up, boy!" Because of a painful back, he sometimes slept on the table's top. In her memoir of living with Fields, Carlotta Monti recalled the time she screamed when she first saw him asleep on the table in his pajamas. Awakened, he looked up and declared: "A pool table was one of my early beds, and all of us unconsciously revert to our childhood."[25]

There were already many successful pool acts in vaudeville. As early as 1889, Joe Weber and Lew Fields had introduced a pool sketch in which Myer (Lew Fields), a bullying pool shark, tries to teach the innocent Mike (Weber) the game, sometimes knocking him over the head with a cue. Numerous champion billiard players also exhibited their skill on the vaudeville stage. Among the most popular were the German champion, Eric Hagenlacher, Willie Hoppe, and Charles C. Peterson, considered the best trick-shot artist.

Fields saw other billiard acts while on tour. A significant influence on Fields was watching Professor Devereaux work with trick billiard contrivances on stage. At Birmingham's Tivoli Theatre in 1901, he shared the same playbill with Kelly and Gillette, who did a billiard routine. He certainly saw or heard about the famous British comedian Harry Tate, known for his bushy wiggling clip-on mustache. He did the wacky sketch, "Billiards," using his cue to improvise several skits. Although he never played on a table, Cinquevalli was a master manipulator of billiard balls. As the "Human Billiard Table," he wore a green felt vest with five net pockets. He then proceeded to quickly move the balls from one pocket to another by rapid bodily movements. Fields did a variation of this act by bouncing balls off the cushions of a pool table and into pockets attached to his coat.

A newsman relayed his eagerness to do a pool sketch in England. "He is going to let us into the secret of playing a game of billiards in one stroke," wrote the reporter. Another news story related that he bought a table at a billiard salon in Birmingham and had it rebuilt by a prop company. More than likely he introduced the routine at his next engagement at the Empire Theatre in Leeds in January. A 1903 postcard illustration depicts Bill and Hattie at each end of a pool table dressed in tattered rags, looking like cave people from the Stone Age, and playing pool using rocks. In large letters at the bottom appear the words "W. C. Fields Empire Leeds."[26]

After Leeds, Bill and Hattie sailed home. For his upcoming American tour, Fields ordered a custom-made pool table from the Chicago sales office of the Brunswick-Balke-Collender Company. Founded by Moses Brunswick in 1845, the enterprise became the world's largest manufacturer of pool tables and was noted for its excellence in design and craftsmanship. In May 1941, Fields wrote the company's president: "I carried one (especially prepared) around the world twice with me when I was in vaudeville doing a pool table act. I felt so darn lonesome without a Brunswick-Balke-Collender combination billiard and pool table that I just had to order one."[27]

Fields personally designed its specifications according to the tricks he planned to do. Edwin Glover, a stage electrician, manager, and employee of the Atlantic City Electric Bureau, reconstructed the pool table. "I knew him during his lean years as a juggler in Atlantic City," recalled Glover. "I made the pool table he used in his famous billiard stunt." The table had rounded cushions that allowed the balls to fly into the air at various angles. It was slightly shorter than standard size and collapsed into sections for easier handling. "I still have the billiard table," he wrote Glover. "I do not know whether you recall it or not but you were the old mongler [sic] who had so much to do with the ten balls going into the pockets simultaneously." This was a phenomenal stunt he did later.[28]

Fields received "tremendous applause" when he performed his pool table routine at his first engagement at Keith's refurbished theater in Providence, Rhode Island. "He does a wonderful trick in catching balls from a pool table in his pocket," wrote a reviewer. To do the stunt, he used tennis or rubber balls disguised as pool balls and wore a special, spacious hip pocket in the rear of his pants. Leaning over the table with legs in the air, Fields made the ball hit the top of his head and then fall into his rear pocket. As Bill became more proficient, he made the ball bounce from the cushion to his knee on his upright right leg and from there to the top of his foot, which kicked it into his rear pocket. If the ball fell to the floor he would mutter "curses." To show his frustration, he sometimes threw bogus money onto the stage floor.[29]

Critical to his success were the theater managers' reports back to Keith headquarters. Charles Lovenberg, who oversaw the Provincetown theater, found his twenty-minute act greatly improved with the addition of new tricks. Among them, he wrote, were "some billiard double shots that are most surprising. Among them, that of shooting a ball on the table to the opposite cushion having it bounce back and go over his head falling into his hip pocket." Lovenberg's review was enough to give him star billing: "This act will probably be of the most value to us of any on the bill." The reports continued to be good as Bill and Hattie followed their itinerary. "He made a big laughing hit, and is one of the features of the show," wrote the manager of Keith's Boston Theater. "This man is the peer of all comedy jugglers," reported Samuel Hodgdon, manager of the Union Square and a major figure in Keith's operation.[30]

The addition of a pool table capable of multiple tricks enhanced his vaudeville routine, and equally significant, he performed variations of the sketch during his entire career. Whenever he could, Fields included a pool sketch in his Broadway revues and motion pictures. Sometimes directors

insisted that it did not fit in with the plot; other time they left the sequence on the cutting room floor. Variations of Fields's pool routine nonetheless appeared numerous times on the stage and screen. On the Broadway stage he performed the sketch in his first *Ziegfeld Follies* (1915) and in *Ballyhoo* (1930), his last appearance on the Great White Way. The two performances, fifteen years apart, thus form the bookends to his Broadway career. The pool routine likewise became the bookends of his movie career. The first commercial movie he made was *Pool Sharks* in 1915, and nearly thirty years later, he did a pool exhibition in *Follow the Boys* (1944), one of his last screen performances before he died in 1946. In between these two dates he displayed his pool playing skills in other films. Two of the best are *Six of a Kind* (1934) and *The Big Broadcast of 1938.* His encounter with a pool hall as a youngster in Philadelphia therefore generated the creation of a famous specialty.

Bill and Hattie next went to Philadelphia where they performed before a hometown crowd at Keith's newly opened 2,300-seat lavish French Renaissance theater on Chestnut Street. Fields was listed in the number three position on the playbill that featured the strongman Eugene Sandow as the headline act. Wanting to wow fellow Philadelphians, he astonished the crowd with his juggling and pool act. "In our estimation he is good enough for a headliner in any show," reported the manager H. A. Daniels.[31]

While in Philadelphia he and Hattie stayed at his parents' home at 3911 Marshall Street, located in the same neighborhood where he grew up. As an itinerant entertainer, he lacked a permanent address and was listed in most city directories as "Claude Duckenfield, actor, 3911 Marshall Street" until 1918. His genial mother always kept a room in their home for him. Age had mellowed his sixty-two year-old father, but his son was not yet able to forgive Jim for causing his nightmarish childhood.

Bill and Hattie next headed west playing the Orpheum Circuit again during March and April until they reached San Francisco, where they planned to board a ship bound for engagements in Australia and South Africa. In the course of five years, Fields had managed to become a well-known entertainer in the United States and Europe—now he had the opportunity to become a worldwide attraction. An adventurous traveler, he was excited about performing in another part of the globe. The Antipodes beckoned but suddenly Bill was confronted with a problem. Hattie refused to accompany him.

# 9. To the Antipodes ◆

"I was afraid of a long trip," Hattie said. "I don't travel very well on the water." After undergoing rough crossings across the Atlantic, she refused to face an ocean voyage to Australia, which could last up to three weeks. Plus she was also exhausted from the fast-paced itinerary during the last two years. Her husband implored her to go, realizing that her charm and role as a foil was vital to his act. "There was still time to return to the hotel and pack your clothes," Bill told her. She remained adamant, and they quarreled up to the last moment. Hattie remained bitter that she was still "background work" in her husband's routine and had never been able to present her musical talent on stage. Bill possessed a much stronger commitment to show business as a career compared to Hattie, who wanted to settle down and raise a family. As a compromise, she finally agreed to join him in a few months. In the meantime, she would stay in Los Angeles with friends and take music and vocal lessons.[1]

Fields, fortunately, had already convinced his nineteen-year-old brother, Walter, to accompany him. Taller, burlier, and much heavier than his brother, Walter was then working as a laborer. As the older brother, Bill watched over Walter and offered him advice over the years. Fields felt he lacked ambition to better himself. "You have spent half your life sitting at the open window snapping your fingers and watching the car go by," Bill once wrote. "For goodness sake, get up and better yourself...You've got to get out and hustle." The advice came from an entertainer who worked diligently alone to improve his stage skills, an experience that caused Fields to strongly believe in self-help. As for Walter, he was devoted to his brother and following Bill changed his last name to Fields. We "didn't think W. C. was the funny guy in the family," said Fields's sister Dell. "They thought it was his brother Walter."[2]

Walter cared for the props, especially the pool table that weighed three hundred pounds. "I have this pool table," his brother told him, "I will show you what to do, take it apart and put it together." To transport the table, it was broken up into sections and packed into three trunks. "The top came

off and the two sides and two ends came off and the legs came off," Walter recounted. "With fourteen pieces of luggage containing other props, makeup, and costumes, it was a chore to move from town to town."[3]

When the *S. S. Sonoma* left on May 15, Hattie stood on the dock and waved until she no longer saw her husband waving on deck. Bill and Walter were so seasick the first two days that they stayed in their bunks in their first-class cabins paid for by their Australian manager. Compared to the large steamships routed to Europe, the 100-passenger 6,279 ton vessel, built in 1900, was small with tiny cabins. "The few ships that traverse the 6000 miles of turbulent water are antiquated and none too seaworthy," Fields wrote. "Many a stormy night I never expected to stand before another audience."[4] The numerous rough-looking Australian sheep and cattle ranchers on board looked to him like Wild West cowboys or characters from an Alexander Dumas novel. Before the boat made its first stop in Honolulu, Fields spent time reading the books Hattie had bought. Walter, who had minimal schooling, practiced learning to write by copying pages from his brother's books. His good looks caught the attention of ladies on the boat, including a Countess who lured him to her cabin.

As the ship reached the outskirts of Honolulu, native Polynesians dived off outriggers into the ocean seeking coins that the passengers threw into the water, a customary ritual. After years of friction between the island's monarchy and the powerful land-owning American fruit companies, Hawaii had recently been established as a US territory in 1900. In Honolulu, Bill posted a typed letter to Hattie with numerous spelling and typing errors. "Dear Fropper, Good Wife," he began. "It is very hot, when you come prepare for a hot journey, and bring plenty of clothes with you, and plenty of light ones, that is light in weight." He thanked her for the books calling her "a thoughtful wuf." "I shall buy you a post card at Honolulu, and myby a souvenir spoon. Will close with love and smacks from Sarded Sod" (a British expression meaning bugger or rascal) and with baby talk "Fieldsie weelsie boysie goo goo."[5]

After stops in Pago Pago and Auckland, Bill and Walter disembarked in Sydney feeling exhausted from the long trip but excited about arriving in Australia. They took a train to Melbourne in time to open at the New Grand Opera House on June 15. The theater was among the numerous venues operated by Harry Rickards, an influential impresario whose Tivoli Circuit dominated Australian vaudeville. An engine-driver's son from East London, Rickards's life was a rags-to-riches story. A colorful debonair and dapper gentleman with a stirring baritone voice, Rickards gained fame as a comic character singer, a *lion comique*, portraying a suave swell in British

music halls. In 1892, Rickards moved to Sydney where he recognized the need for vaudeville venues in major Australian cities that were undergoing a population boom. Initially composed of six separate colonies, Australia had become a new commonwealth officially on January 1, 1901. With an economy dominated by huge sheep and cattle stations owned by wealthy landlords, the continent was a leading worldwide exporter of wool and meat. When Fields arrived, the country was recovering from a severe ten-year drought from 1892 to 1901 that had caused a 50 percent decline in the number of sheep and a depressed export market. During this time a large number of sheep and cattle drovers found work in the cities, which also attracted settlers from Great Britain. Once the drought ended, prosperity returned to the country. In 1903, both Sydney and Melbourne were inhabited by half a million people eager for vaudeville entertainment.

Known as the king of Australian vaudeville, Rickards gobbled up theaters with the goal of importing the world's finest talent. He made annual trips to the United States and Europe to scout for performers who might appeal to Australia's "most critical and distracting" audiences. He had learned from experience that artists who were popular in England might "meet with chilling indifference in the Land of the Southern Cross." "The Australian people will have nothing but the very best," Rickards asserted.[6]

On the lookout for US performers, Rickards was completely overwhelmed when he caught Fields's act at the Hippodrome and immediately offered him a twenty-week contract to join his new traveling show called the Tivoli Vaudeville and Specialty Combination. Besides Melbourne's New Grand Opera House, Fields performed at Rickards's New Tivoli theaters in Sydney and Adelaide. Fields held a lifelong suspicion of showbiz moguls, but Rickards was among the few higher ups, including Martin Beck and William Morris, who played major roles in promoting his vaudeville career.

Fields juggled with hats, sticks, balls, and cigar boxes as well as performed his pool table act. Billed as an eccentric juggler, Fields entered the stage wearing his outfit from the Hippodrome, a shabby fur coat, military-style hat, large dark goggles over his eyes, black whiskers on his face, string tie on a dress shirt, and a whip in his hand. Charles Waller, a popular Australian magician, wrote in his memoirs that Fields wore white gloves on his hands that he slowly removed one finger at a time. "As he did this," Waller wrote, "each finger emitted a funny noise of its own—one squeaked, another whistled, a third groaned, while the removal of the last brought forth the clang of a cow bell." As he juggled tennis balls, one would fall to

the floor and "he would horsewhip it." Waller noted that Fields added a new comic twist to his repertoire: "He discovered with concern that a leg squeaked when he moved. So, producing an oil can, he oiled his knee. A little experimental dance showed that all was right again."[7]

Placed between a character comedian and a hometown popular comic in the program's second half, Fields felt the audience might not respond to his subtle humor after seeing a minstrel show in the first part. But as soon as he arrived on stage the audience burst out laughing at his costume. "Expecting that he would prove merely one of the weak imitators of Cinquevilli, the audience, at the outset, was preparing to despise Mr. Fields, but he was on stage only a few seconds when it changed its mind." The critic called Fields "an instinctive humorist" and his act "a highly amusing turn of a distinctively original type." Although he was mostly silent during his performance his remarks when he made a mistake caused so much laughter that one wondered if the "error was not intentional." The reviewer noted that Fields drew the spectators' interest by "all the time standing in a comically pathetic attitude."[8]

His biggest hit was his pool table routine, especially his trick of pocketing all the balls with one stroke that sent "the audience into a fit of admiration." "The balls were wooden balls with little holes in it, with a little screw eye," Walter recalled. To disguise the trick, he tied a green string that matched the felt's color to the screw eyes of every ball so that they were connected to each other. "I use to cut the string with a knife at the back of the table, so the balls would go in the correct pocket after I had cut it." Above the table was placed a mirror so that the entire audience could view the trick. In Adelaide where he was the headliner, his pool table act was given considerable publicity. An ad in the *Adelaide Advertiser* called it "Marvelous. Simply a Revelation. Lovers of billiards should all see it." "He made an India rubber ball perform wonderful antics in obedience to his cue," wrote the critic in the *Adelaide Register*. Over time, his pool table act became a major feature of his repertoire on the stage. The routine likewise formed the centerpiece of his first commercial silent short, *Pool Sharks* (1915), followed by numerous other films, and two years before his death in *Follow the Boys* (1944).[9]

A few days after arriving in Australia, Bill sent Hattie a first-class prepaid ticket for the crossing. She departed on July 16 on the *S. S. Sonoma* and arrived three weeks later to join the act in Sydney. Fields went to the terminal to meet her. Hattie recalled that he "leaped from the dock to the boat to greet her." In Sydney they performed at Rickards's new Tivoli Theatre (1900). Confident that his pool table act would go smoothly with

Hattie's assistance, Bill drew a rousing reception from the spectators who cheered in appreciation. Reviewers commented on Hattie's coquettishness, white satin breeches, and perfectly fitting panties. "She is calculated to fill the eye and thrill the heart" and "helps materially in the decided success of the act." Near the end of his two-month run in Sydney, Fields had gained so much popularity that he was headlining the program's variety section.[10]

Two future famous American comedians and cultural icons—Fields and Will Rogers—first crossed paths in Sydney during September 1903. Fields incorrectly wrote that he initially encountered Rogers in Durban, South Africa. He saw a young man outside a corral full of mules "swinging a lariat and chewing gum. This young man was Will Rogers." He was delivering a boatload of livestock from South America to a wealthy Natal landowner. But that was in late 1902, and he left the country for Australia on August 9, 1903, well before Fields arrived. Known as the "Cherokee Kid," he had performed a lassoing act in South Africa with Texas Jack's Wild West Show. The only time their itineraries matched was during fall 1903 when they were both in Sydney where Rogers was about to join the Wirth Brothers' Circus in Australia. Fields partially corrected himself when he later recalled that Will "went to Australia in 1903, where I first met Rogers when he was doing a roping act with Fitzgerald [Wirth] Brothers Circuit [Circus]." No record of their conversation unfortunately exists. After meeting again on the vaudeville trail, the cowboy philosopher and the eccentric juggler next rendezvoused during the 1916 *Follies*.[11]

Fields took time off to go the Benjamin Falk Studio for some publicity photographs. Standing before a professional cameraman for a formal photograph, Bill wore a dapper three-piece tailored suit with a watch chain hanging from his vest. Fields appears as a confident business man rather than a vaudevillian. With his hair slicked down and parted in the middle, the twenty-four-year-old looks dashingly debonair. The photograph appeared on the front cover of the *New York Dramatic Mirror*, a leading theatrical weekly on May 7, 1904. Its publication was a publicity coup, given he had been in vaudeville for only four years. Although someone (possibly William Morris) used their influence to get it published, the photograph indicates Fields's interest in publicity to forge a showbiz career.

Another photograph depicts Fields in dressier attire looking handsome, dapper, self-assured, and contented. He appears like a successful man of the world, a burgeoning international vaudeville headliner, who is ready for greater achievements. Among his numerous early photographs, this

**Figure 9.1**   W. C. Fields in Sydney, Australia, ca. July–September 1903. Courtesy W. C. Fields Productions, Inc., www.wcfields.com.

rarely seen portrait best captures his determination to reach the zenith of his profession.

Fields eventually felt at home in Australia and made friends with the country's vaudevillians. During the day when there was no matinee, he and Hattie went to the city's sparkling beaches with fellow performers. Several times the couple attended the horse races, a popular sport in the country. Fields learned how to throw a boomerang, a curved throwing stick indigenous to the native population. Friends came to Sydney's rail station to bid farewell to them as they left for Melbourne to perform another engagement. "The handshaking, hurrahs, and waving of hats and handkerchiefs as the train sped away, must have been very gratifying to Mr. and Mrs. Fields," wrote a reporter. "Mr. Fields is the greatest drawing card Mr. Rickards has had for years."[12]

Their stay in Australia was not without incidents. Fields became extremely agitated if anyone made a negative remark about Hattie or if he

thought someone was flirting with her. One story reported that Fields saw the grandson of Lord Byron talk to her at a Sydney racetrack. He promptly hit him with his heavy gold-handled cane, which he habitually carried for self-defense. Another time three cockneys made rude comments about Hattie. Bill and Walter proceeded to fight with them and severely beat up one aggressor who carried a blackjack.

While in Australia Fields gave interviews that greatly fabricated his youthful escapades. He related a tale about his train trip out West when he was held up by Indians and robbers. Another stated that he was "a good revolver shot and a capital horseman; his favorite hobby is to mount his fiery mustang, Fluke, and ride hot-hoof over the trackless prairie into the sunset."[13] Fields felt that there was nothing wrong with tongue-in-cheek exaggeration. Making his early life more adventurous made good copy for reporters anxious for a spicy story.

The day before their departure to South Africa, Hattie visited a milliner's shop on fashionable Collins Street, where numerous retail shops were located especially in the Block Arcade. "Doing the Block" was a favorite activity for wealthy Aussies, who were always smartly dressed in the latest fashion. As she was leaving the shop dressed in a skirt, two Australian ladies laughed at her appearance. Hattie walked up to them and in a "slow drawl" admonished them: "I guess you women are losing time round here laughing at ladies. You should be further down, where the gentlemen are; it would be a sight better for your purses." "You call yourself a lady?" said one of the women who laughed out loud. "I guess I do," Hattie replied, "and I'm very sorry for you folks, who can never know what a delicious feeling it is."[14]

On November 11, Bill, Hattie, and Walter boarded the *S.S. Commonwealth*, a new twin-screw steamer, headed for South Africa. Petrified of long ocean trips, Hattie boarded the vessel with trepidation questioning why she had joined her husband in the first place. Fields left knowing that his Australian tour was a success. As for the country, he later wrote that he "found the people very backward ... The poorest cities in America have much finer, more up-to-date stores."[15]

The 6,300-mile voyage across the Indian Ocean to South Africa seemed endless. The frequent storms tossed the boat side to side and slowed its speed. "Many a stormy night I never expected to stand before an audience," recalled Fields.[16] They were heading to a country recently devastated by the second Boer War (1899) between the British and Afrikaners, descendants of the Dutch Settlers. The war formally ended on May 31, 1902, approximately eighteen months before Fields arrived.

After thirty-three grueling days and nearly a week late, the ship arrived in Durban on the southeastern coast of the British colony of Natal. To avoid substantial port duties levied on passengers, the three voyagers boarded a small boat. According to Fields, they next climbed into an eight-foot high wicker basket supported by a cable that landed them on shore with a thud so hard that Walter's large 165-pound body nearly fell on top of his brother's slight 123-pound frame. "I felt like a rubber ball," Bill recalled.[17]

They were immediately mobbed by a crowd of Zulu rickshaw drivers yelling "Me Jim Fish," the legendary name of the fastest driver in Natal. Although the Zulus outnumbered the colonists in Natal, they were subjected to discrimination and white control by both the British and Afrikaners. Once a powerful chiefdom, Zululand was incorporated into the colony in 1897. After their farms and villages were burned by the British during the war, they sought refuge in the cities where they worked as laborers for low wages in menial jobs. Typical of most foreigners at this time, Fields found the Zulu's dress and adornments bizarre rather than expressive of a unique rich culture noted for their decorative arts, handicrafts, beadwork, animal-hide clothing, jewelry, and hairstyles. They wear "weird makeup," he remarked, "legs and bodies covered with various designs in whitewash, horns adorning their heads and bone handkerchiefs or scrapers hung in their ears."[18]

To get to their hotel, the Fields's party sat on a seat atop two large wheels as the kaffir holding two poles in his hands ran barefoot along the road. Since it was nearly summer the drive to the city over dusty, bumpy roads was hot, and large pesky mosquitoes kept biting Fields, who was bathed in sweat when the party reached the Royal Marine Hotel. Even the mosquito netting over their beds failed to stop the biting.

Compared to Sydney and Melbourne, Durban looked like a frontier town with mainly wagons and rickshaws on its unpaved streets. Fields soon learned that the Tivoli Empire Theatre in Johannesburg, where he was scheduled to open on December 14, had been damaged by a fire but would soon reopen. More problematic was getting to Johannesburg via train since a citizenship card was required to buy a ticket and the government limited travel to the Transvaal. Since he had a play-or-pay contract that stipulated if he did not show up he would have to forfeit his salary, it was imperative that he obtain a pass.

In typical Fields's fashion, he later concocted two different stories about how he connived to get to Johannesburg. One involved encountering in the local railroad station a small humpbacked candy and magazine train salesman who he had met while traveling by rail on the Pacific Coast Orpheum

Circuit. A Dutch South African, he agreed to loan Fields his citizenship card that allowed him to purchase train tickets. A second tale concerned an attempt to get a pass from the American consul who told him that that if granted it would take five to six weeks to obtain the document. Then he and Walter, faking British accents, convinced the English consul to give them a pass.

Having finally obtained train passes for the 322-mile trip, the three arrived in Johannesburg. Then a wild mining town where liquor flowed and prostitution thrived, it claimed 312 bars and hotels, 3 social clubs, numerous sports clubs, and 4 theaters. The discovery of gold in the Witwatersrand in 1886 had brought hordes of immigrants from Australia, Europe, the United States, and many others. By 1896, Johannesburg was the largest city in South Africa.

After checking into their hotel, Fields met the manager of the Empire Theatre. He "was surprised to see me," recalled Fields. "I think he had given orders to keep me out of town until the Empire opened. The manager obtained an engagement at the Standard Theatre for four nights where the audience was composed of tough-looking Boers with thick beards and carrying double-barrel shot guns. Fields quickly learned that Johannesburg was a rough town and dangerous at night with its mixed population of British and Afrikaners still tense from the war. "You must also be on the alert lest you get smitten on the brain with a piece of hardware after a certain hour at night." he wrote fellow juggler O. K. Sato. "The country is full of crooks and what a field they have! At eleven they close this town up, and the cops go to sleep lest they interfere with the night workers."[19]

"His performance is one that must not be missed," wrote a reporter after attending the December 18 opening at the newly decorated Empire Theatre.[20] During every performance he wowed the audience with his juggling tricks and pool table routine, received a standing ovation, and performed encores. Dressed in a well-tailored suit and vest and his right hand protected with a glove that held his gold-headed cane, Fields had his photograph taken before a huge billboard about three times his height and which highlighted his name as an eccentric juggler. The sign was attached to a horse-led wagon and driven through the city.

Fields did not face much competition for the top spot on the playbill. Compared to England and Australia, managers in South Africa had a difficult time booking top American troupers because of the long voyage that caused them to lose weeks of salary. The best vaudeville theaters were controlled by one organization, the Tivoli Company, headed by the Hyman

brothers, Sydney and Edgar. To lure the best talent, Sydney made trips to the United States and established connections with music halls in England. He also hired Robert Girard, a top international agent, to establish regular exchanges of vaudeville acts between the United States, England, and South Africa. The global circuit gave entertainers, like Fields, more than a years' work performing in three English-speaking countries. The Hyman organization not only paid for transportation to South Africa but also offered higher salaries to lure performers. The famous strongman Eugene Sandow, for example, who also appeared at the Empire in Johannesburg in 1904, earned in six weeks $20,000 in gold coins plus a percentage of the box-office receipts. Fields, who lacked Sandow's worldwide fame, received approximately $300 a week.

During his first week Fields had an argument with the manager who demanded preshow rehearsals before every performance. Accustomed to only one weekly rehearsal, Fields felt numerous tryouts were useless and decided to skip them. The manager was so annoyed that he told Fields to go on last at 11:30. Rattled about his late stage time, he made numerous mistakes during his juggling tricks and pool table routine. His act consequently ran overtime, thirty-one minutes rather than twenty-two minutes, and when he finished he received a chorus of boos. The manager was furious. When Fields learned that he performed one minute after midnight, he told the manager that his contract stipulated that he would receive a $300 bonus if he worked after midnight. Fields demanded his correct salary. Ranting and raving, the manager threw $300 at his feet. Fields warned the manager not to put him on last ever again.

The British High Commissioner of South Africa, Viscount Alfred Milner, saw Fields's act at the Empire and was so impressed that he received an invitation to perform at his house. Milner was not only the area's most prominent statesman and colonial administrator but also a British imperialist, who staunchly believed in white Anglo-Saxon supremacy. He played an instrumental role in supporting the Boer War when the Afrikaners refused to give British citizens equal rights in the Transvaal.

Bill stood outside the house in the pouring rain with his cigar boxes, golf clubs, and rubber balls, while numerous footmen debated whether he could enter. After twenty minutes a drenched Fields entered the house where he entertained the children for thirty minutes. "I had a running refrain of 'Wot's 'E Do That For?' to help me along and the cunning little tykes were only too willing whenever I purposely dropped a prop in the mistaken notion I was planting an effect, to pick it up and gum my trick for me." He repeated his performance when Milner arrived but the

children again messed up his tricks. "When it was all over, I was allowed to go out in the rain again and without a fine or anything."[21]

In a letter to her mother from Johannesburg, Hattie wrote that her husband performed before the commissioner and invited guests in Milner's private drawing room and "made the biggest hit he ever made." Hattie was too ill to attend because she was three month's pregnant with a baby conceived in Australia. "I am still in the same poor health and can't do or think anything else but throwing up," she wrote. News of an expected baby brought Bill closer than ever to Hattie. "I coaxed Claude to let me stay home and since I have been ill, there isn't anything he won't do for me or let me do," she wrote her mother. "He is too good I think sometimes, as everyone tells me he spoils me."[22]

Bill's next engagement was in Cape Town for six weeks at the Tivoli Palace of Varieties. "Maybe the change of climate will do me good," Hattie wrote her mother.[23] Compared to the current wet season in Johannesburg, Cape Town's weather was mild and dry. The long and bumpy 779-mile train trip caused Hattie to become extremely nauseous. The picturesque city was beautifully located at the northern tip of Cape Peninsula and at the base of Table Mountain. Fields admired the city's dramatic setting especially when the southeast winds blew clouds over Table Mountain.

As the headliner, the Tivoli publicized him on a poster as "America's Greatest Burlesque Juggler in a New and Novel Performance." The theater's atmosphere was staid compared to a rowdy concert saloon. The venue banned smoking and alcohol and only served light refreshments. On February 17, Fields appeared in the tenth spot as part of a thirteen-act playbill, which featured numerous comedians including the comic monologist R. G. Knowles, who became a friend of Fields. As Hattie's replacement, Walter had gotten better at pulling the strings under the table that sent the balls scampering into every pocket. The heterogeneous audience composed of British theatergoers and a range of gold-seeking *uitlanders* (foreigners) represented a challenge to Fields. He was nonetheless a big hit. The children at the Saturday afternoon family matinee especially enjoyed him. Ida Patsy Smith, the press agent for the Hyman organization and *Clipper* correspondent, described his appearance. He had "blond hair, a round face, and slender legs, and weighed between 125–130 pounds."[24]

Fields's trip to South Africa had its difficulties. The summer heat became unbearable. From Cape Town, he wrote O. K. Sato warning him about the high cost of living. "Fairly good hotels will cost you one pound per day; rotten ones will cost you four pounds per week." Consumer goods were "ten times as much as you pay for the same article in civilization."

Seasonal watermelons cost two dollars each. Since the country grew few staples food needed to be imported. Fields felt all the cooking tasted the same. "By the time it arrives here the aroma is estimated to be about sixty-two horsepower."[25]

The letter to Sato caused quite a stir when published in the *New York Clipper*. Fields's negative comments caused the paper's South African correspondent to defend his country. He felt the comedian was joking. During the time he spent with Fields and his wife, he had never heard any complaints. Hotels, he wrote, which catered to vaudevillians have good food and private baths, cost three pounds a week (about fifteen dollars) and many vaudevillians can also rent rooms where they do their own cooking. Fearing that his letter would give American vaudevillians a bad impression of South Africa, the correspondent wrote: "I can assure you Americans are very much in favor in this country, that performers are treated very well by the various managements out here."[26]

Although written in typical Fields's tongue-in-cheek exaggeration, his letter to Sato contained a degree of truth. South Africa at the time was a country devastated by the Boer War. During the conflict British soldiers mounted a "scorched earth" policy that burned many Afrikaner farms and killed their livestock. Both sides experienced massive loss of lives and casualties. Even the *Clipper* correspondent warned performers not to expect the same comforts as in England or America. South Africa is a "new country, where traveling is so expensive, rents high, and the country in general so barren of vegetation."[27] Thus Fields saw a country that was in the throes of chaotic reconstruction. Segregated black Africans lived in squalid communities where sanitation was poor and disease rampant. A month after Fields left Johannesburg, the city was hit by an outbreak of bubonic plague. After a three-month stay, Fields was glad to leave behind the conditions in South Africa.

Their next stop was England where he had six months of engagements scheduled. Nearly five months' pregnant and prone to sea sickness, Hattie dreaded the sixteen-day voyage up the western coastlines of the entire African and European continent. "I am all prepared for another spell of sickness," she wrote her mother.[28] The three were happy when the boat finally arrived, especially Fields who felt a special kinship to his family's native country.

During a return multi-week engagement at London's Hippodrome starting in early April, he was warmly received by audiences and critics. "His facial by-play and the expression of his feelings by weird noises are irresistibly funny," wrote a reviewer. His pool table stunt was the big hit

and the nonchalant way he pocketed all the balls in one stroke overshadowed the fact it was a hoax. "When the white ball hits the red ones they all vanish into the pockets like lightning," a reporter observed. "A trick? Undoubtedly. But how is it done?" An innate trickster, Fields loved conning the spectators. Later on the Broadway stage and the screen he slipped into the role of the sly confidence man with ease. The character fit him to a T.[29]

At the Hippodrome during Easter week he found the playbill a rude awakening. Accustomed to being the headliner in Australia and South Africa, he was now back at a famous London variety theater where he had to play second string to top vaudeville acts. As the headliner, the strongman Eugene Sandow gave a lecture on physical culture, lifted heavy dumbbells, and elevated numerous heavy objects. Also on the program was the Great Houdini, then a rising star known for his escape artist feats such as unlocking himself from handcuffs and leg irons within minutes.

Sandow and Houdini were hard acts to follow but Fields held his own. He earned a good review in *The Era*, London's leading theatrical weekly: "It is hard to say which we admire the most, his remarkable skill or his irresistible drollery." His picture also appeared on the front cover of the *Hippodrome* magazine looking extremely dapper and handsome with his blond hair combed in the middle. The cover story entitled "Comedy Billiardist" hailed his skill "pocketing no less than fifteen balls in one stroke, the fantastic way he handles the cue, and his little bits of humour intervening all the while."[30]

The reviews were extremely significant because they emphasize the amount of comedy Fields is now exhibiting on stage. He is combining two elements mentioned by *The Era* critic —"remarkable skill and irresistible drollery."[31] Fields is beginning to transform his act by including humor in almost every manipulation and maneuver he makes on stage. In short, the spectators at the Hippodrome are witnessing the birth of a comedian.

# 10. The Trouper on the Flying Trapeze ✑

With Hattie now six months pregnant, they had to decide where they wanted the baby to be born. Already committed to engagements in England until the end of the year, Bill wanted Hattie to remain with him. "Why not stay in London and have the baby, or in Germany?" he asked. But Hattie wanted the baby to be born on American soil for purposes of citizenship and better care. "No, I would rather go home to mother," she said. Her mother, who lived in New York, could help her when the child was born. If Hattie stayed, she would have to reside in London as Bill toured the provinces. If her husband went with her, he would have to break his contracts and hope to find engagements in the United States. Bill tried to convince her but again Hattie's strong will won out, and on April 29, she boarded the *Deutschland* bound for New York. Busy entertaining, Fields sent her a telegram wishing her "bon voyage."[1]

In June, Fields began to tour the provinces mainly performing at top-notch music halls belonging to the Moss's Empires Circuit, the most prestigious chain in Great Britain. From June to October he mainly did one-week engagements traveling as far north as Edinburgh and Glasgow, Scotland; as far west as Cardiff, Wales; and as far east as Hull. There were performances in the London suburbs and multi-week stops in Liverpool and Manchester. In the latter city a reporter described Fields offstage as a "slim young man with yellowish hair. He wears a daring flat-brimmed billycock hat."[2] The exhausting merry-go-round itinerary commenced with Monday afternoon rehearsal and concluded with two nightly shows on Saturday; the following day Fields traveled to the next engagement in time for the Monday tryout again.

Unless a music hall favorite was on the playbill, he was often the headline act. "Marie Loftus is on the bill with me this week she is toping over me," Fields wrote to Hattie from Nottingham where he was appearing at the Empire Palace with the famous elegantly dressed singer, pantomimic,

and leading lady, known as "The Sarah Bernhardt of the Music Halls." He watched her perform from the wings singing her signature song, "To Err is Human to Forgive, Divine." Fields was well received everywhere, but it was impossible to top a beloved British music-hall star such as Loftus. The review in *The Era* devoted all its space to praising her while Fields was never mentioned. At his next stop in Leicester, Marie Loftus was again on the playbill but this time *The Era* mentioned Fields's "enjoyable juggling." In mid-August Fields shared the playbill with the British stage star Lillie Langtry at Oswald Stoll's 1,638-seat newly built (1903) Empire Palace in Shepherd's Bush, a west London suburb. After gaining fame in the legitimate theater, "Jersey Lillie" (born on the Channel Island of Jersey) began playing comedy and dramatic sketches in music halls and American vaudeville houses. At the end of August, Fields appeared at the Empire (1901) in Holloway, a northern London suburb with Bransby Williams, "The Hamlet of the Halls." Fields intently watched his clever impersonations of Dickens's characters—an act he greatly admired because of his own fondness for the English novelist.[3]

Fields ended his engagement in England by appearing in the newly built lavish Empire theaters in the London suburbs. Among them was the 3,000-seat venue in New Cross (1899), situated in southeastern London. These turn-of-the-twentieth-century spacious theaters with luxurious interiors signified that the old-time smoky music halls with drinking in the auditorium were slowly disappearing. The lavish suburban London theaters designed by Frank Matcham, England's most prolific theater architect, had regular fixed seating and the bars were placed in the rear separate from the auditorium. The new venues were being called variety theaters rather than music halls to make them distinct from the latter. Instead of catering primarily to a male audience, the theaters were built to attract a wider audience, especially families. The new entertainment providers such as Stoll and Moss insisted that their shows be respectable and free from vulgarity. They used the terms "palace," "empire," and "coliseum," to describe their theaters' ambience. Fields fit in perfectly with the goals of the owners since his juggling act appealed to both children and their parents. As a silent humorist, he never delivered risqué gags and one-liners. These attributes made Fields a prime attraction for the classy variety theaters arising in London and its environs as well as in provincial capitals.

Bill kept in touch with Hattie, who was now living with her mother in New York on West 27th Street. From Birmingham he sent a telegram congratulating her on her twenty-sixth birthday on June 7 wishing her "many happy returns." As the baby's expected date neared, Fields grew

increasingly excited. On July 9 he sent his wife a postcard depicting a father holding a baby and added the following: "Papa," said the baby; "Yes dear," said the father. "Just about what I would say aint it. Hat. Eh. Love, Sod." Hattie also gave her husband a new nickname "I started at first to call him Father and then to make it more babylike I called him Sarter, and he called me Hunky-Punky for a while."[4]

By a twist of fate Fields was performing at the Empire Palace in Sheffield, where his father and grandfather had lived, when he received a telegram on July 29 from Kitty, Hattie's sister, that a baby boy was born on July 28. He immediately dispatched a telegram to Hattie: "HURRAH FOR BRICKET [one of her nicknames] GET WELL SOON HAVE KITTIE WRITE LETTER EXPLAIN-ING ALL LOVE KISSES. SOD." After receiving Kitty's cable he was "speechless for about two hours." He had always wanted a boy and soon learned that he was named William Claude Fields Jr. after his father. "Ain't it great Hat?" he wrote. Before the show he went to a pub with cast members who toasted the new arrival. Fields was so ecstatic that he was "next to the worst thing that ever went on the stage."[5]

The next day after receiving the news he wrote an affectionate letter to Hattie hoping she was well and urging her to remain in bed and not to discharge the doctor or nurse. He wanted to see his son as soon as possible. "Bring him over until I kick the stuffing out of him." He promised to send fifty dollars for baby clothes. "Will close now with lots of love & Kisses & quick recovery to health & strength. Sod."[6] The letter was the most tender he would ever write Hattie.

Hattie soon traveled to Philadelphia to show off the baby to her in-laws. Jim and Kate were overjoyed to see Claude, as he was called, who was their first grandchild. Being summer, the family went with Hattie and Claude to Atlantic City for a vacation to spend time in the surf. On September 8 Bill wrote Hattie to buy "the old gent" a second-class ticket to get "a peep at Merry England" while he was still touring the music halls. Jim had always wanted to visit the "old country" where he was born. "Now Hat git him off as soon as possible by the next steamer as he is getting cold feet."[7]

Mixed motives were behind Fields's invitation. The offer was certainly a generous gesture, but he undoubtedly wanted to show his father how successful he had become. Although Jim at age sixty-three was still eking out a living in the produce business and would not retire until 1910, Fields contributed to the family finances by occasionally sending money home. The arrival of Jim's first grandchild reduced some tensions between Bill and his father. Both father and son were strong-willed personalities, who still held grudges from the past. Bill warned Hattie that "he may be an

incumbrance [sic] to you rather than instead of assisting you, so git him off and we will be through with his trip."[8]

When Hattie wrote back that she could not leave until October, he encouraged her to remain in America. He was uncertain how long he would stay now that "my old English cold is back again and having all kinds of fun with me." The overcast skies, fog, and dampness made London "truly rotten," he wrote Harriet. "I am expectorating large black gobs every morning that would make those jelly fish we saw in the Paramatta river look like fly specks." Fields had gone to an English doctor who encouraged him to go to a warmer climate since staying in rainy England with a continual cold could affect his lungs. He reminded Hattie of their first time in Berlin when a German doctor told him he had consumption. "Eat raw wine," the doctor said, "or you'll die." "Nobody thought he was going to live very long in the early days," recalled Hattie.[9]

Fields changed his mind about postponing his wife's trip. "I am dead anxious to see him," he wrote. Hattie thought that the baby resembled her husband. "I am more than pleased that the baby takes after me in Nose and DOCKIE [?]," he replied. "I am waiting anxiously to get a photo of him, he must be a pippin." Bill's entreaties convinced Hattie to bring their nearly three-month-old infant to England and take Jim along with his wife. "Keep track of the fights he has," Bill wrote Hattie. Kate, a homebody, had no desire to travel so the three sailed without Jim's wife on the *S. S. Kaiser Wilhelm II* in October.[10]

When they arrived, a surprised Fields was overjoyed to see his wife and infant son. A proud father, Fields could not keep his eyes off Claude and cuddled him in his arms. Soon they were off to Paris where Fields had multi-week engagements to perform at the Folies-Bergère and the Olympia, the city's oldest hall famous for its extravagant revues and other attractions. Lacking early support for his juggling from his father, Bill wanted desperately to show him his success. The moment came as Jim stood in front of the Folies-Bergère and spotted his son's name highlighted on a billboard. A cold and distant figure, Jim rarely displayed emotion. But Fields could tell by the way his father stared at his name and smiled that Jim was proud of his son's achievement.

Fields showed his father the sights of Paris by horse-drawn carriage. Photographs depict Fields and his father seated comfortably in the backseat of a Parisian carriage smoking cigars. Another shows Bill standing up in the carriage before his seated father and looking extremely confident as if he had conquered the world. The scene contrasted with the time Bill and Jim sold produce on a wagon pulled by White Swan. Now they were being chauffeured

**Figure 10.1**   Fields showing his father the sights of Paris. Standing upright is Fields. Seated is his father smoking a cigar opposite an unidentified man. November 1904. Courtesy W. C. Fields Productions, Inc., www.wcfields.com.

around Paris by a coachman and his sleek horse. The comparison illustrates the long, hard trail Fields had travelled from the clubs in Philadelphia to the Folies-Bergère, among the most famous theaters in the world.

After Bill performed in Marseilles and Milan (headlined as a "*Straordinaro Successo*" eccentric juggler), the family returned to England in time for Fields to perform in the *Cinderella* pantomime in Manchester at the Prince's Theatre. As mentioned earlier, the Christmastime panto-mime shows were an English tradition. Fields played the part of Freake, an attendant at the palace, a nonspeaking role in two scenes designed to show off his specialties. In "the Billiard Room of the Palace," he did pool table tricks in his tramp costume, and in the other he juggled hats using pantomimic gestures that amused the audience and drew rave reviews. He also appeared in the third act playing an eccentric bartender. Designed to appeal to families over the Christmas holidays, the show drew parents and their children. The latter especially delighted in Fields's funny antics and giggled during his routine.

During the show's run of the show until early February, Fields's family was beset with health problems. Manchester, a large industrial polluted city, was a miserable place in winter. A permanent pall of black smoke hung over the city causing numerous respiratory and other industrial-related diseases.

The conditions of the working class, who worked long hours and resided in poor housing, seemed similar to the time Friedrich Engels exposed the city's squalor in his classic *The Conditions of the Working Class in England in 1844.* With an average temperature of forty degrees, the weather was exceptionally dreary, cold, and wet in January. The raw climate caused Hattie to develop a painful bout of rheumatism, an affliction that her father had battled, causing her to need a crutch and cane in order to walk. Unable to take good care of the baby, she fretted constantly and began to regret coming over to be with her husband.

Stuck primarily in Manchester, Fields's father became restless, grouchy, and temperamental again. With Hattie unable to control his daily whereabouts and Fields busy entertaining, he was becoming increasingly a burden. Except for their jubilant encounter at the Folies Bergère, Fields never mentioned his experience during his father's visit. His silence on the subject could suggest that there was still considerable tension between the two. After nearly three months, their tolerance for each other had ended. Undoubtedly, he had overstayed his welcome and was ready to return home. Fields's disgruntled father promptly boarded a transatlantic steamer in January.

The story handed down by Fields's sister Adele (Dell) was that he was disappointed in his home country because the hours of the drinking pubs were regulated and closed on Sunday. "When our Father saw there was no place he could get a drink on New Year's Eve, he had W. C. put him on the first boat home," she said. Since December 31 that year fell on a Saturday he must have complained about not getting a drink after midnight. Arriving at the family home, he headed for the kitchen without inquiring how everyone was. "What's for dinner?" he asked. When Kate admonished him for not questioning about the family, he replied "I knew you would be okay." "[He] never again raved about England," Dell said.[11]

Faced with obligations to tour the Continent again after *Cinderella* closed, Fields needed to make a decision about Hattie and the baby. She was obviously too sick to travel with him or go home. Hattie decided to reside in Blackpool with friends and where the baths might alleviate her rheumatism. Fields therefore crossed the channel alone and headed for Copenhagen where he had an engagement at the National Scala Theatre, a premier showplace across the street from the famous Tivoli Gardens. Fields received considerable publicity including a tramp silhouette covered with photos of his act on the back cover of the Scala's magazine.

"It was in Copenhagen that I had one of my funniest experiences," he recalled. On an unusual bad night he failed eight times to kick a hat from

his foot to a cane balanced on his chin. Frustrated, he threw the hat in the air and hit it with his cane. "It soared high above the stage, twirled dozens of times, hit the back curtain and bounced right onto a peg in the hat rack placed beside me." The audience went wild and clapped for several minutes. Because of the reception, he decided to add the stunt to his repertoire by rigging a back curtain with a net that snared the hat back stage where an undetected stagehand quickly threw a replica of the hat onto a peg on the hat rack. "It proved a sensation and the act over which I had worked and sweated blood for three years to perfect was supplanted by this simple contrivance." Once again Fields had created a trick based on deception. "Anything for a laugh," he once confessed. "Laughs and applause are all a comedian can hope for, that spells his triumph."[12]

Like other comedians, Fields sometimes hired a group of kids, called claques, to begin the applause whenever a trick failed to amuse the audience. At one performance one boy asked for an autographed photograph instead of money. Handing the photo to the boy, Fields patted him on the head and "told him he'd go far." Years later at a Hollywood party a guest got up and did a trick of his. "Where d'you learn that?" Fields asked. "In Copenhagen when you gave me a photo for clappin' so nice and loud." The guest was the Danish movie star Carl Brisson who appeared in twelve films. "I told him that he'd go far," stated Fields.[13]

From Copenhagen, Fields traveled to Berlin for a return engagement at the Wintergarten. Although he was less nervous compared to his first appearance here, his act did not receive a good reception. "I didn't get a tumble," he recalled. "My act was as good or better. They just didn't like me. Maybe it was because I followed a horse act. Maybe they figured the horse could've done my tricks better."[14]

Field believed his lukewarm reception cost him a two-week engagement in Vienna. The manager of the Vienna theater saw his act and wanted to know how much money he would take to break his contract. The news made him feel miserable as if "it was the end of the world, its hell. Here you think you're king of the roost...and all of a sudden you're frost." W. C. told the manager he would take $500. "For two weeks I suffered as I never suffered before."[15]

Following this misfortune his engagement in Russia in May was cancelled due to massive civil unrest led by striking workers demanding several democratic reforms, which resulted in numerous casualties by Czar Nicholas II's troops. Although the strikes generated a few democratic changes, the massive casualties sparked continual opposition by the Bolsheviks. The 1905 revolt, which prevented Fields's trip, is viewed as a

prelude to the 1917 revolution that overthrew the Czar and brought the Communists to power.

Fields instead went to Hamburg where he appeared at the Hansa Theatre, one of Germany's top variety theaters. According to Fields, he walked into a small venue where he saw a midget on a horse juggle eight balls. At the time he had only mastered six balls and felt intimidated. "Mortified, I hurried from the theatre, and got eight balls," he recalled. "I spent all my waking hours in practice until I had mastered the midget's feat." While in Hamburg, he watched the juggler perform every day. "Unknown to fame, he was a very great artist."[16]

His performance at Madrid's Circo Parish in June generated another tale. At the time Americans were not welcome due to their bitterness about losing the Spanish-American War. The manager consequently tried billing him as an Englishman. But half the crowd saw through the ruse and booed him. According to Fields, this was one of the rare times he was hissed. After a time, the audience recognized Fields's talent, and he received good reviews.

Madrid was the last stop on Fields's tour, and he was eager to return home as soon as possible. While in the city, Bill wrote a letter to Hattie urging her to "be ready to 'git' when I give the 'high sign'."[17] In early July, Bill and Hattie boarded the *Deutschland*, which had first brought them to Europe in 1901. Both were delighted to be home once the liner docked on July 14 in New York.

Fields was looking forward to a new venture in show business. Before leaving Europe, James McIntyre, and Thomas Heath had asked Fields if he wanted to join their new stage show, *The Ham Tree*. As mentioned earlier, Fields had made friends with the blackface team during their long Orpheum tour. The show's producers, Abraham Erlanger and Marc Klaw, initially balked at Fields's salary demand of $275 per week. When their representatives saw him wow audiences in Europe they agreed to his terms. His salary was a bargain for the producers since his vaudeville paycheck was often more than $300 per week.

Fields accepted a cut in salary because he was tired of treading the vaudeville trail and juggling night after night. The grind of traveling from one country to another had become exhausting. He had been away for over two years from May 1903 to July 1905. During that time he had circled the globe hopping from Australia to South Africa and on to England. In addition, he made two round trips from Britain to the Continent and back. He performed in the same theaters multiple times and was nearly running out of new countries and cities where he could entertain. Bitten by

a wanderlust, he loved the adventure of travel and discovering new sights. But after a time he felt he was like the man on the flying trapeze (to borrow a title of his movie), an itinerant trouper swinging back and forth nonstop from one country to another and from one theater to another. To keep his act fresh, he was continually stressed to invent new juggling tricks.

Besides the constant pressure and grind, there existed another problem. Fields thought he was at an impasse in his career, stuck, he said, in "a sort of backwater"—"ticketed and pigeonholed as merely a comedy juggler." *The Ham Tree* promised more than a year's steady work and included a comic speaking part that appealed to Fields. "I wanted to become a real comedian...I jumped at the chance, because it opened the gate into the field I wanted to be."[18]

# 11. The Ham Tree ❧

The show's title, *The Ham Tree*, was derived from a sketch McIntyre and Heath had performed on the stage. Greatly influenced by the minstrel show, the popular veteran song-and-dance blackface team developed comic routines in which they performed caricatures that degraded African Americans through exaggerated dialect and stereotyped portrayals. Heath played the straight man, foil, and fool to McIntyre, the smart-alecky trickster who ridiculed and lampooned his partner. As vaudeville headliners, they performed numerous sketches, the most popular being "The Georgia Minstrels" and "The Man from Montana," which they performed on the Orpheum Show. From their skits they developed Broadway shows using similar formulas: cross-talk between their two caricatures, reworked routines, funny songs, and dancing clogs and jigs. *The Ham Tree*, for instance, was generated from a sketch with the same name.

*The Ham Tree* was produced for audiences who still enjoyed minstrel-type humor. Although the minstrel show's popularity had declined by 1900, it continued to influence stage productions. Given *The Ham Tree*'s successful two-year road tour, there were apparently more than enough people in America's heartland to see racial stereotypes degrading African Americans on stage. Living in the Jim Crow Era (1890–1920), with its widespread segregation, lynching, disenfranchisement, and race riots, numerous whites viewed blacks as inferior and thus never questioned the team's routines. Many theaters where *The Ham Tree* was staged had separate entrances and inferior seating for blacks. A reviewer wrote about McIntyre and Heath: "Their audiences will be composed of those who remember them and want to see them again and those who have heard of them and want to see them for the first time."[1]

Fields had no qualms about joining a minstrel-type production. He had befriended McIntyre and Heath when their acts shared the playbill on the 1901–02 Orpheum Show. As discussed previously, he had once appeared in a blackface minstrel show in Atlantic City. Growing up during the late nineteenth century, Fields inherited the prevalent racial views

of his time. As a youngster in Philadelphia he assumed that blacks lived in separate squalid neighborhoods and worked in poor-paying manual-labor jobs. Fields's contact with black entertainers in the theater and his travels abroad tended to modify his prejudice. But he was unable to completely shed the racial views of his time. Depending on the situation and person, Fields made positive statements about African Americans, but at other times he reverted to bigotry. As a good friend of Bert Williams in the *Ziegfeld Follies,* he made certain that the famous entertainer was a member of Equity, the actors' union. By contrast, he intended initially to create a college for orphans of all races in his will, but, according to an anecdote, he changed the description to read "white orphans" after an argument with an African-American servant. Like so many of his other opinions, his racial views presented a baffling contradiction.

Called a musical vaudeville, *The Ham Tree* featured dancing and singing numbers, a chorus of pretty girls and athletic-looking men, variety turns, and an inane plot that displayed the talents of McIntyre and Heath. Responsible for *The Ham Tree*'s staging and music was Ned Wayburn, one of the foremost choreographers of the twentieth century. A minstrel show devotee early in his career, he had produced the *Minstrel Misses* (1902–03), which presented blackface chorus girls and minstrel-type dances. *The Ham Tree* included musical numbers such as "The Merry Minstrel Band," the finale to the first act, which one reviewer called "brilliant."[2] Another show stopper was "Honey, Love Me All the Time" danced and sung by the Honey Girls and Boys.

*The Ham Tree* primarily showcased McIntyre and Heath. Heath plays Henry (pronounced Hennery) Jones, a pompous "dandy" with shiny clothes and pillowed belly, while McIntyre impersonates Alexander Hambletonian, a livery stable attendant known for his wisecracks. Alexander is a naïve, character with a whiny voice and a victim of Henry's schemes. The smooth-talking Henry convinces the gullible Alexander to join a minstrel show operated by Ernest, the manager of the Georgia Minstrels. Ernest is in love with Tessie, the daughter of a millionaire New Yorker, a minstrel show aficionado. But Tessie's mother, Mrs. Nickelbacker, a society matron (played by Jobyna Howland, a former Gibson Girl) wishes her to marry a stuffy English nobleman called Lord Spotcash.

After the show flops, Henry and Alexander walk hundred of miles carrying props from the show, a trunk, trombone, and bass drum. Alexander regrets he has joined the show and wants to get his job back at the livery stable. A scene in the second act allows McIntyre and Heath to reprise their popular "Ham Tree" sketch that takes place in the woods where a

starving Henry imagines a tree with hams on its branches. Alexander, equally hungry, believes that Henry has lost his mind but goes along with the ruse. Henry tells Alexander that he has seen pretzels grow on vines and Swiss cheese in a swamp located on a river of beer. "How high grows the tree?" Alexander asks Henry. "Oh! About three hundred feet," replies Henry. "Don't get them too high you won't get a ham," warns Alexander.[3]

Fields plays the detective Sherlock Baffles, described as a mysterious "omnipresent knave of mystery." On opening night, Fields suffered stage fright because the play was his first speaking part since burlesque. Adding to his nervousness was that he was given the opening line. Looking at his pedometer Baffles says: "I have walked 986 miles. I am Lieutenant Peary and I'm looking for the North Pole. I'll have to get another job. I think I'll be a detective. I must go and find somebody to detect." During the play he appears intermittently as a comic fool who taunts Lord Spotcash, who disdainfully calls Baffles a "tramp chap." Baffles decides to become a matchmaker, who wants to embarrass Spotcash so that Ernest and Tessie can get engaged. In Act 3, Henry and Alexander impersonate an Indian Rajah and his wife at a party hosted by Mrs. Nicklebacker's at her Fifth Avenue mansion. Fields appears uncomfortably dressed in evening clothes as the Rajah's interpreter. Due to Baffles's efforts, Spotcash finally realizes that Tessie loves Ernest. Left alone on stage in Act 3, Fields does his comic juggling specialty tossing cigar boxes, balls, canes, and hats.[4]

Before opening on Broadway, dress rehearsals for *The Ham Tree* were presented at Rochester's Lyceum Theatre where Fields received a rave review in the *Evening Times* for his acting and juggling: "Fields should be given more to do, more lines to speak and more business," wrote the critic. "He has added a new twist to his juggling act that he did in vaudeville, and it went like wildfire last night." He continued to be praised for his performance when the show opened at the New York Theatre on August 28. The *New York Times* critic wrote that outside of McIntyre and Heath, Fields's role was "especially appreciated."[5]

Having been away two years, Fields must have marveled at the burgeoning Broadway theatrical life. New theaters offering legitimate productions, vaudeville, burlesque, musicals, and revues had suddenly sprung up. Here were located the headquarters of theatrical newspapers, agents, producers, music publishers, costume makers, and scene designers. Restaurants abounded in the district ranging from gilded "lobster palaces" for the affluent to cheaper eateries for actors. Stars could afford luxurious domiciles such as the Hotel Astor while lesser known troupers patronized inexpensive

hotels and boarding houses located on the side streets. Unbeknownst to Fields, Times Square would play a huge role in his stage career.

Reviewers felt Fields stole the show in New York and on the road. His "comic juggling far surpassed in intellectually anything in the way of lines uttered during the entire three hours of the performance," wrote a critic. Another mentioned that "his bearing, his lines and bits of business are all eccentric and laugh compelling."[6]

Fields still used considerable pantomime in his act. While the show played Chicago during the first week of January, Fields wrote a newspaper article, "Confessions of a Tramp Juggler," which called pantomime "a universal language." "One of the beauties of my kind of entertainment is its cosmopolitan character. Everyone admires a dextrous, graceful exhibit that appeals strongly to the eye and when this is accompanied by a good measure of inoffensive buffoonery, the enjoyment is complete." He described juggling as a special stage art "that cannot be written, but must depend on the originality, physical adaptability, and ingenuity of the performer." The article signaled his interest in writing, a pursuit that led later to composing his own stage sketches, film scenarios, and a syndicated column, which reappeared in the book *Fields for President* (1940).[7]

During the show's long road trip, an incident occurred that involved Fields. In Duluth, Minnesota, during March 1907, the local paper reported that he got into a squabble with Rangbal Bergeson, a sixteen-year-old elevator boy who worked at the Hotel Spalding where the cast was staying. The story was headlined to attract readers: "Enraged Men Chase Actors: Ugly Row at Spalding Grows out of Juggler Striking a Bell Boy." The reporter claimed that Fields and Bergeson had become "quite friendly...and had joshed each other in a light way when they happened to meet in the hotel." Before departing for the train with other cast members, Fields asked the youngster to get his suitcase. "All right sweetheart," Bergeson replied. "What's that you said?" questioned Fields angrily. When Bergeson repeated the remark, Fields hit him. The blow led to a brawl between the bell boys and the male cast in *The Ham Tree*. Some local men in the lobby came to the boys' rescue, which caused the cast to escape out the entrance and run to the railroad station where they boarded a train to their next destination.[8]

Fields wrote a letter to the paper explaining the "true version of the affair." The elevator boy "was an utter stranger to me," he wrote. While waiting for his luggage, Bergeson had asked, "What can I do for your sweetness?" "[I] slapped his face with my open hand," Fields claimed. "I did not hurt the boy and had no intention of doing so. I merely wished

to teach him a lesson, and surely any man would resent such a remark." Taking his own suitcase, Fields left the hotel with six bell boys in pursuit, which caused Bill and two chorus members from the show to chase them back to the hotel. "I had no time to fool with bell boys" or to "josh" with them, he wrote. The incident did reveal that Fields was easily provoked by any questioning of his manliness; indeed, he went to great lengths to stress his athleticism and virility during his career.[9]

Fields attained considerable publicity during the two seasons he was with *The Ham Tree*. His photograph was published on the front cover of *Billboard* magazine on February 17, 1906, with the caption "W. C. Fields, The Eccentric Juggler, now with McIntyre and Heath, in the Ham Tree." Dapper and looking self-confident with a tight-lipped smile and hair parted in the middle, Fields appears smartly dressed in a coat, a vest with a chain carrying a medallion, and a tie knotted under a white high-collared shirt. The story claimed that he "is proving himself as an actor" and that the "press notices Mr. Fields has received for his work in this part would fill many volumes." Joining the cast of *The Ham Tree* undoubtedly gave Fields significant acting experience playing the mysterious Sherlock Baffles, which would pay off in the not too distant future.

Another photograph was printed on the front page of the *New York Dramatic Mirror* on October 6, 1906. The author of the cover story gave him kudo: Fields was "doing a very clever bit of character work" and his comic juggling "never fails to bring down the house." To be on the cover page of two major stage periodicals containing favorable reviews was a publicity coup for Fields and boosted his reputation.[10]

The half-body portrait on the front cover of the *Dramatic Mirror* printed nearly eight months later than the *Billboard* photograph reveals an entirely different Fields. He is dressed in a jacket with a bow tie and hair parted on the side, but he glares at the camera defiantly. His wide-open, penetrating eyes produce a troubled, ominous look. His lips are closed without a trace of a smile. Clearly, he is not a happy soul. His ominous expression suggests that something very portentous has occurred. Just what exactly transpired during those eight months is certainly among the most momentous episode in his private life.

# Part IV "What Therefore God Hath Joined Together, Let Not Man Put Asunder" ⌒

# 12.  The Breakup ❧

On July 21, 1905, one week after Fields's arrival in New York from Europe, Maud Fendick and her younger sister Hilda disembarked the Cunard line's *Campania*, a luxurious passenger ship that had once held the Atlantic crossing record. With $300 in her pocket, Maud walked down the gangplank and checked into a New York hotel. A stunning woman with curly dark hair, luminous light gray eyes, and a radiant complexion, Maud was now involved with a married man in a clandestine affair. Infatuated with her beauty, Fields had asked her to join him in the United States. "It is believed that she followed my father and mother to America, when I was about 1 year of age," wrote Claude Jr. in connection with his father's probate trial.[1]

Approximately seven years older than Fields, Maud Emily Fendick was born in 1873 in St. Pauls Deptford, a London suburb known for its shipbuilding trade due to its location on the south bank of the Thames. The next to youngest of six siblings, Maud was seven when the family moved to the parish town of Pinner, Middlesex county, located twelve miles from central London where her father operated the Railway Hotel. In 1895, she married Charles Henry Coppock, who died in 1911, but no record exists if they divorced. Before she left for the United States, Maud lived in Richmond, a picturesque town on the bank of the Thames about nine miles southwest of London, where she worked as a hairdresser specializing in scalp treatments.

Maud and Billy, as she called Fields, met sometime in 1904, likely after Hattie left England in late April to give birth to their son. Given Richmond's proximity to London, they could have crossed paths while Fields performed in August at several theaters in the city's suburbs. Maud's beauty and charm attracted Billy immediately as well as her disposition, which differed from his wife's temperament. If Hattie could be occasionally hardhearted and unbending, Maud was a sensitive, caring and a noncontrolling companion—qualities that attracted Fields. Like many itinerant troupers, Fields often felt alone on the vaudeville trail and with

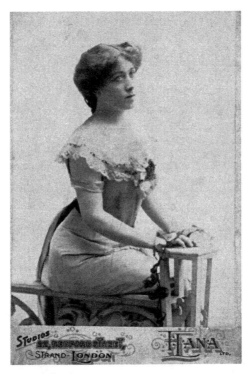

**Figure 12.1**  Portrait of Maud Emily Fendick. ca. 1897–1904; age 24–31. Author's collection. Courtesy Denise Sanborn Schoo.

Hattie absent, he needed companionship. After a time Billy found Maud to be a loving mate who could provide the tenderness he needed and rarely received from his parents and wife.

Before she left to join Fields in 1905, she had her portrait taken at the London studio of George Henry Hana, a well-known photographer, who opened his studio on Bedford Street, Strand, Westminster in 1897. Hana specialized in theatrical pictures and photographs for the pictorial press, notably *The Sketch*.

Maud had no qualms about joining Fields on his tours. He knew that Hattie had developed an antipathy to vaudeville with its lengthy itineraries and particularly to its harsh ocean voyages. With an infant to care for, he wondered if she could accompany him on the road. Hattie argued that the constant moving each week would be unhealthy for

their infant. Some vaudevillians such as Joe and Myra Keaton traveled with their children and used a trunk as a crib for their baby Buster. Hattie, however, refused to reexperience the rigors of continual travel. Ideally, she wanted her husband to give up show business and settle down with another job.

Her strong stance put her husband in a quandary. Having grown up with a volatile, cold, and distant father, Fields yearned for a close-knit family life. But show business flowed in his blood to the degree that giving up the theater was out of the question. Fields was now well known on the stage in the United States and abroad and was making approximately $300 a week. More important, Fields thrived on the audience's adoration and applause. His perennial insecurity bred despair numerous times, caused him to question his talent, and produced fleeting thoughts of quitting, especially when the spectators sat on their hands. Admiration from theatergoers gave him the recognition and love he craved, needs he rarely had attained from his family and other close relationships. Given the choice between a family life and a career as a performer, Fields chose the latter.

A restless wanderlust also ran in his DNA—an attribute he shared with his grandfather, who, as stated earlier, abandoned his family for a new life in California. He once confessed to a reporter that "I do not think I could settle down anywhere now. I have caught the wanderlust so badly that I must always be on the move. When I tire of one place I go to another."[2]

Evidence of tension in his marriage surfaced as early as August 1905 when Fields was in Buffalo appearing in tryouts for *The Ham Tree*. His correspondence suddenly became terse and less affectionate. Hattie was upset when she received a letter without a salutation and her complaint angered her husband. "Now that big noise you made about leaving out addressing you at the top of the letter was all nonsense [*sic*]," Fields wrote back. "I was leaving it until the last & trying to think of something funny."[3] Or was he? Given his relationship with Maud, he might now have hesitated to use an affectionate nickname such as "Bricket." His future letters addressed her simply as "Dear Hattie," and he signed them "Your Husband" and "Claude."

Instead of reconciling their differences, Bill and Hattie frequently quarreled. He accused her of using a strong "line of talk" in New York. As their relationship cooled, Harriet began to see another side of Bill. She had found him initially kindhearted and loving. But he had his dark moods, especially when he was overcome with bouts of depression reinforced by

feelings of insecurity regarding his career and marriage. If anyone crossed him in any way, he would lose his temper and become furious. Looking back after his death and resentful of the way her husband had treated her, Hattie categorized him as "a coward." "He liked to bully people—waiters particularly—and it didn't matter whether they had been mean to him or not."[4]

Bill felt Hattie had changed with the birth of their child. She was no longer the beautiful assistant in his juggling act but instead had chosen to become a domesticated housewife. Hattie wanted him to stay home, find another job, and be with her and Claude. Moreover, she had recently become an avid Catholic. Religion, by contrast, was anathema to Fields. He also began questioning his marriage to Hattie. Had he really fallen in love and married the first woman in his life? Embarrassed by living with Fields as an unmarried woman on the road, she had given Bill an ultimatum—either marry or separate. If he had those years to live over, he might have acted differently.

He found Hattie's letters "full of bombast" during his initial months traveling with *The Ham Tree* cast. Every letter she wrote pestered him about the money he was sending and complained that the payments were always late. "Wired you $100.00 so you won't have to walk the Streets with the boy," Bill wrote from Cincinnati a week before Christmas 1905. "Had you answered when you should have you wouldn't have had to wait a minute for your money...Now I want you to know how you and I stand financially...I want to know when you receive the money I send you...Now don't go fooling too much as you may regret it. When you answer this letter, refer to it and answer my questions." Disturbed that her letters did not contain any news about their son, he wrote: "I also want to know from time to time how the boy is."[5]

The deteriorating relationship lingered on through 1906. While he was on the road, Hattie and Claude stayed with the Dukenfields in Philadelphia. Living in close quarters, Hattie began to have mother-in-law disagreements with Kate. Coming from different backgrounds, they had little in common and their strong-willed personalities clashed. Kate's drinking and comments about her neighbors bothered her prudish daughter-in-law. Nor did Hattie and Jim get along. Jim had grown up in the rough-and-tumble atmosphere of working-class Philadelphia, while Hattie stemmed from Manhattan's lower-middle class. She was raised with proper manners and received a college education. The Dukenfields sensed there were marital problems between their son and Hattie, and their rift must have contributed to their attitude toward her. When

Fields's father wrote a rare letter to his son about the tensions in his house, his son replied: "Regarding a certain person [Hattie], I don't care to know any more about her, and am positive Mother gave her all she gave Mother."[6]

Hattie sensed that another woman was causing her marriage to deteriorate. She received a letter from Belle Gold, a cast member in *The Ham Tree*, confirming her suspicions. Hattie had befriended Gold when the show was in New York. She warned Hattie that her husband was traveling with Maud. "This woman has him completely under her control and will do anything she asks." In her date book Gold had recorded the names of the hotels where they had registered as husband and wife during *The Ham Tree*'s first season and offered to do it for the second season. "I sincerely sympathize with you," she told Hattie.[7]

Gold advised his wife to act as if she never knew about the relationship. "I shouldn't worry...if I were you. I think the less you appear to notice things, the more it will worry him and pique her." Taking Gold's advice, Hattie accepted her husband's invitation to bring Claude to Philadelphia where he was visiting his family in August 1907. For the trip she bought a fashionable outfit and went to a beauty parlor where she received a stylish hairdo. Fields could not keep his eyes off her when he saw her. Learning of the encounter, Gold wondered "what Maud would say if she knew how he was acting." "Perhaps if he asks you to come back now that he thinks you are looking so well and is behaving like a man, you might gain your point and get him to leave her—oh, I hope so."[8]

When Fields returned to New York for the summer break between seasons of *The Ham Tree*, he invented excuses for his long absences in order to reside with Maud. "He just went out to fill a contract and when he came back he didn't return to the same place where we were living," Hattie later recollected. His visits to see Claude resulted in arguments with his wife. "Why haven't you come back?" she asked. "This is your home." Hoping to regain his affection, she continued to urge her husband to forego traveling so that he could spend more time with their son. "I always prayed and prayed that he would change."[9]

Hattie decided to "set the trap" to confront Maud. In a letter to her friend Georgie Hargitt, Hattie related the horrific moment. Hattie went to the boardinghouse where Maud lived and waited in the parlor until she was invited to visit her room. As soon as Hattie walked in Maud knew who she was. Hattie immediately spotted a photograph of her husband on Maud's dresser. "Did you know that Mr. Fields was a married man?" Hattie asked. Maud was so embarrassed and stunned that she was initially

unable to respond. "Your duty is to go back where you came from but you do not look to be capable of any such strength of character so I guess I am going to surprise you by freely giving you Mr. Fields, my husband, as he is <u>not worth</u> the trouble which usually results in a case of this sort." Hattie asked her how she met her husband. "Through a lady," Maud replied. She is "most likely a <u>prostitute</u> like herself," Hattie retorted. Thinking she had made her point, Hattie left feeling vindicated. "To this day he does not know how I found out about her or <u>how</u> I ever located her," she wrote Hargitt. "I have bared my heart to you. I trust to your secrecy."[10]

The next day Fields angrily confronted Hattie with a note in his hand from Maud stating that she been insulted by his wife. They quarreled for a long time until Fields left. My husband and I "have not lived in the same

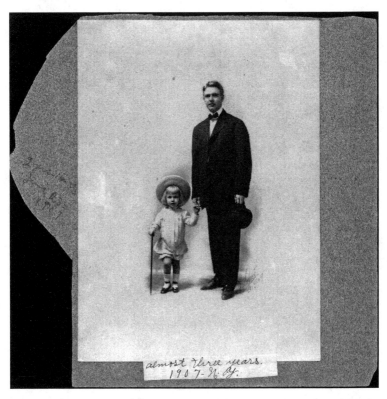

**Figure 12.2**    Happier times with Claude Jr. Courtesy W. C. Fields Productions, Inc., www.wcfields.com.

house since I made that <u>discovery</u>," she wrote Hargitt. We "ceased to live as man and wife in 1907," Hattie recalled.[11]

Hattie could have filed for divorce based on her husband's adultery but she claimed it was against her religion. As a staunch Catholic, she strongly believed in the sanctity of marriage. During her life Hattie kept their marriage certificate in a frame highlighted by the words: "What Therefore God Hath Joined Together, Let Not Man Put Asunder."[12] There were other reasons she clung stubbornly to her husband. Remaining married gave Hattie, who was extremely possessive, control over the rearing of Claude. Her possessiveness in regard to their son eventually tore the two apart even more and drove a wedge between Claude Jr. and his father.

To save face, Hattie later alleged that it was Fields who refused to divorce. She recalled that her husband told her, "Listen, you can't get any divorce from me. I fixed things up so you couldn't." "I know why," replied Hattie, "you just want to keep me as a play safe." Years later, Fields's son agreed: "He probably liked the married status, so long as he didn't have to work at it; it was a good stand-off against some of the girls."[13]

Fields's attachment to Hattie provided a good excuse to never again get ensnared in a marriage. His stormy relationship with Hattie embittered him on matrimony—one of the sacred cows he vilified later as a curmudgeon. In the film *You're Telling Me* (1934), he advises his daughter not to be in a hurry to marry. "Pick and choose, dear. Liberty is sweet. Once you're married, it's just like being in jail." The marital experience also soured him on the word "love." He told the author Max Eastman for his book on laughter: "I never would try to make love funny."[14]

Hattie never obtained a legal separation agreement that would have required her husband to pay her alimony. He nevertheless sent her money weekly starting with $25 and over the years he gradually increased the payments to $75. Their abrasive letters after their separation were mostly about money, practical matters, and Claude Jr. Hattie's correspondence regularly included grievances that her husband's financial support was meager; complaints about missing a weekly payment; and pleas for additional money for special needs, especially about better housing and Claude's education. Fields was now making $300–$350 a week, about average for a well-known trouper but much below such stars as Vesta Victoria, the British music-hall singer, who received $2,500 to $3,000 a week. His salary zoomed later in the *Ziegfeld Follies* and Hollywood, but Hattie's allowance remained stagnant.

Fields had considerable expenses as a vaudevillian: railway and baggage costs (his heavy pool table); payments for lodging and food; salary

for an assistant; money for publicity matters and props; and when needed commissions to agents and booking offices ranging from 5 percent to 10 percent of his earnings. In addition, Fields supported Maud and sent his parents and siblings money.

When his salary jumped to $350 later in vaudeville, he gave Hattie on average $35 a week or about $1,820 a year, which was more than the 1910 US annual income ($700–$750). Since Hattie needed money for Claude's support, $35 a week, equal to 10 percent of his salary, could be interpreted as tightfisted. If Fields's expenses totaled roughly $100 a week before paying Hattie, he still had more than $200 either to spend or bank. Extra money went into rainy-day saving accounts that he opened around the country in case he ever fell out of favor with the public or became persona non grata with the magnates that ruled the theater and film industries. Fields once told Hattie that his goal was to accumulate $45,000 in a "rainy day" fund in case he lost his talent.

Haunted by memories of his difficult youth and struggle to break into show business, Fields was petrified that he would someday lose his talent and become a has-been. To a reporter he recounted a period he called the "hard years." "I slept in parks and was always hungry. When I could stand it no longer I'd swipe fruit or vegetables from the street stands."[15] He quickly learned that show business resembled a roller coaster ride—up one minute, down the next. He knew of numerous jobless vaudevillians who slept on park benches; some were so depressed they committed suicide. As a fledgling performer, Fields had felt the pain of deprivation—walking the streets of New York in the cold looking for a juggling job and left stranded in Kent, Ohio, by the crooked burlesque manager James Fulton.

In addition to saving money, he enjoyed an expensive lifestyle. He bought costly automobiles that met his passion for driving, ate in classy restaurants, and wore dapper clothes. On the road he stayed in first-class hotels rather than drab boardinghouses where most of his colleagues resided. Buster Keaton and his parents, for example, lived in New York at the Ehrich House, a theatrical boardinghouse. Fields, by contrast, resided in a lavish hotel located in Times Square. He chose first-class accommodations because it gave him comfort and confirmed his success. "To this day when I climb in between clean sheets, I smile," he said. "When I get into bed and stretch out—god damn, that's a sensation!"[16]

Fields never told Hattie what first-class hotels he was staying in since that might confirm her suspicion that his life was "a bed of hollyhocks." But through her contacts, Hattie knew about her husband's spending sprees, which justified her need for additional money. She accused him

of living a life of pleasure and hiding his wealth while she was having difficulties paying bills. Bill thought she had the wrong perception. His life as a trouper, with its grind of constant traveling and living out of a trunk, was hardly "a bed of roses." He believed Hattie led the easy life. "Think of someone else who has it as soft as you."[17]

Hattie's entreaties for more money fell on deaf ears. "He just told me he didn't care what I did with it; that is all I would get." Since there was no legal separation agreement, Fields could reduce her payments any time he wanted. "I would just have to take what he gave me. He would raise me five dollars and then diminish it to ten dollars a week." When Fields faced financial problems due to a salary cut he decreased the amount to $25 a week. Such an episode occurred when he performed out West where he had higher transportation costs and open weeks due to the long distances between stops. "I have been working one week and laying off a week and the heavy expenses incurred on this tour leaves little profit," he wrote from Portland, Oregon. He also received less salary when he toured New England theaters owned by Sylvester Poli, who hired performers with an open week and needed work rather than go unemployed. "Am playing a few cut weeks through this part of the country so will send $25.00 for three weeks," he wrote Hattie while appearing at Poli's theater in Bridgeport, Connecticut. Hattie complained to her friend Georgie Hargitt: "He cuts me down so terribly in money…all we get is $25.00 weekly. So you see it is a hard struggle."[18]

Fields enclosed her weekly funds in short and brusque letters mentioning the amount he was sending. When he cut her allowance to $35 due to additional expenses in Europe, Hattie angrily wrote back that the amount was too little. "$35.00 is a very comfortable sum," he retorted. Stop plotting "how you can get me to raise the allowance. I have told you two million times, as long as I have anything you will get your portion but you won't get every cent I make because if you did I wouldn't be able to make any more money." The more she complained the angrier he got. Fields ended his letter with a stern warning: "You nagging will serve to make me diminish the amount rather than increase it." "You are constantly kicking about the difficulty of making ends meet and want to put the bee on me for a few extra dollars."[19]

Traveling in Europe made it difficult for Fields to send her money on time because his letters had to cross the Atlantic. Constant complaints about the tardiness of his payments caused angry replies: "Your letter telling me I am two weeks shy on the usual amount is very annoying…You will naturally be two weeks behind on account of the distance." In case his

correspondence got lost, he registered his letters. "I will trace the last letters," he wrote. "And in the future please do as I tell you and say what town and date my letter had on it."[20]

Several factors lay behind Fields's reluctance to give Hattie more money. A staunch believer in self-reliance, he reminded his wife that no one had helped him. Success in life depended on do-it-yourself initiative and diligence. He constantly urged Hattie to support herself by finding a job and to try show business again—a fruitless suggestion given her reluctance to return to the stage. "Mrs. Lynch called yesterday of Lynch & Jewell & said she was anxious to do an act with you," he wrote. "Why don't you both get to-gether." Another time Bill wrote: "I notice you gave up the idea of duplicating my act when you discovered it involved hard practice." He urged her to "devote more of your leisure time to study or occupation that will get you a few elusive coins occasionally." Except for a job as a waitress, she rarely worked while raising Claude. Raised by prudent parents during the late nineteenth century with its genteel ways, Hattie held conventional beliefs and felt a woman's role was in the home.[21]

Fields remained firm regarding his payments to Hattie due to a deep-rooted reason—he rarely forgave people who angered or betrayed him. In his eyes, Hattie had deceived him by her failure to join him on the road and her selfish control over Claude. To easily "forgive and forget" was not in Fields's repertoire. He hated being suckered. To him, suckers were the weakest, most gullible people in the world. He wholeheartedly believed in his famous adage—"Never give a sucker an even break."

Fields nonetheless could be generous to those he trusted such as ex-troupers down on their luck, loyal friends, and close women friends, like Maud, who gave him care and affection. Examples of his munificence are as numerous as his callousness. One night Fields left the theater and encountered a poor, elderly lady selling apples. Seeing they had fallen on the street, he picked them up and began juggling them. Soon people were putting money in the lady's basket. While shooting the last scene in *Two Flaming Youths* (1927), Fields fell off a bicycle and fractured his third cervical vertebra. Unable to move, he lay on the ground. As part of the sequence, a truck came barreling down toward him, the driver unaware of Fields's accident. He would have been killed if it was not for Johnny Sinclair, a stuntman, who grasped his legs and pulled him clear of the truck. To express his gratitude, Fields hired Sinclair as a stunt man in his films until the mid-1930s. Depending on the situation and person, Fields could be coldhearted or kindhearted. His relationship with Hattie and others reflects a complex multi-sided disposition capable of demonstrating antithetical traits.

Besides Georgie Hargitt, Hattie's other confidant was her mother, Lizzie, who lived near her in Manhattan and naturally sided with her daughter. She felt Fields was mistreating her daughter. "Well, my child," she wrote, "I hope your trouble will soon end, after which you receive the final letter from Fields who will settle all your business affairs."[22] But a letter drawn up by a lawyer legalizing her support and signed by Fields never materialized.

Disagreements arose when Hattie asked Bill repeatedly to lease or buy her a house with new furniture. "I am not so well financially prepared to furnish you a house now as I was some time ago. Give me some idea what it would cost and I will consider the matter. I am positive it can be arranged financially." She wrote Fields that she was thinking of residing in Philadelphia in a six or seven room house. "There are lots of small, comfortable up-to-date houses in sedate neighborhoods available for $18 to $20 per month." He advised her to live in Philadelphia several months before deciding to live there. "[I] would not consider it a delectable city in which to live...," he wrote. "On Sunday it is very dull." If she wanted to reside in Philadelphia, Fields suggested that she live in one of the single family rental houses on three lots on Warnock Street that they had purchased in 1903, but she declined the offer. Bill finally decided to furnish a home but on one condition. "If you expect me to furnish a home for you, and a continuance of $40 you are mistaken. If I give you $500 for the purpose of furnishing a home, I will send you $25 per week afterwards." Fields, however, never sent her money for the furnishings nor made an arrangement to pay her rent or buy a house. "Will consider the house proposition later," he wrote in mid-1913, postponing the problem indefinitely. By then Hattie was leasing an apartment in Brooklyn.[23]

He also declined to buy a piano for Claude Jr., who expressed an interest in music. "Was inclined to laugh at your Bovine re. the piano," Bill wrote. "If you are living up to your $35.00 per week then I am thoroughly convinced you are off your Burr and shall close in on you. But I know you are not, and that you have money in hand in case I should fall back for one week."[24]

Hattie remained bitter about her husband's philandering with Maud. She professed to Georgie Hargitt: "In the meantime, just think how a woman of my disposition and affection has dragged out a loveless amount of years and what Claude must be to me and how proud I am to know I am clean and far above the man I married—do you blame me for calling him 'Brutus'?"[25]

# 13. The Affair ❧

If "brute" became Hattie's favorite pejorative to describe her husband, Fields had his own verbal weapons. "You have been a lazy, ignorant, bad-tempered, arguing, trouble-making female all your life... I havent one good thought or memory of you, and the very thought of an interview with you fills me with rage." Taking a pencil, Hattie wrote on the back of the letter: "What I wanted to ask this brute was—if he would not advance us our first month's rent to start us in our home again when I could secure an apartment."[1]

Stuck in an unhappy marriage to a woman who refused to divorce him due to her strong Catholic beliefs, Fields was fated to pursue affairs the remainder of his life. Number one was Maud, who was Billy's constant companion from 1907 to 1914. She despised Fields's wife ever since their fiery encounter. In Fields's battles with Hattie, she naturally sided with her partner. Maud believed that Hattie was preventing her from ever legally marrying Fields. That did not stop them from posing together as a married couple. Transatlantic passenger lists confirm that she traveled on every voyage Fields took to Europe and back from 1908 to 1913 as well as his last trip to South Africa and Australia in 1914. On the ships' manifests, she registered either as Maud Fields or Mrs. William Fields.

Concerned about his career, Fields worried that theater managers where he performed might discover that he was married to someone else. He therefore urged Hattie not to send her letters to the venues where he appeared but to his family's house in Philadelphia. "Aren't you afraid people will point you out as the wife of a juggler if you continue to put 'From Mrs. W. C. FIELDS' at the back of your envelopes," he wrote. When she continued the practice, he issued an ultimatum. "And please drop that Mrs. W. C. Fields on the back of the envelope just put Hattie Fields I like it better. A little thing like that might make me forget to send you my route."[2]

Starting with his tour in *The Ham Tree* and afterwards on the vaudeville trail in the United States and abroad, Billy and Maud traveled together as Mr. and Mrs. Fields and registered as a married couple at hotels. At the

time there still existed considerable bias against unmarried couples living together, especially in less populated locales in the United States and the provinces in England. Rather than defy propriety, Fields introduced Maud as his wife to performers, friends, and acquaintances. Raised in Victorian England with its proper standards of behaviour, Maud held the traditional tenets of her time and might have insisted like Hattie that they travel together as husband and wife. When they were in England, she apparently introduced Fields as her husband to her family.

In Maud's home country they traveled together in Fields's automobile as they sped from one engagement to another. "He is an enthusiastic auto-mobilist, and with his charming wife [Maud], who accompanies him upon his journeys, they make many trips into the surrounding country in their auto, and enjoy the beauties of nature," wrote a reporter. They travelled in "a dandy little roadster" he had shipped from the states. A newspaperman commented that sometimes Maud would take the wheel. "She is 'Johnnie on the spot' when it comes to driving an auto. She can handle a car in a way that would make the ordinary chauffeur think he was [an] engineer of a baby carriage." Along the way Maud would show Fields important sights.[3]

In May 1914 a reporter from the magazine *Table Talk* interviewed them in a hotel in Melbourne where Fields was performing. The article revealed that some tension had developed in their relationship. After nine years of travelling with Billy, Maud wanted to settle down and share a perma-nent home with Fields. "I must confess I would like a home and to settle down...And he is just the man to find pleasure in his home if he had one, for he loves to do things and putter about, and would be so interested in a garden." But Fields told the reporter that he would find it difficult to live in one place. "What I think I should miss is the companionship—the meeting of other people, and the interchange of ideas. I think if I had to go straight home and stay there every night it would soon weary me. It is meeting people after work is over, and having a little chat that I enjoy, and you can do that when you travel and move about from place to place." Like Hattie, Maud had arrived at the point that she was tired of traveling and wanted Fields to reside with her in a home.[4]

She still hoped that Billy could find a way to divorce Hattie so they could marry. But she lacked the willpower to give him an ultimatum. "I'm the one thats been lacking," she admitted later in a letter to Fields. "If only I had been firm about it my position would have been so different." She grew increasingly bitter that his marriage to Hattie stood in her way. "I should have insisted on your getting rid of H. She has been a millstone

around your neck all your life and a thorn in my side—to this day I am not even able to write her name." In another letter she stated that "you should have cut this tie definitely many years ago, its always been a thorn in your side and as for myself no one will ever know the pain and shrieking agony it has caused me and is still causing me."[5]

Fields's catastrophic involvement with Hattie soured him on marriage. The experience, however, created a lasting benefit—it sharpened his knife-like rage against matrimony. His stage and screen appearances are loaded with cutting jibes against the sacrosanct institution. "Tell my wife not to wait for me tonight because I won't be home for a month (*Man on the Flying Trapeze*). Portrayals of wives browbeating their husbands surface in the stage scenes he wrote for the *Follies*; exemplified by the constantly nagging Mrs. Fliverton in "The Family Ford" sketch (1920) and Ma Jones castigating Pa Jones in the "Back Porch" scene (1925). Shrewish wives appear regularly in his films from the snotty, disparaging Mrs. Brisbee in *So's Your Old Man* (1926) to the bossy, complaining Mrs. Bissonette in *It's a Gift* (1934).

No solid proof exists that Hattie is the prototype for these wives. Then again, who else could have set Fields on this course? Fields's humor allowed him to exorcise the pain he felt from his marriage. "I was in love once myself," he said, "and that's too painful—that's too painful!"[6]

As soon as Fields joined the *Ziegfeld Follies*, the Maud–Billy liaison started to unravel. The reason was twofold. He was tiring of the relationship and had begun an affair in 1916 with Bessie Poole, a *Ziegfeld Follies* chorus girl. Unable to sustain a lifelong bond and settle down permanently, after a time he pursued new relationships, even if it meant giving up someone as loving as Maud. In regard to women, Fields was not a philanderer or a Lothario seeking one-night stands or short affairs. But he grew tired of his relationships after a time. His talent agent, Bill Grady, who knew him well, felt he "was a one-gal guy. I never knew him to two-time. An amazing thing, though; he had a change of heart every seven years. I could always tell when a seven-year amour was ending. He'd call my attention to some girl he eyed."[7] Actually his affairs varied; some were shorter or longer, but with some women Fields did experience a "seven year itch."

His wanderlust—a proneness to be constantly on the move—impacted his affairs with women. Incessantly, he sought the ideal woman who might fulfill his needs and tolerate his mercurial personality—a quixotic quest. If he was gifted in his professional life, he sometimes acted graceless in his affairs with the opposite sex. He was persistently tormented by the pain he experienced with Hattie, and the hurt impacted his attitudes toward love

and marriage. His experience yielded numerous quotable quips: "I was in love with a beautiful blond once. She drove me to drink—tis the one thing I'm indebted to her for" [*Never Give a Sucker an Even Break*].

Even when his relationships were going well, he feared that doomsday was around the corner. "I have fought and been in a bad temper so much in my life that I am unhappy and lonesome when everything goes right for me," he told Maud. Some women took advantage of this weakness and manipulated him. A year before his death, he wrote Maud about Carlotta Monti, his last lady friend. "The Mexican girl who caused so much bad publicity is back again causing me more grief. What a sucker I am for punishment."[8]

Maud and Billy remained friends but her association was infected with bitterness. There were occasional visits and dinners in New York while Fields performed in the *Follies*. They last saw each other around 1923. After that date their relationship continued through considerable correspondence. Maud's tear-stained letters to Billy regretted about the way their romance had ebbed. "I've written you wild love letters with the tear blots all over them and destroyed them. So you see I am not the calm unmoved woman you pictured me." She cried during writing one letter that "she had to wear a shade over" her eyes when she went to her job and pretend she had a cold. I have "no blame for you in my heart," Maud stated in a touching letter. "I am sending you my love. It's not the love that would satisfy you or fill your life but I love you just the same." She added a postscript: "I don't know that you ever had any faults if you had I've forgotten them."[9]

To his credit, Fields still cared for Maud and felt an obligation not to completely abandon her. He gave her money to support a scalp specialist parlor in midtown Manhattan. Her business flourished as numerous clients sought her advice on hair growth. Although she used her real name in her profession, at other times Maud continued masquerading as Mrs. Fields. On September 24, 1921, she was granted a US passport using the alias Maud Fields, and more baffling was that the application stated that her husband was William Fields. She listed as her permanent residence 3823 N. Marshall Street, Philadelphia. More than likely she meant 3923 N. Marshall Street, the last home of Fields's parents, and where he stayed when performing in Philadelphia. Although no record of her naturalization has been found, Maud alleged on the application that she was a native citizen and swore her allegiance to the United States.

"Why have you not broken with me?" Maud asked in a letter. Is it your "fear of hurting me?" We are equally to blame for "drifting apart," Maud

admitted. His affair with Bessie Poole also contributed to her despair. You have a "silly habit of not removing one rope from around your neck before putting another there. And I think this is why I have to make a decision for you. We must eventually part...It will be easier for us to break right away now than to start marital relations again and have to break later." As for "starting life together on the old footing I honestly don't think I could do it, even if you could and would and I'm quite sure you couldn't and wouldn't." She ended her letter on a blunt note stating that he had three women in his life: Hattie, Bessie Poole, and herself. "One [Hattie] I'm afraid is a barnacle that you'll never rid yourself of. The last [Poole] by all evidence is the one you wish to cling to. And so I'm going to step out of it as quietly as possible."[10]

The last time they saw each other was about 1922, but Maud never disappeared completely from Fields's life—he was too fond of her. In 1923, he drew up a will that gave Maud one-sixth of his estate, five dollars to his son, and no money to Hattie. After Fields moved to California in 1927, they frequently wrote one another up to the time of his death.

Their later letters concern Hope, a young British girl Maud had adopted after her parents were killed in a car crash. Born in 1921, Hope accepted Maud as her new mother and Fields, who she called "Uncle Billy," as her substitute father. "She has sort of adopted you as the male of importance in her young life," Maud wrote to Fields. "You have always fostered this by sending her your love, photographs, and gifts."[11]

Hope became the link that now connected Maud with Billy. "Your letter quite thrilled her,"declared Maud. "I am deeply grateful for all of your kindness to her." Hope told Maud: "Of all the men I know there is only one I'd like to have for a Father and that's Uncle Bill, he's kind, everything I hear about him proves he's kind." Hope treasured Fields's letters and carried them in her school bag. She told her classmates about him, and the students called her W. C. Fields the second. "Rather an odd thing isn't it that the youngster should have such an affection for you," Maud wrote. "I have never tried to impress her about you in any way, but of course she has always heard praise and affection expressed by the family." Hope only knew Fields through his letters and watching his movies. He persuaded celebrities to sign her autograph book, telling Maud "that it will be pretty good when I send it back and she'll be very proud of it."[12]

The letters Maud wrote during the 1930s deal mostly with her serious financial problems due to the Great Depression. Her business sharply

declined as many customers could not afford her scalp treatments. She was unable to pay the rent on her store and also owed money on the lease of her house. She was threatened with a court summons demanding payment of her debts. In desperation, she asked Fields to help her. "Billy I am going to ask you to do something definite for me if I had the legal right which I should have insisted on having during the years we were together things would be very different for me here. I have asked you to give me a little weekly allowance. I don't expect or want to be kept in laziness that way, just to have the feeling that I can pull thru the bad times without constantly begging...I want help until the good times come back again as I know they will do." She pleaded: "If you do this for me, Billy, you will be doing a splendid thing and taking a great burden from me—if you don't help me and very soon now I'm finished there is no other way."[13]

Busy making money in the movies in Hollywood, Fields wrote back that he did not believe there was a depression in New York. Maud responded: "If you could see what I see in New York in my small world you would be amazed. Women and men who all their lives until now have worked and earned anything from $25 to $100 or more a week now can get nothing to do...Saks store on 5th Ave. advertised for 15 women last week. They had 3800 come in to answer the advertisement. There are according to statistics 13 million people out of work in the USA."[14]

Maud's request exposed a raw nerve. Despite his affection, Fields balked at the idea of sending her a weekly check. His continual battles with Hattie over money and constant nagging had hardened Fields to people asking for handouts. "I would like so much to help you," he wrote Maud, "but it would drive me nuts if I put anyone else on a weekly or monthly remittance, no matter how small." Fields repeated his self-reliance justification. No one had aided him when he made a living as a juggler and later had to find a job in the movies. "I have worked and worked along the lines that I knew would be remunerative...You say I have never changed my line of business. I think from juggling to acting and speaking lines is quite a change—one of the direct antitheses to the other." He encouraged her not to sit around waiting for better times. He enclosed one hundred dollars stating that it is "the only way I can help you now." She should be grateful. "If I were broke tomorrow, I have not one soul that I could turn to borrow $100."[15]

She asked Fields for money again when the bank was about to foreclose on her house in New Rochelle. "I cannot tell you how it grieves me to receive your sad letter," Fields replied. "And it will not help you for me to tell you that I warned against such a plight on many occasions."[16] When he

suggested transferring the mortgage under his name, she rejected the offer. The bank eventually foreclosed on her house.

Maud wrote him that she was thinking of going to Australia to find a new opportunity. Fields wrote back that he had found Australia a second-rate country compared to the United States. "I am not a rabid American. The politics, the graft, the crookedness, the mayhem is all pretty terrible but as long as I have any ambition, I'll stay here and take American for mine." He advised her not to sit around until the good times reappear. "Nothing ever turns up—you've got to go out and get…If you work harder, you will be much happier. Do not let too many people stand in your way. It is as much as we can do in this world to take care of ourselves."[17]

She regretted that she had to stoop so low and beg for money. "I can understand how you feel [about] people laughing round your neck, gold-digging," Maud replied. "When I parted from you I made no claim on you, at that time I was able to keep going and times were good in business and such a thought never even occurred to me. I am not the type to give up and expect someone to keep me. Unfortunately fate has given me a nasty jolt the last two years but I hope to pull through and come out on top at the finish." Nearing sixty-seven, she worried about being abandoned in her old age since Fields had failed to regularly support her. Honor the "memory of the years we spent together and make my old age at least bearable," she pleaded. "I never can tell you how I have suffered and am still suffering from your failure or difference to setting thing right for me." Maud was never able to shake the bitterness she felt for Hattie. As late as 1939 she wrote: "I should have insisted on you getting rid of H. She has been a millstone around your neck all your life and a thorn in my side—to this day I am not even able to writ[e] her name." Maud's last known letter to Billy was written fifteen months before Fields's death. "[I] am still suffering from your failure or indifference to setting things right for me."[18]

In one of his most blunt letters to her, he declared that he never "asked for a 'partner'. I have always been a lone wolf." He told her that he had not obtained a film role for some time and "have no prospects in the off-ing. My bank roll is dwindling and you feel sorry you didn't make some arrangement with me. What arrangement?" Obliged to give weekly payments to Hattie and money to help out Walter and Dell, he refused to concur to a similar agreement. "I am burdened with many weekly responsibilities and I definitely refuse to burden myself with any more." (Fields had plenty of money stashed in banks across the country and was then making $200,000 per film.) "'Shake a leg,' and stop singing the blues," he

advised her. "I am sorry if this letter seems cruel but I am merely 'talking turkey'." Inside the envelope was a check for fifty dollars. "From time to time, I will naturally try to help you," he wrote in a more genial letter. The sums ranged from small amounts to several hundred dollars. The last gift was the year before his death when he gave her $25 to spend on "something or other from candy to champagne" and ended sending his "fondest love."[19]

As her letters reveal, Maud never lost her love for Fields. Hanging on the wall above Maud's bed was a photograph of Fields with a cane over his shoulder. She expressed her feelings for Billy poignantly: "I still love you, Billy, and always will…I shall love you until the end comes to me."[20] As the years passed, Fields rarely conveyed strong emotions in his letters to Maud. Burned by Hattie and others, he had developed a thick skin to prevent being wounded again by women.

By the end of his life, he ostensibly cherished the memory of the years they lived together. His relationships with other partners never attained the intimacy that the two had for each other. In his affairs with women, Fields seemed destined to repeat the same heartbreaking endings. You have a habit of letting things slide "where women are concerned," wrote Maud.[21] Maud came the closest to being the ideal woman but Fields abandoned her for another affair. Unable to sustain a lifelong relationship with a woman, Fields spent his adult life searching in vain for the love he had missed since childhood.

Maud realized that the ideal woman Bill sought was a phantasmagoria. Closing the door on the relationship, she wrote: "I am sending you my love. It's not the love that would satisfy you or fill your life but I love you just the same."[22]

Adoration, instead, stemmed from his fans. Saddled by an insatiable need for recognition and fame, Bill was plagued by relentless anxiety about his reception by the public. But like romantic love, adulation came and left, returned and disappeared again in an endless cycle. Ecstasy flourished when he was at the apex of his career. Whenever the applause ebbed and his films flopped, causing his popularity to plummet, Fields plunged into an unbearable period of blackness.

"My bete noir is lonesomeness," Maud once wrote Fields. She recalled the times when she dined with him at restaurants where there were "a number of elderly and old women dining alone…They left a picture in my mind which I've never forgotten and always feared…And perhaps loneliness will come upon me before the finish." Unfortunately it did. Hope married in 1942 and left home to live with her husband; Maud's sister,

Hilda and her son Denis, went to San Antonio, Texas, where she died in 1949. Maud resided alone in New Rochelle, New York, without any close relatives until age seventy-nine. She died on December 5, 1952, six years after Billy, who remembered Maud in his last will and testament, bequeathing her $5,000.[23]

# Part V  The Labyrinth to the *Ziegfeld Follies* ⌘

# 14. The Road to the Palace ∾

During the time (1905–14) Maud and Billy were companions, Fields's show-biz career looked like navigating the tricky twists and turns of a labyrinth, one path to avoid flopping and the other to achieve acclaim. After two seasons with *The Ham Tree*, Fields fretted about his future on the stage. Despite good reviews, he grew tired of repeatedly playing Sherlock Baffles every night. Hoping to find another major comic speaking part in a play, he left the cast in mid-May 1907. To his dismay, he discovered that Broadway producers would not hire him. They "couldn't seem to see anything except that label of 'comedy juggler' that had been pinned on me ... I begged and pleaded like the rawest beginner, but they only laughed at me, and told me to stick to the thing I knew how to do. I had to live; so I went on with my vaudeville engagements."[1]

His options to return to vaudeville were limited. As mentioned earlier, Fields had been under contract to the producers Klaw and Erlanger during the run of *The Ham Tree*. The two magnates helped form the powerful Theatrical Syndicate, a monopoly that controlled most major legitimate theaters, productions, and bookings. Known as the "little Napoleon of the theater," Erlanger ruthlessly stifled competitors who did not cooperate with the Syndicate. Although mild-mannered, Klaw could be equally Napoleonic when crushing opponents.

Believing they could have the same supremacy over variety, the two formed a new circuit, Advanced Vaudeville, but they faced a potent rival. In 1907, Keith and Albee had pressured leading circuit and theater owners to join their United Booking Offices (UBO). Together they forged a potent combine that dominated the booking of performers in the East and Midwest. Like a two-way sword, the UBO gave vaudevillians more consecutive weeks of work, but it regulated salaries and charged a booking fee.

Blinded by ambition, Klaw and Erlanger naively thought they could drive the UBO out of business. To showcase Advanced Vaudeville, they made an alliance with the Shubert brothers to stage their attractions at their theaters. They presented lengthy playbills featuring numerous

European and American headliners at low-admission prices. In retaliation, the UBO blackballed performers who were associated with their competitors. Caught in a war between the two factions and under contract to Klaw and Erlanger, Fields was legally bound to perform in Advanced Vaudeville.

He opened his eccentric juggling act at the opulent Chestnut Street Opera House in Philadelphia on May 21. His engagement was a homecoming since it gave friends and family an opportunity to see him on stage. Returning to Philadelphia gave him an opportunity to prove that he was now a hit on the stage. Ten years had passed since he had started as a teenager juggling in the city's clubs and church buffets. His visit unleashed a flood of pleasurable and painful memories, from pranks with the Orlando boys to his altercations with his tyrannical father. Although his relationship with Jim was less tense, the fights caused a permanent wound that persistently haunted him.

Fields next appeared at the famous summertime roof garden atop the New York Theatre. With most indoor theaters closed during the hot summer before the advent of air cooling systems, roof gardens became popular with theatergoers, who could eat and drink amidst refreshing breezes while watching the show. Klaw and Erlanger hired the young impresario Florenz Ziegfeld to produce shows. Compared to the lavish showplaces he had seen in Paris, Ziegfeld found the open-air venue staid and cramped and immediately ordered it redesigned. To give the place a more stylish title, Ziegfeld renamed it the *Jardin de Paris*. Fields appeared as an eccentric juggler at the *Jardin*'s opening on May 27. But to his chagrin, he was overshadowed by the headliners from London's Empire Theatre, who staged tableaux, stationary poses of paintings and statues by actors dressed in skin-tight see-through garments. Daring for its time, the act created a sensation and dominated the reviews. Approximately a month later, Ziegfeld staged his first *Follies* at the *Jardin de Paris*. Fields needed to wait eight more years before he joined the *Follies*.

His experience at the roof-top theater prompted Fields to write an amusing fictional piece about the Reverend W. C. Felton (his mother's maiden name), whom he invited to attend a dress rehearsal of the tableaux. "Bless you my boy," the reverend said. "I would be more than delighted, it will be quite an experience, and I may be able to gather a little copy for next Sunday's sermon." Fields never told him that the performers would appear nearly naked. By the third painting the reverend began squirming in his chair. "What a fitting garment, and what an exquisite contour," he said. "Contour yes, but garment no," replied Fields. "With the exception

of a little white paint, she's as nude as the day she was born." The reverend sat there stunned. "Suffering sciatica!" the reverend said. "I hope Brother Hoofnagle or any of the flock [never] get to hear of me so far forgetting myself."[2] Typed on his stationery but never published, the piece reads like vintage Fields lampooning morality with sardonic humor.

When Advanced Vaudeville collapsed in mid-November due to poor management, box-office losses, and lack of theaters, the UBO acquired the performers' contracts, which let Fields tour the Keith-Albee Circuit and its affiliated-UBO theaters. Feeling that he needed to refresh his routine during the winter of 1908, Fields altered his stage costume by appearing as a swell on the skids. He entered wearing a tattered sable coat that he had found backstage. Underneath the coat was a wrinkled tux with tails; a dress shirt with sash, string, or bow tie; white gloves that gripped a billiard cue or long walking-stick; a cigar in his mouth; and a battered top hat. He still had a scruffy beard, dark facial makeup, and wore oversized but-toned flat-soled shoes that enabled him to keep his balance while juggling. Audiences could easily identify with Fields's characterization of a million-aire on the skids. "Fields knows just where to place his points, and he never fails to get the laugh," wrote Bert Holland after seeing Fields perform at Keith's venue in Cleveland. "There are a lot of comedy jugglers, but hats off to this fellow, he is the Big Chief in that line."[3]

Performing at Oscar Hammerstein's famous Victoria Theatre during the week of February 10 was among the tour's highlights. Known as the Corner because of its location at Seventh Avenue and Forty-second Street, the 1,250-seat venue featured programs that drew top headliners such as Harry Houdini, Will Rogers, and the Three Keatons with young Buster. Its manager, the showman Willie Hammerstein, Oscar's son, made the colossal theater the most renowned variety venue by presenting long play-bills comprised of worldwide eclectic acts. After seeing Fields perform, a critic from the *Dramatic Mirror* declared that he "has few equals as a pan-tomimist."[4] Bill's photograph appeared on the front cover in conjunction with his appearance. His vaudeville career is now back on track.

Fields's growing reputation spawned imitators at home and abroad. A comedy juggler, DeArno, "juggles plates, then balls a la W. C. Fields," reported *Variety*. Charles D. Weber, another eccentric juggler, performed an act similar to Fields. Copycats were more rampant in Europe. "It maybe a compliment to Fields that he is probably the most copied man on the vaudeville stage...the feats he spent years in evolving have been used by a dozen at least," reported the *Manchester Sunday Chronicle*. In Germany, a comedy juggler not only duplicated his stunts but copied his stage

outfit and stole his posters erasing Fields's name and substituting his own. "Copyists, fortunately, cannot steal a personality," noted a critic. "And it is the possession of this that makes Mr. Fields secure in his possession as one of the most popular entertainers in vaudeville."[5]

Although Fields's unique "comic side-play" and pantomime gestures were difficult to imitate, the copycats angered him, and ignited his insecurity. Fearing loss of his originality, the anxiety drove him to constantly invent new tricks. "The only thing that keeps me in the business is what I see other jugglers doing," he said. "Then I start with renewed vigor."[6]

Fields's obsession with imitators reached a crescendo when he published an advertisement in *Variety* chastising performers who pilfered his routines. Bill claimed that he originated the stunt of "walking off the stage as the curtain rises and walking on as it descends." "I so wish to stamp my prior right to it and recall to those in the profession that the bit belongs to me under the accepted code of ethics in vaudeville. I have suffered much from acts in my own line of work. I don't feel like remaining quiet while another and a foreigner may be using my material in my own country, and asking credit for originality upon it." He asked theater managers to prevent performers from using his curtain routine.[7]

Stealing routines in vaudeville was rampant. As pointed out earlier, Fields had filched from other vaudevillians including Harrigan. Nor could Fields prove that he created the curtain routine unless he had copyrighted it, a practice he did not begin until 1918. "To say that something in vaudeville was the first to do a certain act, gag, or piece of business is sticking your neck out further than a giraffe!" wrote Joe Laurie, Jr. "There are very few things new, especially in show biz!"[8]

Fields arranged his itineraries so that he performed in England from late spring to early fall in order to avoid the winter months and the miserable colds he caught. Afterwards he returned home for engagements until the trees blossomed announcing it was time again to return to England. He followed this schedule like clockwork. During a five-month tour of England from early June to early November 1908, he made weekly appearances in the Empire Circuit's theaters situated in provincial capitals and London suburbs, including a multi-week return engagement at the Hippodrome and a farewell performance at the Coliseum.

He returned home to begin a tour of UBO-affiliated venues at Percy Williams's Colonial Theatre in Manhattan. Having risen from a wagon medicine show operator to a prominent impresario with showplaces in New York's boroughs, Williams's career illustrated a show business success story. Listed as number three on the playbill, Fields arrived onstage before

the comic monologist Nat Wills, a highly paid headliner, who still wore his tramp wardrobe and thick black makeup. Bill wowed the crowd by taking five bows after a "big finish."[9]

Wills's career took a nosedive from headliner to has-been. He faced similar problems as Fields: worries about growing stale, marital problems, and large payments to a divorced wife. Unable to overcome his predicaments, he committed suicide by purposely leaving his car running in his closed garage, although others claimed he unintentionally got trapped inside the locked garage. On the vaudeville trail, Fields met numerous performers who took their own lives. Herculean stamina was needed to avoid the quicksand that buried vaudevillians unable to keep their act fresh.

At his repeat engagement at Hammerstein's Victoria, "Broadway" Sime Silverman, the influential founder and publisher of *Variety*, noticed that Fields possessed the tenacity to always offer the audience a novel stunt. Returning to his office, he wrote, "There is no juggler who secures as much humor out of rubber balls as Fields, who is a comedy juggler with a little something each time around." Three years earlier, Silverman had founded *Variety* as a vaudeville paper, and soon the weekly became the leading show business trade journal. Brash, feisty, and a strict editor, he insisted that his talented staff compose lively candid reviews in contrast to other critics who habitually accepted bribes from performers in exchange for a good review. Sime's opinions could make or break a vaudevillian. "Broadway Sime" boosted Fields, calling him a juggler and comedian who "occupies a niche alone in a distinct class." His favorable reviews were therefore a significant factor in Fields's rising reputation.[10]

After the Victoria, his nonstop whirlwind tour began again—a grind of five months on the road traveling as far North as upstate New York and Montreal, as far West to major midwestern cities, and then back to the East Coast, concluding with stops at numerous New York venues. At the Fifth Avenue Theatre, he took six bows at the end. "W. C. Fields had it all his own way and he deserved it. New York ought to present him with a loving cup," noted a critic.[11] When the grass turned bright green in Central Park, it was time to return to Great Britain again for a five-month tour.

He returned to the United States on October 6 to begin the grind all over again. For eight months he toured the Keith Circuit theaters and its UBO-affiliated venues, returning to many of the same theaters as the year before. Whether new spectators or returning fans, the audience never tired of seeing him perform. He reprised his surefire comedy juggling tricks with hats, cigars, and walking stick. The stunts were enhanced by his dexterity, facial grimaces, asides, and tomfoolery, which kept the audience in a

continual state of amazement and amusement. By now, Fields's pool table stunt was a key part of his repertoire and pocketing all the balls in one stroke assured a grand finale. "W. C. Fields, with his inimitable juggling of balls is claiming much of the applause," stated a reporter in Columbus, Ohio. "Juggling as Mr. Fields does it looks remarkable easy and his feat of 'pocketing' fifteen balls racked on the pool table is absolutely marvelous (!)"[12] When the tour finished in early June 1910, he returned again to England and the Continent. From the deck of the *Mauretania,* he watched the New York skyline disappear on the horizon. He had no idea that he would be gone for nearly two years!

During his voyage home in late March 1912, his chronic insecurity flared up again. Would the public at home remember him after his long absence? He had seen so many fellow vaudevillians vanish overnight, at the apex of fame one moment and at the bottom the next. Fred Allen called the cruel cycle "A Treadmill to Oblivion." But Fields was a fighter and self-promoter. Refusing to be forgotten, he ran an advertisement in the *New York Morning Telegraph.* Headlined in large bold print was the sentence "I CAME BACK W. C. FIELDS." Below the heading appeared a list of recent favorable newspaper reviews.[13]

His comeback started with a homecoming at Keith's Philadelphia Theatre where he received considerable applause and a good review. "He does not utter a word but his pantomime speaks for itself and makes a real joy of the half hour he is still on stage." After the evening performance he stayed at his parent's house on Marshall Street where his mother prepared a room for him. His sister Dell recalls that "he would get in late from a performance, but he always came straight home—he never stopped with the other performers." He aimed to sleep until noon but there was a continual parade of visitors, from the milkman to a salesman who interrupted his sleep. "Our mother made a concerted effort to keep everyone quiet so that W. C. could sleep," Dell believed. But Bill told his sister that his mother made as much noise as the vendors. "Mother was downstairs at the front door, telling everyone from the milkman to the mailman that 'he's home now, he's asleep upstairs.'"[14]

Out of the experience a comedic scene was made for the ages. The disturbances surfaced in his hilarious "Sleeping Porch" or "Back Porch" routine first performed on the Broadway stage in 1925 and reprised in the film *It's the Old Army Game* (1926) and *It's a Gift* (1934). Trying to get some shut-eye by reclining on a hammock attached to the porch's beams, Harold Bissonette (Fields) in *It's a Gift* is awakened by the clanging of the milkman's bottles. "Please stop playing with these sleigh bells," Harold shouts.

Other noisy merchants from his past appear, chiefly an insurance sales-man who tries to sell him a policy. The intruder runs up the backstairs where he finds Harold trying to sleep. Standing over him, the salesman starts his spiel.

*Salesman*: The public are buying them like hot cakes. All companies are going to discontinue this policy after the 23rd of this month.

*Harold*: That's rather unfortunate.

*Salesman*: Yes, it will be. Say, maybe you would be interested in such a policy!

*Harold*: No, I would not.

*Salesman*: Say, what's your age?

*Harold*: None of your business.

*Salesman*: I'd say you were a man about fifty.

*Harold*: Ah, you would say that.

*Salesman*: Let me see...Here we have it. You can, by paying only five dollars a week, retire when you're 90 on a comfortable income...And should you live to be a hundred... (Exasperated, Harold fetches a cleaver causing the salesman to flee downstairs.)

*Harold*: (calling after him) I suppose if I live to be 200, I'll get a velocipede.[15]

After another engagement at Hammerstein's Victoria in late June, Fields toured the Pacific Northwest on the Orpheum Circuit, which had grown by opening new venues. Vaudevillians could now obtain engagements at show-places that stretched from the Ohio Valley to the Pacific Coast and from west-ern and central Canada to New Orleans. Responsible for the circuit's growth was its general manager Martin Beck, who was in charge of booking.

Beck's staff arranged an itinerary that gave Fields seven months of con-secutive engagements. He was advertised as the Silent Humorist rather than the Eccentric Juggler—an indication that his pantomimic comedy was now dominating his performance. "He says never a word in the 18 minutes he holds the stage," reported a critic. Fields became neither a stand-up monolo-gist who rattled off one gag after another nor a slapstick comic skidding on a banana peel. He drew laughter with clever nonchalant gestures, facial expres-sions, and body movements. Talking, he felt, was a distraction, while silence enabled the audience to concentrate on his antics. "You can't talk through a laugh. If you do, you'll kill it. But a pantomime comedian can continue to build up one laugh on another until the audience is hysterical."[16]

After stopping in Winnipeg, Canada, a frontier town that reminded Fields of thinly populated settlements in Australia's outback, the Orpheum troupers took the railroad to Seattle. On the way, the train suddenly stopped to avoid a large boulder that had slid down a mountain blocking the tracks. "Saved by a minute," he wrote to "Bucky" Buchanan-Taylor. After Seattle, a booming city with several vaudeville theaters, the group travelled by railway train down the Pacific Coast with a stop in Portland and then on to San Francisco.

For two weeks Fields headlined the playbill at San Francisco's new 2,500-seat Orpheum (1909), rebuilt on the original site of the circuit's first theater, which had been demolished by the 1906 earthquake. With its stunning French Renaissance façade and plush interior, the theater was the largest and most expensive venue in the West to date. During Fields's pool table routine the audience roared with laughter. Wearing a rumpled black cutaway coat, dress shirt with bow tie and sash, and oversized shoes, Bill made numerous trick shots with different cues, including one as crooked as a corkscrew. Balls caromed off the cushions flying into the pockets of his coat, under his hat, and on top of his shoe until it was time for his socko finale. A mirror placed above the table enabled all the spectators to see how one shot made the balls "disappear into the most unlikely places with uncanny precision." Waldemar Young, the dean of San Francisco theater critics, wrote: "Fields is not only the best comedy juggler in the world today…but he is also a comedian with more of the real comedy genius than almost any who style himself in the legitimate field."[17]

Visiting San Francisco again brought back several memories. He recalled his first performance here in 1900 when, as a twenty-year-old, he debuted as a tramp juggler. After twelve years of grueling hard work and the grind of constant traveling, he had slowly climbed from an unknown novice to a top entertainer. He remembered his marriage to Hattie during their initial visit. They were then deeply in love, happy, and excited about their future together. What happened to shatter their dreams? Bill felt Hattie's stubborn refusal to accompany him on his tours caused their separation. Hattie believed that Bill had wrecked their marriage by choosing show business over domesticity. His life was like a ride on a seesaw. As Bill's vaudeville career escalated upward, his relationship with Hattie slid downward.

His next stop was Los Angeles, which had grown larger since his last visit. Since 1890, the city's population had escalated sixfold from 50,395 to 319,198 in 1910. The downtown streets were crowded with workers and shoppers. Opening in 1911, the Orpheum's stunning 2,000-seat theater resembled a Renaissance palace located on Broadway between Sixth and

Seventh, an area where numerous other vaudeville venues were situated. Among them were two small-time theaters operated by the impresarios, Alexander Pantages and the other by Tim Sullivan and John Considine. Here struggling vaudevillians performed three to four shows a day for less pay while Fields did two shows a day as "the topper" on the Orpheum playbill.

A Los Angeleno could see Bill entertain at a matinee in a ten-cent gallery seat and one dollar for a box seat. He performed his hat-cigar-cane trick, ball juggling and pool table routines, and closed with his manipulation of cigar boxes. The funny nonchalant way he performed his stunts drew kudos from a reviewer: "If he never did anything but be funny, he would be acclaimed as one of the world's greatest humorists, just as, if he made no fun at all, he would head the lists as a juggler." He makes "more fun to the square inch than any man alive."[18]

Fields wrote an article about the Orpheum for *Variety* in which he called the theater "a paragon of perfection." He praised its courteous service for patrons with enough "ushers free to take you directly to your seat." He lauded the manager Clarence Drown for giving the performers "every consideration" and "getting every ounce of value out of the actor."[19] The piece was probably a collaboration between the comedian and the theater's publicity agent. The article nonetheless signifies a new line of work for Fields. During his career he wrote magazine and newspaper articles, stage sketches, screenplays, radio scripts, and a book, among others.

In addition to writing, Fields was a skilled illustrator. In Los Angeles he published three superb self-portraits for the *Times* entitled "Versatility," two showing him shooting pool and the other in crumpled evening clothes with his nose layered with so much thick paste it resembled an orange carrot. "In addition to being possibly the most finished eccentric juggler in the world," wrote the *Times* reporter, "Fields also knows how to handle line splatter—as these neatly-finished art-department products show." For the *Los Angeles Tribune* he drew illustrations depicting two acts on the Orpheum playbill with a byline that read: "Mr. Fields learned cartooning as an avocation in case he ever decided to give up the stage. He draws only for his own amusement and the amusement of others."[20]

At stops along the vaudeville trail local newspapers hired him to do drawings of the cast and self-portraits. At Shea's theater in Buffalo, Fields shared the bill with McIntyre and Heath, who performed a surefire routine from *The Ham Tree*. For the local *Evening Times*, Fields drew an illustration of the forlorn and hungry pair carrying their trunk through farmland while seeking food. The newspaper also published another cartoon

by Fields that showed him bent L-shape over a pool table with a cue in his hand.

Once his drawings were published in newspapers, he began to get a reputation. Most of his illustrations were signed W. C. F. or W. C. Fields. When he played Columbus, Ohio, the local newspapers printed a self-portrait depicting Fields in his decrepit evening clothes and two others showing him juggling. The drawings served both as advertisement for the show and the promotion of Fields as the main attraction. One newspaper called his drawings a "clever publicity scheme...which is gaining him more newspaper space than a first-class agent could secure for him."[21]

His illustrations accompanied either a story about himself or a review of the vaudeville show in which he was featured. For an article in the *New York Star*, Fields drew a self-caricature depicting his bizarre outfit. The paper described the illustration: "This quaint little portrait of Mr. Fields does only faint justice to his beauty as he walks out on stage in a scrubby beard and evening clothes that must have seen better days."[22]

Fields once wrote about the time he worked as a cartoonist for a San Francisco newspaper as a young man. Arriving at the paper's office at sunrise, he began drawing as fast as he could. Before long the managing editor confronted him. "For heaven's sake, hustle along that cartoon." Next came the dramatic editor who yelled: "What in the name of the immortal bard is the matter with that dramatic layout?" Soon the sports editor stood at his desk ordering him to "skin off a couple of more dashes on them pitchers and slip 'em to me." Fields quit because he disliked the pressure of deadlines and working at a nine-to-five job. "It was a great life," he stated. "And I am glad it is all over with." He wrote Maud: "If you remember, I once took up cartooning and worked pretty hard on it but I could not make a go of it."[23]

Like his habit of avid reading, drawing became a passionate undertaking to pass the humdrum time between performances. "When good books are not available Fields makes time merrily by drawing sketches," observed a reporter.[24] He found the art of illustration relaxing, an outlet from the grind of performing two times a day, six or seven times a week. To assuage his long days on the road and his restlessness, he needed to keep constantly busy. His high-strung nerves never permitted him to keep still or sleep well. If unoccupied, his mind might ruminate about his problems with Hattie, young Claude, or his future as an entertainer.

Bill was naturally gifted as an illustrator despite never taking a drawing class. He glided his pen and pencil over his drawing board with quick, effortless facility. In his dressing room, he worked on a bristol board making

numerous sketches of the cast, his various juggling stunts, and pool-table routine. He sometimes copied the details of a theater's interior including the proscenium arch. Between matinee and evening performances, he often took his sketch pad with him looking for picturesque scenes in the city he was visiting. Bill especially found Hull charming, a medieval English port city located near the North Sea at the confluence of the Hull River and the Humber estuary. He stopped to draw a number of Hull's historic structures, including the Guildhall and ancient warehouses.

After his evening performance at Hull's Tivoli Theatre, Fields granted an interview backstage to a reporter nicknamed Mac from *The Daily Mail*. Entering his dressing room, Mac found Bill busy sketching a motor car. On

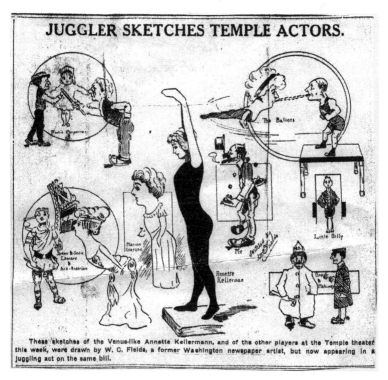

Figure 14.1 A typical newspaper illustration by Fields depicting fellow performers on the playbill at the Detroit Temple Theater. Note Fields in the center with his familiar signature and the famous swimmer and diver Annette Kellermann. Courtesy W. C. Fields Productions, Inc., www.wcfields.com.

the table were drawing materials and caricatures of presidents Theodore Roosevelt and Howard Taft. Fields was in a talkative mood and conversed about the cities he preferred. I like to "read about the early history of the towns I am visiting. The bigger the city the better I like it—when I have plenty of money." His ideal place was "where people look at you in a friendly way, where you meet a few goods fellows and enjoy yourself in a decent kind of manner."[25] As a gift for the reporter, Fields drew a sketch showing him driving a cue through a pool table—a surefire laugh-getter in his routine.

To make the characters he drew stand out, Fields sometimes used either a blackened or clear circle as a background. In his self-portraits, he accented certain parts of his attire such as his sable coat, shoes, top hat, and cigar. His self-portraits look like exaggerated comic spoofs of himself. Fields's expressionist style resembles the technique of the prominent cartoonist Frederick Burr Opper. He might have learned about Opper from the writer and lyricist George V. Hobart, who wrote the book for *The Ham Tree*. Opper illustrated Hobart's volume *D. Dinkelspiel: His Conversationings* (1900), considered a classic of ethnic humor for its exaggerated German American dialect. Opper created the popular Irish hobo "Happy Hooligan" comic strip that ran for thirty-two years. As discussed earlier, the appearance of "Happy Hooligan" influenced Fields's tramp character. Equally influential was Opper's hilarious "Alphonse & Gaston" cartoon characters—two over polite gentlemen whose behavior satirize French manners. Opper's illustrations of the lanky Gaston resemble the way Fields appears in his self-portraits.

From Los Angeles, Fields headed east along the Orpheum route, with weekly stops in Ogden and Salt Lake City, Utah; Denver, Colorado; Lincoln, Nebraska; and Des Moines and Sioux City, Iowa. By the time he reached Minnesota it was mid-November and the weather was getting colder. After a mid-December engagement in Chicago, he spent Christmas in St. Louis. He had been toiling on the Orpheum circuit for six months as the end of 1912 approached.

Fields spent New Year's Day entertaining a packed house at the Orpheum in Memphis. A new contingent of players joined him. Among them were the famous husband-and-wife actors Sidney Drew and Gladys Rankin, who appeared in a one-act play. Presenting playlets with actors from the legitimate fields exemplified the goal of Beck and other big-time executives to refine vaudeville and to draw a more upscale audience. The Drews, in fact, were so well known that they replaced Fields as the headline act. At his next stop in New Orleans, Fields was a hit.

"[He] entertains with the cleverness of his act," reported the *Times-Democrat*. If he misses a trick, "the audience is made to believe it was intentional."[26]

From New Orleans, Fields traveled north to Cincinnati where he joined the Keith Circuit and made other stops in midwestern cities, including Cleveland's 3,000-seat Hippodrome, where "he carried off the honors of the bill on a silver tray."[27] At Pittsburgh a spectator named Pat Lacelle saw Fields jam his cue through his pool table by using a disguised hole. Lacelle tried to imitate the trick at a local billiard parlor and proceeded to make a large dent in the table. Spotting the damage, the parlor's owner called the police, who arrested Lacelle and a judge sent him to the workhouse for thirty days.

After performing engagements in upstate New York, Fields joined Sylvester Poli's New England circuit for three weeks in Massachusetts and Connecticut. A shrewd Italian businessman who started as a sculptor and became the king of New England vaudeville, Poli booked performers who had an unscheduled week. Rather than not working, they accepted less salary. "Why lay off? Cop this dough," the agent William Morris advised his clients.[28]

While performing at Poli's theater in Hartford, Fields received news that his seventy-three year-old father died from intestinal and bladder cancer on April 15. His son regretted that he had not seen much of his father in his later years since he was always on the road. With money from a Civil War pension and from his son, Jim had retired as a produce merchant at age 70 in 1910. Among the few letters that survive between them is a warm one that his son wrote in 1906 about regularly sending him money now that he was making $350 to $375 a week. "Your welcome letter in hand, and contents noted, glad to know all at home are well . . . I am enclosing you five dollars in this letter and will enclose five every week. Love to all, your son Claude."[29] Several photographs show Jim playing with Fields's son at the seashore in Atlantic City. The companionship of Claude Jr. gave Jim great pleasure during his later years. But the enjoyment of having a grandson only slightly moderated the tension between Fields and his father.

Given that both had headstrong personalities, a resolution between them was impossible. As Jim aged, his overbearing strictness and harsh temperament had mellowed. As his son matured and grew worldly, Bill lost part of that youthful whippersnapper attitude, which had ignited the firestorms with his father. The impenetrable wall between the two nonetheless never split apart. The trait that made reconciliation unattainable

for his son bears repeating. Fields found it impossible to forgive any person who had chastised him. The pain that his father inflicted on him as a youth became a wound that never healed. Cold, distant, and authoritarian, Jim failed to give his oldest son the fatherly nurturing he needed. As if it was a family curse, Fields behaved the same way to his own son—a conduct that precipitated an estrangement for years.

To his credit, Fields gave his father a decent burial. Two days after his death, Jim was laid to rest in the modest family plot at the Greenwood Cemetery. Fields purchased the tombstone which read:

<div style="text-align:center">

DUKENFIELD

JAMES L.

FATHER

1841–1913

A GREAT SCOUT

</div>

A metal rod with a GAR emblem on top, which honored his father's service in the Civil War, was placed in the ground next to the gravestone. Attending his father's funeral must have been an extremely trying time.

His return to the stage took his mind off the heartrending event. The month of May became one of his most exciting times on the vaudeville trail. Willie Hammerstein engaged him for a two-week return visit to the Victoria. Afterwards Fields appeared at the new Palace Theatre located in Times Square at Broadway and 47th Street.

How the Palace became the crown jewel of the big-time is an intriguing story that reveals the cutthroat practices in the vaudeville business. Instrumental in initiating the Palace was the Orpheum's Martin Beck, who wanted to present high-class acts starring top vaudevillians and celebrities from the legitimate theater. But a territorial agreement between the Orpheum and the Keith-Albee Circuits permitted the Orpheum to operate theaters only from Chicago to the Pacific Coast. The East was Keith territory. If Beck proceeded with his plans, Albee threatened legal action and warned that every performer who played the Palace would be blacklisted. Fearing a collapse of the Orpheum's territorial alliance, Beck capitulated, and the Keith-Albee Circuit gained controlling interest in the Palace. As a consolation prize, Beck was awarded the privilege of overseeing the bookings.

When the Palace opened with fanfare on a cold, rainy night on March 24, B. F. Keith's name sparkled on the marquee. The nearly 1,800-seat

theater, which cost $1 million to construct, was lauded for its stunning decor. A lobby in Pavanezzo marble led to an inner lobby embellished with Sienna marble. The luxurious auditorium with its excellent sight lines and acoustics featured sparkling crystal chandeliers hanging from the ceiling and seats upholstered in beautiful flowered cretonne. The interior housed an art gallery with rare paintings, a ladies' powder room decorated in the Louis XV style, and a men's smoking room in the Elizabethan mode. For performers, there were thirty-two private dressing rooms, a large lounge, and a reading room.

The Palace's fame did not happen overnight. The theater initially lost money due to mediocre acts, poor reviews, and high admission prices, which kept average-income earners away. During May the Palace gained prominence with the appearances of "Divine" Sarah Bernhardt and her company, which presented scenes from her famous plays at sold-out performances for three and a half weeks. At the age of sixty-eight the famous French star had lost some of her brilliance due to physical ailments. In her Palace debut, Bernhardt consequently appeared less self-assured in her movements, walked slowly around the stage, and sometimes sat in a chair. She nonetheless wowed the crowd with her charisma. Due to the famous French star and other high-class turns, the Palace soon became the nation's most prestigious vaudeville theater.

Bernhardt had signed a contract with Beck for the record-breaking salary of $7,000 a week with the proviso that she could approve other acts on the playbill. She refused to perform with blackface acts, acrobats, animal acts, and jugglers, among others. At the start of her third week Bernhardt told the manager to remove a circus specialty from the playbill (she was an avid animal rights advocate). As a replacement she recommended Fields. He is "a rare artist" different from run-of-the-mill jugglers. I have seen "his performance from the wings several times. I appreciate both his humor and extraordinary dexterity." When he heard the news, Fields grew excited about playing the Palace. He was listed in the third spot in the program, which featured besides Bernhardt the raucous singer Bessie Wynn; Robbie Gordone and her company doing tableaux scenes; and Owen McGiveney impersonating characters from Dickens's *Oliver Twist*. Silverman gave Fields's performance a rave review. "The Palace Theatre maintains a certain atmosphere by the magnificence of its construction and appointments. Fields, with his high art pantomime comedy juggling, belonged to that atmosphere as much as the marble base of the box seats."[30]

Playing the Palace signified that Fields had finally attained the peak of success in vaudeville. A glowing performance at the Palace became the

goal of every big-time vaudevillian. Looking back, Fields's tortuous climb uphill toward the Palace felt like ascending a never-ending maze of zigzag trails to the top. Due to his success at the Palace, Fields had reached a new zenith in his stage career. He could not have hoped for a better send-off when he boarded the *Kaiser Wilhelm Der Grosse* in late May for a six-month tour in England. As the boat departed, he had no idea that Sarah Bernhardt would play another significant role in his life.

# 15. The Second Home ❧

"I'm quite as much home here as in America," Fields told a reporter from a British newspaper. "I have a great regard for the English music halls. The best audience I ever played to have been in the west-end halls of London."[1] Many reasons prompted Fields to undertake half a dozen trips to England during his vaudeville career. In the summer many American indoor theaters were closed due to inadequate cooling ventilation, while most music halls stayed open during the summer. Compared to home, the distances between engagements were less so that performers rarely missed a weekly pay check. Although a silent humorist, he had no language problem in England whenever he might mumble or make an unexpected comment. Salaries were slightly lower in England but the cost of living was less.

Under the British entertainment system, performers often signed contracts one to several years in advance. These agreements gave theater owners and actors guaranteed bookings. The play-or-pay contracts, however, were difficult to break and carried financial penalties if the performer failed to appear. The long-term contracts, however, gave Fields assured engagements each time he left the United States.

Due to his many tours, Fields became well known in England. Numerous photographs of Fields appeared in widely circulated British stage weeklies. Some depicted him in various costumes; others in everyday attire. Since billiards was a popular game in England, fans especially enjoyed the way he made the balls disappear in one stroke. Lured by his affection for Britain and its theaters, Fields kept returning year after year.

Fields belonged to a lucrative transatlantic trade that sent American performers to Europe and British thespians to the United States. Representatives of big-time circuit owners in European capitals sent the best talent to America and international agencies in New York booked performers to cross the Atlantic. Numerous British music-hall stars appeared on US vaudeville stages such as Harry Lauder, Albert Chevalier, Beatrice Lillie, Alice Lloyd, Vesta Victoria, and Vesta Tilley. The most popular British turns were in demand by American theater managers, who paid

whopping four-figure salaries. Both Lauder and Vesta Victoria, for example, received $2,500 a week.

Business in the music halls and variety theaters soared during the time Fields performed in England. The popular theater flourished due to a number of economic factors: rapid urbanization, improved railway transportation, and economic growth. A night at a variety theatre drew patrons from the affluent to the middle class. "It was an era when the new wealth of the financiers was added to the old wealth of the great families of landowners," wrote J. B. Priestley. A surge in the number of white-collar office workers produced a large clientele who earned enough money to buy a ticket. To serve theatergoers, almost every city in the provinces had at least one or more halls, and London and its suburbs were overrun with venues. But the popularity of the variety theatre disguised a growing social unrest in British society. Prosperity had not filtered down to the working class. Edwardian England remained beset by class divisions with the upper crust living in luxurious splendor exhibited by high-society balls and glamorous garden parties. By contrast, the poor toiled seventeen hours a day, seven days a week for thirteen cents an hour in grisly factories and lived in squalid conditions. Priestley saw "millions, still engaged in sweated industries, living in the slums condemned in theory but not in practice, in mean streets just behind the mills or close to the coal pits, in sweet cottages that were menacing unsanitary." The dire circumstances that drove Fields's ancestors to leave the county had not improved.[2]

During his numerous trips to his father's home country, Fields never wrote about the social conditions among the poor. One reason is that he was a Social Darwinist who believed that survival of the fittest applied to humankind's ability to succeed without help. Another is that he had not yet developed his biting iconoclasm that later ripped apart injustices in all walks of life. He did, however, possess a social consciousness from the time he saw poverty in Philadelphia's squalid slums and witnessed the hard times of his family. The Dukenfields had left Sheffield in pursuit of a prosperous life in Philadelphia only to find adversity. Fields's tramp outfit sent a message to theatergoers that hunger, unemployment, and deprivation ran rampant in American society. In an unbridled money-making economy the affluent could lose their wealth overnight and end up as homeless hobos seeking handouts.

The contrast between Fields and another tramp comedian, Charlie Chaplin, is illuminating. Born nine years after Fields, Chaplin's early life in the London slums profoundly influenced his concern for the poor, and

his films echo the pain and deprivation of his youth. Chaplin graduated from the British music hall to the cinema much quicker than Fields, who made two silent shorts in 1915 and did not return to the screen for ten years. Chaplin's head start left Bill so far behind that he was unable to overtake Charlie's reign as the nation's foremost silent comedian.

Like Fields, Chaplin's experience as a music hall performer provided an influential training ground for the development of his numerous skills, especially his brilliant talent for pantomime. Their paths almost crossed when Fields entertained in Dublin during the week of June 21, 1909. That same week Fred Karno's troupe performed in Belfast the sketch "Mumming Birds" (called "A Night in an English Music Hall" in the United States) in which Chaplin impersonated a comic drunk who heckled the actors from a box in the theater. Karno's troupe performed "Mumming Birds" in Dublin two weeks later but by then Fields had returned to England. Since Fields and Karno's company were headline acts on the Empire Circuit, they never appeared on the same playbill. The two would later meet on several occasions in the United States.

Another reason for England's burgeoning variety theater was the formation of several syndicates that controlled the first-class provincial and London showplaces. Like the domination of big-time vaudeville by an oligopoly (Keith-Albee and Orpheum), the music-hall business also experienced consolidation. Of the 123 music halls listed by the *Performer* in 1907, 74 belonged to the 7 largest syndicates. During 1908 Fields had a 16-week commitment to perform in theaters operated by the Moss Empires Circuit and Stoll Companies, England's most powerful syndicate. The combination derived primarily from a 1900 merger of Empire Properties owned by Sir Edward Moss, a Scottish entrepreneur, and Sir Oswald Stoll, the circuit's managing director. By 1906, the Empires Circuit operated thirty-six venues—nine in London and twenty-seven in the provinces. The Empires–Stoll combination could send entertainers on long tours like the Keith-Albee and Orpheum circuits. Capitalized at more than two million pounds, the circuit claimed to be "the greatest aggregation of variety theatres in the world."[3]

Similar to the American big-time, syndicate theaters catered to a wider audience by presenting wholesome shows in palatial-like surroundings. The company stressed clean entertainment by instructing performers that "their business must be clear from all vulgarity."[4] To distinguish their programs from working-class music halls where liquor flowed and prostitution reigned, the owners increasingly called their shows refined entertainment and their venues variety theaters. As a popular comic juggler

who appealed to both adults and children, Fields's routine was exactly the type of wholesome entertainment that the Empire–Stoll syndicate owners liked. Because of his popularity, Fields performed at their theaters during his next four trips in Great Britain.

If a playbill featured an English music-hall star, Fields never appeared as the headliner. As mentioned earlier, British fans remained loyal to their own luminaries. American entertainers therefore rarely received top billing when competing against noted British music-hall performers. Thus at the Empire theater in Leeds during the week of June 29, 1908, Hetty King, a famous male impersonator, was the headliner rather than Fields.

Preferences for English hometown favorites sometimes spawned incidents. In London, Fields was once heckled by a spectator because the theatergoer resented the fact that an American boxer had recently defeated an English fighter. "Don't go to Great Britain 'at the time some American boxer or athlete beats'," an Englishman warned Fields. Another time he was heckled by a man in the audience. Going to the front of the stage, Fields told the spectators about a similar experience when he was jeered by a man who had escaped from an insane asylum. "The keeper of an insane asylum came down the aisle and took the poor chap out and back to the institution."[5] Fearing he might be brought to a mental institution, the present heckler decided to keep quiet.

As mentioned previously, Fields had learned that the cold damp winters in England played havoc with his propensity to catch colds. The theaters, moreover, were not heated during the winter. "You can't juggle with cold fingers," he told a reporter. "In order to keep my fingers warm enough to go through my turn...I had to carry a small oil stove with me all over the country." When he entertained in England during the winter of 1911–12, he caught a bad cold that assaulted him for months. "I had my worst attack of grippe about five weeks ago and even to-day as I write I have a high temperature and feel 'Purdy Rockey' [sic]," he wrote to Hattie from Glasgow.[6]

"I like England," Fields stated, "particularly in the summer time, because there are fine roads for automobiling." In 1910, he shipped an American Underslung automobile to England. Its name derived from its upside-down design that hung the chassis beneath the axles and the suspension system placed above. Marketed as "The Car for the Discriminating Few" by its manufacturer, the American Motor Car Company, the expensive automobile had various models that sold between $1,250 and $4,000.[7]

The Underslung whetted Fields's appetite for driving fancy cars at high speeds on the open road. He once took a friend for a ride and asked him to watch the speedometer so he could keep his eye on the highway. Fields

drove his car as fast as he could over a country road. When he put his foot on the brakes, he turned to his friend: "Well, old chap, how fast did she go?" "Well, the fact is I was so busy looking for a soft spot to fall on that I forgot all about the speedometer."[8] Bill drove his car to Antwerp for a one-week engagement where he discovered that its forty-inch tires were worn and that they were not available in Europe. He consequently needed to leave the car in Antwerp for several months until he received new tires.

The expensive purchase of the Underslung illustrated Fields's upscale lifestyle. In order to avoid any confrontation about the auto's cost, he never told Hattie about the car. Since she was living solely on the money he sent her, his wife would surely view the acquisition as an extravagance and complain about her small weekly allowance. Performing in England provided an escape from face-to-face venomous encounters with Hattie.

But there was a definite downside to the long time he spent in England. By making regular tours abroad from 1908 to 1914, he missed some of his son's most crucial development years from four to ten years of age. His absences allowed Hattie to dominate Claude's upbringing and to shape his attitude toward his father. She naturally created a very unfavorable picture of Claude's father, a distortion that emphasized the terrible deeds he did. Claude's impression of his father was so indelibly cemented in his mind, it never entirely vanished. All Fields could do while abroad was to ask Hattie to convey his love to his son. "I hope my son is well and enjoying himself. If he is learning to write at his school please tell him to write me a letter, once in a while. Give him all my love."[9] By choosing to become an itinerant showman, Bill suffered a frightful casualty—an endangered relationship with his son.

Fields's 1908 itinerary was a whirlwind tour of the large provincial cities and included many engagements in London and its suburbs. After performing in Birmingham, he headed south to London where he appeared at Shepherds Bush's Empire (1903) in the suburbs. With its 1,638 seats, the theater illustrated the Empires Circuit's goal to build theaters for a growing audience in the city's environs. The venue was designed by the prominent architect Frank Matcham, who built numerous lavish theaters for the circuit. He became known for his ornate and eclectic facades that successfully blended numerous motifs. Fields headlined the playbill and received a thunderous ovation. "Richly deserved," commented *The Era*'s critic: "A more delightful, a more amusing and a more clever juggling act we do not remember to have seen."[10]

Bill travelled as far north as Glasgow, Scotland's largest city, where he performed at Matcham's attractive neo-Renaissance Empire Theater

(1897). By the early twentieth century, Glasgow's industries and commerce had produced a large middle and working class that supported a vibrant theater culture that was second only to London. Seating 2,500 spectators, the Empire was known for its critical audience who demanded first-class entertainment. The venue was called the graveyard by comedians who flopped and never returned. Fields, however, did not "die." Dressed in tattered clothes, including a well-worn faux sable coat bought for seventy-five cents from an actor and wearing a scruffy unkempt beard, he wooed the crowd with his amusing manipulation of three Indian rubber balls and pantomimic gestures. "His facial-by-play and the expression of his feelings by weird noises are irresistibly comic…If you miss W. C. Fields and his tricks you will miss one of the best turns in that particular line of business which America has yet sent us."[11]

Pleased by his reception in Glasgow and other cities in the provinces, Fields returned to London where he performed again at the huge Hippodrome during August. Fields's appearance in a rumpled tux rather than as a tramp complemented the Hippodrome's stylish environment. The critic for *The Era* liked his change in attire: "He discards the dirty make-up and ragged garments of the tramp, and for this relief much thanks."[12] Fields's pool table routine dazzled the audience. Using his cue, he shot tennis balls disguised as real pool balls toward the top cushion from where they rebounded into the roomy hip pocket of his waistcoat. With brother Walter pulling the invisible strings, Fields finished his act by making all fifteen balls disappear into the pockets with one stroke. He then walked off the stage to the tune of "The Man Who Broke the Bank at Monte Carlo," leaving the stunned audience wondering how he did the trick.

Fields's routines primarily remained the same as he journeyed across Britain. To draw laughter, he still intentionally missed juggling tricks, incoherently mumbled to himself, and entertained the audience with his hilarious pantomimic gestures. "He would reprimand a particular ball which had not come to his hand accurately, whip his battered hat for not staying on his head when it ought, mutter weird and unintelligible expletives to his cigar when it missed his mouth," wrote his British agent "Bucky" Buchanan-Taylor. A critic who watched Fields perform later at the Coliseum wrote: "His travesty of billiard playing—a ludicrous exhibition of deadly earnestness and incorrigible blundering—caused uproarious mirth."[13]

Fields made his inaugural debut during late October at Sir Oswald Stoll's majestic 2,358-seat London Coliseum (1904) on St. Martin's Lane near Trafalgar Square. Another Matcham theater, it featured an

impressive neo-Romanesque facade with a tall tower topped with a revolving globe that spelled out the theater's name. To draw an upscale audience, the Coliseum's elegant interior was lavishly decorated, especially the Grand Salon embellished with alabaster friezes, marble pilasters, and a gold-painted ceiling. For the attendance of royalty, the Coliseum featured a separate entrance with an opulent moveable lounge attached to car tracks, which led directly to the Royal Box. But the "King's Car," as it was called, failed during its first use. While transporting King Edward VII and his party, it blew a fuse causing the apparatus to be stuck on the rails. The King found the incident hilarious and laughed all the way to his box.

Fields once said that he performed before Edward VII. He went on stage and with arms extended walked toward his Majesty as if he was greeting a good friend. To prevent him from insulting the King, the curtain suddenly descended. He returned to the stage two more times to perform the stunt that he had arranged with the stage manager. Fields recalled: "As the curtain rose each time, the audience would see me crestfallen, then pick up hope and go forward again...I can still see the King smiling." After his performance Fields stood outside in front of the theater when the manager told him, that "a gentleman wishes to greet you." The gentleman was King Edward VII. "He greeted me courteously and congratulated me upon making so much merriment at his expense." Fields called the King "a majestic man." The episode was never reported in an English newspaper, but Fields only told his friend Jim Tully, a rough-looking, colorful Irishman whose adventurous life started as a hobo and pugilist and ended as a Hollywood publicist and prolific unheralded novelist. Fields's hyperbolic story resembles the many tall tales he concocted for gullible readers of movie magazines.[14]

At the Coliseum, Fields encountered Oswald Stoll, one of the most influential figures in British popular theater. Besides partnering with Moss in the Empires Circuit, he also owned theaters such as the Coliseum. An imposing figure, Stoll resembled a banker with his grey frock coat, black trousers, raised collar embellished with a cravat and pearl pin, and an au courant top hat. The impresario believed in keeping his venues spotlessly clean. He once reprimanded a theatergoer for dropping a lighted cigarette on an expensive plush red carpet: "Pardon me, sir, but you wouldn't have done that in your own home, would you."[15] Possessing a reserved snobbish personality, many performers found Stoll cold and ruthless in his business dealings. After Moss died in 1912, he became the most powerful impresario in the country's variety theater enterprise.

Insisting on refined entertainment, Stoll barred blue jokes and lewd songs, and carefully vetted every act. A contract with the Stoll and Empires Company carried the following warning: "Artistes giving expression to any vulgarity or words having a double meaning or using any objectionable gesture when on the stage shall be liable to instant dismissal and if dismissed shall forfeit the salary for the current week... The management may prohibit any part of the performance which they consider unsuitable or displeasing to the audience." When the "red-hot" jazz singer Sophie Tucker refused to cut a racy line from a song, Stoll had the manager drop the curtain during her performance. According to her contract, every song had to be approved by the management. She angrily barged into his office: "Mr. Stoll, you shouldn't be the manager of a vaudeville theatre. You should be a bishop."[16]

There were other stipulations in the contract: artists had to submit all billing matter, programs, and advertisements three weeks before their engagement; report promptly for rehearsals; and appear backstage five minutes before the theater opened. Any performer found intoxicated was fined one week's salary or fired. The option clause gave the management exclusive rights to reengage the artist within eighteen months of the signed contract. Since Fields was a favorite with the managers of the Empires

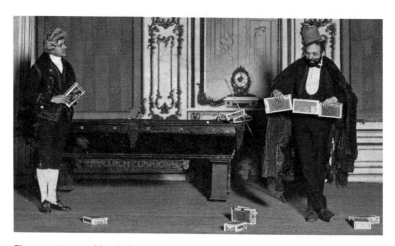

**Figure 15.1** Fields performing his cigar-box trick at the London Coliseum. October 1908. He wears his signature tattered coat, false beard and mustache, flat shoes, battered top hat, accompanied by his inevitable cigar. Walter, his assistant, adorned with wig and dressy clothes, stands to the side. In the background is the rigged pool table that Fields used to pocket all the balls with one cue stroke. Courtesy W. C. Fields Productions, Inc., www.wcfields.com.

Circuit, this provision assured him of future bookings. Like the Keith and Orpheum circuits, the syndicates regulated salaries. For their protection, performers formed the Variety Artists' Federation. A year before Fields's arrival, the union ordered a strike against the owners that granted troupers a few basic rights, including an end to unpaid matinees.

At the Coliseum, Fields was billed below two variety stars, the brilliant impersonator Cecilia "Cissy" Loftus and the charming French chanteuse Yvette Guilbert. He consequently needed to be at his best to stand out. Instead of his tramp attire, he wore a tattered faux sable bought from a down-and-out actor for seventy-five cents over rumpled evening clothes that matched the backdrop, a painting of an elegant drawing room. Standing beside the pool table was Walter dressed like an eighteenth-century gentlemen wearing a fancy embroidered costume and a wig. No one could tell that these two brothers were once boyhood ruffians from rough Philadelphia neighborhoods.

Was Fields mocking the rich? The combination of his ragged sable coat, crumpled attire, and bizarre clowning could easily lead a spectator to interpret his routine as a slap against the wealthy. If so, this was Fields's initial attempt to parody the manners, pomposity, and foibles of the upper crust as he later did in his films.

Fields's attitude toward the British aristocracy is revealed in his stage sketch, "The Caledonian Express" (1922). Although there are several drafts of the skit, the plot that takes place at a Scottish train station is essentially the same. The story concerns the stubborn American Ed Breeze accompanied by a beautiful English girl who boards a compartment reserved for a Lord Robert R. Roberts. The girl insists that they should leave: "Really, you're not in Yankeeland now, and this thing is not tolerated here."[17] Slightly drunk and smoking, Breeze refuses to move and confiscates the reserved sign from the window. Several people attempt to remove Breeze: the Lord, his secretary, a porter, a guard, the conductor and stationmaster, and a police officer. Breeze, however, refuses to budge and wins the argument. Drawing on an actual experience as many of his sketches do, Fields based the skit on a train ride he took from Glasgow to London and refused to leave a reserved compartment. The sketch was first performed on the stage in *Earl Carroll Vanities* (1928) and a variation appears in Fields's last film, *Sensations of 1945*—another instance of his fondness to transfer his stage material to the screen.

To avoid the English winter weather, Fields sailed back to the United States in mid-November, but by mid-May 1909, he was back in England in time to begin his tour at the London Coliseum. Two headliners topped

the lengthy program: the enchanting avant-garde dancer, Ruth St. Denis, who performed a cobra dance and again "Cissy" Loftus. Despite not being the headliner, Fields held his own. "American humor is well represented by W. C. Fields, who gets away from the beaten path of the juggler, and devotes himself to furnishing the audience with the unexpected, and its happenings are invariable droll," wrote *The Era* critic. The unforeseen—taking the audience by surprise when they think something else is going to happen—became one of Fields's means to gain laughter. He next toured the Empire theaters in the provinces and the London suburbs. In Manchester, Fields was hailed as "undoubtedly the greatest of all eccentric jugglers" and in Birmingham the reviewer felt that it was "impossible to keep a straight face whilst W. C. Fields, the American, is on the stage here."[18]

Four months later, he left England for a tour of the Keith Circuit. A passionate Anglophile, W. C. seemed increasingly more at home in England and regretted his stay was so short. The British audiences adored him and he had many more opportunities to headline at their variety theaters. Eight months later, Bill returned on the Cunard Line's *Mauretania* for his longest tour of England and the continent that lasted from June 1910 to March 1912—a period of twenty-two months of engagements.

Stepping off the boat in Liverpool on June 7, he felt contented that he was back. England was like a breath of fresh air, an escape from his constant battles with Hattie and a place where he was warmly greeted by the British. The English were still in shock from the sudden death of King Edward VII a month earlier and the ascendancy of King George V fifteen days after Fields arrived. With its massive assemblage of royalty, aristocracy, and ambassadors representing seventy nations, the pomp of the King's funeral was without equal in British history. Huge crowds gathered along the route of the royal coffin on its way to Windsor Castle to pay their respects to "Good old Teddie," as he was affectionally called by his subjects. Fields had set foot in a different country about to enter four years of turmoil from 1910 to 1914, a period that set the stage for the start of World War I.

During his nearly two years abroad, Bill pursued a grueling, marathon tour. Fields first traveled to Glasgow for a week's turn at the Pavilion starting June 13. From here he wrote Hattie assuring her that he would send money each week. "I wish though that you would save a few dollars each week in case I have an accident," he added.[19] After closing in Glasgow, he crossed the rough North Channel by ship in order to reach Belfast in time for his June 20 opening at the city's Hippodrome. Then it was back to England for a tour on the Empires Circuit. He performed in middle-sized

cities such as Ashton and Preston as well as larger urban areas, including Manchester and Liverpool.

Bill spent autumn on the continent where he performed in Brussels, Copenhagen, and Berlin. The trip's highlight was a return engagement at the Wintergarten. From his window at the luxurious Central Hotel located next to the theater, Fields could see the leaves turn a bright yellow and red. Compared to his first trip, Berlin had become more prosperous with its strong financial and thriving industrial system. In the air was the rise of German nationalism and militarism incited by the country's bellicose leader, Kaiser Wilhelm II. A renaissance simultaneously occurred in the German arts from the avant-garde music of Richard Straus to the philosophic writings of Nietzsche, which venerated the *Ubermensch*. The legitimate theater produced a wave of new playwrights and the popular theater was at its peak.

The Wintergarten remained as popular as ever with Berliners anxious to be entertained by the world's best performers. The venue had hardly changed since Fields's first appearance. The floor was covered with row upon row of tables where patrons ate bratwurst and drank from steins full of frothy beer. In the auditorium, joviality reigned supreme as spectators watched a fast-paced show, which matched the rapidity and energy of pre-war Berlin. Theatergoers in the huge hall roared with gales of laughter so loud that they could hardly hear the performers. Fields went over bigger than his initial visit because the buffoonery he had added was just what the fun-loving Germans craved. Despite the ovation and excellent reviews, Bill was rarely content with his act. Obsessed by perfection, he constantly felt pressure to enhance his routine by adding new stunts, costumes, and pantomimic movements.

Afflicted by chronic insomnia, he spent his nights plagued by thoughts on how to keep his name before the public. He dreaded failure. "I had the feeling that although I didn't actually have anything right now, I was working to have something soon," he divulged to a friend. After ten years on the grueling vaudeville trail he still did not know where he was headed. "I think that was the part that got to me—all was going fine, but I didn't <u>have</u> anything, somehow. I was on a train rushing toward a good place, but I couldn't seem to get there."[20] His thirst for fame always seemed elusive, continually beyond his grasp. Only his most trusted friends knew how insecure he felt.

By December he was back in Great Britain. He wrote Hattie two days after Christmas that he was not coming home "until the latter part of 1911 this saves me much expense and open time."[21] He still usually sent Hattie

$35 weekly, a small percentage of his earnings. Among his contracts, Fields saved one that listed his salary at £70 or about $300 a week to appear in early April 1911 at the Grand Theatre in Bolton. At famous London venues he earned between $400 to $500 weekly, average compensation for a popular artist but below famous music-hall stars who received £500 to £1,000. He justified his sparse allowance to Hattie on the grounds that he was working hard while she was sitting home with no thought of supporting herself. Fields believed that he deserved the amenities his salary purchased—luxurious hotels, fancy cars, fine restaurants, and first-class transatlantic ship accommodations.

Bill had signed contracts to entertain again at the Empire theaters. He received favorable reviews when he headed the playbill at the Empire in Hackney, a borough of London, during Christmas week 1910. "The place of honor is filled by W. C. Fields, who goes far to justify his program description as the 'greatest of all eccentric jugglers,' reported *The Era* critic. "This artist stands well in the select circle of supreme jugglers, and only the great amount of comedy introduced into his turn could tend in any way to obscure the fact that Mr. Fields's whole act is exceptionally clever. The audience was quick to appreciate his marvelous dexterity, and he deservedly gained a great reception."[22]

When he returned home in March 1912, the United States seemed like a foreign country after nearly two years abroad. As mentioned previously, his fourteen month tour culminated with his hit performance at the Palace. He hardly had time to celebrate since he was scheduled to return to England. After he arrived at the port in Plymouth on June 2, 1913, he quickly headed to Leicester, a provincial capital in central England, in time to open as the headliner at the Palace Theatre of Varieties on June 9. The 2,750-seat theater, designed by Frank Matcham, typified the elaborate houses that had sprung up in England's provincial capitals, industrial cities, seaside resorts, and heavily populated suburbs to attract a larger audience. Fields performed two shows a night as The Silent Humorist or what the English called noises off (a nontalking "dumb act" in the United States). His new billing demonstrated that pantomimic comedy had now become the centerpiece of his act.

During an engagement at the Empire in Sheffield in early September, Bill might have recalled that the industrial city was where his father had lived before immigrating to America. Sheffield was also where he had first heard news of his son's birth nine years ago. While in the city he wrote to Claude Jr. thanking him for his letter that he had sent in August. "It is the first you have ever written to me. I am pleased to hear you are having such

a fine vacation…Wish you would write me from time to time letting me know what progress you are making at school…Will bring a football back with me."[23] He felt thrilled that his nine-year-old son was finally writing to him but also regretful that he had rarely seen him due to his travels.

In England Fields was represented by his friend "Bucky" Buchanan-Taylor, who operated a booking office in London on Charing Cross Road. His agent placed two large advertisements in show business papers that promoted Fields as "The Silent Humorist" and highlighted his upcoming multi-week engagement at the London Coliseum. "The greatest of all jugglers is back in England," the ad proclaimed. "He has lots of new tricks and they are all funny."[24]

His engagement from late September to mid-October at the London Coliseum was fortuitous. During his second and third week, he was on the program with Sarah Bernhardt, who performed scenes from her repertoire. A reporter asked Bernhardt again why she permitted Fields, a juggler, to perform on the same playbill. He was an artist "who could not fail to please the best class of audience," she replied.[25]

On October 11, Bernhardt was scheduled to perform before King George V and Queen Mary and their family at the Coliseum, a Good Samaritan benefit to aid London's French and Charing Cross hospitals. The Divine Sarah recommended that Fields participate in the evening's entertainment. Oswald Stoll agreed and asked the Majesty's Office to include him on the program. After the office approved his participation, he received a letter from Stoll inviting him to the royal performance: "Sir William Carington, Keeper of the Privy Purse, informs me that his Majesty the King has graciously approved of my including your name in our programme."[26]

The evening was electrifying. The Coliseum's auditorium was festooned in golden colors. Hanging from the dome were rows of golden garlands illuminated by electric lights, which produced golden rays from thousands of bulbs. The marble columns were bedecked by golden sprays and the boxes were decorated with green foliage and abundant flowers. The theater's three thousand seats were sold out as well as standing room. Outside thousands of people gathered to watch the royal party enter the theater. Arriving at the white and royal blue reception room, the king and queen were greeted by Stoll and others dignitaries. Joining them were numerous members of the royal entourage, including their children, the Prince of Wales and Princess Victoria. The royal family was well aware of being associated with celebrities from the theatrical world. They had earlier faced a scandal when King George's father, Edward VII as Prince of Wales, had pursued a notorious affair with the stage star Lillie Langtry.

The program began with the national anthem followed by the famous leading lady, Ellen Terry, reading the prologue. The long playbill featured music-hall luminaries, including Yvette Guilbert, Maud Allen, George Robey, and Harry Tate. Both Tate and Fields performed billiard, golf, and motoring sketches; the latter two Bill premiered in the *Ziegfeld Follies*. The music-hall star might have influenced Fields to use similar settings, but Tate's turns are much more riotous, bombastic, and dependent on comic repartee. Bernhardt was scheduled to perform Act 2 of Rostand's *La Samaritaine,* but the sordid details of a prostitute gaining redemption through Christ's teachings was removed from the program due to the king's objections and instead she performed scenes from Racine's *Phèdre.*

As the sole American to perform, Fields wowed the audience with his juggling and pool stunts. "Mr. Fields appeared to suffer very little from nerves, and his juggling feats were carried out in his usual accomplished fashion," wrote a reviewer. The *Daily Mail* reported that Fields's "nonsense with the billiard balls and a trick table caused great amusement to Princess Victoria." Even the queen "rocked with laughter at the vagaries of Mr. W. C. Fields, the remarkable pyramid player." Concluding just before midnight, the "Marseillaise" was played to honor Bernhardt followed by "God Save the King," which drew a rousing cheer from the audience. "What a feast!" exclaimed a columnist.[27]

Two dramatic actors, Ellen Terry and Sarah Bernhardt, were the only artists invited to meet the king and queen afterwards at a reception. Although there were many more music-hall performers on the program, the snub signified that the legitimate stage was still the favorite among the aristocracy. A few days later, Fields received a letter from Stoll thanking him for his appearance: "You will be pleased to hear that on leaving both the King and Queen expressed to me their great delight at the success of the performance; and I think that you yourself would have noticed how greatly their Majesties and the rest of the Royal Party enjoyed themselves."[28] After the benefit, a large crowd of fans stood outside the stage door to see their favorite entertainers. The popular comic vocalist George Robey began singing for the throng and encouraged Fields to join him. Fields next performed his juggling tricks, which delighted the many children. His appearance at the invited benefit became the high point of his many tours in England.

Fields's appearance before the king and queen boosted his standing before the public. After the event he was the headline act at the Shepherds Bush Empire. "Direct from his appearance before their Majesties" ran the advertisement. He continued to be the principal attraction at other Empire

theaters during October and November. Reviews pointed out that Fields had successfully blended juggling and comedy, and the combination made him stand out among his rivals. "Jugglers are as common as daises in June, and comedians are ever more plentiful," commented a reviewer, "but there is only one man who has really combined the two, without sacrificing one or the other." Another critic wrote: "He never speaks, but the audience roars at his lackadaisical manner of going about his tricks. It is not until afterwards that a realization of the wonderful dexterity of the man dawns on one. That is the true art of entertaining."[29]

Back in England he was lured by lucrative contracts to tour the Antipodes again. "He has just been booked by Rufe Naylor for a six months' tour of Africa, Australia, and India," the *Chatham Standard* reported on November 19.[30] He had earlier written his son that he hoped to return to the United States in January. But once again his adventurous spirit trumped family. Fields decided to travel to the Antipodes even though he would lose salary during his long time at sea. It took four weeks to travel to South Africa, three weeks to go to Australia, and seven weeks back to the United States.

Bill warned Hattie that her allowance faced possible reduction due to his mounting expenses and loss of salary while traveling to the Antipodes. His correspondence to Hattie continued to be cold, a couple of sentences justifying the money he was sending ranging from $25 to $35. Hattie's letters constantly pleaded for more money. From Paris, where he was booked during December 1913 at the *Folies-Bergère* and the Alhambra Theatre, he wrote that it would cost him $200 for excess baggage just to cross the Channel and return to London. His transportation and excess baggage to the Antipodes would "amount to a sum that would frighten a man with money," he told Hattie.[31]

Standing by the ship's railing as the vessel left Southampton for South Africa in January 1914, Fields watched the coastline of England slowly disappear. A grey winter sky hovered above. Over the years, his performances in his second home had contributed greatly to his success as a comedian. He was nonetheless happy to leave the cold, damp climate that impinged on his health and looked forward to reaching South Africa at the height of summer. Lurking on the horizon were the omens of a devastating conflagration, which would explode in seven months into a carnage of mass death branded as the Great War for Civilization. As England disappeared from his sight, Fields had no idea that he had just completed his last tour of the country and would never again see the home of his paternal ancestors.

# 16. "They Had Me Sweating Blood" ✑

Arriving in Johannesburg, Fields found the city in utter chaos with the Boers and British again at loggerheads. "Not since the Boers laid down their arms to the Britons in 1902 has the Rand [South Africa] been as near a state of war as it is to-night," reported the *New York Times* correspondent stationed in Pretoria.[1] The turmoil had begun a year earlier when Boer miners went on strike due to a wage freeze. The walkout triggered rioting in Johannesburg between the strikers versus the police and army, a clash that led to the death of twenty-one demonstrators. Although the strike was eventually settled, it inflamed South Africa's civil strife.

In addition, the country was in the midst of a contentious railroad strike due to the nationalization of the railways, which caused job cuts. A general strike in support of the railway workers was called, an action that prompted the government to mobilize reservists. "The town is under martial law and we all must be in bed by eight o'clock each evening and the music-halls are closed." wrote Fields. "It is now eight o'clock and the quiet is absolutely appalling. Not a soul on the streets except soldiers and policemen with guns over their shoulders." The turmoil ended when a large infantry detachment surrounded the strike leaders trapped inside the trade union building. Forced to surrender, eight of the organizers were deported. The tumult reminded Fields of the time he was here in 1903–04. The accommodations were still poor and the food terrible. "I am down here in Africa eating food that would not tempt the palate of a respectable canine," he told Hattie.[2]

Bill finally opened at Johannesburg's Empire Palace the last week in January. During his two-week engagement he presented his juggling tricks and pool routine to a new audience. As the program's headliner, he was billed as the "World's Grotesque Juggler—the Silent Humorist." "W. C. Fields is just the man to cheer us after our dark days," wrote the critic for

the *Rand Daily Mail*. He was amazed at Fields's ability to carom rubber balls over his head and into his back pockets. "Every item is conducted in humorous expressiveness...and fully deserved the ovation accorded him."[3]

Variety theaters had mushroomed since Fields had performed here ten years ago. Bill was under contract to the African Theatres Trust, which operated twenty-four theaters in the country. During February he performed as the headliner in Durban, Germiston, and Pretoria. At Pretoria's theater critics noted that he made "weird sounds" that were synchronized with his stunts—"dumb patter which did not require vocal expression." In Durban, he scored another big hit. "He keeps the house in a state of continual laughter" and was "called back half-a-dozen times."[4]

His unnerving experience in South Africa left no toleration for Hattie's complaints that he lived a life of luxury while she scraped together every penny to live. From Johannesburg he wrote: "Received your wail concerning my picnic and your drudgery...You are constantly kicking about the difficulty of making both ends meet and want to put the bee on me for a few extra dollars...My lot isn't a bed of hollyhocks and every year the task becomes more difficult and I am not getting any younger." The fact that she was not earning any money by working bothered her husband. As a strong believer in self-reliance, he thought she lacked the perseverance to improve herself. "I noticed you gave up the idea of duplicating my act when you discovered it involved hard practice." Why don't you "devote more of your leisure time to study or occupation that will get you a few elusive coins occasionally? Think of someone else who has it as soft as you...I am sending more now that I can really afford so...be satisfied with an even break."[5]

Was Fields giving Hattie an "even break"? According to the contract he had signed with the African Theatres Trust company before leaving England, he was receiving £100 (equal to about $500) per week including first-class transportation via steamer. While in England, he had secured another lucrative contract from Harry Rickards's Tivoli Theatres circuit to perform in Australia from April to August at the same salary plus traveling expenses. He kept his earnings secret from Hattie, who continued to send "more 'Destitute circumstances' cables." The $25 he sent Hattie represented only 5 percent of his earnings. Fields could have given her more if he had wanted, but Bill was reluctant to help people who had hurt him. By contrast, he was generous to steadfast friends, supportive family members and colleagues, especially to performers who had hit the skids. Bill accordingly fluctuated between miserliness and munificence during his

life. A good example of the latter quality is when he received a letter from the eminent silent comedian Harry Langdon in 1935 asking him for $200. "Desperate circumstances force me to ask for help. Ex-wives and income tax authorities accomplished their purpose, and left me temporarily flat financially." Bill sent him $200.[6]

Fields was glad to leave South Africa and its chaos behind when he sailed to Australia in March to begin a three-week voyage to Sydney. On April 4 he opened as the headliner at Rickards's Tivoli Theatre where he was again billed as The Silent Humorist. Advertisements hyped Fields's performance before George V as "The Man Who Made Kings Laugh." His "ludicrous comedy stunts…keep his audience in roars of laughter," wrote a critic.[7] Another reported that Fields kept the audience in hysterics continuously from start to finish by never letting a second go by without a new stunt. The reviewer counted 109 tricks during 20 minutes on stage. Once his multi-week engagement was completed he went to Melbourne where Fields performed at the Tivoli during the month of May.

A reporter from the magazine *Table Talk* interviewed Bill in Melbourne. He called Fields "a simple and unaffected good fellow, with no non-sense…He talks in a very quiet, though a cheerful fashion, with a little hint of humor from time to time." The interviewer described Fields as "genial-looking" and "rather Teutonic in appearance with very thick blond hair." He asked Fields how he liked Melbourne. The city, Bill felt, was charming despite having grown tremendously since he was here. As for relaxation, he told the interviewer that he plays golf, which enables him to "forget everything." The writer wondered why he became a juggler. "I was looking around for some thing to do which would not necessitate getting up in the morning, and this seemed to fit the need very well." But my parents "tried to discourage me in every way in their power. They used to hide the things I practiced with, and interrupt me…and were rather ashamed of me."[8]

At his next destination in Adelaide Fields read about the growing turmoil in Europe due to the assassination of Archduke Ferdinand at Sarajevo on June 28. Fields was planning to sail to Perth when Great Britain declared war on Germany on August 4. As a member of the British Commonwealth, Australia quickly pledged its support and prepared to send forces overseas. Although Australia was vulnerable to attack on the high seas, Fields chose to continue his trip to Perth. He boarded the *SS Orsova*, a 1,310 passenger ship, which reached Perth by sailing across the Great Australian Blight with its dramatic cliffs and shark-infested waters. He arrived in Perth, the capital of Western Australia, in mid-August. A

population explosion escalated the number of inhabitants from 67,541 in 1901 to 116,181 in 1911. To serve its growing citizenry, several new theaters offered productions ranging from legitimate plays to variety shows. Fields performed at Rickards's Tivoli on a playbill that included a tableau with a patriotic theme, which indicated that the war fervor had reached Perth.

Concerned about his plan to travel next to India, Fields avidly read the city's newspapers, which carried alarming stories about the war. The conflict left Fields in a quandary. Should he take a boat to India where he had six weeks of engagements scheduled or return to the United States as soon as possible? He had always yearned to visit India and had traveled to Perth mainly for that purpose. But British Commonwealth ships were already being attacked in the Indian Ocean by German naval vessels.

Fields's adventurous spirit eventually trumped his hesitation. Soon after Fields's ship left port the captain learned that the German light cruiser, *SMS Emden*, was in the area. On August 8, the *Emden* armed with ten 4.1 inch guns had been deployed to attack British and Allied shipping in the Indian Ocean. The cruiser was commandeered by the legendary Karl von Müller, who would become famous in the annals of naval warfare for his courage and chivalry. Realizing his vessel was no match against the *Emden*, the captain ordered his ship to quickly return to port. If it was not for the decisive captain, Fields might have been killed. Within the next three months the *Emden* sank or captured thirty Allied vessels before it ran aground on November 10, 1914, during the Battle of Cocos. "I played the Malay Straits, down through India," Fields once wrote knowing this never happened.[9] As long as it made good copy, he did not mind magnifying an adventurous life.

His second trip to the Antipodes had unnerved Fields. Looking back, he remembered this period as extremely chaotic—first, the civil strife in South Africa and second, the outbreak of war that derailed his plans. "From the time I left England to go to Africa I did not know what a contented mind used to be, they had me sweating blood."[10] He had no choice but to take a coaster from Fremantle, Perth's seaport, back to Sydney and from there catch the first ship back to the United States.

On August 29, Fields boarded the *S. S. Ventura* bound for San Francisco via Pago Pago and Honolulu. Suspicious that someone on the liner might steal his savings, Fields converted $3,000 into gold pieces. He carried them in belts wrapped around his waist during the entire voyage. To pass the time, he played deck quoits, a game similar to horseshoes in which a player throws a ring made of rope or iron around an upright pin. A concert was presented for the guests in which Fields joined a quartet.

When the ship docked in San Francisco on September 17, Fields was delighted to be home after his unsettling experiences in South Africa and Australia. Compared to his first visit, the second had been a nightmare. Years later he recalled the snags that he encountered: "If the public envies those performers who draw salary for traveling through those distant Pacific countries, which seem so romantic on paper, let them bear in mind that every journey is a hazard almost equal to a flight across the North Pole."[11] By the time he arrived in New York via train his trip from Perth had taken thirty-nine days. After circumnavigating the globe twice and completing six trips to England since 1902, Fields had just completed his last trip overseas.

With so much time to ruminate on the trip home, he began to fret about his future on the stage. His demonic insecurities surfaced once again. Would audiences, agents, and managers still remember him after his absence abroad? Approaching age thirty-five, Bill worried about how long his dexterity as a juggler would last. After fourteen years on the vaudeville trail, he was exhausted by its week-to-week grind. He thought of finding a role in a Broadway show, which if successful would yield a steady income and less traveling.

Bill told a magazine writer how he felt. "I was seeing the world and the world was seeing me. But was I getting anywhere? I went around the globe twice. But when I came back to the same old place, I was the same old Bill Fields, doing the same old sort of thing—a comedy juggling act that was all."[12]

Questions about his personal life also plagued him. How to deal with Hattie, who had become an albatross around his neck with her continual complaints? How to improve his relationship with his son, who was being raised by a possessive mother? When the train arrived in New York, he was full of foreboding about his broken family and career.

# 17. Backstabbed ⤫

Before leaving Sydney Fields had received a message from the producer Charles Dillingham. "[He] appraised me for a role in *Watch Your Step* and cabled me an offer to Australia."[1] Dillingham was among the most respected producers on Broadway. A suave and well-groomed impresario with a carefully clipped mustache, Dillingham was easily spotted in Times Square with his derby hat and a neatly folded handkerchief peaking out of his coat's breast pocket. A renaissance man in the American theater, his illustrious career from 1902 to 1934 spanned a wide range of endeavors: drama critic; operator of the Globe Theatre and the Hippodrome where he staged extravagant spectacles; and producer of more than two hundred shows, including popular musicals by such leading composers as Victor Herbert and Jerome Kern.

In addition, Dillingham fostered the careers of numerous stage performers. He had been impressed by Fields ever since he had seen his performance in *The Ham Tree*. Dillingham's proposal to join a new Broadway musical was tempting especially since Fields had reached a crossroads in his career. Here was an opportunity to appear on Broadway.

Hungry for a new venture, Bill decided to accept Dillingham's offer. Since rehearsals were two months away, he needed to find work until the show opened. The circuit owners were offering lower salaries due to box-office losses caused by an economic downturn following the outbreak of war. A surplus of available foreign performers who had fled Europe also caused earnings to decline.

Fields solid reputation as a top-flight comedy juggling act fortunately enabled him to quickly acquire numerous vaudeville engagements. In late September, he headlined the program at Atlantic City's B. F. Keith Theater located in a stately four-story building on the Garden Pier. Bill could hardly recognize the beach resort, which had burgeoned in the number of showplaces since his appearance at Fortescue's Pavilion in 1898. By the second week of October, Fields returned to the Palace Theatre. Heading the playbill was Alice Lloyd, the British music-hall star and chanteuse. Fields was

placed in the fourth position on the playbill preceding the ethnic comic Joe Welch, his colleague from the Orpheum Show. "Joe Welch had a hard time of it, and would have gone much better had he not been compelled to follow W. C. Fields," reported a reviewer. Bill garnered several excellent reviews for his juggling and pool routine, including a laudatory critique by "Wynn" (John J. O' Connor) in *Variety*: "The evening's honors went to W. C. Fields whose distinctive style defies duplication... Fields was a hit at every angle."[2]

A month later Fields began rehearsing his role in *Watch Your Step*, scheduled to open on Broadway in early December. The producer acquired an all-star cast for the musical extravaganza. Among the featured stars were the famous society dancers Vernon and Irene Castle, who had popularized refined ballroom dancing by accenting precise graceful movements rather than sensual physicality. "We were clean-cut; we were married and when we danced there was nothing suggestive about it," wrote Irene Castle. The show's title derived from the first line of a song— "you'll have to watch your step"—that Irene Castle sang about teaching the fox trot to the chorus. She later claimed that the show was their "best work upon the stage." Other well-known performers included the comic monologist Frank Tinney, who impersonated a doorman in blackface, and the comedian Harry Kelly, who did his funny "dog that wouldn't roll over" routine.[3]

In addition, Dillingham recruited a talented staff to write the book and music. Harry Bache Smith wrote the book about money-hungry heirs battling over a will, which left two million dollars to any relative who avoided falling in love. Among the most prolific writers for the musical stage, his productivity included more than 300 librettos and 6,000 lyrics. Smith admitted that the story, which stemmed from an older play, was so slight that he suggested that the credit should read "Plot (if any) by Harry B. Smith." *Watch Your Step* featured syncopated foot-stomping music and lyrics by twenty-six-year-old Irving Berlin. Already known for his Tin Pan Alley hits such as "Alexander's Ragtime Band," the show represented Berlin's first complete score for a musical. Dillingham gambled by hiring Berlin to compose the music and lyrics for a Broadway show since he was then mainly considered a Tin Pan Alley composer. The production featured Berlin's ragtime tunes interspersed with waltzes, trots, ballads and polkas, including several famous songs such as "Play a Simple Melody." "It was the first time Tin Pan Alley got into the legitimate theater," Berlin recalled.[4]

The show opened on November 26 at the Empire Theatre in Syracuse for a three-day trial run. "At rehearsals the material did not seem promising,"

wrote Harry Smith. But Irene Castle believed the production was a "sure thing and everybody connected with the show knew it, even before it opened."[5]

To Fields's chagrin, he was given only a small role as a pool hustler in a first-act scene set in an automat." "I woke up next morning and had all the papers sent up," Fields remembered. "Every review gave me a great sendoff." In *Variety*, Silverman wrote that "W. C. Fields, the original tramp juggler, was interpolated during the first act scoring the individual hit of the evening." Fields was elated especially since Dillingham was paying him $400 a week. "I sank back on the pillows, ordered fresh coffee and thought: 'At last, Bill old boy, you're made. No more barnstorming. You've crashed the big time'."[6]

The afternoon after the opening, Fields went to the theater where he was "swaggering around backstage" when he ran into Dillingham. "I've bad news for you, Bill," the producer said. Suddenly, Fields "gagged." "Whassa matter, feel you gotta give me a raise?" Gaining the upper hand, Dillingham retorted, "No, you're through." Bill stared at him in disbelief. "Through? Why I was the hit of the show. The papers said so. I remembered the audience laughing." "Sorry," Dillingham said, "but the pool table is too big. We have to cut down." Since the producer had the final say, Fields had no recourse to change his mind. "There was nothing to do but for me to go." He felt dejected and bitter about Dillingham's decision. "I traveled forty days and nights to Syracuse, N.Y. only to be fired after the first performance. This I claim was the longest one-night stand jump in the world."[7]

Dillingham thought the production was too long and lagged, especially the first act, which left the audience anxiously waiting the appearance of the other stars. Fields's role was poorly conceived since it had no relation to the story line. But his part could have been rewritten to fit the plot and include humorous dialogue. Harry Smith believed that Fields's ability was strictly limited to his juggler/pool table routines and that he lacked experience speaking on stage. Did Smith know that Fields had a speaking role as Sherlock Baffles in *The Ham Tree*?

Fields discovered the truth when he encountered Irving Berlin twenty-five years later and started talking about *Watch Your Step*. "Bill, did you ever find out why you didn't stay with that Dillingham show? I'll tell you. Tinney and the Castles read the reviews next day and got sore. They made up their minds they weren't going to play second fiddle to a juggler and they told Dillingham it was either you or they'd quit. That's what happened."[8] Fields looked at Berlin in disbelief. Underneath he was seething.

Bill had been sacrificed to pacify envious performers, a practice common in the cutthroat world of show business, but in this case he felt he had been brutally backstabbed.

Fields's firing became another episode in his zigzag career as a performer. Unexpected pitfalls, Fields said, were what made him "crazy and nuts" and added to his perpetual insecurity. "[It's] why I never feel safe in this blankety-blank business I juggled myself into," he said.[9] Equally disturbing was that he missed out on a show that ran for 175 performances on Broadway.

To his credit, Dillingham honored Fields's contract, which included a twenty-week guarantee, by getting him vaudeville engagements at a salary of $350 weekly on the big-time circuits. The office also paid for his railroad fare, baggage expenses, and the 5 percent commission charged by the UBO booking office. Fields felt fortunate since he could not return to England due to the war, and in the United States, theater attendance had declined because of the conflict. To offset box-office losses, managers were cutting salaries. "There never was a whiter guy than Charles Dillingham," Fields later admitted. "He had to do what he thought was right by the show. It wasn't his fault. But it wasn't mine either."[10]

"I have at last settled some consecutive time," he wrote Hattie, "and considering what a bad season it is I feel lucky." Hattie was still sending what Bill called "doleful" letters complaining about her financial problems and need for better housing in New York. In a more conciliatory mood, Fields agreed again to find her "a nice comfortable home" in Philadelphia in a "respectable neighborhood." But each time he offered her a house in Philadelphia, she refused.[11]

At his first stop in Ottawa, Canada, Fields sent a friendly letter to Dillingham congratulating him on the "colossal success" of *Watch Your Step.* "Hope you continue to pack 'em in," Fields wrote. He told Dillingham he would prefer being in the show rather than on the vaudeville stage. But "as you say things are coming out all right some time, somewhere, somehow."[12]

With his brother Walter as his assistant, Bill tread the vaudeville trail through April 1915 making many stops in the Midwest, both on the Keith and Orpheum circuits. Billed as the "silent humorist," he wore a crumpled black dress suit, with black paste over his eyebrows, and red makeup on his nose. He performed his usual juggling tricks with hats, tennis balls, and cigar boxes as well as his pool table routine. The tour was uneventful until mid-January when he reached Columbus, Ohio, and found himself on the same playbill with the four Marx Brothers. They were doing a

forty-five-minute musical comedy act with a cast of fifteen called, "Home Again," which featured considerable horseplay. "They sang, danced, played the harp, and kidded in zany style...Never saw so much nepotism or such hilarious laughter in one act in my life," recollected Fields.[13]

But there was one major problem. To his displeasure, Fields was placed last on the playbill after the Marx Brothers, a spot usually reserved for an audience chaser. One newspaper believed that Fields upstaged the Marx Brothers: "One has to wait until the last act for a really finished and expert performance." Fields's pride was nonetheless hurt causing his hasty departure from the program before the evening performance on the second night. He blamed it on a "bad right hand, the result which I received several weeks ago." The *Columbus Journal* reported that Fields had injured his hand performing his pool routine the week before. According to Groucho, Bill told the manager "you see this hand? I can't juggle anymore because I've got noxis on the conoxsis and I have to see a specialist right away. He just had made up a word because he didn't want to continue following our act!"[14]

Years later, Groucho encountered Bill at a party. "How's your noxis on the conoxis?" Groucho asked. "We knew there wasn't a goddamned thing wrong with you!" "You didn't think I was going to follow you cocksuckers with that act you had plus a harp and a piano," retorted Fields. "And I was up there fucking a lot of boxes!"[15]

During the week of March 8, Fields encountered another future famous comedian when he shared the same playbill with Buster Keaton at the Orpheum in Madison, Wisconsin. Nineteen-year-old Buster then performed with the Three Keatons, a family act with his parents Joe and Myra doing a roughhouse knockabout routine. Unlike his clash with the Marx Brothers, Bill had no problem being on the same program with Buster, who began his slapstick silent movie career two years later. Although their comedic styles diverged, Keaton later called Fields "one of the greatest creative comedians on the American stage. He is unique, original and side-splitting."[16]

By the spring of 1915, Fields had reached another crucial crossroads in his career. Bill had recently turned thirty-five and had performed in vaudeville for fifteen years. Despite continual rave reviews, his act had not changed much in the last few years. He was again faced with a decisive question: How long could he keep doing the same routine night after night? If Fields wanted to sustain his popularity, he needed to refresh his act and perhaps transit from vaudeville to another performance form.

Fifteen years on the vaudeville stage had brought Fields to a pivotal junction in his career. To get to this point, Fields had traversed a tortuous path paved with potholes, forks, dips, and steep climbs. He had experienced years of exhausting juggling practice; walked the streets of New York seeking a job while shivering in the cold; endured the constant grind of traveling every week to another city; and faced painful periods of insecurity. Since 1898 he had appeared in about every performance form in the popular arts during the early twentieth century: summer park shows; Fortescue's Atlantic City seaside showplace; a minstrel show; New York museums; burlesque shows; *The Ham Tree*, a Broadway and touring musical; US vaudeville, and British music halls.

To perform, he traversed the United States by car and train countless times; crossed the Atlantic by ship six times to England; and entertained twice in South Africa and Australia. Among his peaks: Performing in

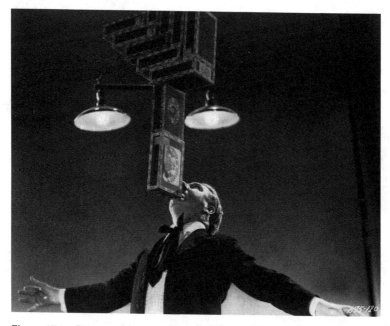

**Figure 17.1**   Reprising his vaudeville specialty in the movies. As Gabby Gilfoil, bankrupt leader of a motley small carnival troupe, Fields performs his cigar-box stunt in the lost silent picture *Two Flaming Youths* (1927). Courtesy W. C. Fields Productions, Inc., www.wcfields.com.

world-class theaters—the Wintergarten, Folies-Bergère, and at the London Coliseum before King George. Among his high points at home: Appearing at the Palace, Hammerstein's Victoria, Koster and Bial's Music Hall, and the big-time venues on the Keith and Orpheum Circuits. American vaudeville theaters and British music halls were valuable training grounds to test his routines while playing before different audiences. During these years Fields developed an intuitive sense of timing to gain laughs by slowly building up to the momentous moment when he knew the audience was in his hands. At that split second he delivered a socko ending. This comedic modus operandi remained with Fields throughout his career.

Juggling, he discovered, was more than an exhibition of his dexterity but a means to keep the audience continually amused as he manipulated balls, cigar boxes, hat, and canes. Props became essential tools in his repertoire throughout his career. Fields's artistry as a juggler and a pool hustler is reprised in his motion pictures. As Gabby Gilfoil in *Two Flaming Youths* (1927) and the Great McGonigle in *The Old Fashioned Way* (1934), Fields exhibits his juggling skills. His pool table act appears at the beginning and end of his film career—from *Pool Sharks* (1915) to *Follow the Boys* (1944).

The vaudeville stage shaped Fields's skills as a pantomime artist using body language, facial expressions, and subtle gestures to generate gales of laughter. As early as 1906, he wrote: "Every one admires a dexterous, graceful exhibition that appeals strongly to the eye; and when this is accompanied by a good measure of inoffensive buffoonery, the enjoyment is complete."[17]

Fields continued to use pantomime in his films to express a wide range of emotions from frustration to disgust. Bill's talent is especially evident in his silent movies in which his unique voice does not take precedence over his actions. As the foolish inventor Samuel Bisbee in *So's Your Old Man* (1926), Fields flails at the string curtains in his living room, which keeps hitting him in the face. In his sound films there exist silent periods that display his flair for pantomime. Harold Bissonette in *It's a Gift* (1934) tries shaving with a small mirror tied to an electric light string that constantly keeps moving in a circle. Bissonette's futile attempts to hold the mirror in place with one hand and the other clutching his razor illustrates Fields's ability to transfer his pantomime skills to the screen. Another example is his trademark Fieldsian flinch—the way he reacts to threatening objects or people about to assail him—a gesticulation that he repeats in many films.

As a sly conjurer, who fools the audience with his juggling stunts and pockets every pool ball in one stroke, Fields foreshadows his cinematic portrayals of the con man and rogue. From his travels and show biz experiences,

Fields saw these nefarious characters swindle suckers. As Eustace P. McGargle in *Sally of the Sawdust* (1925) and the Great McGonigle in *The Old Fashioned Way*, Fields drew on his firsthand knowledge of deceitful managers (James Fulton) who fleeced performers.

The vaudeville stage provided the stepping stones for the Tramp Juggler to morph into the Silent Humorist. Fields called his time in vaudeville "the good old days." "I like to look back over the good old days," he wrote. "They were all happy because they were full of promise.[18] That promise enabled Fields to discover his talent as a humorist way before his film career. Treading the vaudeville boards from 1900 to 1915 (nearly one-third of his performance years) made Fields a comedian.

# Epilogue: The Defining Moment ᴥ

G ene Buck, Florenz Ziegfeld's ace talent scout, sat watching Fields's performance in *Watch Your Step*. Known for his sharp eye for spotting exceptional up-and-coming entertainers, he had heard rumors that Fields's role might be cut. Buck and Sime Silverman later ate in a restaurant after the show and spotted the comedian eating alone. A Fields's aficionado, the *Variety* founder convinced Buck that Fields was a rising star. Ziegfeld's right-hand-man fired off a quick note to Fields: "See me in New York if anything goes wrong."[1]

Fields soon visited Buck's office in Times Square where he encountered one of Broadway's most respected and influential show-biz figures. A multi-talented Renaissance man, Buck was a prolific lyricist, librettist, sketch writer, producer, director, and illustrator of sheet music covers. Most important for Fields was that Ziegfeld valued Buck's opinion. Bill picked out a spiffy suit, parted his slicked down hair in the middle, and wore a fake mustache attached by a wire clip to his nose that he used in his act. "The mustache, I wear," he told an interviewer, "isn't even supposed to look as if it belonged to me. It is a black one and falls off. It makes people laugh."[2]

As he straightened his jiggling mustache back into place, he walked nervously into Buck's office. Sitting behind the desk was an amiable mild-mannered showman, who immediately made Fields feel at home. Bill was still seething about his mistreatment in *Watch Your Step*, which had become a Broadway hit. "Did you see me in that turkey?" he asked.[3] After conversing for a time, Buck told Fields that he would ask Ziegfeld to engage him for the *Follies*, considered the most dazzling revue on Broadway. Buck warned Fields about Ziegfeld's belief that beautiful showgirls were the key to the *Follies'* success. The impresario viewed comedians as fillers until the next titillating scene arrived. As he left, Buck cautioned him not to be overly confident.

After much persuasion by Buck, Ziegfeld decided to give Fields a chance. Bill was in Duluth when the local newspaper reported the news: "W. C. Fields, The Silent Humorist, now playing at the Orpheum will close his vaudeville work after next week and it will be the last vaudeville audiences will see of him for some time as he will go immediately to New York to begin rehearsals for the new Ziegfeld Follies, which will open in New York, June 1."⁴

Fields was ecstatic when he received the final confirmation: "Kindly report, New Amsterdam Theatre, stage entrance, Ten AM Wednesday, the 19th for rehearsals, Follies of 1915."⁵ Fields eagerly jumped at the chance to join the *Follies*. He viewed Ziegfeld's popular revue as an outstanding opportunity to end the grind of vaudeville with its long road trips, to enlarge his repertoire as a comedian, and to write his own sketches. The newspaper's prediction that his performance in Duluth "will be the last vaudeville audiences will see of him for some time" proved partly true. During the next ten years his appearances in big-time vaudeville were limited to sporadic presentations of his *Follies* sketches.

A carpet of fresh grass, the color of light green jade, covers Central Park on the bright spring morning of May 19, 1915, when Fields approaches the stage door of the New Amsterdam Theatre. Bill is about to embark on a new undertaking in the home of the *Ziegfeld Follies*, the most spectacular revue on the Great White Way. He suddenly senses that this is not an ordinary morning but the start of a pivotal turning point. As Fields enters the *Follies* stage door for the first time, he is at a defining moment in his career.

To Be Continued

In Book Two

W. C. FIELDS ON STAGE, RADIO,
AND SCREEN: BECOMING A
CULTURAL ICON

# Notes ✑

## PROLOGUE

1. W. C. Fields, "Alcohol and Me," *PIC*, October 13, 1942, 34.
2. Ibid.
3. *History of State Fairgrounds*, assessed December 17, 2008, http://www.groundsforsculpture.org/fairhist.htm.
4. *NYW*, July 3, 1929, scrapbook #13, WCFP.
5. *Boston Traveler*, August 21, 1924, scrapbook #10, WCFP; Fields, "Alcohol and Me," 34.
6. "W. C. Fields Knew McGargle When He Was a Boy," *New York Sun*, April 3, 1924, scrapbook #10, WCFP.
7. Ruth Waterbury, "The Old Army Game," *Photoplay*, October 1925, 68.

## 1   MEET THE DUKENFIELDS

1. James Smart, "The Difficulty of Being Leroy Dukenfield," *PSBM*, March 23, 1969, copy PFL; *Poppy* advertisements, box 9, clippings 1920–29, WCFP.
2. Henry Ashmead, *History of Delaware County* (Philadelphia, PA: L. H. Everts, 1884), 530, assessed June 25, 2014, http//:www.delcohistory.org/Ashmead/ Asmead/_pg530.htm.
3. Walter Licht, *Getting Work: Philadelphia, 1840–1950* (Cambridge, MA: Harvard University Press, 1992), 16, 28.
4. Ibid., 16.
5. Application for Mother's Army Pension of Ann Dukenfield, Protective War Claim Agency of the US Sanitary Commission, pension file #67844; George Dukenfield, file designation #44846, US National Archives & Records, Washington, DC.
6. 1880 Federal Census and San Francisco City Directories (1879–81), http:// www.ancestry.com; *San Francisco Call* Database—Death Index, accessed February 14, 2009, http://www.jwfgenresearch.com/SFCall/6900-44.htm; Letter to George Stevenson, March 11, 1935, box 11, genealogy, WCFP.
7. Letter to Jack Norworth, June 10, 1941, correspondence, box 4, WCFP.

8. *The Barber Shop*, dialogue script, copyrighted July 28, 1933, MPD-LOC; *W. C. Fields: Six Short Films*, Criterion Collection, 2000.

9. Letter to Harry Antrim, October 21, 1943, box 1, "A" personal file, correspondence, WCFP.

10. John Lukacs, *Philadelphia: Patricians & Philistines, 1900–1950* (New York: Farrar, Strauss, Giroux, 1981), 30; "W. C. Fields by Himself," box 20, file 2, Biographical Writings, WCFP.

11. Charles Dickens, *Works of Charles Dickens, Vol. XV: Pictures from Italy and American Notes* (Cambridge, MA: Riverside Press, 1877), 282–83; Henry James, *The American Scene, Together with Three Essays from Portraits of Places* (New York: Charles Scribner's Sons, 1946), 282–83.

12. *The Quotations of W. C. Fields*, compiled by Martin Lewis (New York: Drake Publishers, 1976), 10; *WCFALOF*, 215.

13. 1880 Philadelphia Census, Fields's biographical clipping file, AMPAS; "W. C. Fields: The Philadelphia Connection," Darby Free Library; Philadelphia City Directories, PHS; Smart, *PSBM*, March 23, 1969, 6.

14. Fields's letter to Clerk, County of Common Pleas, County of Philadelphia, PA, February 19, 1942, box 11; copy of official decree from Court of Common Pleas, Commonwealth of Philadelphia, PA, May 9, 1951, box 11, WCFP.

15. Smart, *PSBM*; Corey Ford, *The Time of Laughter* (Boston, MA: Little Brown, 1967), 173.

16. Corey Ford, "The One and Only W. C. Fields," *Harpers* (October 1967): 65; Alva Johnston, "Juggling for Cakes," *This Week*, September 12, 1938, clipping, scrapbook #4, WCFP; *WCFBH*, 12.

17. *The Barber Shop*, dialogue script, MPD-LOC; *W. C. Fields: Six Short Films*, Criterion Collection, 2000.

18. Ed Sullivan, "That Loveable Liar," *Silver Screen*, September 1935, 15.

19. *WCFBH*, 12.

20. Jack Regan and Grace Reid, "The Two Sides of W. C. Fields," *Movie Mirror*, April 1935, 39.

21. Sherri Broder, *Tramps, Unfit Mothers, and Neglected Children: Negotiating the Family in Nineteenth-Century Philadelphia* (Philadelphia: University of Pennsylvania Press, 2002), 14.

22. Letter to Jack Norworth, June 10, 1941, WCFP.

23. Ibid.

24. *NYEW*, January 28, 1931, clipping, scrapbook #13, WCFP.

25. Smart, *PSBM*; Mary B. Mullett, "Bill Fields Disliked His Label So He Laughed It Off," *American Magazine* (January 1926): 19.

26. David Thomson, "Fields of Dreams," *New Republic*, May 26, 2003, 36; *WCFBH*, 12.

27. *WCFBH*, 12.

28. "Am I Laughing?" clipping, February 2, 1935, Johannesburg, South Africa, scrapbook #4, WCFP; James Smart, "Our Hero's Birthday…City Disregards It," *PEB*, January 29, 1970.

29. "Walter Winchell on Broadway," ca. 1934, clipping, scrapbook #8, WCFP; Letter to John Bowyers, January 9, 1935, box 1, "B" miscellaneous correspondence file, WCFP.
30. "W. C. Fields at Home," *Table Talk*, May 28, 1914, scrapbook #29, WCFP.
31. *WCFBH*, 6.
32. *Philadelphia Oakdale Weekly*, May 13, 1913, clipping, box 19, vaudeville itineraries, WCFP.
33. W. C. Fields copyright sketches, MSD-LOC.
34. *Green Room*, July 1, 1914, clipping, scrapbook #29, WCFP.
35. Smart, "Our Hero's Birthday…City Disregards It"; James Smart, *W. C. Fields in Philadelphia* (Philadelphia, PA: The Shackamaxon Society, 1972), 2, 6; Letter to WCF, Jr., April 12, 1943, box 3, WCFP.

## 2   LIFE WITH FATHER

1. Smart, "Our Hero's Birthday," B3.
2. Smart, "W. C. Fields in Philadelphia," 10.
3. "The Ice Wagon Cometh," *American Heritage Magazine* (June 1966), accessed November 26, 2008, http://www.americanheritage.com.
4. Ida Zeitlin, "Life Begins at 20—Says W. C. Fields," *Motion Picture*, September 1935, 70.
5. *So's Your Old Man*, MPD-LOC.
6. Smart, *W. C. Fields in Philadelphia*, 6; Alfred Lief, *Family Business: A Century in the Life and Times of Strawbridge & Clothier* (New York: McGraw-Hill, 1968), 74–75.
7. *PI*, October 14, 1997, Fields clipping file, PFL.
8. Smart, *W. C. Fields in Philadelphia*, 4.
9. Ibid., 3–4.
10. Mullett, "Bill Fields Disliked His Label So He Laughed It Off," 19.
11. Smart, *W. C. Fields in Philadelphia*, 7; Autobiography #2, box 20, file #2, biographical writings, "W. C. Fields by Himself," WCFP; Teet Carle, "Beating the Drums for Another Comic of the Silents—W. C. Fields," *LAT*, December 19, 1971, U22.
12. Letter to Jack Norworth, March 9, 1940, box 4, WCFP; *WCFBH*, 450.
13. Alva Johnston, "Profiles: Legitimate Nonchalance—1," *New Yorker* (February 2, 1935): 24.
14. Mullett, 19, 24.
15. "The Most Delectable Food I Ever Tasted, by Gourmet Fields," miscellaneous writings, box 20, file #6, WCFP; reprinted in *WCFBH*, 4–5.
16. "An Actor Can Relax Only After He's 60," *NYP*, November 22, 1940, scrapbook #4, WCFP.
17. John Chapman, "The Beloved," *Sunday News*, October 16, 1938, clipping, WCF file, NYPL.

18. Deposition of Walter Fields, box 38, file #24, July 31, 1951, WCFP; Jim Tully, "Let's Laugh at Life with W. C. Fields," *Screen Play*, June 1935, 31, 81.
19. Letter to Harry Antrim, October 21, 1943, box 1, "A" personal file, correspondence, WCFP.
20. Letters to Thomas A. Hunt, June 23, 1938, July 26, 1944, correspondence, box 3, WCFP.
21. "Never So Insulted in My Life, Says Fields, Actor 40 years," clipping, WCF file, NYPL; *WCFBH*, 186.
22. Chapman, "The Beloved"; Mullett, 19.
23. C. H. W., "Good Old Billy, May His Shadow Never Grow Less," *Theatre* (March 1904): 23, clipping, scrapbook, # 27, WCFP; *WCFBH*, 20–21.
24. Maude Cheatham, "Juggler of Laughs," *Silver Screen*, April 1935, 30.
25. Ida Zeitlin, "Life Begins at Fifty!" *Screenland* (April 1935): 86; Carle, "Beating the Drums for Another Comic of the Silents," U22; Carle, "Biography of W. C. Fields," May 1932, Mack Sennett Collection, folder #1021, AMPAS; *W. C. Fields Straight Up*, television special, unedited interview with Teet Carle, UCLA Film and Television Archive.
26. Chapman, "The Beloved; Jim Tully, "Clowns Never Laugh," *This Week*, magazine section, September 6, 1936, 7, WCF clipping file, HTC.
27. E. B. White, Obituary, "Note," *New Yorker*, December 23, 1950, 39; Fields's letter to Roger C. Spratt, March 25, 1938, *WCFBH*, 12; Johnston, "Legitimate Nonchalance—1," 23–24.
28. Letter from Tom Geraghty, March 4, 1935, correspondence, box 3, WCFP; see also Fields's letters to Geraghty, February 11, 1935, March 26, 1935, WCFP.
29. Robert Lewis Taylor, *W. C. Fields: His Follies and Fortunes* (New York: Doubleday, 1949), 20.
30. "W. C. Fields at Home," Melbourne *Table Talk*, May 28, 1914, scrapbook #29, WCFP.
31. W. C. Fields, "Ups and Downs of Long and Interesting Career Told by W. C. Fields, Down Memory Lane!," clippings, May 2, 1926, MCNY.

# 3   THE TRAMP JUGGLER

1. *PI*, October 10, 1893, 2.
2. *Eight Bells* script, RBD-LOC, copyright stamped, May 14, 1891, #16671.
3. "Clang! Clang! Clang! Comedian W. C. Fields Rides the Air Waves to New Fame," *St. Louis Star-Times*, June 4, 1937, scrapbook #9, WCFP.
4. *CT*, April 19, 1902, scrapbook #20, WCFP; *Washington Herald*, November 15, 1925, scrapbook #10, WCFP; W. C. Fields, "From Boy Juggler to Star Comedian," *Theater* (October 1928): 44.
5. *VW*, 33.

6. "Simple Juggling Tricks 'Take' Where Difficult Stunts Fail," *Portland Evening Express*, April 23, 1908, scrapbook #23, WCFP; "How I Became a Juggler," *Music Hall and Theatre Review* (London), August 28, 1908, scrapbook #23, WCFP; *NYH*, February 10, 1924, May 18, 1924, scrapbook #10, WCFP; *Washington Herald*, November 15, 1925.

7. *Blackpool Times and Flyde Observer*, July 6, 1901, scrapbook #20, WCFP; *Washington Herald*, November 15, 1925; Smart, *W. C. Fields in Philadelphia*, 7; *Sioux City Livestock Record*, November 14, 1902, scrapbook #2, WCFP.

8. *WCFBH*, 7; *NYH*, February 10, 1924; http://www.juggling.org/fame/cinquevalli, assessed July 5, 2009.

9. *NYH*, February 10, 1924; J. P. McEvoy, "Go on Make Me Laugh," *SEP*, December 24, 1932, scrapbook #14, WCFP; "W.C. Fields at Home," 35.

10. http://www.juggling.org/fame/cinquevalli, assessed July 5, 2009; Joe Laurie, Jr., *Vaudeville: From the Honky Tonks to the Palace* (New York: Henry Holt, 1953), 479.

11. Letter to Thomas A. Hunt, July 26, 1944, correspondence, box 3, WCFP; "Talkies and Talkers," *Philadelphia Record*, ca. 1933–34, scrapbook #8, WCFP.

12. Letter to Jimmie Lane, April 3, 1941, correspondence, box 3, WCFP.

13. H. M. Lorette, "W. C. Fields Gets Help From His Friends," *Newsletter*, May 1957, accessed June 8, 2007, http://www.juggling.org.

14. *Sioux City Livestock Record*, November 14, 1902, scrapbook #2, WCFP; "Clang! Clang! Clang! Comedian W. C. Fields Rides the Air Waves to New Fame"; "Simple Juggling Tricks 'Take' Where Difficult Stunts Fail"; Elizabeth Borton, "I Take a Juggling Lesson from W. C. Fields," *Hollywood*, September 1935, 50–51.

15. W. C. Fields, "Fields Juggled Balls Before He Played with Laughs! He Tells Us How!" ca. 1935, assessed July 26, 2009, http://www.randomhouse.com/knopf/authors/curtis.html.

16. Ibid.

17. *BG*, August 10, 1924, scrapbook #10, WCFP.

18. Letter to Harry Antrim, correspondence, box 1, October 21, 1943, WCFP; "Silent Juggling by the Man Who Invented It W. C. Fields," *Sunday Chronicle Pantomime Annual*, ca. 1913, 62, scrapbook #29, WCFP.

19. "How I Became a Juggler."

20. *NYEW*, January 28, 1931, scrapbook #13, WCFP; "Clang! Clang! Clang! Comedian W. C. Fields Rides the Air Waves to New Fame"; "Silent Juggling by the Man Who Invented It."

21. Todd Depastino, *Citizen Hobo: How a Century of Homelessness Shaped America* (Chicago, IL: University of Chicago Press, 2003), 158–59.

22. H. M. Lorrete, "About Tramp Jugglers," assessed June 7, 2009, www.juggling.org.

23. *PI*, September 22, 1895, 17, September 24, 1895, pt. 3, 3.
24. James Harrigan, "A Comedy in One Act Entitled 'The Tramp Juggler'," 1897, accessed June 29, 2007, http://www.memory.loc.gov.
25. *Sioux City Livestock Record*; "A Self-Made Artist," *Sidney Sun* (Australia), April 12, 1914, scrapbook #29, WCFP; Lorette, "About Tramp Jugglers."
26. *WCFBH*, 27–28.
27. Scrapbook #34, WCFP.
28. Smart, *W. C. Fields in Philadelphia*, 11.
29. Letter to William Dailey, August 7, 1941, box 1, correspondence, D-personal, WCFP.
30. Ibid.; Scrapbook #31, WCFP.
31. Biographies, subject files, box 8, WCFP; *Sioux City Live Stock Record*.
32. "W.C. Fields at Home"; Deposition of Walter Fields, box 38, file 24, July 31, 1951, WCFP; Sioux City, Iowa, interview, November 14, 1912, WCFP; "The Real Billy Fields," *Green Room* [Adelaide, Australia], July 1, 1914, scrapbook #29, WCFP.
33. "W.C. Fields at Home."

## 4   INITIATION RITES

1. Robert Lewis Taylor, *W. C. Fields, His Follies and Fortunes* (New York: Doubleday, 1949), 37.
2. *WCFBH*, 16–17.
3. Ralph Parker, "The Secret Marriage of Hollywood's Bachelor," *Screen Play*, August 1934, scrapbook #30, WCFP.
4. Fields, "From Boy Juggler to Star Comedian," 44; John Chapman, "The Beloved Mountebank," *NYN*, October 16, 1938, 55.
5. Irwin R. Glazer, "The Atlantic City Story," *Marquee*, vol. 12, no.142, 4–5.
6. Lorette, "W. C. Fields Gets Help from His Friends"; Bernard Sobel, *Burleycue: An Underground History of Burlesque Days* (New York: Farrar and Rinehart, 1931), 118.
7. Charles E. Funnell, *By the Beautiful Sea, The Rise and High Times of That Great American Resort, Atlantic City* (New York: Alfred A. Knopf, 1975), 83.
8. Lorette, "W. C. Fields Gets Help from His Friends."
9. *Atlanta Constitution* clipping, August 17, 1941, scrapbook #3, WCFP; Fields, "From Boy Juggler to Star Comedian," 44.
10. *WCFBH*, 307.
11. *Atlanta Constitution*, August 17, 1941, scrapbook #3, WCFP; Sobel, *Burleycue*, 117.
12. Fields, "From Boy Juggler to Star Comedian," 44; *NYH*, October, 10, 1924, scrapbook #10, WCFP.
13. Irving Zeidman, *The American Burlesque Show* (New York: Hawthorne Books, 1967), 11; derived from *Variety*, December 11, 1909.

14. *Toledo Times*, April 30, 1910, clipping, NYPAL.
15. Court Transcript of Harriet Fields, box 38, August 1, 1951, WCFP; *Washington Post*, March 15, 1986, B1.
16. Sobel, *Burleycue*, 9.
17. Theatrical Date Book, 1898–99, box 19, WCFP; clippings, November 17, 1898, March 24, 1899, scrapbook #27, WCFP.
18. Lawrence, Massachusetts, New Theatre program, ca. September 20, 1899, Lowell, Massachusetts, Music Hall program, ca. March 9, 1899, scrapbook #31, WCFP; *Portland Leader*, January 3, 1899, *Daily Press* clipping, March 14, 1899, scrapbook #27, WCFP.
19. "A Self-Made Artist," *Sydney Sun* (Australia), April 12, 1914, scrapbook #29, WCFP; Mullett, 143.
20. "A Self-Made Artist"; Fields, "From Boy Juggler to Star Comedian,"44.
21. Fields, "From Boy Juggler to Star Comedian," 44.
22. Sobel, *Burleycue*, 117.
23. Ibid.
24. *Ravenna Republican*, December 10, 1898; accessed June 2, 2014, http://www.Kent.patch.com.
25. Dunham Thorp, "The Whole World Laughed at Him," *Picture Play*, ca. January 1927, 89–90; *Columbus News*, February 14, 1910, scrapbook #23, WCFP.
26. Jim Tully, "Let's Laugh at Life with W. C. Fields," *Screenplay*, June 1935. 81–82; W. C. Fields (as told to Jim Tully), "Whiskers Started Him on Road to Fame," clipping, box 24, scrapbook #12, WCFP.
27. Fields, "Whiskers Started Him on Road to Fame."
28. Letter to Mrs. Paul Trask, February 4, 1942, *WCFBH*, 468.
29. Parker, "The Secret Marriage of Hollywood's Bachelor," 91; "W. C. Fields by Himself," autobiography #1, box 20, file #2, biographical writings, WCFP.

# 5   THE SLY CONJURER

1. Mullett, "Bill Fields Disliked His Label, So He Laughed It Off," 143; Andrea Stulman Dennett, *Weird Wonderful: The Dime Museum in America* (New York: New York University Press, 1997), 59.
2. Fred Stone, *Rolling Stone* (New York: McGraw-Hill, 1945), 109.
3. *NYDM*, February 4, 1899, 18, February 11, 1899, March 24, 1899, scrapbook #27, WCFP; *Lowell Citizen*, March 10, 1899, scrapbook #27, WCFP.
4. *Philadelphia Record*, May 23, 1899, scrapbook #27; letter to Fields, September 17, 1941, box 1, correspondence "D" file, WCFP.
5. *Lowell Citizen*, June 13, 1899, scrapbook #27, WCFP; *Lakeview* unidentified newspaper, June 20, 1899, scrapbook #27, WCFP.
6. Mullett, "Bill Fields Disliked His Label, So He Laughed It Off," 143; clipping, March 24, 1899, scrapbook #27, WCFP; "A Self-Made Artist," scrapbook #29, WCFP.

7. Steel Pier Minstrel, Thirty-fifth Anniversary advertisement, box 9, file 1930–39, scrapbook #2, WCFP.
8. Sobel, *Burleycue*, 118; Fred Irwin, "The Man Who Can Come Back," *Variety*, December 10, 1910, 42.
9. Letter to W. C. Fields, September 17, 1941, WCFP.
10. Mullett, 145.
11. *Indianapolis Journal*, August 29, 1899, scrapbook #27, WCFP; *LAT*, August 2, 1951, 12.
12. Letter from Lizzie Hughes to Fields, August 22, [18]99, *WCFBH*, 13.
13. Harriet Fields to WCF, February 25, 1926, 1926 file, WCFP.
14. "Opening," Cincinnati newspaper clipping, scrapbook #27, WCFP.
15. Ibid.; *Louisville Daily Commercial*, ca. August, 21 1899, scrapbook #27, WCFP; *Dayton Journal*, February 27, 1900, scrapbook #27, WCFP.
16. W. C. Fields, "It's a Tough Spot," *St. Louis Post Dispatch*, August 10, 1930, scrapbook #13, WCFP.
17. Fields, "Whiskers Started Him on Road to Fame"; Fields, "From Boy Juggler to Star Comedian," 44, 76; Mullett, 143.
18. *Indianapolis Sentinel*, August 29, 1899, scrapbook #27, WCFP.
19. Wm. C. Fields, "New Juggling Tricks," in *The Magician's Handbook: A Complete Encyclopedia of the Magic Art for Professional and Amateur Entertainers*, ed. "Selbit" (Percy T. Tibbles), 3rd ed. (London: Marshall, Brookes & Chalkley, 1904), 123–24.
20. Ibid.
21. "A Tramp Juggler," *Black and White Budget* (London), March 16, 1901, 744, box 25, WCFP.
22. W. C. Fields, "Silent Juggling by the Man Who Invented It," "*Sunday Chronicle*" *Pantomime Annual*, ca. 1913–14, scrapbook #29, WCFP.
23. Fields, "From Boy Juggler to Star Comedian," 76.

## 6   THE BIG TIME

1. "A Self Made Artist"; *VW*, 60–61; *NYC*, March 3, 1900, 5.
2. "Whiskers Started Him on Road to Fame."
3. Gelett Burgess, *Bayside Bohemia: Fin de Siècle San Francisco & Its Little Magazines* (San Francisco: Book Club of California, 1954), 13.
4. Ibid, 38, 39; Frank Norris, *McTeague: A Story of San Francisco, An Authoritative Text, Backgrounds and Sources, Criticism*, ed. Donald Pizer (New York: W. W. Norton, 1977), 61.
5. *SFDM*, March 20, 1900, March 24, 1900, scrapbook #27, WCFP.
6. Unidentified clipping, box 24, WCFP.
7. *Broadway Photographs*, "Frederick Bushnell Biography," assessed June 24, 2014, http://broadway.cas.sc.edu/content/frederick-bushnell.

8. *LAEE*, April 10, 1900, scrapbook #27, WCFP; *LADT*, April 10, 1900, scrapbook #27, WCFP.
9. *Adelaide Advertiser*, June 17, 1914, scrapbook #29, WCFP; "Magnificent Rogue," aired February 28, 1956, on *Biography in Sound*, NBC Radio.
10. ELP, box 31, file 6, 26.
11. *SFDR*, March 24, 1900, scrapbook #27, WCFP; ELP, box 31, file 6, 37–38.
12. John Chapman, "The Beloved, W. C. (Rags-to-Riches) Fields Would Still like to Ride Rods," *Sunday News*, October 16, 1938, clipping, WCF file, NYPAL.
13. *Kansas City Missouri Times*, April 20, 1900, scrapbook #32, WCFP; *NYC*, May 19, 1900, 281.
14. *Detroit Journal*, May 29, 1900, scrapbook #27, WCFP.
15. *Detroit Evening News*, May 29, 1900, scrapbook #27, WCFP.
16. *Rochester Post Express*, September 18, 1900, scrapbook #27, WCFP.
17. ELP, box 31, file 6.
18. Robert Grau, *Forty Years Observation of Music and Drama* (New York: Broadway Publishing Co, 1909), 4; unidentified clipping, scrapbook #27, WCFP.
19. W. C. Fields, "Over a Barrel," *Esquire*, October 1931, 34.
20. *NYC*, June 23, 1900, 356; *New York Journal*, June 13, 1900, scrapbook #27, WCFP; W. C. Fields, "From Boy Juggler to Star Comedian," *Theatre Magazine*, October 1928, 44.
21. "Whiskers Started Him on Road to Fame"; Fields, "From Boy Juggler to Star Comedian," 76.
22. Fred Allen, *Treadmill to Oblivion* (Boston: Little, Brown, 1954).

## 7 "A MASTER PANTOMIMIST"

1. Fields, "From Boy Juggler to Star Comedian," 76.
2. *WCFBH*, 23, 29; Ruth Waterbury, "The Old Army Game," *Photoplay*, October 1925, 102.
3. W. Claude Fields, Jr., "W. C. Fields," *A Tribute to W. C. Fields*, The Gallery of Modern Art, 1967.
4. Claude R. Salvucci, *The Philadelphia Dialect Dictionary* (Bucks County, PA: Evolution Publishing, 1996), 13, 75, 83, 85; Curtis, *W. C. Fields*, 300*n*, 549.
5. Harry Houdini, "European Music Hall and Managers," *NYDM*, December 23, 1905, xxii.
6. W. C. Fields, "Over a Barrel," *Esquire* (October 1931): 139; Fields, "Confessions of a Tramp Juggler," *Chicago Record-Herald*, January 7, 1906, scrapbook #23, WCFP.
7. W. C. Fields, "Silent Juggling by the Man Who Invented It," "*Sunday Chronicle*" *Pantomime Annual*, ca. 1913–14, scrapbook #29, WCFP.
8. Ibid.

9. "Silent Humorist as His Say by W. C. Fields," *The Theatre* (Sydney and Melbourne), June 1, 1914, scrapbook #29, WCFP; "W. C. Fields 'at Home,'" *Table Talk*, March 28, 1914, scrapbook #29, WCFP.
10. J. B. Priestley. "W. C. Fields," *Atlantic Monthly* (March 1947): 43.
11. W. Buchanan-Taylor, *Shake the Bottle* (London: Heath Cranton Limited, 1942), 216.
12. Arthur M. Longworthy, "W. C. Fields—and Why?," *Park Avenue Social Bulletin* (August 1925): 28, scrapbook #11, WCFP.
13. Ibid.; *NYC*, February 2, 1901, 1088.
14. Mullett, "Bill Fields Disliked His Label, So He Laughed It Off."
15. *The Football Post* (Nottingham, England), September 10, 1904, scrapbook #27, WCFP.
16. Joe Laurie, Jr., *Vaudeville: From the Honky-Tonks to the Palace* (New York: Henry Holt, 1953), 133.
17. Samuel Hynes, *The Edwardian Turn of Mind* (New York: Random House, 1992), 15.
18. *The Era*, "Music Hall Gossip," August 8, 1920, 1904.
19. *The Quotations of W. C. Fields*, compiled by Martin Lewis (New York: Drake Publishers, 1976), 110.
20. *WCFBH*, 14.
21. *The Showman* (March 1, 1901), 139, scrapbook #20, WCFP.
22. "A Tramp Juggler," *Black and White Budget* (March 16, 1901): 744.
23. H. L. Adam, *Black and White Budget*, March 16, 1901, scrapbook #32, WCFP; *The Showman*, 139.
24. *NYC*, May 25, 1901, 286.
25. Ibid.
26. *WCFBH*, 38*ff.*
27. "The Seagull," *Blackpool Times and Flyde Observor*, July 6, 1901, scrapbook #20, WCFP.
28. *NYC*, May 25, 1901, 286.
29. "Silent Humorist as He Says," *The Theatre* (Sydney and Melbourne, Australia) June 1, 1914, scrapbook #29, WCFP; *New Yorker*, July, 30, 1938, scrapbook #4, WCFP.

## 8    "MY ART NEVER SATISFIES ME"

1. *NYTEL*, August 13, 1901, scrapbook #27, WCFP; Fields, "Confessions of a Tramp Juggler."
2. "Magnificent Rogue: The Adventures of W. C. Fields," *Biography and Sound*, narrated by Fred Allen, aired, February 28, 1956, on NBC Radio.
3. Clipping, Columbia Theatre, Cincinnati, box 25, file #7, WCFP.
4. Douglas Gilbert, *American Vaudeville: Its Life and Times* (New York: Dover, 1940), 291.

5. Box 25, file 7, WCFP; *Indianapolis Journal*, November 26, 1901, scrapbook #20, WCFP; *NYTEL*, October 24, 1901, scrapbook #20, WCFP.

6. *LAT*, August 2, 1951, part 1, 12.

7. "The World's My Oyster" conference with Harriet Fields and William C. Fields, Jr., box 31, file 6, p. 14, ELP; Ida Zeitlin, "Life Begins at Fifty!," *Screenland*, April 1935, 88.

8. Letter from Grant Felton, January 27, 1902, box 1, correspondence, WCFP.

9. Box 31, file 6, p. 31, ELP; *Cleveland World*, April 24, 1902, scrapbook #20, WCFP.

10. Zeitlin, "Life Begins Again at Fifty!," 87–88.

11. *NYTEL*, May 28, 1902, scrapbook #20, WCFP.

12. Ida Zeitlin, "W. C. Fields' Real Life Story," *Screenland*, July 1935, 52.

13. Ibid.

14. Anthony Slide, ed., *Selected Vaudeville Criticism* (Metuchen, NJ: Scarecrow Press, 1988), 79.

15. "Comedy Jugglery, W. C. Fields at the Hippodrome," *The Hippodrome*, December 1902.

16. *NYC*, May 25, 1901, 286; "Silent Humorist as His Says."

17. *Sporting Mail* (Adelaide), June 18, 1914, scrapbook #29, WCFP.

18. "Ups and Downs of Long and Interesting Career Told by W. C. Fields," May 2, 1936, clipping, MCNY; *The Football Post* (Nottingham, England), September 10, 1904, scrapbook #27, WCFP.

19. *Music Hall and Theatre Review*, December 5, 1902, scrapbook #20, WCFP.

20. Ibid; Box 31, file 6, pp. 14, 31, ELP.

21. J. P. McEvoy, "Go on Make Me Laugh," *SEP*, December 24, 1932, scrapbook #14, WCFP; *Sporting Mail* (Adelaide), June 18, 1914, scrapbook #29, WCFP.

22. "Silent Humorist as He Says."

23. *NYC*, "Memorial Number," February 28, 1903, xii; Fields, "Confessions of a Tramp Juggler"; Fields, "Silent Juggling by the Man Who Invented It."

24. Maude Cheatham, "Juggler of Laughs: W. C. Fields Can Balance a Plug Hat on a Cane or an Audience on a Gale of Laughter," *Silver Screen*, April 1935, 30–31, 62.

25. Monti, *W. C. Fields and Me*, 32–33.

26. "Comedy Jugglery, W. C. Fields at the Hippodrome"; *WCFBH*, 38*ff.*

27. Letter to R. F. Bensinger, May 2, 1941, correspondence, box 1, file b personal, WCFP.

28. Edwin Glover, "Pictures with a Past: Remember When," *SEP*, October 15, 1955, 17; Letter to Edwin Glover, September 22, 1943, WCFP.

29. *Providence Evening Telegram*, February 10, 1903, scrapbook #22, WCFP; *San Francisco Town Topics*, March 18, 1903, scrapbook #22, WCFP.

30. Managers' report, Providence, February 9, 1903; Boston, February 16, 1903; New York, February 23, 1903, KAC.

31. Manager's report, Philadelphia, March 2, 1903, KAC.

## 9   TO THE ANTIPODES

1. Court transcript of Harriet Fields, box 38, file, August 1, 1951, WCFP; "Tense and Poignant Drama Marks Fields Estate Battle," *LAT*, May 5, 1949, clipping, box 11, WCFP.
2. Letter to Walter Fields, December 10, 1935, March 11, 1943, correspondence, box 3, WCFP; "A Proboscis Worth Preserving," *LAT*, January 18, 2007.
3. Deposition of Walter Fields, box 38, file 24, August 1, 1951, WCFP.
4. "Fields Gazes into Past But He Sighs Not," *Hartford Daily Courant*, October 6, 1929, clipping, Shubert Archive, New York City.
5. To Harriet Fields, May 21, 1903, box 1, correspondence, file 1903, WCFP.
6. *The Era*, May 29, 1909, 24.
7. Charles Waller, *Magical Nights at the Theatre* (Melbourne, VIC: Gerald Taylor Productions, 1980), 120.
8. *The Morning Argus*, Melbourne, Australia, June 15, 1903, scrapbook #22, WCFP.
9. *Melbourne Arena-Sun*, July 9, 1903, scrapbook #22, WCFP; Deposition of Walter Fields; *Adelaide Register*, clipping, scrapbook #23, WCFP.
10. Box 31, ELP; *The Sportsman*, Sydney, August 26, 1903, WCFP; *Melbourne Truth*, October 17, 1903, scrapbook #22, WCFP.
11. *WCFBH*, 20, 152.
12. *Music Hall and Theatre Review*, December 11, 1903, scrapbook #22, WCFP.
13. C. H. W. "W. C. Fields: An Appreciation," *The Theatre* (Australia), March 1904, 23, scrapbook #27.
14. Harriet Fields to Elizabeth Hughes, clipping, January 18, 1904, box 11, WCFP.
15. Letter to Maud Fendick, Box 1, August 1, 1938, WCFP.
16. "Fields Gazes Into Past But He Sighs Not," *Hartford Daily Courant*, October 6, 1929, clipping, Shubert Archive.
17. Ronald J. Fields, "The Advantages and Mis-Advantages," *Argosy*, August 1974, 68.
18. "The Ham's Soliloquy," ms. in WCFP; reprinted in *WCFBH*, 18.
19. Fields, "From Boy Juggler to Star Comedian," 76; *NYC*, April 2, 1904; see also *NYDM*, January 30, 1904.
20. *Rand Daily Mail*, December 19, 1903, scrapbook #22.
21. W. C. Fields, "Speaking of Benefits," *NYT*, November 25, 1923.
22. Letter to Elizabeth Hughes, January 18, 1904, box 10, Harriet Fields correspondence, 1903 file, WCFP.
23. Ibid.
24. *WCFBH*, photograph, 38ff; Testimony, Fields's probate case, August 13, 1951, box 38, file #8, WCFP.
25. *NYC*, April 2, 1904; see also *NYDM*, January 30, 1904.
26. *NYC*, June 11, 1904, box 9, clippings, WCFP.

27. Ibid.

28. Letter to Elizabeth Hughes, January 18, 1904.

29. *The Sportsman*, April 7, 1904, scrapbook #22; *Topical Times*, May 1904, scrapbook #22, WCFP.

30. *The Era*, April 30, 1904, 21; *The Hippodrome*, April 1904, 10. WCFP.

31. *The Era*, April 30, 1904, 21.

## 10   THE TROUPER ON THE FLYING TRAPEZE

1. Court Probate Testimony, box 38, August 1, 1951, 1022, WCFP; Telegram to Harriet Fields, April 29, 1904, box 1, correspondence, 1904 file.

2. *Manchester Daily Dispatch*, August 10, 1904, scrapbook #27, WCFP.

3. Letter to Harriet Fields, September 8, 1904, box 1, correspondence, 1904 file, WCFP; *The Era*, September 17, 1904, 21.

4. To Harriet Fields, June 5, 1904, box 10, Harriet Fields correspondence, 1904 file, WCFP; July 13, 1904, box 1, correspondence, 1904 file, WCFP; Probate Court Transcript, box 38, file 2, p. 222, WCFP.

5. To Harriet Fields, July 29, 1904, box 1, correspondence, 1904 file, WCFP; *WCFBH*, 21.

6. *WCFBH*, 21.

7. To Harriet Fields, September 8, 1904, box 1, correspondence, 1904 file, WCFP.

8. Ibid.

9. To Harriet Fields, September 27, 1904, box 1, correspondence, 1904 file, WCFP; To Harriet Fields, September 8, 1904, box 1, correspondence, 1904 file, WCFP; Ida Zeitlin, "Life Begins at Fifty," *Screenland*, April 1935, 86; Box 31, ELP.

10. To Harriet Fields, September 8, 1904, box 1, correspondence, 1904 file, WCFP; *WCFBH*, 23.

11. *WCFBH*, 23.

12. Maude Cheatham, "Juggler of Laughs." *Silver Screen*, April 1935, 30–31 "Anything for a Laugh," *American Magazine*, September 1934, 73: 129–30.

13. Ida Zeitlin, "W. C. Fields' Real Life Story," *Screenland*, July 1935, 53.

14. Ibid., 52.

15. Ibid., 53.

16. Jim Tully, "Let's Laugh at Life with W. C. Fields," *Screenplay*, June 1935, 82–83.

17. *WCFBH*, 30.

18. Mary B. Mullett, "Bill Fields Disliked His Label, So He Laughed It Off," *American Magazine*, January 1926, 143.

## 11   THE HAM TREE

1. Clipping, Metropolitan Theatre, Minneapolis, ca. March 1907, WCF file, NYPAL.
2. Ibid.
3. THTS-SCNU, Act 2, p. 14.
4. *Dayton Journal*, December 19, 1905, scrapbook #22, WCFP; THTS-SCNU.
5. *Rochester Evening Times*, August 15, 1905, scrapbook #22, WCFP; *NYT*, August 29, 1906.
6. Clipping, scrapbook #22, August 29, 1905, WCFP; *Detroit Journal*, September 25, 1906, scrapbook #22, WCFP.
7. W. C. Fields, "Confessions of a Tramp Juggler," *Chicago Record-Herald*, January 7, 1906, scrapbook #23, WCFP.
8. *Duluth New Tribune*, March 11, 1907, scrapbook #23, WCFP.
9. "The Version of Mr. Fields," *Duluth Evening Herald*, March 14, 1907, scrapbook #23, WCFP.
10. *Billboard*, February 17, 1906, scrapbook #23; *NYDM*, October 6, 1906, scrapbook #23, WCFP.

## 12   THE BREAKUP

1. "Maud Fendick," box 44, Estate/Probate Folder, WCFP.
2. "W. C. Fields 'at Home'," *Table Talk* (Melbourne), March 28, 1914, scrapbook #29, WCFP.
3. *WCFBH*, 31.
4. Ibid., 32; box 31, file 6, pp. 37–38, ELP.
5. *WCFBH*, 32.
6. To James Dukenfield, box 1, April 22, 1906, WCFP.
7. From Belle Gold, Harriet Fields correspondence 1907, box 10, postmarked August 15, 1907, WCFP.
8. Ibid.; From Belle Gold, Harriet Fields correspondence 1907, box 10, September 29, 1907, WCFP.
9. Probate Court Transcripts, box 38, August 1, 1951 file, p. 906; box 38, August 3, 1951 file, p. 1110, WCFP.
10. To Georgie Hargitt, September 29, 1914, box 10, correspondence 1914, WCFP.
11. Ibid.; *LAT*, May 5, 1949, part 1, 2.
12. Oversized scrapbook #52, WCFP.
13. Probate Court Transcript, box 38, August 3, 1951, file, pp. 1108–09, WCFP; box 31, file 6, p. 36, ELP.
14. *You're Telling Me*, Paramount Pictures Script Collection, Release Dialogue Script, March 28, 1934, AMPAS; Max Eastman, *Enjoyment of Laughter* (New York: Simon and Schuster, 1948), 336.

15. Cheatham, "Juggler of Laughs," 30.
16. Alva Johnston, "Legitimate Nonchalance," *New Yorker*, February 2, 1935, 24.
17. *WCFBH*, 51.
18. Probate Court Transcripts, box 38, file 1 & 2; to Harriet Fields, box 2, correspondence, 1912 file, August 12, 1912, March 31, 1913, WCFP; to Georgie Hargitt, September, 29, 1914, box 10, Harriet Fields correspondence 1914, WCFP.
19. *WCFBH*, 43, 51.
20. Ibid., 42.
21. Ibid., 37, 51.
22. From Elizabeth Hughes, September 12, 1912, box 10, Harriet Fields correspondence, WCFP.
23. To Harriet Fields, box 2, correspondence, 1912 file, ca. September 7, 1912, WCFP; *WCFBH*, 45, 48.
24. *WCFBH*, 45.
25. Letter to Georgie Hargitt, correspondence 1914, September 29, 1914, WCFP.

## 13   THE AFFAIR

1. Letter to Harriet, February 4, 1920, *WCFBH*, 65.
2. *WCFBH*, 51
3. *Lynn Evening News*, May 7, 1908, scrapbook #23, WCFP; "Simple Juggling Tricks 'Take' Where Difficult Stunts Fail," *Portland (Maine) Evening Express*, April 23, 1908, scrapbook #23, WCFP.
4. "W. C. Fields at 'At Home'," Melbourne *Table Talk*.
5. Letters to WCF, undated; July 25, 1939; ca. 1935–36, box 1, correspondence, Maud Fendick file, WCFP.
6. Eastman, *Enjoyment of Laughter*, 336.
7. Bill Grady, *The Irish Peacock: The Confessions of a Legendary Talent Agent* (New Rochelle, NY: Arlington House, 1972), 21.
8. Letters to Maud Fendick, February 7, 1935; October 4, 1945, box 1, Maud Fendick file, WCFP.
9. Letter to WCF, undated, box 1, correspondence, Maud Fendick file, WCFP.
10. Ibid.
11. Ibid.
12. Letters to WCF, July 25, 1939; undated, WCFP.
13. Letter to WCF, undated, WCFP.
14. Letter to WCF, ca. August 1938, WCFP.
15. Letters to Maud Fendick, September 6, 1938; May 12, 1938, WCFP.
16. Letter to Maud Fendick, August 1, 1938, WCFP.
17. Letters to WCF, July 25, 1939; undated, WCFP.

18. Letters to Maud Fendick, May 12, 1938; October 4, 1945; letters to WCF July, 25, 1939; October 1, 1945, WCFP.
19. Letter to WCF, undated, WCFP.
20. Letter to WCF, July 25, 1939, WCFP.
21. Letter to WCF, undated, WCFP.
22. Ibid.
23. Letter to WCF, July25, 1939, WCFP.

## 14   THE ROAD TO THE PALACE

1. Mullett, "Bill Fields Disliked His Label So He Laughed It Off,"143.
2. *WCFBH*, 38.
3. *Cleveland Clipper*, January 25, 1908, scrapbook #23, WCFP.
4. *NYDM*, February 22, 1908, scrapbook #23, WCFP.
5. *Variety*, October 25, 1912, scrapbook #2; May 17, 1908, scrapbook #23; *NYDM*, February 22, 1908, scrapbook #23, WCFP.
6. Buchanan-Taylor, *Shake the Bottle*, 217.
7. *Variety*, May 4, 1912, scrapbook #2, WCFP.
8. Joe Laurie, Jr., *Vaudeville: From the Honky-Tonks to the Palace* (New York: Henry Holt, 1953), 317, 318.
9. *Zit*, November 29, 1908, scrapbook #23, WCFP.
10. *Variety*, December 5, 1908, March 9, 1908, scrapbook #23, WCFP.
11. "Keith & Proctor's Fifth Avenue Track," clippings, 1904–22, box 9, WCFP.
12. *Columbus Evening Dispatch*, February 16, 1910, scrapbook #23, WCFP.
13. *NYMT*, April 21, 1912, scrapbook #2, WCFP.
14. *Philadelphia Ledger*, April 9, 1912, scrapbook #2, WCFP; *WCFBH*, 12.
15. Simon Louvish, *It's a Gift* (London: British Film Institute, 1994), 53–54.
16. *Spokane Daily Chronicle*, July 22, 1912, scrapbook #2; J. P. McEvoy, "Go on Make Me Laugh," *SEP*, n.d., 46, scrapbook #14, WCFP.
17. *WCFBH*, 46; *SFC*, August 19, 1912, scrapbook #2, WCFP.
18. "Just Out of College," *LAT*, September 8, 1912, p. IIII.
19. W. C. Fields, "A Regular House," *Variety*, December 20, 1912, 34.
20. *LAT*, September 16, 1912, III, 4; September 21, 1912, scrapbook #2, WCFP.
21. *New York Review*, February 13, 1910, scrapbook #23, WCFP.
22. "The Man Who Juggles," *New York Star*, December 19, 1908, 13, scrapbook #23, WCFP.
23. "Cartoonist's Lot Hard, Says Juggler," *Salt Lake Tribune*, October 2, 1912, scrapbook #2; letter to Maud Fendick, September 6, 1938, box 1, correspondence file, "Fendick, Maud," WCFP.
24. *Cleveland Plain Dealer*, February 11, 1910, WCF file, NYPAL.
25. Mac, "Fresh Fields," *The Daily Mail*, July 9, 1913, scrapbook #2, WCFP.

26. January 7, 1913, scrapbook #2, WCFP.
27. *Cleveland Leader*, ca. February 11, 1913, scrapbook #2, WCFP.
28. Laurie, *Vaudeville*, 398.
29. To James Dukenfield, April 22, 1906, correspondence, box 1, WCFP.
30. *London Sporting Life*, July 1913, scrapbook #2; *Variety*, May, 24, 1913, scrapbook #2, WCFP.

## 15   THE SECOND HOME

1. Mac, "Fresh Fields," scrapbook #2; *The Standard* (Montreal), March 22, 1913, scrapbook #2, WCFP.
2. *The Edwardians* (New York, Harper & Row, 1970), 56–57, 71.
3. *Era Annual Advertiser*, 1915 & 1916, n.p.
4. Ibid.
5. W. C. Fields, "From Boy Juggler to Star Comedian," 76.
6. Mac, "Fresh Fields"; *WCFBH*, 44.
7. "Simple Juggling Tricks 'Take' Where Difficult Stunts Fail," *Portland (Maine) Evening Express*, April 23, 1908, scrapbook #23, WCFP; Wikepedia.org /wiki/ American Underslung, accessed, July 16, 2010.
8. "London Chat," *Daily Citizen*, November 11, 1913, scrapbook #29, WCFP.
9. To Harriet Fields, correspondence, box 1, 1910 file, June 20, 1910, WCFP.
10. *The Era*, June 13, 1908, 21.
11. June 22, 1908, scrapbook #23, WCFP.
12. *The Era*, August 29, 1908, 21.
13. *Shake the Bottle*, 216; "The Silent Humorist in Eccentric Juggling," *News of the World*, June 29, 1913, scrapbook #2, WCFP.
14. W. C. Fields (As Told to Jim Tully), "Whiskers Started Him on the Road to Fame," clipping, scrapbook, box 24, WCFP.
15. Felix Barker, *The House That Stoll Built* (London: Frederick Muller, 1957), 40.
16. Ibid., 54.
17. *WCFBH*, 435.
18. *The Era*, June 5, 1909, 21; July 17, 1909, 7; July 24, 1909, 5.
19. To Harriet Fields, June 16, 1910, correspondence, box 1, 1910 file, WCFP.
20. Robert Lewis Taylor, *W. C. Fields: His Follies and Fortunes* (Garden City, NY: Doubleday, 1949), 121.
21. To Harriet Fields, December 27, 1910, correspondence, box 1, 1910 file, WCFP.
22. *The Era*, December 24, 1910, 24.
23. *WCFBH*, 49.
24. *The Performer*, June 12, 1913; *The Encore*, June 12, 1913, scrapbook #2, WCFP.
25. Unidentified clipping, October 12, 1913, scrapbook #32, WCFP.
26. Oswald Stoll to W. C. Fields, August 13, 1913, scrapbook #29, WCFP.

27. *The Stage*, October 16, 1913; *Daily Mail*, ca. October 13, 1913; *The Star*, October 13, 1913, scrapbook #2, WCFP; unidentified clipping, October 13, 1913, scrapbook #2, WCFP.
28. Oswald Stoll to W. C. Fields, October 14, 1913, scrapbook #2, WCFP.
29. Shepherds Bush Empire playbill, October 13, 1913, scrapbook #2, WCFP; "Empire Theatre," *Preston Herald*, October 25, 1913, October 29, 1913, scrapbook #29, WCFP.
30. *Chatham Standard*, November 19, 1913, scrapbook #29, WCFP.
31. *WCFBH*, 50.

## 16    "THEY HAD ME SWEATING BLOOD"

1. *NYT*, January 11, 1914.
2. *Daily Sketch*, February 19, 1914, scrapbook #29, WCFP; *WCFBH*, 51.
3. *Rand Daily Mail*, January 27, 1914, box 9, WCFP.
4. *Durban Pictorial*, February 13, 1914; unidentified clipping, February 14, 1914; *Natal Mercury*, February 10, 1914; *Natal Advertiser*, February 10, 1914, scrapbook #29, WCFP.
5. *WCFBH*, 51.
6. *WCFBH*, 54; Harry Langdon to WCF, May, 28, 1935, box 3, correspondence L personal, WCFP.
7. *WCFBH*, 52.
8. "W. C. Fields at 'At Home'," Melbourne *Table Talk*.
9. W. C. Fields, "From Boy Juggler to Star Comedian," 76.
10. *WCFBH*, 55.
11. Fields, "From Boy Juggler to Star Comedian," 44.
12. Mary B. Mullett, "Bill Fields Disliked His Label, So He Laughed It Off." *American Magazine*, January 1926, 143.

## 17    BACKSTABBED

1. W. C. Fields, "From Boy Juggler to Star Comedian," 44.
2. *New York Evening Journal*, October 10, 1914; *Variety*, October 10, 1914, scrapbook #29, WCFP.
3. Irene Castle as told to Bob and Wanda Duncan, *Castles in the Air* (Garden City, NY: Doubleday, 1958), 86; Mrs. Vernon (Irene) Castle, *My Husband* (London: John Lane, 1919), 65.
4. www.answers.com/topic/watch-your-step; accessed March 11, 2014; Laurence Bergreen, *As Thousands Cheer: The Life of Irving Berlin* (1990; repr, New York: Da Capo, 1996), 101.
5. Harry B. Smith, *First Nights and First Editions* (Boston: Little, Brown, 1931), 281; *Castles in the Air*, 133.

6. *Variety*, November 26, 1914, scrapbook #29, WCFP; "W. C. Fields—Who Wouldn't Play Stooge to a Dummy," *Chicago Daily News*, May 21, 1938, clipping, scrapbook #3 & oversize #67, WCFP.
7. "W. C. Fields—Who Wouldn't Play Stooge to a Dummy; "Autobiography #1," box 20, file #2, biographical writings, "W. C. by Himself," WCFP.
8. "W. C. Fields—Who Wouldn't Play Stooge to a Dummy."
9. Zeitlin, "W. C. Fields' Real Life Story," 83.
10. Ibid.
11. *WCFBH*, 55–56.
12. Fields to Dillingham, December 12, 1914, CBD.
13. Stefan Kanfer, ed., *The Essential Groucho: Writings by, for, and About Groucho Marx* (New York: Vintage Books, 2000), 45.
14. *Columbus Journal*, January 12, 1915, scrapbook #29, WCFP; letter to Bruce Edwards, January 19, 1915, CBD; Groucho Marx and Richard Anobile, *The Marx Brothers Scrapbook* (New York: Darien House, 1973), 17–18.
15. *The Marx Brothers Scrapbook*, 17–18.
16. *Poppy* advertisements, box 9, clippings 1920–29, WCFP.
17. W. C. Fields, "Confessions of a Tramp Juggler."
18. W. C. Fields, "From Boy Juggler to Star Comedian," 76.

## EPILOGUE: THE DEFINING MOMENT

1. "Talk of the Town," *New Yorker*, January 25, 1947, clipping, WCF file, NYPAL. Several anecdotal tales have been written about how Fields's started with the *Follies*. The story presented here seems the most logical one.
2. Sally Benson, "It Is Much Easier to be Funny Without Saying Anything," *NYST*, January 13, 1924.
3. "Talk of the Town."
4. *Duluth Herald*, April 22, 1915, WCF file, NYPAL.
5. Ziegfeld correspondence, box 19, WCFP.

# Index

Page numbers in bold refer to illustrations.

Academy of Motion Pictures Arts and
 Sciences, xiii–xiv, 1
Advanced Vaudeville circuit,
 181–2, 183
African Americans, 76, 149–50.
 See also *Ham Tree, The;*
 minstrel shows
African Theatres Trust, 214
Albee, Edward F., 92, 181, 194
alcohol, use of
 by WCF, 4, 5
 by WCF's father, 22, 144
 by WCF's grandfather, 14, 17
 by WCF's mother, 19
"Amazing Peregrinations and
 Pettifoggery of One William
 Claude Dukenfield, The..."
 (museum exhibit), 1
American Minstrels (minstrel show),
 74, **75**–6
Antrim, Harry (boyhood friend),
 36, 48
Arlington House, Darby,
 Pennsylvania, 9, 10, **11**
asides, comic, Fields's use of, 19–20,
 74, 89
Association of Vaudeville Managers
 (AVM), 92
Atlantic City, New Jersey, 58–9, **60**,
 74, 219
Australia, 126–31, 215–16
automobiles, Fields's passion for, 164,
 170, 200–1

"Back Porch, The" (stage sketch), 2,
 20–1, 28, 171, 186–7. See also
 *It's the Old Army Game* (1926)
 and *It's a Gift* (1934) (film)
Baker, Tony, 57, 58
balance. *See* juggling
*Ballyhoo* (stage show), 124
*Barber Shop, The* (film), 16, 20
Barnes, Paul (tramp performer), 50
Barrasford, Thomas, 108
Bartram, John, 9
Batley Hall (Philadelphia), 53, 54
Beck, Martin, 84, 113, 127, 187, 194
bell boys, argument with, 152–3
Belle Otéro, La (dancer), 99
Berlin, Germany, 98–9
 performances in, 94, 101–2, 117,
 145, 207
Berlin, Irving, 220, 221
Bernhardt, Sarah, 195, 209, 210
*Big Broadcast of 1938, The* (film), 124
Bijou Theatre, Keith's (Philadelphia),
 45, 51, 93, 186
*Billboard* magazine, 153
billiard acts, 44, 122. *See also* pool routines
blackface, 63, 74–76, **75**. *See also*
 McIntyre and Heath
Bloom, Lew (tramp performer), 50
Boer War, second, 131
booking arrangements
 alliance between Keith/Orpheum
 circuits, 91, 92, 194
 commissions, 58, 164, 222

booking arrangements—*Continued*
  in England, 117, 197, 199, 204–5
  United Booking Offices (UBO), 93,
    181–2, 183, 184, 185, 222
  wildcatting, 62
Bowery Theatre (New York), 73, 80
Bowyers, John (boyhood friend), 23
Brisson, Carl, 145
Broadway
  pool routine on, 124
  *Ham Tree, The,* 149–53
  *Watch Your Step,* 219–22
  *Ziegfeld Follies,* 2, 4, 28, 124, 171,
    227–8
Brunswick-Balke-Collender
    Company, 122
Bryan, William T., 63
Buchanan-Taylor, W. "Bucky,"
    101, 202, 209
Buck, Gene, 227–8
Burgess, Gelett, 86–7
burlesque shows, 61–3, 64–7, 69,
    73–4, 76–8, 79–82, 85
Burns, George, 38
Bushnell, Frederick, 88
Byrne, Matthew, 43
Byrne Brothers, 43, 100

"Caledonian Express, The" (stage
    sketch), 205
Cantor, Eddie, 38
Carle, Teet, 38
cartoons, 51, 189–92
Castle, Irene, 220, 221
Castle, Vernon, 220
Catholicism, 12, 63, 78, 79, 88–9, 160, 163
Chaplin, Charlie, 38, 198–9
Chapman, John, 38
charlatan character. *See* con man
    character
child labor in Philadelphia, 24–5, 38
chorus girls, 62, 63–4, 66, 171
cigar boxes, tricks with, 52, 53–4, 81,
    83–4, 101, **204, 224**

cigar shop, Fields works in, 27
Cinquevalli, Paul, 44, 46, 122
circuses, 43, 61, 71, 76–7, 100
Civil War, xxiv, 15, **32**, 194
classes, social
  in England, 102, 105, 144, 198, 205
  in Philadelphia, 28–9
  *See also* economic conditions
Coliseum (London), 202–3, **204**,
    205–6, 209–10
comedy. *See under* Fields, W. C.
comic strips. *See* cartoons
*Comic Supplement, The* (1925)
    (play), 20
commissions, 58, 164, 222
con man character, xxiii–xxv, 2, 27,
    39, 58, 66–8, 72, 84, 98,
    120–1, 137, 225–6
"Confessions of a Tramp Juggler"
    article (Fields), 152
Coppock, Charles Henry, 157
costumes
  as eccentric character, 116, 118, 127
  as ethnic character, 87
  as millionaire on the skids, 183,
    202, 205
  in Orpheum Show, 114, 116
  of tramp characters, 50, 81,
    106, 113

*D. Dinkelspiel: His Conversationings*
    (Hobart), 192
Dailey, William T., xxiii–xxv, 54, 57,
    73, 77
Daniels, H. A., 124
Darby, Pennsylvania (Fields's
    birthplace), xiv, 9–10, **11**
Depression, Great, 173–4
Dickens, Charles, 18, 98, 140
Dillingham, Charles, 219, 220, 221–2
divorce. *See under* Fields, Harriet
Donaldson, Andy (ice wagon driver),
    27–8
Drew, Sidney, 192

drinking. *See* alcohol
drowning stunt, 60–1
Du Bois, W. E. B., 76
Duckenfield, Ann Lyden
(grandmother), 11, 12, 13, 14
Duckenfield, John (grandfather),
10–12, 13, 14–15
Dukenfield, Adele "Dell" (sister),
19, 20, 21, 23, 33, 86, 125,
144, 186
Dukenfield, Claude William. *See*
Fields, W. C.
Dukenfield, Elsie May (sister), 19, 68
Dukenfield, James Lydon "Jim"
(father)
character of, 21–2
in Civil War, 15, 32, 194
early life of, 12, 14, 15
employment of, 9, 10, 21–2, 30–2
end of life, 193–4
Hattie and, 93, 160–1
marriage of, 15
negative view of show business,
86, 93
relationship with WCF, 22–3, 28,
30–3, 35, 37, 40, 54–5, 58,
86, 144
shell game and, xxiv
visiting Europe, 141–2, 142–3, 144
Dukenfield, Kate (née Felton)
(mother), 16
birth of WCF to, 9
character of, 21
disagreements with Hattie, 160–1
family of, 15–17
humor of, 19–20
tenderness for WCF, 21, 86
and WCF's rift with his father, 35
Dukenfield, Leroy (brother),
19, 21, 22
Dukenfield, Walter (brother).
*See* Fields, Walter
Dukinfield, George
(great-grandfather), 10

Dukinfield, Lord of Cheshire (possible
great-great-grandfather), 10
dumb acts (silent acts), 57, 77, 208
Durban, South Africa, 129, 132

*Earl Carroll Vanities* (1928), 24, 205
eccentric performers, 87, 88, 89, 93,
115–16, 127, 183
economic conditions, 38
in England, 198
Great Depression, 173–4
inequality, 80
Panic of 1857, 14
Panic of 1893, 21
Edward VII, King, 103, 203, 206, 209
*Eight Bells* (Byrne), 43
Empire Theatre (Glasgow, Scotland),
201–2
Empire Theatre (London), 105
Empire Theatre (Shepherds Bush,
England), 201, 210
England
as Fields's second home, 197–211
billiards routines in, 122
booking arrangements in, 117, 197,
199, 204–5
economic conditions in, 198
industrialization in, 13, 102–3, 107
theater culture in, 103–6, 107, 197–200
WCF's first performance in, 102
WCF's heritage, 10
WCF's return engagements in,
136–7, 139–41, 143, 197–211
*Era, The,* 103, 107, 137, 140, 201, 202,
206, 208
Erlanger, Abraham, 146, 181, 182
ethnic characters, 87
ethnic humor, 114, 192
Europe. *See* specific countries

*Fatal Glass of Beer, A* (1933) (film), 34
Felton, Annie (grandmother), 17, 36,
53, 54
Felton, Grant (uncle), 36, 115

Felton, Kate Spangler. *See* Dukenfield, Kate
Felton, Thomas (grandfather), 17
Felton, William Claude (uncle), 17, 18, 36, 73
Feltonville, Pennsylvania, 16
Fendick, Hilda (Maud's sister), 157, 176–7
Fendick, Hope (Maud's adopted daughter), 173, 176–7
Fendick, Maud Emily (romantic partner), **158**
  arrival in America, 157
  background of, 157
  bitterness about Hattie, 170–1, 173, 175
  character of, 157
  end of life, 176–7
  Hattie's confrontation with, 161–2
  letters after separation, 172–6
  relationship with WCF unraveling, 171–3
  traveling as Mrs. Fields, 169–70
  in WCF's will, 173, 176
Fields, Claude (son). *See* Fields, William Claude, Jr.
Fields, Harriet (granddaughter), xiii
Fields, Harriet Veronica "Hattie" (née Hughes) (wife)
  health of, 144
  as model of nagging wife character, 171
  nicknames of, 90, 141
  personality of, 157
  physical characteristics of, 63
  relationship with WCF
    arguments with WCF, 115, 159–61
    as chorus girl, 63–4
    as Claude's primary caretaker, 201
    confronting Maud, 161–2
    courtship of, 68–9, 78–9
    financially supported by WCF after separation, 163, 164–6, 167, 206, 207–8, 211, 214, 222

  influences WCF's interest in literature, 97–8
  marriage of, 88–9
  meeting WCF's family, 93
  pregnancy of, 135, 136, 139, 140–1
  refusing to divorce WCF, 163, 169
  wanting to settle down, 90, 125, 158–9, 160
  in WCF's will, 173
  travels of
    joining WCF in Australia, 128–9, 131
    refusing to travel to Australia, 125
    in South Africa, 135
    traveling to England with baby Claude, 142
  and WCF's routine
    as assistant in burlesque and vaudeville shows, 77–8, 88, 92, 101, 106–7, 110, 115, 125, 129
    on playbill, 114–15
Fields, Lew, 53, 122
Fields, Maud. *See* Fendick, Maud Emily
Fields, Ronald J. (grandson), xiii, xv, 1
Fields, W. C.
  birth and birthdate of, 9, 10, 18, 19, 88
  career of
    on Advanced Vaudeville circuit (1907), 181–2
    back to England (1913), 208–9
    as comedy juggler after *Ham Tree* (1907–1910), 181–6
    on Empires/Stoll Circuit in England (1908), 199–200, 201–2
    engagement for *Ziegfeld Follies* (1915), 227–8
    England again, playing at Coliseum for royal family (1913), 209–10

as entertainer in variety of
performance arts, 2
first European tour (1900–1901),
94, 97–100, 101–2, 106–11
first performances in
Philadelphia clubs and halls,
Plymouth Park, Atlantic City,
and *The Monte Carlo Girls*
(1898–1899), 48–9, 53–4,
57–61, 65–6
in Fulton's burlesque show
(1898–1899), 61, 62–3, 64–9,
73–4
in *The Ham Tree* (1905–1907),
149–53, 181
high points of, 224–5
as illustrator, 189–92
imitators of, 183–4
inspiration for, 43, 44, 45
in Irwin's burlesque show
(1899–1900), 76–82, 84
joining Broadway's *Watch Your
Step* (1914), 219–22
joining Orpheum Circuit (1900),
85, 87–8, 89–90, 91–4
on Keith-Albee Circuit
(1908–1910), 183, 184–6
literary influences on, 98
in minstrel show (1899), 74–6
as museum entertainer (1899),
71–2
on Orpheum Circuit
(1912–1913), 187–9, 192–4
with the Orpheum Show
(1901–1902), 113–16
performing at Coliseum
(1908–1909), 202, 203–6,
209–10
playing at Palace (1913), 194–6
playing in Antipodes
(1903–1904), 124, 125–36
return engagement in Antipodes
(1913–1914), 211, 213–14,
215–16
second European tour (1902),
117–20, 122
stage fright, 57–8, 59, 65–6, 151
stage names of, 48–9, 53, 64
third European tour
(1904–1905), 136–7, 139–40,
142–3, 144–6
on vaudeville trail after Broadway
(1914–1915), 222–4
characteristics
bad temper of, 115, 152–3,
159–60
belief in self-reliance, 80–1, 125,
166, 174, 175, 198, 214
callousness of, 4, 36–7, 166, 174,
175–6, 194
cynicism of/duping suckers, xv,
27, 31, 36, 39, 60–1, 166
dialect of, 98
dislike for authority, 36, 37,
58, 74
dislike of marriage, 163, 171
dislike of religion, 89, 160
dislike of sentimentality, 36–7
fear of losing money, 88, 164, 216
generosity, 4, 166, 214–15
insecurities, 94, 115, 159, 186,
207, 217, 222
insomnia, 207
stressing manliness of, 152–3
tenacity of, 36, 166, 194
traits shared with father, 22
traits shared with grandfather, 15
wanderlust of, 23, 90, 94,
159, 171
comedy
development of, 19–20, 80–1,
89–90, 92–3, 137, 225–6
appeal to families, 135, 140, 143,
199–200
henpecked husband character, 2,
4, 29, 171
from his own experiences, xv,
20–1, 24, 29, 34, 72, 186–7

Fields, W. C.—*Continued*
  influenced by stage career,
    2–3, 58
  juggling and, 3, 46, 47, 48,
    74, 225
  pantomime in, 3, 89–90, 100,
    111, 152, 187, 208, 225
  poking fun at morality, 182–3
  pool routine in, 120–4, 128
  style of, 20
  through missed tricks, 81,
    89–90, 101
  through surprise, 89–90, 206
  use of asides in, 19–20, 74, 89
  *See* props/objects
  health of, 102, 142, 200
  names of
    birth name of, 18–19
    nicknamed by Hattie, 90,
      126, 141
    nicknamed Whitey in boyhood,
      xxiii, 23
  physical appearance of, xxiii, 22,
    64, 135, 139, 153, 215, 227
  relationship with father
    birth of Claude and, 141
    in childhood, 22–3, 28, 30–3,
      35, 37, 40, 58
    Jim's mistrust of show business,
      54–5, 86
    Jim's visit to England, 142–3, 144
    later in life, 193–4
  relationship with Hattie
    arguments starting, 115
    courtship of, 68–9, 78–9
    financial support of, 163, 164–6,
      167, 206, 207–8, 211, 214, 222
    first meeting with, 63–4
    looking back on, 4, 188
    marriage of, 88–9
    as newlyweds, 90–1
    pregnancy and, 135, 139, 140–1
    protective of, 91, 130–1

  separation from, 162–3
  tension mounting, 159–61
  relationship with Maud Fendick
    affair with, 157–8, 161–2
    ending of affair, 171–3
    financial support of, 172, 174–6
    tension developing, 170–1
    traveling with, 169–70
  relationship with mother, 21, 35, 86
  relationship with son, 4, 163,
    194, 201
  salary of
    in England, 208
    financial support of family and,
      163–5, 211, 214
    for *Ham Tree,* 146
    in Irwin show, 77, 80, 81, 85
    play-or-pay contract, 132
  silent movies
    *It's the Old Army Game* (1926), 2,
      21, 28, 186
    *Pool Sharks* (1915), 2, 124, 128,
      225
    *Sally of the Sawdust* (1925), xv,
      **xxiv,** 226
    *So's Your Old Man* (1926), 29,
      171, 225
    *Two Flaming Youths* (1927), 72,
      166, **224,** 225
  sound movies
    *Barber Shop, The* (1933), 16, 20
    *Big Broadcast of 1938, The* (1938),
      124
    *Fatal Glass of Beer, A* (1933), 34
    *Follow the Boys* (1944), 124,
      128, 225
    *Golf Specialist, The* (1930), 2
    *International House* (1933), 20
    *It's a Gift* (1934), 2, 21, 28, 49,
      171, 186–7, 225
    *Man on the Flying Trapeze* (1935),
      171
    *My Little Chickadee* (1940), 18

*Old Fashioned Way, The* (1934), 32, 37, 67–8, 225, 226
*Poppy* (1936), xv, 36
*Sensations of 1945* (1944), 205
*Six of a Kind* (1934), 124
*You Can't Cheat an Honest Man* (1939), 61, 72
*You're Telling Me* (1934), 29, 163
stage appearances
  as eccentric character, 116, 118, 127
  as ethnic character, 87
  as millionaire on the skids, 183, 202, 205
  in Orpheum Show, 114, 116
  as tramp character, 50, 81, 106, 113
  as vaudeville juggler, 222
stage sketches/shows
  "Back Porch, The" (stage sketch), 2, 20–1, 28, 171, 186–7
  *Ballyhoo* (stage show), 124
  "Caledonian Express, The" (stage sketch), 205
  *Comic Supplement, The* (1925) (stage show), 20
  *Earl Carroll Vanities* (1928) (revue), 24, 205
  *Ham Tree, The* (1905–1907) (stage show), 149–53
  *Monte Carlo Girls, The* (burlesque show), 61, 62–3, 64–5, 66–7, 69, 73–4
  "My School Days Are Over" (stage sketch), 24
  *Poppy* (1923–24) (Broadway play), xv, 36
  "Sleeping Porch, The" (stage sketch), 2, 20–1, 28, 171, 186–7
  *Watch Your Step* (1914) (Broadway show), 219, 220–2, 227

*Ziegfeld Follies (revue)*, 2, 4, 28, 124, 171, 227–8
tall tales (anecdotes) about, 30, 33, 34, 37–9, 131, 203
travels abroad
  Australia, 125–31, 215–16
  England, 103, 104, 136–7, 184, 186, 197–211, 201–2, 206–7, 207–8
  Europe, 94, 97, 98–100, 101–2, 106–11, 116–18, 122, 142–6, 207
  South Africa, 131–6, 211, 213–14
use of alcohol by, 4, 102
vaudeville expenses of, 163–4
will of, 173, 176
writings by
  "A Regular House," Los Angeles Orpheum, 189
  "Confessions of a Tramp Juggler," 152
  "Most Delectable Food I Ever Tasted, The," 35
  "New Juggling Tricks," 81–3
youth, xxiii–xxv, 22–5, 27–8, 30–4, 35–6, 37, 38, 39–40
  education, 23–4;
  jobs in, 25, 27–9, 30–2
  as runaway, 33–6, 37–9
  sexual initiation, 64
  twenty-first birthday, 102
Fields, Walter (brother)
  as assistant in WCF's show
    on Australia/South Africa trip, 125–6, 128, 131, 132, 133, 135
    in London, 202, **204**, 205
    in US on vaudeville trail, 222
  birth of, 19
  and his father, 23
  on WCF and their father, 54–5
  on WCF as boy away from home, 35

Fields, William Claude, Jr. (son)
  birth of, 141
  as child, **162**
  correspondence with WCF, 208–9
  Hattie's control over, 163, 166, 201
  in Hattie's letters to WCF, 160
  with his grandfather, 193
  infancy of, 142
  interest in music, 167
  on Maud Fendick, 157
  relationship with WCF, 4, 163,
      194, 201
  on WCF's interest in literature, 98
  on WCF's marriage, 163
  in WCF's will, 173
Fields Papers, xiii, 1–2
films
  pantomime in, 225
  slow start in, 199
  stage sketches recycled in, 2, 20–1,
      28, 123–4, 186, 205
  *See also under* Fields, W. C.
Finigan, Harold (resident of Darby,
      Pennsylvania), 10
flinch, Fieldsian, 3, 32, 90, 101, 225
Folies-Bergère (Paris), 109–10,
      142, 211
*Follies. See Ziegfeld Follies*
*Follow the Boys* (1944) (film), 124,
      128, 225
Fortescue's Pavilion (Atlantic City,
      New Jersey), 58, 59–**60**
fraud. *See* con man character; theft
*Fred Irwin's Burlesquers*, 3, 76–8,
      79–81, **82**, 84, 85
Fulton, James C., 62–3, 64, 65, 66–7,
      73, 74

gallery gods, 73
George V, King, 206, 209, 215
"Georgia Minstrels, The" (McIntyre
      and Heath), 149
Geraghty, Tom, 39

Germany
  performances in, 94, 101–2, 108,
      117, 145, 146, 207
  stealing routines in, 100, 183–4
  treatment of entertainers in, 99
  World War I, 215–16
Gibson, Alf A., 74, 75
Glasgow, Scotland, 201–2, 206
Glover, Edwin, 123
Gold, Belle, warns Hattie about Maud
      Fendick, 161
golf sketch, 2
*Golf Specialist, The* (1930) (film), 2
Grady, Bill, 53, 171

*Ham Tree, The* (Hobart), 149–53
  as new opportunity for WCF,
      146, 147
  WCF's affair during, 159, 160, 161
Hammerstein, Willie, 183, 194
Hana, George Henry, 158
Happy Hooligan, 51, 192
Hargitt, Georgie
  letters to Harriet Fields about Maud
      Fendick and WCF, 161–3,
      165, 167
Harkins, Jim, 90
Harrigan, James Edward (tramp
      juggler; influence on Fields),
      51–3, 81
Hawaii, 126
Heath, Thomas. *See* McIntyre and
      Heath
Hinds, George (train station agent), 68
Hippodrome (London), 117, 137, 202
Hobart, George V., 192
hobos. *See* tramp character
Hodgdon, Samuel, 123
Holland, Bert, 183
hook, removing performers from stage
      with, 73
Hotel Spalding (Duluth, Minnesota),
      152–3

Houdini, Harry, 99, 137
Huber's Palace Museum (New York), 71–2
*Huckleberry Finn* (Twain), 98
Hughes, Elizabeth "Lizzie" (Hattie's mother), 63, 78–9, 113, 167
Hughes, Harriet "Hattie" (wife). *See* Fields, Harriet
Hughes, John (Hattie's father), 63
Hughes, Kathryn "Kitty" (Hattie's sister), 113, 141
"Human Billiard Table, The" (Cinquevalli), 44, 122
Hunt, Thomas (boyhood friend), 34, 36, 46
Hyman, Sydney, 133–4
Hynes, Samuel, 105

ice wagon, Fields's job on, 27–8
illustrations, 51, 189–92
imitation
    of Harrigan, 52–3
    WCF's fear of others copying him, 100, 183–4
India, 216
Industrial Revolution, 13, 14, 102–3
industrialization
    in England, 13, 102–3, 107
    in Philadelphia, 14, 17–18
*International House* (1933) (film), 20
Irwin, Fred, 76–7. See also *Fred Irwin's Burlesquers*
*It's a Gift* (1934) (film), 2, 21, 28, 49, 171, 186–7, 225
*It's the Old Army Game* (1926) (film), 2, 21, 28, 186

James, Henry, on Philadelphia, 18
Jardin de Paris (New York), 182
Johannesburg, South Africa, 133, 213
Johnston, Alva, 38–9
juggling
    balance and, 46, 118

    in burlesque, 79–80
    childhood work and, 28
    comedy and, 3, 46, 47, 48, 74, 225
    as eccentric character, 87, 88, 89, 93, 115–16, 127
    imitators of Fields, 183–4
    inspiration to become, 43–4
    in minstrel show, 76
    practice at, 45–6, 110, 118, 146
    requirements of, 100, 110, 152
    as tramp character, 49–50, 51–4, 65, 73, 81
    tricks, 47–8, 81–3
    WCF's beginning in, 45–9, 57–8, 59–60
    *See also* missing tricks

Karno, Fred, 199
Keaton, Buster, 159, 164, 223
Keith, Benjamin Franklin, 71, 91, 181
Keith Circuit, 51, 123, 183, 185, 193
    Orpheum Circuit and, 91–2, 194
Keith's Bijou Theatre (Philadelphia), 45, 51, 93, 186
Kent, Ohio, 67, 69
Klaw, Marc, 146, 181, 182
Knickerbocker Ice Company, 27–8
Koster and Bial's New Music Hall (New York), 93–4
Krystall-Palast Theatre (Leipzig, Germany), 108

Labov, William, 98
Lacelle, Pat, 193
Lane, Jimmie (boyhood friend), 47
Langdon, Harry, 215
Langtry, Lillie, 140, 209
Laurie, Joe, Jr., 105, 184
Leavitt, Michael Bennett, 61–2
Leipzig, Germany, 108
Leno, Dan, 105
Licht, Walter, 14
Lloyd, Harold, 9, 111

Loftus, Marie, 139–40
London, England
  theater culture in, 103–5
  theaters in, 105–6, 117, 137, 140, 202–3
Lorette, H. M. (boyhood friend), 47, 52, 59, 60
Los Angeles, California, 89, 188
Lovenberg, Charles, 123
Lyden, Ann (later Ann Duckenfield) (grandmother), 11, 12, 13, 14

*Magician's Handbook* (Selbit), 81
*Man on the Flying Trapeze* (film), 171
Manchester, England, 143–4
Marriage. *See* Fields, Harriet
  jibes against, 163, 171
Marx Brothers, 222–3
Mary, Queen, 209, 210
Matcham, Frank, 201, 208
McIntyre, James. *See* McIntyre and Heath
McIntyre and Heath
  in England, 106
  in *Ham Tree,* 146, 149, 150–1
  in Orpheum Show, 113–14
  WCF's illustration of, 189
Melbourne, Australia, 127, 215, 216
Metz, Theodore A., 63
military themes in *The Monte Carlo Girls,* 65, 66
Milner, Alfred, 134–5
Miner, Henry, 73
minstrel shows, 62, 74–6, 149, 150
missing tricks
  blaming Hattie as cover-up for, 77–**8**, 107, 115
  comedy as cover-up for, 46
  comedy through, 89–90, 101
  deliberately, 3, 81, 83, 202
  fear of, 59
  through nerves, 49, 101, 117, 134
*Mme. Rentz's Female Minstrels* (burlesque show), 61–2

money
  Fields's fear of losing money, 88, 164, 216
  financial support of Fields's father, 193
  financial support of Hattie, 160, 163–4, 165–6, 167, 201, 207–8, 211, 214–15
  financial support of Maud Fendick, 172, 174–6
  *See also* salaries
*Monte Carlo Girls, The* (burlesque show), 61, 62–3, 64–5, 66–7, 69, 73–4
Monti, Carlotta, 72, 121
morality and performances, 182–3, 204
Morris, William, 85, 93, 127, 129, 193
Morton, Charles, 105–6
Moss, Edward, 117, 140, 199
Moss Empires Circuit (Britain), 117, 139, 184, 199, 201, 203, 204–5, 206–7, 208, 210–11
"Most Delectable Food I Ever Tasted, The" (story), 35
Murphy, John E., 74, 75–6
museums, entertainment at, 71–2
music halls (England), 103–4, 107, 140, 197, 199
*My Little Chickadee* (1940) (film), 18
"My School Days Are Over" (stage sketch), 24

names of characters, 97
Natatorium Hall (Philadelphia), 48
National Scala Theatre (Copenhagen), 144
New Grand Opera House (Melbourne, Australia), 126
"New Juggling Tricks" article (Fields), 81–3
New York City
  Great Depression in, 174
  theater life in, 151–2

theaters in, 73, 80, 93–4, 182, 183, 185, 194, 194–6, 219–20
*New York Vaudeville Stars* (burlesque troupe), 74, 77
newsboy, Fields as, 27
newspapers/magazines reviews
  *Adelaide Register,* 128
  *Birmingham Daily Argus,* 108
  *Chatham Standard,* 211
  *Columbus Journal,* 223
  *Daily Mail* (London), 210
  *Daily Press* (Boston), 73
  *Daily Press* (Portland, Maine), 65
  *Evening Express* (Los Angeles), 89
  *Evening Times* (Buffalo, New York), 189
  *Evening Times* (Rochester, New York), 151
  *Johnstown Pennsylvania Democrat,* 65
  *Kent Courier,* 67
  *Los Angeles Times,* 189
  *Los Angeles Tribune,* 189
  *Manchester Sunday Chronicle,* 183
  *New York Clipper,* 63, 85, 91, 93, 102, 111, 136
  *New York Dramatic Mirror,* 73, 129, 153, 183
  *New York Morning Telegraph,* 186
  *New York Star,* 190
  *New York Times,* 151, 213
  *New Yorker, The,* 38–9
  *Philadelphia Inquirer,* 43
  *Philadelphia Oakdale Weekly,* 24
  *Pittsburg Leader,* 65
  *Rand Daily Mail,* 213–14
  *St Louis Post Dispatch,* 80
  *Times-Democrat* (New Orleans), 193; *See also Variety*
Norris, Frank, 87
Norworth, Jack (boyhood friend), 34, 35

O'Connor, John J. "Wynn," 220
*Old Fashioned Way, The* (1934) (film), 32, 37, 67–8, 225, 226

Opper, Frederick Burr, 192
Orlando (Orland) Social Club, 34, 36, 46–7, 54, 64, 102
Orpheum Circuit, 85, 113, 124, 187, 192
  Beck's management of, 84
  Keith Circuit and, 91, 92, 194
Orpheum Show, 113–16, **114**
Orpheum Theatre (Los Angeles), 89, 188, 189
Orpheum Theatre (San Francisco), 87, 188

Palace of Varieties (London), 105–6
Palace Theatre (New York), 194–6, 219–20
Panic of 1857, 14
Panic of 1893, 21
pantomime
  in England, 106, 143
  Fields's use of, 3, 89–90, 111, 152, 187, 208
  of pool players, 121
  stage fright and, 58
  as universal language, 100, 106, 110, 152, 225
Paramount Studio, 38
Paris, France, 109–10, 142–3, 211
Pasadena, California, 90
Peabody Hall (Philadelphia), 49
performance position
  as dumb act, 57, 77
  going on last, 134, 223
  from headliner in Antipodes back to regular performer in England, 137
  as headliner in England, 139
  as headliner in South Africa, 133, 135
  moved to better position, 79–80, 102
  and other performers, 184–5, 200, 219–20, 223
  at Palace with Sarah Bernhardt, 195
  in Philadelphia, 124
  at Wintergarten in Berlin, 117

Perth, Australia, 215–16
Philadelphia, Pennsylvania
    child labor in, 25
    class divisions in, 28–9
    described, 17–18
    dialect pattern of, 98
    economic downturns in, 14, 21
    Hattie thinking of living in, 167
    John Duckenfield's move to, 13
    pool halls in, 120
    provincialism of, 18
    race in, 76, 150
    theater culture in, 44–5
    WCF's performances in, 48–9, 53,
        54, 73, 93, 124, 182, 186
    WCF's youth in, 17–18, 30, 43, 51
*Philadelphia Negro, The* (Du Bois), 76
play-or-pay contracts, 132, 197
Plymouth Park, Pennsylvania, 57
Poli, Sylvester, 165, 193
pool routines, 2, 120–4, 128, 136–7,
        186, 188, 193, 202
*Pool Sharks* (1915) (film), 2, 124,
        128, 225
pool table prop, 122–3, 125–6, 128,
        193, **204**
Poole, Bessie, 171, 173
*Poppy* (1923–24) (play), xv, 36
*Poppy* (1936) (film), xv, 36
Priestley, J. B., 101, 198
Prop comedian. *See* props/objects
props/objects
    assembly of as teenager, 47
    cigar boxes, 52, 53–4, 81, 83–4,
        101, **204, 224**
    pool table, 122–3, 125–6, 128,
        193, **204**
    pretense at clumsy handling of,
        89–90, 101
    tricks with, 81–4, 92, 107, 118–19,
        144–5
publicity
    about WCF as runaway kid, 3–4,
        33, 37–9, 131

during *The Ham Tree,* 153
    WCF's illustrations as, 190
    WCF's investment in, 88,
        129–30, 186

racism
    Fields's attitude toward African
        Americans, 75–6, 149–50
    in South Africa, 132
rags-to-riches stories, 3–4, 37–9
railroads, 17, 29, 50, 132–3, 213
Rankin, Gladys, 192
religion, 79, 89, 160, 163
Rentz-Santley troupe (burlesque
        show), 61–2
Rickards, Harry, 126–7
Rogers, Will, 129
Russia, 145–6

salaries
    cutting of, 64
    in England, 104, 208
    financial support of family and,
        163–5, 211, 214
    for *Ham Tree,* 146
    insecurity of, 62, 66, 74
    in Irwin show, 77, 80, 81, 85
    play-or-pay contract and, 132, 197
    South Africa performances and,
        134, 214
*Sally of the Sawdust* (1925) (film), xv,
        **xxiv,** 226
San Francisco, 86–7, 188
*San Francisco Dramatic Mirror,* 88
Sandow, Eugene (strongman), 134, 137
Santley, Mabel, 61–2
Sargent, Epes Winthrop "Chicot,"
        113, 116
Sato, O. K. (Frederick L.
        Steinbrucker), 52–3
    letters to, 133, 135–6
*Screenland,* 38
self-reliance, Fields's belief in, 80–1,
        125, 166, 174, 175, 198, 214

*Sensations of 1945* (film), 205
sexuality/vulgarity in performances
  barred from Stoll/Empires shows,
    140, 199, 204
  in burlesque, 61–2, 65, 79
  in Folies-Bergère shows, 109–10
  morality lampooned in WCF's
    humor, 182–3
  in WCF's comedy, 20, 24
Sheffield, England, 11, **12**, 13,
    141, 208
shell games, xxiii–xxv, 72
Shubert brothers, 181
silent acts (dumb acts), 57, 77, 208
Silverman, Sime, 62, 185, 195,
    221, 227
Sinclair, Johnny, 166
*Six of a Kind* (1934) (film), 124
"Sleeping Porch, The" (stage sketch),
    2, 20–1, 28, 171, 186–7. See
    also *It's the O ld Army Game
    (1926)*; *It's a Gift* (1934)
    (films)
Smith, Harry Bache, 220–1
social classes. *See* classes, social
*So's Your Old Man* (1926) (film), 29,
    171, 225
South Africa, 131–6, 213–14
stage fright, 57–8, 65–6, 151
stage sketches
  recycled in films, 2, 20–1, 28,
    123–4, 186, 205
  *See also under* Fields, W. C.
Standard Theatre (St Louis), 80
Steel Pier (Atlantic City, New Jersey),
    59, 74
Stoll, Oswald, 140, 199, 203–4,
    209, 210
Stoll Companies, 199, 204
Stone, Fred (dancer), 73
Strawbridge and Clothier's (store),
    28–9, 30
strongmen, 44, 124, 134, 137
stuttering, 57–8, 66

suicide, 185
Sweet, Charles R. (tramp performer),
    50
Swinburne, Eva (burlesque performer),
    63, 66, 67

*Table Talk* magazine, 170, 215
Tate, Harry (music hall star)
  influence on Fields, 122, 210
Taylor, Robert Lewis, 39
theater circuits
  alliances between, 85, 91–2, 181–2,
    183, 194, 199
  in Australia, 126–7
  in Britain, 117, 199, 204–5
  creation of, 62, 77
  wildcatting and, 62
Theatrical Syndicate, 181
theft
  as a boy, 30, 31, 35, 54
  fear of losing money, 88
  stealing juggling tricks, 52–3, 100,
    183–4
  of WCF's savings by father, 28
timing, comedic, 20, 46, 225
Tinney, Frank, 220, 221
Tivoli Circuit (Australia), 126, 127
Tivoli Company (South Africa),
    133–4
Tivoli Empire Theatre (Johannesburg,
    South Africa), 132
Tivoli Palace of Varieties (Cape Town,
    South Africa), 135
Tivoli Theatre (Sydney, Australia),
    128–9, 215
Tivoli Theatre of Varieties
    (Birmingham, England), 108
Tower Circus (Blackpool, England),
    110
tramp character, 49–52, 81, 106,
    113. *See* Fields, W. C., stage
    appearances
"Tramp Juggler, The" (Harrigan),
    51–2

travel. *See* wanderlust; Fields, W. C,
    travels abroad
Trenton Inter-State Fair, New Jersey,
    xxiii
Trocadero Theatre (Philadelphia), 45, 73
Tucker, Sophie, 204
Tully, Jim, 38, 203
Twain, Mark, 98
*Two Flaming Youths* (1927) (film), 72,
    166, **224**, 225

Union Square Theater (New York), 93
United Booking Offices (UBO), 93,
    181–2, 183, 184, 185, 222

Van Tagen, Charles (boyhood friend),
    46–7
*Variety,* 183, 184, 185, 189, 220, 221.
    *See also* Silverman, Sime
Variety Artists' Federation, 205
variety theaters, 103, 140, 198,
    199–200
vegetable/fruit wagon operated by
    Fields's father, 30–2, 45
    Philadelphia market illustration, **31**
Victoria, Queen, 103
Victoria Theatre (New York), 183,
    185, 194

*W. C. Fields: A Life on Film* (Ronald
    J. Fields), xv
*W. C. Fields By Himself* (Ronald
    J. Fields), xv, 1

Waller, Charles, 127, 128
wanderlust, 15, 23, 49, 90, 94,
    159, 171
*Watch Your Step* (1914) (Broadway
    show), 219, 220–2, 227
Watson, Billy, 58
Wayburn, Ned, 150
Weber, Joe, 122
Welch, Joe, 220
Western Circuit of Vaudeville
    Theatres, 85
White, E. B., 38
wildcatting, 62
Williams, Bert, 150
Williams, Bransby (Dickens's
    impersonator), 140
Williams, Percy, 1, 84
Wills, Nat (tramp performer),
    50, 185
Wintergarten Theatre (Berlin), 94, 99,
    101–2, 117, 145, 207

*You Can't Cheat an Honest Man* (1939)
    (film), 61, 72
Young, George (boyhood friend), 23
Young, Waldemar, 188
*You're Telling Me* (1934) (film), 29, 163

Zeitlin, Ida, 37–8
Ziegfeld, Florenz, 182, 227–8
*Ziegfeld Follies,* 2, 4, 28, 124, 171,
    227–8
Zulus, (South Africa), 132

Printed and bound in the United States of America

3/25/16 2x 3/9/16